From Printing to Streaming

'Chanan's rich historical investigations of the evolving technologies of artistic production provide a fascinating new basis for a politics of culture.'
—Michael Hardt, author of *The Subversive 70s*

'Drawing on nearly fifty years of writing and teaching about the media and making films, Michael Chanan presents us with a series of overlapping histories of different media technologies, and the discourses developed around them, which is both authoritative and original.'
—Julian Petley, Honorary and Emeritus Professor of Journalism, Brunel University

Marxism and Culture

Series Editors:
Professor Esther Leslie, Birkbeck, University of London
Professor Michael Wayne, Brunel University

From Printing to Streaming

Cultural Production Under Capitalism

Michael Chanan

First published 2022 by Pluto Press
New Wing, Somerset House, Strand, London WC2R 1LA
and Pluto Press Inc.
1930 Village Center Circle, Ste. 3-384, Las Vegas, NV 89134

www.plutobooks.com

British Library Cataloguing in Publication Data
A catalogue record for this book is available from the British Library

ISBN 978 0 7453 4095 1 Hardback
ISBN 978 0 7453 4096 8 Paperback
ISBN 978 1 78680 801 1 PDF
ISBN 978 1 78680 802 8 EPUB

This book is printed on paper suitable for recycling and made from fully
managed and sustained forest sources. Logging, pulping and manufacturing
processes are expected to conform to the environmental standards of the
country of origin.

Typeset by Stanford DTP Services, Northampton, England

Simultaneously printed in the United Kingdom and United States of America

For Rosa Martha

Contents

Series Preface

Michael Chanan's addition to the *Marxism and Culture* series is a work that is *historical* and *materialist* in all the right ways. Materialism, in the sense operationalised in these pages, matters because capitalism is itself peculiarly allergic to matter. The singularities of cultural mediums and the singularity of the aesthetic products they produce pose questions for an economic system premised on abstracting away all difference, all concrete labour, into the homogeneity of exchange value. Materialism means a double conception of matter: matter as a bodily form, whether of a 'vendible good' or the body of performers and the materiality of social forces that comes from relations. Bodily forms always work in an invisible force field of relations and relations depend on bodily forms to work between. The bodily form of the book and the creative work that makes it is quite different to the bodily form of music. Photography, film, radio, music, television: there are multiple histories to be found in this book.

Outside of the digital world the vendible form of cultural products is different and even in digital form each have different attendant modes of production and consumption. These differences pose resistance to how they can be made into profitable commodities. Full subsumption under capital is elusive, replacement of artistic labour by fixed capital, difficult. As a form of craft labour, artistic production is both (so far) an inelimina-ble residue of older pre-capitalist forms of labour that retained their own guild autonomy and an anticipation of post-capitalist forms of emanci-pated labour. Labour as craft, as paid or wage labour, as professional, as unionised or not, as amateur, as above and below the line talent, in short, all the struggles to configure or contest the technical and social division of labour, is another important history woven into Chanan's story. Along with labour and capital, goes tussles over ownership, control, royalties, aesthetics, monopoly capital and independents of various hues.

This book is a world away from the so-called 'new materialism' which is popular in media studies. New materialism is a regression, bracketing off social relations in any substantive, structured sense. It is a new empiricism in many ways. The original empiricist was peculiarly also a relativist. For David Hume, every connection perceived by the senses was

merely a custom imposed by the mind and no more could be said about a cause and effect than it was a 'constant conjunction'. The new materialism has reunited empiricism and relativism, which went their separate ways for a while.

By contrast in *From Printing to Streaming* the reader will find fascinating mini-histories of cultural forms, their technological basis, as well as their interdependencies with the broader infrastructure of capitalism. The reader discovers secret connections between technologies, cultures, aesthetics and mediums. Pianos, clocks and print media, for example, have points of connections that a historical materialist methodology is or ought to be particularly interested in, since, as Fredric Jameson once said, history is at one level, an indivisible web.

A first condition of any approach to cultural production is to find a point somewhere between the excessive pessimism of Adorno regarding the culture industry and at the other end of the spectrum, the apologetics which celebrate the subsuming of culture into international capitalism. But this attitudinal stance must be grounded in a robust methodology of historical materialism and specifically, what Raymond Williams would call cultural materialism, of which this book is a fine example. Historically a linear approach may have its virtues, but here we see the benefits of moving sideways and backwards as well as forwards. Spatially as well, culture moves in ways that require crossing borders and continents freely.

In line with the series editors' preferences, this book exhibits an authorial style that lifts it above bland academic discourse. Style is an important part of aesthetic pleasures and it also indicates creative individuation in scholarly work as well. If you can express yourself in an individuated style it would be a contradiction to not be sensitive to specificities of various sorts, such as how the technical structure of an artistic medium relates to other variables such as labour, capital, audiences, production. For historical materialism the specific and the universal can be synthesised: the materiality say of a technical structure can be synthesised with the 'universal' or rather the pseudo-universal that is capital, and its all-encompassing pressures and patterns that accompany the drive to commodify, to exploit and to profit from culture. That larger story has always been the strength of historical materialism, but what has always been the challenge has been to then drill down into the rich deposits of cultural history. And drill down this book does.

Mike Wayne and Esther Leslie, November 2021.

Preface

The coronavirus pandemic which engulfed the world in early 2020 has thrown the thesis of this book, which was written under lockdown but conceived in beforetimes, into unexpectedly sharp focus, because cultural workers, like many people in other sectors where activity ceased, have been heavily exposed to the effects of lockdown on their jobs and employment. In Britain, when the performance arts shut down along with museums, art galleries and libraries, and the government offered support for stricken institutions and venues, it emerged that this did not extend to the greater number of those they employed, because some 70 per cent of actors, musicians, dancers, comics and the like were not in fixed jobs but worked in the gig economy under terms which entitled them to no dedicated support. According to a Musicians' Union survey, reported on the same day as lockdown was declared, musicians had already lost an estimated £13.9 million in earnings through cancellations, the closure of schools and the suspension of private teaching, because everyone could already see what was coming. An article in the *Guardian* a week later provided examples under the headline '"Stressed, sick and skint": how coronavirus is hitting arts workers': a screenwriter, a lighting engineer, a comedian, an actor, the director of a theatre education company, an independent writer and lecturer, a live audio systems engineer, a dancer, an artist, a gallery worker, a cellist, a stage manager, a self-employed art tutor (my sister-in-law is one of these), a community artist, an opera singer, a theatre producer – all of whom are used to working hand-to-mouth, contract to contract, gig to gig, all of which were cancelled.

The first response of the spokespeople and stars of the cultural sector was ideologically overdetermined, namely, to put forward the economic arguments in favour of special support for the arts, supposing these to be the only arguments the politicians would listen to, justifying the role of the arts not only in terms of soft power as the projection of the nation's cultural identity but as a tourist magnet, and pointing to the sector's high earnings for Treasury coffers. The figures were quoted. In 2018, the UK's creative sector, which had been growing at five times the rate of

the wider economy and employs more than 2 million people, contributed £111.7 billion to the economy, exceeding the automotive, aerospace, life sciences and oil and gas industries combined. These figures are inflated not only by film and television production but also new media like video games, affirming the transmutation that the term 'the arts' has undergone in public discourse ever since 'popular culture' began to overwhelm 'bourgeois culture' in the 1950s. (Before that, they lived side by side.)

In 2019, Jeremy Corbyn had been pooh-poohed for proposing universal broadband. A year later the population was divided by its unequal distribution as people turned to their screens for remote working, home schooling, online shopping, social communication and entertainment, accentuating trends that have been decades in the making. Some of these trends are beneficial but there is also a downside: during the first months of the pandemic, internet usage rose by 40 per cent, led by streaming video. According to one report, video, gaming and social media account for more than 80 per cent of internet traffic (YouTube alone accounts for over 15 per cent and Netflix 11 per cent). Even if major data centres were powered by renewable energy, the carbon footprint that results from this activity is huge and set to grow. The pandemic has only exacerbated a situation that is ecologically unsustainable.

The paradox of the digital domain, or one way of putting it, is that it's both private and commons. On the one hand, it serves the interests of commerce and capital accumulation; on the other, it enables both information and cultural expression to escape commodification and enter free circulation. On the one hand, the tools of data-farming and of surveillance; on the other, the instruments not just of democratic participation but also the means of aesthetic creation. This, however, only gives rise to further dissonance, whereby democratic participation in the virtual public sphere reveals democratic deficits and deep divisions in the lived reality, and their expression becomes divisive and antagonistic. As for the focus of my interests here, the apparently infinite hunger of the internet for the whole of culture has done little to enrich what is largely, beyond social media, the programmed interaction of gaming or interactive web sites, a passive mode of consumption. Neither capitalism nor authority think of the audience as sentient human beings but merely as punters, and 'the arts' are treated as a marginal economic problem, but not as if the experience they provide matters existentially, for both the individual and the social body. Meanwhile, the digital domain is not just a virtual

public sphere but has intervened structurally and materially in social reality by reconfiguring it, in ways that the pandemic starkly exposed. This reconfiguration, in the long view, is built upon the prior transformation of cultural production which began in the late nineteenth century with the emergence of what would soon be called the mass media. It is the long view – the historical evolution of cultural production that began with the invention of printing and was then transformed by new means of mechanical reproduction over the past century and a half – that forms the subject matter of this book.

* * *

The essay is guided by a framework drawn from Marx, for whom culture was a defining feature of being human, but in a perspective in which Marx lived in another beforetime, the mid-nineteenth century, where he found that capitalist production in the cultural sphere was 'so insignificant compared with the totality of production' that it could be left out of account. Mechanical reproduction changed this, first in the heartlands of capitalism and then globally, through the rise of mass media, and the emergence of the culture industry as a distinct sector of capital. I argue that what remains constant, however, both before and since, is the tension which Marx summed up as the hostility of capitalist production to certain branches of what he called 'spiritual production' like art and poetry, which he traced to the autonomous character of aesthetic labour, which escapes the capitalist control of the labour process. Or at least, this is the thesis that the essay seeks to test out.

The treatment takes the form of overlapping histories of different media technologies – printing, photography, the gramophone, the typewriter, cinema, radio, television, etc. – and of the discourses developed around them, either theoretical and aimed at understanding how value is extracted, or the vocabularies invented by the new technologies themselves. Attention is paid to the means of production, mode of production, and mode of consumption, as a framework to rehearse the functions of authorship, the legal fiction of copyright, the business of advertising, the relationship of art and technology, the role of trades unions, and the socially rooted nature of creative labour, including its collaborative disposition. The analysis reveals how each medium manifests its own idiosyncrasies as a commodity, corresponding to what Walter Benjamin

called its technical structure, and therefore manoeuvres the market in its own manner; but also the ways in which, at the same time, cultural production defies commodification or escapes from it to fulfil its social functions. The composer who hears someone whistling a tune of theirs in the street does not stop them and demand their royalties.

I hope I do this without falling into what Jean-Paul Sartre called 'lazy Marxism', which is reductivist, mechanical and deterministic. Marx, if read correctly and sympathetically, is not. But if I try to follow the spirit of his thinking, it's not as if I think the contradictions, antinomies and paradoxes that a Marxian approach allows us to map have any clear resolution, especially in a historical moment where we see the world through a glass darkly. This book is exploratory, sometimes tracing connections that are not unknown but rarely made, and the reader should be warned that the argument offers no closure and no predictions. Otherwise all I ask is that I be forgiven my lapses.

To accomplish this synoptic purview I draw on work across the gamut of my academic writing, beginning with my first published monograph on the history of trade unionism in the British film industry written some 45 years ago. Readers of my work on music and the history of recording, for example, will recognise certain passages or arguments, and I also draw on my studies of documentary, Latin American cinema, the soundtrack and video activism (these being the source of information where no other reference is given).

* * *

There is a focus on authorship, music and film, because these are the modes of cultural production I know best and from the inside. In parts of the account, from the point where the analysis reaches the 1960s, I have skin in the game. My first love was music, but I wasn't cut out to be a performer and my first steps towards a career were as a freelance music critic, leading to my first films for television in the early 1970s on the avant-garde of the day: Pierre Boulez and Karlheinz Stockhausen. Made for BBC2, this provided an early introduction to both the inside of public service television, and because I wasn't on staff but under contract, the precarious nature of freelance employment. There were lessons to be learned at each step. Good fortune played a role, like getting a summer job during my gap year as what would nowadays be called an intern at the

annual summer school of the National Youth Orchestra; the job wasn't very onerous and I spent most of the time sitting in the rehearsals, closely observing how orchestras work and what a conductor does. I envied those young musicians, whose musical talents I couldn't match, although I had a good voice and sang in choirs both before and after my voice broke, so at university (where I studied philosophy), I grabbed the chance when the opportunity arose to do talks about music on the local radio station as well as music criticism in national publications; all the time, I was learning informally how to carve out a possible future living, while I continued my formal learning as a postgraduate (which of course in those days was fully grant supported) without aiming for an academic career.

I also discovered the inside of another creative collective, the film crew, when I had another stroke of luck in my final undergraduate year. I had only made one short (and rather silly) film on Super-8 when a bunch of four of us was invited to make what would later be known as a 'making of' documentary, when Richard Attenborough came to film *Oh! What a Lovely War* on location in Brighton. We were given free rein to film every aspect of the crew at work, from make-up and props to the editing room where the daily rushes were assembled. We watched the shooting, and the crew, in their idle moments, taught us how to use the equipment we'd been provided with, and then how to use theirs. Our footage went off to the labs and came back the next day, and since Attenborough held open rushes viewings, he showed ours after his, and we drew great benefit from the feedback from the assembled crew. It was like a highly intensive apprenticeship. Later, when I began to write about the film industry, it was this experience on which I would model my understanding of the labour process within film production and the nature of aesthetic labour. And a whole lot more too, about the way the industry functions. We had made our film, with neither script nor any kind of written contract, under the aegis of the movie's producer, Len Deighton, who allocated his publicity budget to it. Then he had a disagreement with the film's backer, Paramount, resulting in his credit being dropped. Our agreement with him was to make a film of 30 minutes, and this we had done, after spending the summer editing; we were only waiting for a scene from the finished movie to insert at the end. Paramount, being miffed, didn't even want to see it. We were called to a meeting with their lawyer, who proposed that we deliver them a ten-minute short which they could use to publicise the film in the USA. But the year was 1968, and we were not about

to bow to the demands of a Hollywood corporation. We declined, and our 30-minuter was never completed. However, it served as my showreel when I came up with an idea for a documentary on the nature of musical performance and on the strength of my activity as a music critic, pitched it to the producer of a BBC2 music magazine programme, who gave me a contract to direct it. Up to then, my only inside knowledge of the BBC came from an older brother, who had learned his craft as a film editor there before setting up as a freelance in 1966 (and continuing to work for them). Now I learned for myself how it functioned.

With the second film came a lesson in the complexities of the corporation's internal scissions. In 1971, Pierre Boulez became chief conductor of the BBC Symphony Orchestra. I had met him in 1966 and attended his rehearsals whenever possible. I not only learned about music from him but also about cultural politics, its scope and its limits. When he launched a series of alternative concerts which took place in London's Roundhouse, a favourite venue for rock music, I suggested a film to him about why, which we ended up calling *The Politics of Music*. Teaming up with my brother, we found that the BBC television's classical music department wasn't interested in an item in which its own chief conductor explained what he was up to – they were at odds with their radio counterparts – but the arts department was, and commissioned us. I realised only later that this was unusual, since few films were commissioned from independent producers before the reforms of the early 1990s when it became policy (they called it 'Producer Choice'), but it was evidence of a certain freedom of manoeuvre allowed to arts as opposed to, say, current affairs. Then a different problem imperilled the film, a union demarcation dispute. We were a freelance crew filming BBC personnel on BBC premises for a BBC programme, but would the electricians in the crew have to belong to the BBC house union or to the ETU? The problem was only solved by the diplomatic skills of the BBC Symphony Orchestra's general manager. This encounter with union politics stood me in good stead when I wrote my first monograph, a short study of the history of the film union, although paradoxically I wasn't yet a member – the ACTT allowed me to work but without at first giving me a union ticket.

Those two films were followed by a flirtation with a phenomenon just then emerging, the talk of video as a new distribution market, and I made a series of educational films funded by private risk capital on the unlikely subject of philosophy; I don't believe the investment was ever recouped,

and I'm not particularly proud of them, but many years later they were digitised by an academic film archive and someone put them on YouTube, and they now circulate in philosophy departments. Then after doing a television production training course at a commercial station, I worked on a pilot series for them, but it wasn't taken up and I was out of work. Basically I was in the condition we now know as precarious labour and found myself unemployed until I got a job teaching film in a polytechnic.

I progressed along a path of what I later learned to describe as participant observation of the processes I discuss in this book, as both a filmmaker and an educator. When I first started teaching film, I felt like an unemployed filmmaker employed to teach other people how to become unemployed filmmakers, until new opportunities arose with the creation of Channel 4 at the start of the 1980s, which provided slots for a whole new generation of independent filmmakers belonging to the tradition of the avant-garde, aesthetic, political, and sometimes both, who cut their teeth in the 1960s and 1970s. After spending the best part of the decade making documentaries in Cuba and Latin America, when the channel's policy changed around the end of the decade I returned to teaching, first in another film school and later in a university. I wasn't the only one. Higher education was expanding, film and media departments proliferated, and many colleagues around the country were likewise alumni of the independent film movement.

I define a film school as one where teaching is structured around the specialist crafts of cinematography, direction, editing and so forth; state funded elite institutions like Moscow, the Centro Sperimentale in Rome, Łodz, or the International Film School in Cuba (where I subsequently went to give workshops). Moving from a film school to a university meant retooling from 16mm film to video, which changes this division of labour, rendering it much more fluid. I had worked on video twice, once in the 1970s, when I made a short video with kids from an inner city youth club; it was never shown anywhere except the club. The second time was about ten years later, when I was asked to make a campaign video for Chile Solidarity, to be screened at the TUC and Labour Party conferences, on the first trade union delegation from Britain to visit Chile since the coup to investigate human rights abuses. The delegation brought back with them an anonymous videotape they'd been given to be incorporated into the video which we shot of their report-back meeting. It carried no title or credits, but was not merely a series of useful shots; I've never forgotten

my amazement on first viewing it to find a fully edited reportage about the repression and the fight-back taking place on the streets. It was only on a visit to Chile many years later that I discovered its provenance: it was made by an alternative newsreel group, funded by a foreign NGO, disseminated domestically through the clandestine circulation which video replication made possible. In taught me that it was in the most inimical circumstances, under brutal military dictatorship, where every shot is filmed in conditions of risk, that video as a political tool came of age.

In short, at every point, I can trace in my own experience many facets of the cultural world I'm writing about. In the 1980s I began to take my films to documentary film festivals; near the end of the decade came my first invitation to serve on the jury at an international film festival. In a journalistic role, I reported on a new feature introduced at the Amsterdam Documentary Festival in the early 1990s, where alongside the screenings, filmmakers were invited to pitch their new projects in public to a panel of industry executives, which for the observer proved a highly instructive form of theatre; it informed my teaching over the ensuing years. The transition to digital video and desktop editing brought me back to filmmaking, at first tentatively, but I saw that an acquaintance who directed television documentaries had taken to shooting his films himself, so I decided to follow his example. By the end of the millennium, academia was beginning to fund video as a form of research-as-practice, or practice-as-research – I don't really know the difference – and I first made a film with academic funding in 2000, and have continued to do so ever since, as well as zero-budget video essays; but I've already given account of that elsewhere.

This personal history helps to explain the perspective from which this book is written. Born in post-war London, radicalised in the late 1960s, drawn by cinema into Latin American cultural politics as both scholar and documentary filmmaker, whose world view was thereby changed and enriched, my cognitive map of the world, lubricated by cheap air travel, remains that of a metropolitan intellectual whose career has been shaped by the attempt to break through the asymmetrical gaze of an imaginary geography. Living in the belly of the beast, this is what I know best, and gives me my frame of reference.

* * *

PREFACE

The idea for this book was born in a conversation with Jean Stubbs and Jonathan Curry-Machado, historians who were editing a series of papers on commodity production. I wrote a 15,000-word draft, entitled 'Cultural Commodities and Aesthetic Labour', and then put it aside, since the three of us were about to make a documentary together about ecology in Cuba. Both had extensive knowledge of the country, and Jean had worked with me as researcher on a film I made in Cuba for Channel 4 in the 1980s, which prompted me to compare what we were about to do with back then. We were a small team with an academic grant of £35K, working independently on video with a local NGO, compared to a television budget of £85K almost 35 years earlier, shooting on 16mm with a full crew accredited as foreign journalists to the foreign ministry. The new film was finished just before the coronavirus appeared, and these differences played on my mind as I sat down to write this book under lockdown and our screenings shifted from live projection in the fleshworld followed by audience discussion to the vicarious experience of streaming and video conferencing – a further shift in the mode of consumption whose effects will unfold not in the time of the writer, but that of the reader.

Should I reach back and think of all the conversations that have informed what I've written, there would be many people to thank, but this book has been written in a strange kind of solitude, so I limit my thanks to the most immediate.

First, Mike Wayne for suggesting I turn the essay into a book, and he and Esther Leslie for their feedback on the manuscript (as it used to be called). Second, to two other attentive readers, my brother Gabriel, who read it chapter by chapter as I was writing and my erstwhile colleague at Roehampton, William Brown, who gave it a very close and characteristic reading of his own when it was complete. Both provided valuable comments, but neither can be held responsible for the way I responded to their queries.

<div align="right">Windsor, 21 December 2021</div>

1
Autonomy of the Aesthetic

CREATIVITY IN QUESTION

Capitalism, as we know it in the twenty-first century, is bent on turning everything into a commodity for sale in an open market driven by a culture of consumerism. In the preceding century consumer culture came to be epitomised by a panoply of cultural goods comprised of records, films, radio and television programmes, books and the press, collectively known since the 1920s as the mass media. Except for printing, which dates back to the 1450s and lies at the origins of modern European culture, they depended on the invention of new technologies of mechanical reproduction in the late nineteenth century and beyond. The effect was not only to create new publics for the arts and entertainments, but through the techniques of advertising and marketing, to generate the allure of consumption for consumption's sake, in which any distinction between art and simple diversion would end up being obliterated. One should ask, of course, where this distinction came from to begin with, if it was not the result of a ruling class cultural hegemony which spent the nineteenth century disparaging popular working class entertainments as rowdy and uncouth. At all events, by the latter decades of the twentieth century, the overall result was not only what Fredric Jameson has called the spectacle of 'sheer commodification as a process', but also 'the penetration of commodity fetishism into those realms of the imagination and the psyche which had ... always been taken as the last impregnable stronghold against the instrumental logic of capital'.[1] Yet people still turn to the experience of art which they value precisely for its transcendence, even as what the cultural critics of the Frankfurt School designated in the 1930s as the culture industry came to encompass the entire production of spectacle, from advertising to tourism, which now overwhelms what we were accustomed to think of as the arts. Where does this leave the inherited idea of art as the creation of a special class of aesthetic objects or perfor-

mances, and the artist, author, composer, etc. as a specially gifted creative individual (not forgetting actors, performing musicians, dancers and singers) driven to self-expression by inner compulsion? Or was the figure of the artist an invention of the Renaissance, an obfuscation born of an excessive individualism that ignored the social dimension, the need of the audience for the expression of shared experience and the consolations of art, to which the artist responded and which provided them with their living? How then has artistic talent and creativity been transformed by consumerist commodification? If T.W. Adorno was right, when he argued in the 1930s that the commodities produced by the culture industry were not cultural products that were also commodities, but commodities through and through,[2] then is anything left of the special prerogatives of the arts? Or is artistic creation still somehow an activity detached from economic determination and autonomous, or as Louis Althusser argued, at least relatively so, governed by its own internal criteria and procedures? Is it, in economic terms, exceptional?

Where to look for answers? For the vast majority of economists, the arts are entirely marginal and raise no special questions; creativity is seen as a natural trait of talented individuals, which has the potential for wealth creation by generating intellectual property in what is nowadays designated an expanded 'creative economy', where the traditional arts sit alongside film, broadcasting, advertising, fashion, computer games, etc. The creative economy, meanwhile, sits alongside another set of terms: the information economy, knowledge economy, etc., which designate a diffuse sector of symbolic production of another kind, the digital encoding of the virtual sphere which subsumes all types of communication and cultural expression. This is far removed from the way Karl Marx thought about culture, who was 19 years old the year that Cooke and Wheatstone patented the first commercial electrical telegraph system, the first electrical technology to establish information as a commodity, of whose impact on trade and commerce Marx would become well aware. It was not the world he grew up in. His early love of literature is well known, but usually taken as a matter of personal taste; less so are certain of his writings in which, when puzzling about labour and the extraction of surplus value, he shows a keen appreciation of the idiosyncrasies of artistic creation and the consequent problems for capital wishing to exploit it. Three of the texts I draw upon here, and which provide me with my cues, were not even published until 1932 (*Economic and Philosophic Manuscripts of*

1844), 1939 (*Grundrisse*) and 1951 (*Theories of Surplus Value*), and few economists, Marxist or otherwise, have paid much attention to these remarks. But if the arts never figured centrally in Marx's economics, it's because in his own time and by his own estimation, they were marginal to the accumulation and reproduction of capital. Speaking at one point of theatre and entertainments, he comments that the 'manifestations of capitalist production in this sphere are so insignificant compared with the totality of production that they can be left entirely out of account'.[3] This, however, was about to change with mechanical reproduction, the rise of mass media, and the emergence of the culture industry as a distinct sector of capital, albeit heavily interlinked with other sectors like electronics, which provide both the technical means of production and the means of consumption. First to arrive on the scene, photography emerged over the years of Marx's childhood and youth; his own oldest surviving photo dates from 1861 when he was 43. He was almost 60 when the phonograph came along, and died well before cinematography appeared. He could not observe how each time, the delay between invention and the growth of a mass market grew shorter and new fractions of capital grew prominent.

As David Harvey puts it, when Marx addressed the prospects for invention becoming a business, he could not foresee the ways it would create entirely new forms of consumption. In particular, the phenomenal growth of 'forms of consumerism where the commodity is not a thing, but an experience, instantaneously consumed', the mode of consumption which now dominates culture, sports and tourism, all of which have been appropriated, monetised or created by capital. Each requires an appropriate infrastructure for its consumption, technical or physical. Consumption is tied in with the hardware needed to play records, listen to the radio, watch television, and nowadays enjoy the internet, all of which require physical manufacture and distribution. Sports require stadiums and access by the crowds. Tourism requires airports, planes, cruise ships, ports, highways, hotels, and myriad cultural institutions: art galleries, concert halls, gardens and restaurants. A huge labour force now exists to cater to these consumers' demands, says Harvey, adding that 'their destructive social and ecological consequences have provoked anti-tourism movements from Venice and Barcelona to Machu Picchu'.[4] As we shall see, however, Marx would not have been mystified by the idea of commodifying experience, since he himself draws a distinction between two types of artistic production, namely, vendible commodities

such as books and paintings on the one hand, and on the other, the performance arts. Though unable to predict the forms they would take, he would also have understood both the generative power and international character of the mass market, which were already described in the *Communist Manifesto*. In fact, the beginnings of modern tourism were already evident in his lifetime: Thomas Cook organised his first excursions in the 1840s and his first foreign tour in 1855, and Mark Twain wrote *Innocents Abroad*, an account of the first organised cruise taking tourists from the USA around the Old Continent, in 1869.

Different fractions and sectors of capital are always fighting to corner markets and create new ones; this in itself is not capitalism but flows from it. Capitalism is the underlying system that progressively transformed the mode of production through new forms of exploitation of labour – wage labour and the factory system in its homelands, slavery and the plantation system in its homelands' colonies. In the homelands, wage labour became a new kind of commodity, whose value was calculated according to the principles of time economy. The class structure of capitalist society was transformed by the emergence of a new proletariat pitted against a new bourgeoisie, topped by the very rich, new and old. Of course this is an oversimplification. The class structure of capitalist society is much more complicated (especially in the middle but also as we shall later see, at the bottom). It is an open question, however, whether this is a single totalising system that shapes and embraces every aspect of our existence, although this is what it comes to seem like, as if, where capitalism is installed, no-one escapes being positioned by it, including those whom it marginalises and excludes; everyone is conditioned by the way it situates them in relation to both the market and the centres of power and authority, and in all classes different factions contest with each other. There are two objections to this construal. At the conceptual level, totalities are chimeras, as elusive as Grand Unified Theory in particle physics; perhaps because of the contradiction that you cannot see a totality when you're situated within it. At the level of everyday life, on the other hand, where the subject's horizons are determined by their material circumstances, there remains the possibility of a split between circumstance and aspiration. The proletariat is said to be alienated from their labour, but consider teachers and nurses, for example, who may be caught within the labour market but still behave according to values which escape calculation and quantification, human values as opposed to the monetary value attached

to the job. They are not well paid for it. As David Graeber put it, the value of caring 'would appear to be precisely that element in labour that *cannot* be quantified'.[5] This would explain how easily it can be rendered invisible in a patriarchal system, where caring is carried out in a domestic setting, mainly by women, beyond the reach of the labour market, though it still, of course, remains work. Artists belong in the same category of people whose work expresses values that escape the calculations of capital, and we shall see in detail in these pages how this plays out. Although embedded in technology, in ways we shall discover, perhaps, then, artistic expression, being the quintessential realm of imagination and the psyche, is still sometimes able to resist instrumentalisation and transcend commodification, at least for those who absorb and enjoy it for its own sake. This is another of our guiding questions.

Mechanical reproduction, however, according to Walter Benjamin, transformed the social functions of art, opening up new markets for cultural products across a range of media to reach ever wider publics with a different relation to the aesthetic than the nineteenth century bourgeoisie. A popular public took shape, quite distinct from the bourgeois counterpublic, the bohemian contingent that disrupted bourgeois values from within and produced the modernist movement, to which Benjamin himself belonged. There was a certain interaction between the two, especially in the cinema, but the mass audience was peculiarly susceptible to new marketing techniques that were themselves the creation of the mass media. Jump forwards to the start of the third decade of the twenty-first century, and despite the wealth of grassroots creativity, every artform revolves around internationally famous names with celebrity status and commensurate income, but these hugely expanded markets are bulk supplied by innumerable cultural workers forced to sell themselves piecemeal to provide a stream of mostly ephemeral and formulaic cultural commodities competing for attention, like the often hundreds of names that scroll by at the end of a movie but in effect remain anonymous. Behind the famous names there have always been anonymous others, apprentices in the studios of successful artists in the Renaissance, backstage crews in the theatres of Marx's day, who now amount to small tribes of studio assistants and crews, themselves skilled creative workers, who are not only anonymous but largely lacking secure employment. Known at different times by different terms – freelance, self-employed – these are euphemisms for what is really subcontracted labour, a system

of precarious employment nowadays known by another euphemism: the gig economy, which also encompasses large swathes of what is called the service industry. It's no accident that the term 'gig economy' derives from the argot for 'engagement' among jazz musicians. Cultural work holds great attraction by promising self-expression and a sense of self-worth and the industry is never short of aspirants, who ensure a reserve army of labour that suppresses wages. Distinction is elusive, however, and the market, which is not so much free as moulded by corporate interests, imposes its own standards and norms, whereby creativity is both lauded and contaminated by commercial criteria. This is a very different world from that of the kind of Romantic artist Marx was thinking of when he remarked that 'Really free labour, the composing of music for example, is at the same time damned serious and demands the greatest effort.'[6] Marx's composer, however, sells their score, not their labour power. Similarly the author. As he writes in another passage, 'Milton produced Paradise Lost as a silkworm produces silk, as the activity of his own nature. He later sold his product for £5 and thus became a merchant.'[7] In this model, where artistic creation is seen as the paradigm of free unalienated labour, artists are not wage-labourers, and their work escapes the capitalist's demand to control the labour process, although they had to please the patrons who commissioned them, or already in Marx's time, the impresario who held the reins in the performance arts.

These, at any rate, were the conditions in the nineteenth century, when cultural markets catering for bourgeois audiences progressively replaced the patronage of aristocracy and church while urban growth created new audiences for popular entertainments, but before the new mass media. Cultural consumption was growing, yet as Marx saw it, capitalist production was hostile to certain branches of what he called 'spiritual production' like art and poetry.[8] The remark is typically quoted out of context and flattened into an oracular pronouncement, which hardly seems to correspond to the facts: the great richness of nineteenth century bourgeois culture, its expanding reach, and the rise of the mass media after the turn of the century which included, on the cinema screen, the birth of a new artform. However, as Adolfo Sánchez Vázquez sees it, Marx is speaking of 'the hostile conditions created by a mode of production which is the antithesis of creative labour'.[9] While these conditions differ according to the historical period, the degree of capitalist development in different

countries, and the specific character of the branch of art in question, capitalism is unable to succeed in fully imposing itself on art

> because of the impossibility of reducing artistic labor to the condition of alienated labor by transforming it into a purely formal or mechanical activity. Even when an artist works for the market, he resists the uniformity and levelling which destroys his creative personality. By the mere fact of realising his creative abilities he finds himself in a struggle against the hostile limits established by the capitalist market.[10]

The only problem with this explanation (apart from its gendered formulation) is not the characterisation of aesthetic labour but the element of wishful thinking in the way it imagines the artist: in the same terms as what Sánchez Vázquez calls Engels' thesis that 'a tendentious spirit is intrinsic to the nature of art'. But then Sánchez Vázquez is Mexican, and this position echoes the manifesto 'Towards a Free Revolutionary Art', written in Mexico in 1938 by André Breton, Diego Rivera and the exiled Leon Trotsky: 'True art is unable not to be revolutionary, not to aspire to a complete and radical reconstruction of society.'[11] You might agree with this, read it and sigh 'if only ...', but it's still a slogan and is also tendentious. There are plenty of artists who fulfil their creative personality without raising such a challenge but still achieve the highest aesthetic insight and satisfaction; as Balzac was for Marx, says S.S. Prawer, a conservative royalist 'for whose profound understanding of social realities Marx had the deepest admiration'.[12] There is no law that those who are aesthetically progressive will also be politically so – or the reverse. As for the mainstream, this is largely made up of those who are content to find fulfilment in following the proclivities of the readership, providing it with diversion, escapism, fantasy and titillation, and while the bottom of the mainstream is clogged up with mediocrity, many of them are extremely expert at doing so. It is the mainstream whom Adorno disparaged as ideological, precisely to the degree that their work, instead of pursuing aesthetic insight, affirms the existing order. They are not excluded from the present study, however; on the contrary, they also have to make a living.

There's another thing to consider. Few artists are able to live exclusively on their artistic production, many because they can't and others because they don't want to. They may engage in parallel and related activ-

ities like teaching, or nowadays increasingly media appearances, because they need the supplementary income; for others, their day job is quite different, and they're classed as amateur. But this is a misleading category for someone who is no mere dabbler but a talented non-professional who earns their living in some other form of labour, but who writes or paints or participates actively in performance arts like music and theatre. This is much more widespread than commonly supposed, especially in the case of music, which remains a privileged site for a proclivity for active participation that is found in every social class, although largely in separate milieux marked by distinct styles; only in settings like religious worship is there a common style, and even then different denominations engender their own, arising from the congregation's own musical vernacular. Professional musicians don't generally play with amateurs, unless they're choirs singing with orchestras, but there's a roll call of musical patrons from Henry VIII to Beethoven's time who were accomplished musicians and performed the works they commissioned. There is also a parallel history of informal music making which takes in the exclusive catch-and-glee clubs in the eighteenth century and the popular Victorian song-and-supper rooms described by Henry Mayhew, as well as pub music and other working class settings. Despite the elimination of much of these traditions by the ubiquity of the loudspeaker, the pub remains a popular musical venue, for both listening and joining in, but a great deal of music making goes on without the aid of alcohol in the wider community. One amateur, a social anthropologist, reported her surprise on discovering in the 1980s just how much musical activity went on in one southern English town, where many amateur ensembles included semi-professionals – people who earned their living in some area of the music business or teaching, though not primarily from performance.[13] According to a report in 2017, more than 2 million people in Britain sing regularly in choirs, of which there are some 40,000 ranging in size from four to over 700 – a similar number to people who go swimming every week, and more than those playing amateur football.[14] Their repertoires include music of all genres.

Nor is the non-professional excluded from literature. While the same report notes that not all choirs require their members to be able to read music, writing is a universal skill, uneven in the individual's degree of accomplishment but easily practised with minimal resources, in other words requiring very little in terms of means of production and no capi-

talisation, only time. Taking up pen and paper (or keyboard and screen), engaging in a solitary and immediately expressive activity, authors are often born by satisfying private needs like writing diaries and letters, or composing stories for their children. Others, whose day job involves handling professional texts, turn to literary writing to express what those texts exclude; spies turn into novelists, clerks compose poetry, scientists write science fiction, or address themselves to a lay readership. Literature expands to include the widest range of genres, but few published writers earn enough from their writing, unless they're also journalists, to make a living from it. This is partly an effect of the branch of activity concerned, and Sánchez Vázquez points out that not all branches of art are subject to the laws of capitalist production to the same degree because not all creative work requires the same degree of capitalisation: 'Today it is possible to write lyric poetry with no regard for ... economic phenomena, especially if the poet lowers his voice and contents himself with a small number of readers, but' – he adds – 'it is not possible to produce films without putting in motion a whole complex economic mechanism ... [and] it is always more profitable to invest in the production of a film than in publishing a book of poems.'[15] Here the only rider needed is what the Mexican philosopher, writing in 1965, could not foresee: that within a couple of decades it would begin to become possible to make films almost as easily as writing poems and at little more expense, no more than the cost of a second-hand car. The problem is no longer production, but distribution.

However compliant aesthetic labour may become to the demands of the capitalist market, for those who control distribution it always retains a certain autonomy which capital is unable to control and which remains unpredictable. This autonomy, which delights in the expressive, symbolic and polysemic qualities of aesthetic utterance is altogether at variance with the monetary value realised by the capitalist who brings the work to market. For the capitalist it can only represent a necessary risk, because the public is a fickle animal, simultaneously conservative and capricious, governed by established tastes but thriving on novel forms of aesthetic stimulation which evolve with the times; and it isn't homogeneous, a single public, but many.

We must return, however, for a moment, to the question of individual authorship, which lays a trap that hides an underlying and persistent problem of a decidedly ideological nature. The source of autonomy is

taken to reside in the individual artist; in other words, the very idea of the artist is bound up with a concept of individualism which has been paradigmatic for modern thought since the Enlightenment, if not the Renaissance, and only intensified by the Romantic turn to subjectivity and the inner life. But this only applies at best to certain artforms where authorship is indeed unique. It is not quite true of performance arts – music, dance, theatre – which are predicated on collective creation (albeit they also take the form of solo performance, and may have a score or a script by a named individual). The solitary author may stride out on their own. The individuality of the performer is always in step with that of others, the endeavour is collaborative; the author of the play, the composer, the choreographer, the screenwriter are entirely dependent on their collaborators (indeed screenplays are often the product of a team of writers). The truth – to be explored in these pages – is that aesthetic creation is not just a product of individual inspiration but equally dependent on collective engagement and collective imagination. Indeed we can safely say that all creativity is social, including that of the individual author, who even in their solitude is always, as Mikhail Bakhtin maintained, in dialogue with others. (We shall return to Bakhtin in the final chapter.)

The primacy given to individual creativity also conceals the apparatus and the industry, the economic structures (publishers, theatres, orchestras, etc.) and invisible wage labour (printers, stage hands, engravers, etc.) involved in bringing the work to market and earning their living from it. Although not themselves claiming to be creative workers, many are highly skilled and talented. Increasingly so in recent times, for digital technology has generated a growing number of jobs in the so-called creative economy, and in the same process, new forms of collective aesthetic creation which flourish in the virtual space of the internet – a paradoxical space which combines many different layers of creative input. The question of what constitutes creativity and creative labour is thereby posed afresh.

To begin the inquiry, the question is best approached by turning to Raymond Williams' indispensable compendium of *Keywords*.[16] The word 'creative', he says, has both a general sense of originality and innovation, and a more specific sense where it refers to the products of the creative imagination in the form of works of art. A slippery word, it slithers between these two senses, but then so is the word 'art', whose general and original meaning referred to any kind of skill 'in matters as various as

mathematics, medicine and angling'. In the plural, 'the seven arts' of the medieval university curriculum included grammar, logic, rhetoric, arithmetic, geometry, music and astronomy, but the term 'artist', emerging in the sixteenth century, belonged to a different grouping, that of the seven muses: history, poetry, comedy, tragedy, music, dancing, and astronomy again, reflecting the hold still exerted by classical Greek culture. (In modern times, the classical context recedes, the muses become the seven arts, and no-one can quite agree what they are.) The founding of the Royal Academy of Arts in 1768 institutionalised a distinction between the 'artist' and the 'artisan', when engravers were excluded from membership because they were 'skilled manual workers' without 'intellectual' or 'imaginative' or 'creative' purposes, while the growing specialisation of intellectual endeavour entailed the differentiation of the sciences and the scientist from both. Further distinctions would emerge in the nineteenth century, between art and industry, between the fine arts and the useful arts, between the scientist and the engineer. 'This complex set of historical distinctions between various kinds of human skill and between varying basic purposes in the use of such skills', says Williams, 'is evidently related both to changes in the practical division of labour and to fundamental changes in practical definitions of the purposes of the exercise of skill. It can be primarily related to the changes inherent in capitalist commodity production, with its specialisation and reduction of use values to exchange values.'[17]

'Culture' is an even more complicated word, 'one of the two or three most complicated words in the English language', says Williams. In its dominant early uses it refers to cultivation or the tending of natural growth, which was extended by metaphor in the sixteenth century to human development, or as Hobbes defined it in 1651, 'the culture and manurance of minds'. But this acquires class connotations, by which people will be distinguished by whether or not they have culture, which links the concept to birth, education, social position, money and ultimately, that other tendentious concept, civilisation. However, there is also a move in a different direction, to the idea of cultures in the plural. The specific and variable cultures of different nations and periods – the territory of history; the various cultures of social and economic groups within a nation – the domain of sociology; while anthropology, driven by imperialist practices, looked outwards, taking culture as the very object of study in societies 'left behind' by civilisation, conceiving it as an ecosystem of relationships and shared knowledge, only later to be applied

back home where it gave rise to the study of subcultures. The disputes between the different disciplines were not resolved by the subsequent emergence in the academy of the synoptic field of cultural studies (in which Williams' work was foundational).

Williams sees three main usages of the term emerging in succession. The abstract noun which describes a general but mainly individual process of intellectual, spiritual and aesthetic development, in the eighteenth century; in the nineteenth century, the sense of a particular way of life of a people, a period or a group; and only then, in the twentieth, does it come to refer to 'the works and practices of intellectual and especially artistic activity'. In the populist parlance of the media, this last 'seems often now the most widespread use', says Williams, and becomes enshrined in the creation of Ministries of Culture. But *Keywords* was published in 1976, and what has happened since then is significant, because in liberal democracies like Britain, this last step had the effect of politicising a domain which government had previously kept at arm's length. The arm's length principle is associated with the economist J.M. Keynes, architect of the post-war international financial regime established at Bretton Woods in 1944, and the cultured liberal behind the UK's wartime Council for the Encouragement of Music and the Arts which became the Arts Council after the war. Keynes thought capitalism an unbalanced system for the arts to thrive in, and before his early death, used his political influence to ensure that the Arts Council would operate free of both big business and direct government control. If the establishment accepted his arguments, it was not out of concern for spreading beauty but because it served an ideological agenda to repudiate the politicisation of culture by both Fascism and Communism, the condition identified by Benjamin in the closing words of 'The Work of Art in the Age of Mechanical Reproduction', which Fascism renders aesthetic, to which Communism responds by politicising art.

In practice, the arm's length principle was treated as a constructive ambiguity, eroded over time by the growth of the culture industry beyond the elitist and metropolitan focus of official patronage. In Britain, where the first Minister for the Arts was appointed in 1964 by Harold Wilson, long before politicians began to talk about the creative industries, the subsequent history of the post reveals growing confusion about what this sector actually consists in, beginning when John Major renamed the post Minister for National Heritage in 1992. Tony Blair renamed the depart-

ment Culture, Media and Sport, Gordon Brown added Tourism, but when David Cameron entered Downing Street he chose Culture, Communications and Creative Industries, then reduced it to Culture and the Digital Economy. Theresa May reversed the priorities to Digital and Culture, then changed it to Digital and Creative Industries. Then it morphed again into Sport, Media and Creative Industries under Boris Johnson, who quickly reverted to May's first designation of Digital and Culture. Who knows what it will be when you read this. Whoever has been in charge, and whatever the ideological gloss, the arts appeared to prosper, but no-one was quite sure what art and creativity consisted in any more.

MARX'S TAKE ON ART

Marx's take on art was shaped by a classical education, voracious reading, the heritage of Romanticism, and his underlying philosophy of dialectical materialism. While he can hardly himself be considered a Romantic, his conception of the aesthetic emerges from a current in German thinking developed by philosophers of the eighteenth century (Lessing, Baumgarten, Kant, Schiller) whose ideas nurtured Romanticism and the notion of the expressive autonomy of the work of art. But because he always thought historically he was struck by the historicity of aesthetic forms and their relation to 'the general development of society'.

Is the view of nature and of social relations which shaped Greek imagination and Greek [art] possible in the age of automatic machinery, and railways, and locomotives, and electric telegraphs? Where does Vulcan come in as against Roberts & Co.; Jupiter, as against the lightning rod; and Hermes, as against the Credit Mobilier? ... What becomes of the Goddess Fame side by side with Printing House Square?[18]

Or again:

Looking at it from another side: is Achilles possible side by side with powder and lead? Or is the Iliad at all compatible with the printing press and steam press? Does not singing and reciting and the muses necessarily go out of existence with the appearance of the printer's bar, and do not, therefore, the prerequisites of epic poetry disappear?

But the difficulty is not in grasping the idea that Greek art and epic are bound up with certain forms of social development. It rather lies in understanding why they still constitute with us a source of aesthetic enjoyment and in certain respects prevail as the standard and model beyond attainment.[19]

As S.S. Prawer tells us in his magisterial study, *Karl Marx and World Literature*, one of the themes of Marx's thinking about literature is familiar to readers of Goethe's *Wilhelm Meister*, Hölderlin's *Hyperion* and I would add, Schiller's *Letters on the Aesthetic Education of Man*: 'the yearning for fullness of development, for overcoming the limitations imposed by that division of labour without which no modern society can function.'[20] When Marx and Engels write, in *The German Ideology*, that 'The exclusive concentration of artistic talent in particular individuals, and its suppression in the broad mass which is bound up with this, is a consequence of division of labour,'[21] it was civilisation itself, said Schiller 50 years earlier, which inflicted the wound upon modern man.

Once the increase of empirical knowledge, and more exact modes of thought, made sharper divisions between the sciences inevitable, and once the increasingly complex machinery of State necessitated a more rigorous separation of ranks and occupations, then the inner unity of human nature was severed too, and a disastrous conflict set its harmonious powers at variance ... State and Church, laws and customs, were torn asunder; enjoyment was divorced from labour, the means from the end, the effort from the reward. Everlastingly chained to a single little fragment of the Whole, man himself develops into nothing but a fragment; everlastingly in his ear the monotonous sound of the wheel that he turns, he never develops the harmony of his being, and instead of putting the stamp of humanity upon his own nature, he becomes nothing more than the imprint of his occupation or of his specialised knowledge ...[22]

When the community makes his office the measure of the man, Schiller continues, when in one of its citizens it prizes nothing but memory, in another a mere tabulating intelligence, in a third only mechanical skill, 'can we wonder that the remaining aptitudes of the psyche are neglected in order to give undivided attention to the one which will bring honour

and profit?' But the results of this neglect are calamitous. We know, he says, that the sensibility of the psyche depends for its intensity and scope upon the liveliness and richness of the imagination; but the preponderance of the analytical faculty, the dead letter which takes the place of living understanding, necessarily deprives the imagination of its energy and warmth.

What Schiller describes here amounts to the adumbration of a concept central to Marx's thinking, the alienation that marks the experience of modern times, over and above the underlying separation from nature that all human society produces. We're not speaking of a unitary category, nor a psychological condition. It will not be found in the *Diagnostic and Statistical Manual of Mental Disorders*. What the term identifies is an existential disposition that no-one can escape because it's a structural property of the capitalist mode of production in which everyone is submerged, in which, as Herbert Marcuse put it, human consciousness 'is made victim to the relationships of material production'.[23] Marx developed the concept in the 1844 *Manuscripts*, where he identified four aspects. In the capitalist system, the worker is not a person but a thing (think of Chaplin on the production line in *Modern Times*, a human cog in a machine). For the worker, their labour no longer seems to belong to them but to someone else who owns the means of production and appropriates the profits. The result is that the worker is separated from the product of their labour, from the act of production, from their own human nature, and consequently, from the society, because alienation from oneself is simultaneously estrangement from others. We should add a rider. Alienation pervades society, but how the angst is experienced depends on where within society or at its margins a person finds themself: their class, their social and cultural capital, what Pierre Bourdieu calls their habitus. It can find ideological expression in an attitude of contrariness towards the social order, contesting it from either left or right, or may collapse into mental disorder and pain. It can also be overcome in the special conditions created by aesthetic engagement, in the creative process and in the reception of the result.

'Human nature' is what Marx calls *Gattungswesen* ('species-being'). This is not, as in Rousseau, some fabled state of nature prior to the violence of civilisation, but a field of human potential that is captured in the difference between instinct and imagination. As Marx wrote in *Capital*, 'A spider conducts operations that resemble those of a weaver,

and a bee puts to shame many an architect in the construction of her cells. But what distinguishes the worst architect from the best of bees is this, that the architect raises his structure in imagination before he erects it in reality.'[24] This potential is not something given and fixed; it is bestowed on us by our DNA but does not exist independently of the particular historical conditions in which it comes to be realised. As Marx puts it elsewhere: 'Hunger is hunger, but the hunger gratified by cooked meat eaten with a knife and fork is a different hunger from that which bolts down raw meat with the aid of hand, nail and tooth'; he adds that 'Production thus produces not only the object but also the manner of consumption, not only objectively but also subjectively. Production thus creates the consumer.'[25] Think McDonald's.

In a word, the relation of production and consumption is reciprocal; they feed back on each other. This means that labour is more than just economic activity and cannot be reduced to a simple function like means of survival. It has a cultural dimension, it has a fertile and inventive quality in which the human being, through mobilising muscle and imagination, engages in free, consciously purposeful activity, and thereby produces – the human being. The capitalist mode of production destroys this quality of self-fulfilment, robbing the worker of its satisfaction. Nevertheless, it persists, in various forms of labour where the worker retains an element of control over the labour process over which the capitalist is unable to impose regulation, or can only do so imperfectly. This not only includes the artisan, for example, the traditional handicraft worker who owns their own means of production and produces commodities, who is neither a capitalist nor a wage-labourer, unless they become small capitalists who exploit themselves (and perhaps a few employees). It also includes those jobs which escape subjection to scientific management, the time-and-motion studies of Taylorism, because their production is immaterial: not fungible goods but the performance of individual services, like doctors and nurses, lawyers, teachers and carers. These jobs are bound not by production lines but by formal controls like professional and contractual obligations – although neoliberalism and information technology have now combined to enable the micromanagement of 'human resources'. One field above all, however, remains as the paradigm of unalienated labour: the free creative labour of the artist. We must investigate how far this is true.

Schiller associates this freedom with what he calls the play drive (*Spiel-triebs*), and in simple terms, art is a higher form of play, its sublimation, which has the special quality that it transcends otherwise divergent drives like reason and feeling. David Graeber describes play as 'the exercise of powers simply for the sake of exercising them', but this involves follow-ing rules, which because this is play, however, are freely chosen. What play offers is the opportunity to pit oneself against the constraints of daily life, but without permanent consequences. That doesn't mean the rules are fixed, because as Ludwig Wittgenstein insisted, the concept of play is not circumscribed: there is no single definition of what a game consists in, and games come in families, related by patterns of family resemblance (ball games, team games, board games, etc.), each governed by their own rules; there are also instances, especially in children's play, where the rules can be made up or altered along the way. Some games require their own special spaces, others can be played anywhere. It's no accident that this also sounds like a description of the arts and the multifarious spaces where creativity is manifest. Art is produced by taking and moulding the appropriate material, internal or external objects, and infusing them with affect and desire, while freely accepting the rules of aesthetics (one of which is knowing when to break the rules). The rules incline towards Apollonian discipline, the desire towards Dionysian unruliness. The result takes shape as a material object or an immaterial and ephemeral performance. In short, and as psychoanalysis teaches, the space of play and art alike is paradoxical and ambiguous: both internal and external at the same time, hence a transitional space where self meets not-self, a potential space to which the inner psychic life and external reality both contribute, to be united in rule-governed make-believe. Hence, as Schiller put it, 'Man is only fully human when he plays, and only when he plays is he fully human.'[26]

Marx concurs that the creative labour of the artist is free and unalien-ated, but in his case, it follows from the analysis of the nature of labour under capitalism. Capital treats labour as a commodity, measured in working hours, which Marx called labour power. The price of labour power is determined in the first place by socially necessary labour time, the average amount of time needed by a worker of average skill and pro-ductivity to carry out the job; the profit comes from paying the worker less value than they create. Marx understood, however, that in the case of creative work the law of averages is elusive and irrelevant, and the artist

wasn't paid by how much labour power they expended. Indeed it makes little sense to try and fix the average amount of time it takes to write a book, compose a symphony or paint a canvas. There are famous stories that Handel wrote *Messiah* in 24 days, while Brahms took 14 years to write his first symphony. We shall see how this plays out as we proceed to examine what happened as capital extended its control over cultural production, but even the film music composer, who owes their job to their facility for composing fast, isn't paid by the number of notes they can put down on paper in an hour, but a fee based on what is judged to be their market value. Perhaps performance arts are more susceptible to such calculation, because time itself is their medium and the capitalist mode of production necessarily imposes the constraints of time economy wherever it can, but that doesn't mean the performer can be treated like factory labour, even if it might sometimes seem that way to the showgirl in the back row of the chorus line. Instead, the business of time management becomes one of the tasks of the choreographer, or the orchestral conductor, or the film director. Marx understood this perfectly well, and even offered the conductor as an example of the work of supervision which the capitalist mode of production separated from the ownership of capital.[27]

Nevertheless, he retains an element of Romantic yearning for the fullness of the human spirit, which spills over in a rare moment when Marx and Engels speak of the promise of Communism, writing in *The German Ideology* that the exclusive concentration of artistic talent in single, unique individuals, and bound up with this, the suppression of such talent among the masses, is a consequence of the division of labour.

A communist society will free the artist from local and national limitations which are solely due to division of labour. It will also free him from limitation to one particular art, from a state of affairs in which an individual must be exclusively a painter, a sculptor, etc.; the very label expresses the bounds of his professional development and his dependence on the division of labour. In a communist society there will be no painters; at most there will be men who – among other things – also paint.[28]

(Of course that doesn't mean everyone will do everything, and his later formulation is more judicious: 'From each according to his ability, to each according to his needs.'[29])

Capitalism would have its own version of this dream of universal creativity when it emerged as a built-in possibility of the technologies of mechanical production, and entrepreneurs could not resist bringing out consumer versions of the new means of aesthetic creation. The pioneer was Eastman when he launched the Kodak camera in the 1880s and brought photography to the masses with the slogan 'You press the button, we do the rest'. The 16mm format was introduced in the 1920s to create a market for amateur filmmaking, and when it was subsequently taken up professionally, replaced by 8mm. The record industry followed a slightly different pattern, since amateur recording only entered the picture after the introduction of tape recording in the 1940s, but tape recording led to videotape and there were soon signs of the same thing happening again. In a polemical manifesto of 1969, 'For an imperfect cinema', the Cuban revolutionary filmmaker Julio García Espinosa wondered about the effects it would bring, and the promise that the technology of cinema would cease to be the privilege of a small few. Long before the internet came in view, but remembering the vision of Marx and Engels in *The German Ideology*, he asked what would happen 'if the development of videotape solves the problem of inevitably limited laboratory capacity, if television systems with their potential for screening independently of the central studio renders the endless construction of movie theatres superfluous?' He envisaged a cultural revolution in which millions of people might discover their hidden talents and follow artistic leanings in their leisure time not for money but quite disinterestedly. This, he said,

would be a fact of extreme importance for artistic culture: the possibility of recovering ... the true meaning of artistic activity. We shall come to understand that art is a 'disinterested' activity. That art is not work. The artist is not strictly speaking a worker.[30]

The results turn out to be a mixed blessing, from videos of cats and other animals doing funny things whose extraordinary popularity has yet to be adequately explained, by way of fake news mash-ups whose viral spread is frightening, to the disturbing consumption of pornography, all mixed in with urgent citizen journalism and biting political satire. Much of it is effectively anonymous, like a new kind of folk art, but in a further twist, this casual and unpaid creative labour is then monetised through the advertising and data mining that produce the platform's income.

Some of these 'content creators' then learn to monetise themselves and give up their day jobs. All the while, an image persists in popular imagination, encouraged by government PR and media tittle-tattle, of the artist as someone who works for the love of it, not for money but for self-fulfilment. Lodged in my memory, but unfortunately not in the cuttings file I used to keep back in the day, is the report of a survey in which some huge percentage of respondents, 70 per cent or more, said that they would rather be artists than doing the job they're doing.

Part of the irony of the situation we now find ourselves in is that an old communist dream now returns to us in a new and double-edged form as a consequence of the technological revolution of the digital, whose corporate structures exploit the results of placing the means of production in the hands of the masses and enabling a huge flowering of popular creativity by non-professionals, amateurs and autodidacts. Should we not invoke the question Walter Benjamin raised about photography – whether its very invention had not transformed the entire nature of art – but this time apply it to computerisation and the digital?

THE PRICE OF AUTHORSHIP

But why that £5 Milton was paid for Paradise Lost? If it isn't the cost of the poet's labour, what lies behind this monetary valuation (equivalent, according to Wikipedia, to approximately £770 in 2015 purchasing power)? The fundamental problem is that the process of artistic creation escapes the quantification of labour power which is entailed by the capitalist mode of production and exemplified by the production line. There's no calculable correlation between the effort of the artist and the amount of time taken to produce the artwork. Creative work requires skill and self-discipline but it isn't standard, uniform or reducible to mechanical procedures, and attempts to make it so involve, as we shall see, the application of formal and external controls which restrict the free play of the creative imagination. The explanation for Milton's fee lies in another factor: the material form in which the poem reaches the market – as a printed book – and the business practices adopted by the publisher in a given time and place in order to supply the market.

These practices paradoxically both promote and disadvantage the author. The coming of the book valorised authorship as the creation of cultural value, but inserted the author into an industry with no certain

means of predicting the commercial value of the product before bringing it to market, other than more or less well-informed expectation. Milton's fee belongs to a time before the author's claim on their creation was recognised in the peculiar legal form of the author's copyright, a time when the author sold their work to the printer-cum-publisher outright in the form of a manuscript, the handwritten original to be copied in print. Once the manuscript was sold, the author had no further rights over their work, and because the principle of literary property did not exist, as Lucien Febvre and Henri-Jean Martin explain, 'any bookseller had the right to publish any manuscript which he had managed to procure without consulting the author'.[31] This, however, produced a chaotic and unregulated market, marked on the one hand by malpractices like piracy, and on the other, by authors self-publishing (Febvre and Martin mention Cyrano de Bergerac, Lessing and Klopstock) 'which more or less required that [writers] turned themselves into businessmen'.[32] The privileged position of the booksellers lay in the royal patents they'd been granted, arrangements that became unsustainable as the feudal order gave way, partly as a result of the transformation of knowledge that the book helped to promote, and authors began to assert what they claimed as their natural and moral rights over their creations in the name of liberty.

The juridical framework for author's rights began as a domestic matter and thus varied from country to country; England became the first country to address the legal question with the Statute of Queen Anne in 1709. Here (as elsewhere) the emergence over the preceding decades of a new literary public sphere is reflected in changing conceptions of authorship. A new authorial autonomy is asserted by the likes of John Locke and Daniel Defoe, advancing the status of the writer not only intellectually but also juridically, as a model of the private individual in the public sphere, a democratic space whose inception, as Jurgen Habermas has taught, is linked with the first newspapers or their forerunners – Defoe first published *The Review* in 1704 – and the locus of the coffee houses where they came under free public discussion.[33]

The public sphere

The public sphere is pictured by Habermas, who gave the term its currency, as an integral dimension of civil society, a manifold social space independent of authority and the state, where citizens meet in the capacity of

social equals to engage in conversation about public concerns, to exercise common powers of reasoning in order to compel political authority to legitimate itself before public opinion. In Nancy Fraser's phrase, it 'designates a theater in modern societies in which political participation is enacted through the medium of talk';[34] it is an arena of discursive relations, not market relations, although fed by the commodities of the print trade. Initially the assertion of the rights of the propertied and educated men who formed the bourgeois public, the public sphere first took shape, in Habermas's account, in the coffee houses, clubs, reading societies, lending libraries and meeting houses which began to appear in the late seventeenth century, at the same time as the beginnings of the press; the new public was from the outset a reading public and the evolution of the public sphere cannot be separated from the growth of the press and its functions – nor from the spread of literacy. Neither is it accidental, as feminist critics like Fraser have pointed out,[35] that these spaces were occupied by property-owning men, who established certain norms of debate – sober, reasoned and unemotional – which resulted in exclusions, primarily of women and the unpropertied working class. Women were relegated to the private sphere of the family, the sphere of childbearing and childrearing and thus of feminine labour, in both senses of the word. This entailed a separation between production and reproduction, between economically gainful employment and the unpaid work of nurture and caring of the domestic sphere. But the same patriarchal authority operated in both.

The public sphere overlaps with the space of artistic creation, where the same male authority applied. It was not totally impermeable to women, but they were largely marginalised, or forced into preconceived roles, and then forgotten, left outside the canon; only now are women painters of the Renaissance being rediscovered. The prohibition on the appearance of women on stage broke down, actresses and opera singers came to the fore, though these occupations were all too frequently regarded as disreputable. Women began to enter the fray as writers, but women novelists would sometimes publish under a male pseudonym. With the growth of commercial concerts in the nineteenth century, space was found for exceptional women, for example as solo pianists, but orchestras were exclusively male, women conductors unimaginable, and there were no real prospects for women composers. Again, only now are their works being played again. In the sphere of bourgeois domesticity, however,

women's musicality thrived. There was a strong belief that musical pursuits provided a valuable means for the socialisation of children. 'The watchword of middle class values', says William Weber, 'was discipline, and musical training helped instil it in young people. For girls especially, learning the piano was virtually a puberty rite, since it was conceived not as a hobby but rather as a social obligation integral to their upbringing.'[36] (The same idea of the benefits of music, which are very real, also becomes the rationale for the activities of philanthropic mill and mine owners who promoted brass bands and choruses among their workers, though probably many would not have made the financial sacrifice if not for the radical activities of the mechanics institutes which first demonstrated the hunger of workers for making music.) It was the salon, modelled on the domestic musical life of the aristocracy, which became the primary site for the musicality of bourgeois women, and in doing so, became a site of social exchange between family and society, a nexus in the formation of taste and opinion, and a network of social obligations lying ready to be exploited. In short, an investment in cultural capital. Yet here women could exert leadership, and those with real musical gifts might even launch professional careers. Beyond the salon the world was far less favourable and they suffered intolerable tensions between their private and professional lives. Most were forced to give up their careers when they married.

The public sphere, then, which Habermas conceived as a universal and democratic space, is an idealisation which is gendered and split up by class and race. First, there is a difference between democracy as idea and actually existing democracy, or as Jodi Dean puts it, between 'democracy as radical ideal, democracy as political practice, and democracy as theoretical justification for rule';[37] differences we should try to remember every time discussion of the democratic comes up. Second, the bourgeois public was never 'the public', which remains an imaginary notion constantly invoked by the media and tabulated by opinion polls which paper over the contradictory positions they frequently manifest. There never was a single, unitary public, but multiple publics, succoured by the growth of literacy and of civil society, which generated voluntary associations of various types, philanthropic, civic, professional, cultural. This proliferation produced divergent and sometimes conflictual and antagonistic interests. Fraser and others speak of competing counterpublics, subordinated and subaltern social groups which create parallel and alter-

native discursive communities. A proletarian public sphere developed its own organs and milieux, which Marx perceived as serving the need for community as such. When workers gather together, he observed in the *1844 Manuscripts* (where he based himself on experiences in France), what they express is a need for social intercourse in order directly to counter the growing fragmentation of society and increasing alienation of the individual: 'Smoking, eating and drinking are no longer simply means of bringing people together. Society, association, entertainment which also has society as its aim, is sufficient for them.'[38] A parallel movement of working class self-improvement, chronicled in E.P. Thompson's *The Making of the English Working Class*, ranging from friendly societies to radical journals, created powerful pressures to cede democratic rights to the propertyless, and the women's suffrage movement followed. 'In the case of elite bourgeois women', says Fraser, 'this involved building a counter-civil society of alternative woman-only voluntary associations, including philanthropic and moral reform societies.'[39] All the time, the public sphere, in theory all inclusive, in practice bends heavily in favour of patriarchal bourgeois hegemony, and develops mechanisms to maintain a proper sense of decorum and social hierarchy and thereby defend the body politic. The public sphere is thus normative as well as liberal; a space where, on the one hand, problems can be uncovered and novel solutions advanced, but on the other, convention, compromise and various kinds of authority are brought to bear in order to restrain independent, divergent and critical thinking. Meanwhile, the growth of the mass press and modern advertising succours practices intended to mould and bend public opinion by more devious means.

Inevitably, the public sphere raises the knotty question of ideology, which permeates it, and which Habermas calls 'systematically distorted communication'. The problem is, distorted how, and at what level? The term is ambiguous but almost invariably pejorative: in common parlance, ideology is something you accuse your enemies of; in philosophy, false consciousness; in psychology, rationalisation. As Terry Eagleton puts it, 'some at least of what we call ideological discourse is true at one level but not another'.[40] This is because it has a tendency to speak half-truths which tell the wrong half, but still remain rooted in lived reality. It is a question, says Eagleton, 'of who is saying what to whom for what purposes ... a function of the relation of an utterance to its social context'.[41] It is duplicitous, essentially linked to legitimising power and sustaining relations

of domination. Or challenging them, because those who did so sometimes accepted the term as a badge of pride. For the Marx of *The German Ideology*, all thought is socially determined and ideology is thought that denies this determination, but for Lenin in *What Is To Be Done?*, the choice is 'either bourgeois or socialist ideology' and socialism is 'the ideology of struggle of the proletarian class'. All this, as Eagleton says, is very confusing, and there's yet another position, let's call it sociological, which holds that it's impossible to live *without* ideology. But this is not the same as saying that ideology is all there is. If there are no values or beliefs that are *not* ideological, then the term becomes empty of meaning. Ideology threatens to expand to vanishing point, as Eagleton puts it; and to believe that consciousness is inherently false is problematic, indeed self-contradictory. For the Marx of *Capital*, it is capitalism that produces mystification, which arises from the opacity of reality, commodity fetishism, and the reification epitomised in the 'ultimate money-form of the world of commodities that actually conceals, instead of disclosing, the social character of private labour, and the social relations between individual producers'.[42] But if ideology is found in what Eagleton calls 'the chronic miscognitions of everyday life', these operate through mechanisms of the psyche that are also the structural devices of ideology: 'Projection, displacement, sublimation, condensation, repression, idealisation, substitution, rationalisation, disavowal: all of these are at work in the text of ideology, as much as in dream and fantasy.'[43] We only have to add that they are also at work in advertising, which from this perspective is nothing more than the aesthetics of commodity fetishism. And also of course, but in a different register, in the autonomous process of artistic creation, where imagination roams free, both in the act of creation and that of reception.

Copyright, a legal fiction

The public sphere promoted the figure of the author. Milton had already spoken of the author's autonomy but his *Areopagitica* of 1644 is not an argument about literary property, says Mark Rose, but 'an angry response to the reinstitution of licensing by Parliament', not simply in defence of the autonomous author but in opposition to the restriction of 'truth and understanding' which 'are not such wares as to be monopolised and traded in by tickets and statutes and standards'.[44] He is arguing that books

are different from regular commodities and continues: 'We must not think to make a staple commodity of all the knowledge in the land, to mark and licence it like our broadcloth and our woolpacks.' His position is that a book is not just an object of commerce but a creation inseparable from the personhood (and personality) of its creator, an object of intellectual content and creative originality, a carrier of knowledges which transcend its material form and through which the polity advances; these sentiments will inform the introduction of a new regulatory regime, as a new abstract right is formulated and the term 'copyright' enters the vocabulary. Twenty years after Locke proposed a theory of intellectual property rights, copyright is defined as the property of the author. The Bill introduced following the Statute of 1709 was titled 'A Bill for the Encouragement of Learning and for securing the Property of Copies of Books to the rightful Owners thereof' (1710), namely, their authors. In England, at least, ownership of the work now belonged to the private individual who wrote it, not the person who printed it, and the author, as we shall now see, joined the ranks of the propertied classes by virtue of the production of their brains. But it wasn't as simple as that.

Locke defended the rights of the author as a matter of natural law, declaring 'I know not why a man should not have liberty to print whatever he would speak',[45] but this involved articulating a new kind of subject and a certain discourse of property that implied an ideology of possessive individualism. As Rose puts it, 'The figure of the proprietary author depends on a conception of the individual as essentially independent and creative, a notion incompatible with the ideology of the absolutist state.'[46] But translating this principle into juridical form was not at all straightforward. Copyright until this point did not protect the work itself but rather a printer's right to publish it, and applied quite literally: it was held by the owner of the manuscript. The booksellers who bought these originals, and were licensed by the Stationers Company, the guild which had been granted a royal monopoly in 1577, argued for a common law definition of property rights on the model of landed property, which implied perpetuity of ownership (no matter that this was of no immediate benefit to them). But the manuscript is a physical object, which is not the same thing as the text that enters public circulation, as the practice of piracy demonstrated. In this sense, the text is an immaterial but reproducible object, and if copyright is, as Rose defines it, 'the practice of securing marketable rights in texts that are treated as commodities',[47] then the emerging

concept of literary property is an abstraction.[48] This idea of copyright as an immaterial property, he observes, paralleled another eighteenth century innovation, paper money, which 'also became fantasmic, a matter of the circulation of signs abstracted from their material basis. Furthermore, just as literary property was underwritten by the personality of the author, so the acceptability of commercial paper depended on the credibility of the note issuers ...'[49]

But if the concept of literary property is an abstraction, then copyright is a legal fiction – if not in the strict legal sense then by extension or analogy – in which this abstraction is ascribed to an author, because you cannot have a piece of property without an owner. Law is about the relationship between subject and rights: rights are possessive, things belong to the person who owns them. Hence, to follow Bernard Edelman (who himself follows Althusser), the author as legal subject is constituted by the form in which they're interpellated by the law, and the law is a construct which endows the subject with certain attributes necessary to the capitalist system of production.[50] The author as legal subject is thus 'a formal representation of the economic subject in commodity society',[51] which nevertheless depends on the myth of the constitutive natural person, while the commodity in question is not the manuscript but the incorporeal text. This is the basis for a signal judgement of 1741 – Rose calls it a foundational case – over the unauthorised publication of some letters by Pope, in which Lord Chancellor Hardwicke distinguished between the piece of paper on which the words were written and the words themselves. By doing so, says Rose, 'Not ink and paper but pure signs, separated from any material support, have become the protected property.'[52] But again there's a rider, because the legal subject is not necessarily a human subject, and under Companies law, companies too are legal entities capable of holding property, making contracts, and of suing and being sued.

Detached from the model of landed property, an alternative to perpetuity of ownership presented itself on the model not of common law but the patent. The legal fiction of copyright lies in this shift, which as Rose observes, implies 'that literary property was not truly property at all, but a privilege granted by the state'.[53] The patent, which governs technological invention – another crucial element in capitalist production, because it drives improvements in productivity and yields technological rents – is time-limited; on this model, during the period of protection, the author

is entitled to enjoy what boils down to a rent for their literary property, called royalties, a term derived from the older arrangements. In effect, the law decided that nature had not decreed that authors created eternal property. Copyright existed because statute granted, for a limited time, the right to produce copies of books.

The recognition of author's rights was designed to reward the author in lieu of the impossible payment for their concrete labour, but legislation was never clear-cut, it had to be constantly fought over in the courts, its principles varied in different jurisdictions, authors were not automatically protected in foreign countries. Besides, things worked differently in the author's other principle market, the theatre, where the script became the property of the theatrical company that bought it and was not initially intended for publication. Theatre is collaborative, as any performance art must be, and the script was not an inviolable text but liable to modification; at the moment of performance, the actors were in control, and no two performances were ever quite alike. The text might be shortened or lengthened or refurbished entirely according to need, with or sometimes without consulting the author. The classic instance of course is the actor William Shakespeare, member of the King's Men and a shareholder in the Globe Theatre, only some of whose plays appeared in print during his lifetime.

Recognition of author's rights would lead to a variety of schemes for the author's remuneration (royalties, advances, commissions, etc.), but this would provide a living for only very few authors, who have generally always needed other sources of income (just as Milton was a schoolmaster and then a civil servant). For the publisher, who controlled the product but not the author's creative labour, and whose primary objective was sales, this double unpredictability entailed an element of risk that was absent with regular wage goods. A few successes would have to pay for numerous failures, and a strong backlist helped. Even today, when millions are spent on marketing and promotion by imprints belonging to conglomerates, the market remains capricious (the same is true of cinema, for which novels are a major source of the narratives it trades on). In short, the book as commodity behaves quite differently from standard commodities for which the demand is predictable and inelastic, and the industry would evolve to cope with the uncertainty.

Composing

Composers were not quite in the same boat as writers, because the musical score is not the same as a book, not intended for reading but for playing, a different form of use which meant a different market and another mode of literacy. It also involved a different technology. Because the inscription of music is radically different from the inscription of language, music printing was not so much a sideline of general printing as a specialised branch of it, with its own technological problems to solve. The earliest music printing consisted in woodblocks for short musical examples in books of theory or instruction, but this was laborious, costly and of limited use as well as technically imperfect. The first musical typefaces required double printing of the notes upon the staves; there were several methods but all required careful registration.

When Petrucci became the first person to offer printed sheet music for sale in Venice in the early 1500s, the market he tapped consisted primarily in music-lovers: the principal customer was the educated amateur performer, not the professional musician. The growth of music publishing thereupon followed the growth of this domestic *musica practica* (musical practice) and becomes its barometer – it is obviously related to the spread of musical literacy – until market conditions and improved technology in the late eighteenth century promoted the music publisher to a new prominence – with corresponding effects on the composer's sources of income. (Luciano Berio once joked that Beethoven was the first truly modern composer because he was the first to sell the same work twice over to two different publishers. In fact, so did his mentor Haydn.) This public was a new one, an emergent bourgeoisie, its tastes were constantly evolving, and publishers eager to exploit them. The result was that despite the considerable technical problems entailed by musical notation and the costliness of the enterprise, printing gave scope to the rapid development of musical styles and genres. In the process, printing not only produced growing standardisation in the appearance of the musical score but also nurtured the growth of the composer – in much the same way that the evolution of general publishing nurtured the author – who became the principal agent not only in the growing complexity of musical language but also its deepening subjectivity. Nevertheless, the composer was still primarily a performing musician, who often took a leading role in the performing ensemble and as a soloist, including their skills at improvisation. The

names that spring to mind – Bach, Mozart, Beethoven, Liszt – are paradigmatic but not unusual in their multiple skills, and what gained them their original following was not publication but audition by the audiences they performed to, a process that accelerated with the rise (after Bach) of the piano as the foremost keyboard instrument (a topic we shall return to) with the capacity to emulate every other instrument, indeed a whole orchestra. (Then, as the orchestra evolved, composers would also often double up as conductors.)

The accelerating evolution of musical language, style, scale and complexity – the line, let's say, that runs through Monteverdi, Mozart and Mendelssohn to Mahler and Messiaen – placed increasing demands on notation, which evolved new signs and symbols and textual instructions, requiring, from the printer, an ever increasing variety of sorts to make up a font, far in excess of the requirements of the printed word. (By the mid-nineteenth century the number of sorts in a single font of musical type reached more than 450.) Even so, single impression movable type was able to meet the needs only of relatively simple music; complicated chords and rapid passages were impossible or too cumbrous. More complex music required the more costly process of engraving, a technology invented in the fifteenth century and primarily employed in the service of printing maps. Engraving would become predominant for high art, but the diversity of the market meant that it never came near to replacing movable type, which remained the process whereby thousands of instrumental and vocal part-books, large quantities of church music, and even stage works streamed from the presses. The two methods were not in competition with each other; each was suited to particular kinds of music, and there was pressure for the improvement of production techniques in both. This multiplication of the machinery of reproduction is not unique to music printing. On the contrary, whereas the rule in industrial production is that new technologies replace old ones, it was one of the features of cultural production that new technologies generally added to production techniques without necessarily displacing them but instead increased the opportunities for artistic creation, commercialisation and consumption. This tells us something about the persistence of aesthetic value, where use-value is not reduced to utility and does not become obsolescent, though it certainly becomes subject to fashion. Even mechanical reproduction largely continued this pattern, in the form technically known as backward compatibility, until the rise of digital media

entirely transformed the rules of the game, but also recycled previous formats.

The role of the composer was expanding. Music printing was hard pressed in the face of the proliferation of styles and forms which this process brings with it and publishers have to learn to differentiate their markets. The musical public is not homogeneous but breaks up into agglomerations of different types: on the one hand it divides according to taste, on the other into different types of physical assembly (salons, private gatherings of amateur performers and listeners, paying audiences). These involve different patterns of expenditure and entail different relationships between performer and listener, publisher and composer. Publics defined by taste are dispersed, but taste remains governed by the audiences that gather to listen to performers, professional or amateur. These differences require different methods of extracting payment, a question we shall have to return to later. The rise of orchestral music involved a particular problem, shared by concert hall and opera house, because in addition to the full score, performance required the production of individual parts, a cost that fell to the publisher (or opera house) and provided piece-rate employment for skilled copyists.

In the eighteenth century, the composer was lucky to find a publisher prepared to pay an advance. The common practice was publication by subscription, by which the expenses could be cushioned – a method nowadays applied in various forms to grant access to web stream-ing platforms. Otherwise composers either relied on the generosity of patrons or had to share or even shoulder the costs themselves, while their income derived principally from a salary or retainer. The transi-tion to a new environment is exemplified by Mozart's trajectory from court employee to public performer in commercial concerts (there is an excellent account of these conditions in his letters). Relations between publisher and composer began to alter with the expansion of the trade in printed music in the latter part of the eighteenth century, which allowed the publisher to take risks in bidding for the composer's services. As publishers began to provide a growing proportion of the composer's income, they began to capitalise the composer, replacing the patronage of the aristocracy as the bedrock of the composer's livelihood. According to the music publisher Ernest Roth, however, only one practical method of paying the composer presented itself at the time: the publisher bought

a work outright for a flat sum, yet it was almost impossible to calculate that sum.

It was a guess, based on the chances of the work's success as the publisher saw them. If he sold more copies than expected he had a good bargain and the composer lost; but the reverse was more frequently the case, because failures are always more numerous than successes, although history does not register them ... If, like Beethoven, the composer had the public behind him the publisher could not bargain. He probably did not even try because he had to outbid the five or six other competitors. If the composer was less well established the publisher secured for himself a premium for the risk that he took. The custom of the flat rate, *à fonds perdu*, as it was called with a hint of sarcasm, continued well into [the twentieth] century ... Richard Strauss still sold his publishing rights for lump sums, reserving for himself performing and mechanical rights.[54]

The rise of opera entailed another scenario, where as Lorenzo Bianconi puts it, the composer participates in what is essentially an entrepreneurial structure (however rudimentary) which 'brings a hitherto unknown degree of exposure to the risks of economic failure and artistic success, the inconstancy of public taste and competition with rivals.'[55] Here the composer worked under contract in the same way as the singer or costume designer, and usually surrendered the score and all their rights over it to the impresario. The score was not for publication but a closely guarded piece of property essential for performance. If the opera was a more than average success, the system worked against the composer and in favour of the impresario, who took all the profits, but the composer could increase their rates as their track record improved. The composer could also lose out, when the opera was a hit, to unscrupulous publishers, who were quick off the mark in bringing out unauthorised arrangements. Mozart was caught out this way by the huge popularity of *The Marriage of Figaro*.

Before the middle of the nineteenth century, musical copyright was either non-existent or else a fragile affair. While payment by commission was a long established practice – there are odd reports of payments to composers for individual works going back centuries – there was no legal protection for the written musical score until well after the interests

of writers had been looked after. As the market for printed sheet music expanded, composers stood to benefit, some of them very considerably; in any case, their interests were aligned with the publishers' aim of selling more copies to purchasers who took the music home to play and sing. As commercial concerts flowered and box office takings increased, conditions were further transformed, but this time not at all in the composer's favour, because there was no such thing as performance rights. The first such legislation was introduced by the French Revolution, which instigated a theatrical performance right; Britain followed suit in 1833. The grant of a right, however, is not the same thing as exercising it. A performance right has to be collected; agencies to collect it were needed, and legal judgements to make people pay up. This was not to be achieved without strategic alliances between composers and publishers, for which the conditions varied from country to country. Significantly, the first effective collection agency in France, the Société des Auteurs, Compositeurs et Editeurs de Musique, or SACEM, dating from 1851, owes its birth to the initiative of an author of chansons, Ernest Bourget, who had started taking his claims for payment against cafe-concerts and similar establishments to the courts and winning; evidence of the growth of popular genres, whose publishers largely controlled the agency's administration. Similar agencies were created in Italy in 1882, Germany in 1903, in Britain not until 1914.

Throughout this period, alternative printing technologies appeared or were improved, including a method of printing by stereotype, patented in Edinburgh in 1725 and soon employed by printers in London and Leipzig, a major contribution to printing technology by which a page of type is turned into a metallic plate by means of a mould (or later by means of electrotyping, introduced in the 1840s). Then came a new musical font from the Leipzig printer Johann Gottlob Breitkopf, based on radical principles, which proved particularly suitable, with the rise of the piano, for the growing market in keyboard music of every kind, solo and accompaniment, instrumental and vocal, which soon came to account for well over half the music publishers' collective output. The same firm, as Breitkopf & Härtel, would play a major role in the canonisation of the German tradition to which their principle composers belonged.

As a specialised adaptation of the technology, music printing also adopted another new process, alternative to both movable type and engraving, in the form of lithography, the invention of one Alois Sen-

enfelder in 1786, also known as 'chemical printing', which used a special stone, special ink and special washes, and served equally for music and for graphic art. The direct nature of the process, says Benjamin, 'permitted graphic art for the first time to put its products on the market, not only in large numbers as hitherto, but also in daily changing forms'. It enabled artists to illustrate everyday life, and 'virtually implied the illustrated newspaper'.[56] It offered comparable advantages to music in the attempt not just to keep up with changes of taste but to exploit passing fashions as well. Lithography was rapidly adopted by leading music publishers in Leipzig, Mainz and Milan. It especially proved its usefulness in the innumerable editions combining music and illustration which became increasingly popular with the continuing expansion of the music market during the course of the nineteenth century. The great nineteenth century music publishers, in the age when they acquired financial prominence in musical life, relied on no single method of printing exclusively, but employed each in accordance with its suitability for a particular sector of the market. Though susceptible to influence in various ways, musical taste was highly volatile, and the publisher was still a long way from the ability to manipulate it easily. As the practice of commercial concerts expanded, as opera flourished and operetta became increasingly popular, the publisher could only create a supply of music to exploit a demand which followed its own laws of progression. The only viable method was to provide a large and varied diet of music for popular consumption – the largest part of it domestic and for the piano – and according to Roth, chance still played a very large element in a publisher's success.

The book as paradigm

What of artists working in other artforms, which reach their audiences in different ways? The performer produces an event which, without mechanical reproduction, is transient. The product of the visual artist remains essentially unique (or comes in series or limited editions) and reaches the buyer through the agency of the gallery or art dealer. Neither author nor artist is a wage-labourer and both sell the product they create, but as Dave Beech points out, the publisher is, in Marx's terminology, a productive capitalist who turns the manuscript into the book by means of wage labour, while the gallery owner, who leaves the work unchanged, is a merchant capitalist – but not of the normal kind. Where the merchant

typically purchases commodities in order to sell them on, the gallery does not purchase the artworks that are then sold on to collectors, museums, etc. but charges commission. For Beech, this means that 'art production does not correspond to the capitalist mode of production, but, nevertheless, commercially successful artists and their dealers make super profits' without involving productive wage labour and the surplus value it generates.[57] This too is a strong argument for art's economic exceptionalism, including the fact that the price that attaches to the gallery artwork, especially when it reaches the auction room, cannot be explained by standard price theories but belongs to the realms of financial speculation. But what if there is a comparable but different exceptionality to be found in each artform or medium, which displaces the regular laws of supply and demand?

The paradigm for present purposes remains the printed book. The coming of the book created an expanding readership, it grew its own public, the consumer of the book-as-commodity, from the casual reader to the proud owner of their own library, the subject of Benjamin's subtle bibliophile's reflections in 'Unpacking My Library'.[58] George Orwell also wrote about his library, but with a very different and more prosaic purpose, when he sets out, in an essay of 1946 called 'Books vs. Cigarettes', to demonstrate that buying books is not such an expensive hobby as to be 'beyond the reach of the average person', and calculates what his own library of nearly 900 books cost him.[59] Adding in newspapers and periodicals and cheap paperbacks 'which one buys and then loses or throws away', he makes out his total annual reading expenses 'in the neighbourhood of £25 a year'. Then he calculates the cost of smoking and drinking (6ozs of tobacco a week and a pint of beer a day cost him close on £20 a year before the war) and comes to the conclusion that 'it looks as though the cost of reading, even if you buy books instead of borrowing them and take in a fairly large number of periodicals, does not amount to more than the combined cost of smoking and drinking'. And of course, in the case of books, you still possess them after you've read them, and you'd be able sell them 'at about a third of their purchase price'.

Comparing reading and going to the cinema, Orwell suggested that four hours reading a book that cost eight shillings is about what it costs to sit in one of the more expensive cinema seats, and is probably the cheapest recreation after listening to the radio. His method of calculation in all this is meticulous. He includes the full price of books given to him

or borrowed (temporarily or kept) 'because book-giving, book-borrow-ing and book stealing more or less even out. I possess books that do not strictly speaking belong to me, but many other people also have books of mine: so that the books I have not paid for can be taken as balanc-ing others which I have paid for but no longer possess.' These are all, of course, ways in which books circulate outside the market. He ends by admitting that the low level of book consumption 'is because reading is a less exciting pastime than going to the dogs, the pictures or the pub, and not because books, whether bought or borrowed, are too expensive.' Whether this remains true 75 years later (when the price of small editions from specialist and academic presses has become exorbitant) would be subject to investigation, but not his caveat, that 'It is difficult to estab-lish any relationship between the price of books and the value one gets out of them.'

Marx criticised the classical economists for placing the act of con-sumption outside the realm of study of political economy, which left them unable to explain how production grew by creating and satisfying new needs, spiritual as well as physical. For Marx, consumption lay within the economic process because it 'produces production' by providing 'the impelling cause which constitutes the prerequisite of production'.[60] Production creates the consumer who creates the demand for more pro-duction. Moreover, production produces not only the object but also the manner of consumption, not only objectively but also subjectively, and for Marx, the arts were the very paradigm of this process. As he writes in the *Grundrisse*, 'The need which consumption feels for the object is created by the perception of it. The object of art – like every other product – creates a public which is sensitive to art and enjoys beauty. Produc-tion thus not only creates an object for the subject, but also a subject for the object.'[61]

The rise of the book is the very epitome of the process, which has been repeated with every new cultural medium. But a book is not a bar of chocolate. It is not a consumable, or to put it another way, what is 'consumed', but without being used up, is not the object but its symbolic content, its aesthetic character, which plays on the imagination and enters the psyche of its readers, both individually and collectively. This has all sorts of consequences, beginning with the spread of knowledge and the role of literature in creating what Benedict Anderson called the 'imagined community' of nationhood. In physical terms, it means that the book cir-

culates beyond the market. The reader doesn't have to own it in order to consume it, it can be read aloud, it can be lent between friends, it can be held in libraries and have many readers. It can also go back on sale in the second-hand market, even while first editions increase in value in the antiquarian market. The author, meanwhile, as someone who derives income from financial title to the special type of property called copyright, becomes a rentier. (Except now that books can be so easily digitised, a new sphere of circulation appears where copyright is difficult to police. How long before this book is pirated? It's already happened to several of this author's previous books.)

The book exemplifies a decisive property of cultural commodities: it passes through the act of exchange to shed its commodity status and acquire a life of its own, in both the personal meaning it holds for the reader and its wider social resonance. As Arjun Appadurai sees it, the commodity is not necessarily one kind of thing rather than another, but one phase in the life of certain objects as they move through different hands, contexts and uses. In this way, such objects acquire a biography.[62] In the art market, this biography takes the form of the provenance that proves the history of ownership of a specific artwork, but this in itself says nothing about the import and significance their owners attached to them. However, like the talismanic rifle whose biography is traced in Anthony Mann's Western, *Winchester '73* (1950) as it passes from one ill-fated owner to another, these objects need not be works of art. Unexceptional objects discarded by celebrities become valuable relics, and imbued with an aura of secular sainthood are re-commoditised on the art market at many times their original value. All sorts of objects of no particular value can be invested with meaning and acquire biographies, like family heirlooms. There are television shows where punters present bric-a-brac and curios they've inherited to be appraised by experts; some of them turn out to be valuable antiques, but the show's fascination is the stories attached to each: life histories contained in the sentimental and symbolic relationship between the object and its owner after the object in question has, according to orthodox economics, exited the market and moved out of the commodity state.

It is also possible for such bric-a-brac to be aestheticised in another way, through incorporation as found material into artworks of various different kinds, a practice initiated in the first flowering of modernism just before the First World War by artists like Braque and Picasso which

has become one of the defining currents of art ever since. In the limit case of Duchamp's readymades, like the infamous urinal, exhibited in 1917 under the title 'Fountain' and signed R. Mutt, the chosen object is completely detached from both its exchange-value and its use-value, and according to André Breton and Paul Éluard's *Dictionnaire abrégé du Surréalisme*, is 'elevated to the dignity of a work of art by the mere choice of an artist'.[63] The beholder is either confounded or amused by this uncanny act of dissociation but in the present context the aesthetic function of the found object, from Dada and surrealism, through the practices of collage and assemblage to conceptual art and pop-art and beyond into the digital domain, is to throw the world of commodification back at the beholder in a spectral form. As for what Appadurai calls 'the social life of things', in which objects are infused with social relations and histories, today's commodity is tomorrow's gift, yesterday's gift is tomorrow's *objet trouvé*, yesterday's *objet trouvé* is tomorrow's junk, and yesterday's junk is tomorrow's heirloom.[64]

The aesthetic object, perhaps like all commodities, is a cultural sign, intertwined with both private and social histories. Museums are often devoted to the latter in displays of everyday objects of yesteryear, but the individual treasures an object because they inherited it, or it reminds them of the trip when they bought it, or because a lover gave it to them as a present; you value it irrespective of its monetary cost, because you don't think of it as a commodity. The producer of a commodity is normally indifferent to the reason for its purchase but this afterlife is recognised in a special class of object – the souvenir – which is intimately connected to the growth of tourism. Like any memento, the kinds of object which serve these purposes may be mass produced or individually crafted – this depends on who makes it and who buys it. Beware the miniature Michelangelo 'David' – it may have been factory-made in China. In Mexico, on the other hand, tourism is supplied by a large handicrafts industry, which according to Néstor García Canclini, is not just the result of the survival of backward forms of production in an underdeveloped country.[65] On the contrary, the boom in *artesanía* in Mexico is an integral element in a process both political and economic, first encouraged by the state following the Mexican Revolution in order to succour a sense of national identity, a project supported by leading artists and intellectuals, and then in response to the incentive of tourism. The effect of the latter was to change the traditional function of handicrafts to provide articles for

self-consumption within indigenous communities, which were increasingly replaced by cheaper manufactured goods, as declining artisanal production was revived by a growing demand for 'exotic' goods, alienated from their original use-values to become commodities in a new market, only in order to take their place in a different aesthetic afterlife when the traveller returns home. This is not to disparage the aesthetic pleasure the tourist may gain from their purchase, but reminds us that the aesthetic is not a fixed ingredient of an object but a perceptual relationship which is affected by its context.

Art – high art, popular art, folk art, popular entertainment, even commercial art – is the communication of experience through symbolic production (and reproduction). All such forms are constituted by symbolic content configured according to their own material form. As a result, all behave, as commodities, in idiosyncratic ways, precisely because their material nature is distinct. A book is portable; a sculpture isn't (though it may be small enough to be movable). A woodcut or engraving is multiple, an oil painting unique. A photograph can be displayed in a frame, put in an album or placed in miniature in a locket, printed in a newspaper, and nowadays transmitted instantly across cyberspace to be viewed on a screen. Before the age of mechanical reproduction, to see a play or opera or listen to an orchestra you had to join an audience at the theatre or concert hall, and exchange-value was realised through the box office. In the cinema, the same actors could be seen by many audiences in different places at the same time, and the box office take was correspondingly multiplied. The gramophone record likewise multiplied the presence of the musician and the singer by turning musical performance into a vendible mass produced object. In short, each and every form of cultural production manifests some kind of peculiarity as a commodity, and the forms in which these peculiarities are expressed depend on the material characteristics of the medium in question, and on what Benjamin, in 'The Work of Art in the Age of Mechanical Reproduction', called its technical structure. These factors are what determine the manner of realising exchange-value, the kind of market that can be reached, and the form of recompense of those who make the work. But they do not determine its *raison d'être*, or the reception of the work.

2

The Changing Logic of Artistic Production

THE CONCRETE NATURE OF AESTHETIC LABOUR

Marx summed up the logic of artistic production as it appeared in the mid-nineteenth century by turning from Milton to music, which curiously he feminises. If Milton's writing poetry was an 'activity of his own nature', then

> A singer who sings like a bird [because it's in her nature to do so] is an unproductive worker. When she sells her song, she is a wage earner or merchant. But the same singer, employed by someone else to give concerts and bring in money, is a productive worker because she directly produces capital.[1]

No matter that the invention of the phonograph would radically transform the production and consumption of music. The point here is that the act of singing as such is in all cases the same; the difference lies in the form of appropriation of value. At the same time, the particular material character of each artform affects the manner in which artistic creation can be subsumed by capital and how it can be made to yield a profit. Milton, said Marx, was not a productive worker being paid for his time, but on the other hand, 'the literary proletarian of Leipzig who produces books, such as compendia on political economy, at the behest of his publisher, is pretty nearly a productive worker since his production is taken over by capital and only occurs in order to increase it'.[2] David Harvey explains that the definition of 'productive' here refers not to the type of work but the production of surplus value. 'Only when a publisher organised as a capitalist enterprise prints Paradise Lost in book commodity form does the possibility of value and surplus value production and real-

isation enter into the picture.'³ With certain exceptions like samizdat, this pretty much held true until digital technology made possible new forms of self-publication and selling into the virtual marketplace (or avoiding the marketplace through open access publication).

In other words, artistic endeavour considered in economic terms can be either productive or unproductive, but how it meets the audience depends in part on what is being produced. A song and a poem are materially different. In *Theories of Surplus Value*, Marx makes a crucial distinction between two types of aesthetic creation; the passage is headed 'Manifestations of Capitalism in the Sphere of Immaterial Production'. The first consists in '*vendible commodities*, such as books, paintings, in a word, all artistic products which are distinct from the artistic performance of the artist performing them', the second, which is immaterial, is where 'production cannot be separated from the act of producing, as is the case with all performing artists, orators, actors, teachers, physicians, priests, etc.'⁴ This little list tells us two things. It indicates a likeness between different kinds of performative labour, artistic and otherwise, which are equally immaterial. It also speaks to us of Marx's cultural milieu; today, rather than orators we might think of the pundits of the mainstream media, but the same principle of performance operates. Indeed with television, performance of the self outside of artistic representation would become a dominant trend in a consumer culture which encourages the manufacture of personality and celebrity, for which television itself provides superlative means and ample reward.

Marx took over the distinction between productive and unproductive labour from Adam Smith, and reinterpreted it. According to Smith in a famous passage in *The Wealth of Nations*, activities like musical performance fell into the category of 'perishable services', the type of activity which 'does not fix or realise itself in any permanent subject, or vendible commodity, which endures after the labour is past'.⁵ Perishable services, he explained, like those of the 'menial servant', do not regenerate the funds which purchase them. The labour of some of the most respectable orders in society, says Smith, as well as some of the most frivolous, is in this respect the same: churchmen, lawyers, physicians and men of letters on the one hand, and on the other, buffoons, musicians, opera singers, opera dancers, etc. Marx commented wryly on the 'polemical effect' of Smith's argument. Great numbers of 'so-called "higher grade" workers – such as state officials, military people, artists, doctors, priests, judges,

lawyers, etc. – ... found it not at all pleasant to be relegated economically to the same class as clowns and menial servants and to appear merely as ... parasites on the actual producers (or rather agents of production)'.[6] Musicians, of course, were used to it. They were often at the bottom of the pile. As Jacques Attali puts it, the court musician, who is not a productive worker, 'is paid a wage by someone who employs him for his personal pleasure ... His labour is exchanged for a wage or paid in kind; it is a simple exchange of two use-values': material sustenance for spiritual sustenance.[7] We know from Mozart what would happen in a court where music was not esteemed: musicians lost their self-respect, and in Salzburg under Archbishop Colloredo ended up drunk and indisciplined. He complained in a letter to his father[8] at the way he was treated by the Archbishop, who employed them both, being sat at the dinner table between the valets and the cooks, and just a few weeks later resigned his post to pursue his fortunes in Vienna, where commercial concerts were on the rise and there was living to be made as both a virtuoso and a composer.

There are certain types of services, says Marx, which can be easily rendered into commodity form and subordinated to the capitalist mode of production; for example, those of the tailor, the shirtmaker or the instrument maker. The labour of the actor in the theatre, on the other hand, could not be sold to the public in the form of a take-away commodity but only in the form of admission to the activity itself; it has to 'be consumed while it is being performed'.[9] There is a necessarily direct and immediate relationship between the physician, the surgeon, the lawyer, the musician or actor and even the servant, and the person who receives their services. It is not a contradiction, says Marx, if the violin maker or the organ builder are productive, but the professionals for whom they produce are unproductive.

It may seem strange that the doctor who prescribes pills is not a productive worker, but the apothecary who makes them up is. Similarly the instrument maker who makes a fiddle, but not the musician who plays it. But that would show that 'productive workers' produce products which have no purpose except to serve as a means of production for unproductive workers.[10]

What it comes down to, says Marx, is that only wage labour that reproduces capital is economically productive; 'even a clown ... is a productive

labourer if he works in the service of a capitalist (an entrepreneur) to whom he returns more value than he receives from him in the form of wages'.[11] Marx was a dozen years in his grave when a novel invention appeared that rapidly created a new form of exploitation of clownish labour. Cinematography did for the perishable performance of the clown what the phonograph (invented in the last years of Marx's life) did for the musician: it allowed their immaterial labour to take the commodity form of mechanical reproduction. The exemplary case is Charles Chaplin, a clown quick witted enough to become his own producer and thus the owner of his own aesthetic labour.

Baumol's cost disease

When it comes to collective forms of cultural production – the performance arts, film production, broadcasting – the character of aesthetic labour has another crucial consequence, which finds expression in what is known in mainstream economics as 'Baumol's cost disease'. The tag gained currency after two Williams, Baumol and Bowen, wrote a study in the 1960s of the ineluctable rise of theatre ticket prices on Broadway, which they then generalised to the world of the performing arts.[12] The problem was the irreducible cost of artistic labour. The amount of labour required to play a string quartet at Carnegie Hall in New York was the same as at the court in Vienna two centuries earlier. Over the same period, productivity in the manufacturing sector rocketed while remaining stagnant in the chamber music sector, with a consequent rise in the relative cost of artistic performances. Baumol's 'cost disease' has since been diagnosed in many fields, particularly education, health and caring, and effectively applies to the whole of Adam Smith's list of perishable services. It is difficult, says Baumol, to reduce the time needed to perform certain tasks without also reducing the quality of their product. 'If we try to speed up the work of surgeons, teachers, or musicians, we are likely to get shoddy heart surgery, poorly trained students, or a very strange musical performance.'[13] But it's not as if there's a simple equation between quality of service and the quantity of labour invested, rather that quality is unmeasurable, a matter of attentiveness and interpersonal engagement. The care of the nurse, the attention of the teacher in front of a class, cannot be quantified because there are no fixed rules; sometimes a little at the right moment goes a long way, at other times patience

is needed. The same is true of the work of nurturing that goes on in the domestic sphere, principally carried out by women, which only counted towards the wage bill in the classes able to afford domestic servants. The burden would be partially relieved by electrical appliances or processed foods, and by the 1960s consumer goods like vacuum cleaners and washing machines were standard items of working class expenditure, but their operation remained women's work. Now, we're told, these and other tasks will be replaced by robots and artificial intelligence – for the lucky few able to afford them. In other fields, the application of AI to the provision of services like the law is said to improve their efficiency, at least in some regards and as long as it doesn't just replace the personal attention of the lawyer, and there are clearly great social and health benefits to be gained from the application of AI in fields like medicine, but it's hard to see how this could apply to nurturing, nursing, teaching, clowning, acting and singing. In this respect, the cultural field, in the narrow sense, is not exceptional, but belongs to a wider culture of human values which capitalism systematically undervalues.

Baumol's cost disease is really none other than a version of Marx's organic composition of capital, the ratio of fixed capital to variable capital; that is, the fixed costs of production (plant, equipment, materials) as against the labour power required to turn all this into the product (or service). The capitalist aims to improve this ratio by increasing the productivity of labour. The dependence of the performance arts on the capital of the impresario, or films upon the studio or producer, allows for formal control over aesthetic labour by various means, but not the intensification of productivity. Aesthetic labour cannot be fully subsumed into the capitalist mode of production because it retains a similar character to artisanal production, which Marx sees as allowing a transitional form in which capital organises but does not directly control the worker, as it does with the full subsumption of labour power in the factory system, where the worker is wholly alienated from the product. This applies both in the production of vendible artistic products and in the sphere of performance, where the capitalist mode of production, says Marx, 'is met with only to a small extent' and only in a few spheres.[14] But, as with Baumol's cost disease, this is not limited to artistic creation. It includes education, where 'teachers in educational establishments may be mere wage-labourers for the entrepreneur of the establishment'. He adds that 'many such educational factories exist in England', and comments astutely

that 'in relation to the pupils these teachers are not productive labourers, they are productive labourers in relation to their employer'. In the present day, under neoliberal managerialism with its extensive bureaucratic regime of formal controls, this now effectively applies to the entire education system, not just to private education; but insisting that universities treat students as customers only accentuates the asymmetry (and cheats the student).

You get the same asymmetry, says Marx, with 'enterprises such as theatres, places of entertainment, etc.': in such cases an actor's relation to their employer is that of a productive worker, but in relation to the public, that of an artist. This, when cinema arrives, will generate the star system, which lifts the successful artiste out of the domain of wage labour altogether, to profit directly from their own status as an aesthetic property by renting themselves out – with the result that production costs are inflated by their astronomical fees. But this dynamic was already true in Marx's day, when backstage crews were typically made up of subcontracted labour while the top Italian opera singers commanded fees large enough for them to become investors in their own right. Marx wryly observes another consequence of this state of affairs in the *Grundrisse*, when he mentions 'theatre directors who buy singers for a season not in order to have them sing, but so that they do not sing in a competitor's theatre'.[15]

Orchestras

In *Capital*, speaking of the way the capitalist mode of production separated the ownership of capital from the work of supervision, Marx offers the example of an orchestra conductor, who 'need not own the instruments of his orchestra, nor is it within the scope of his duties as conductor to have anything to do with the "wages" of the other musicians'.[16] It sometimes happened nonetheless, or did so at least in the case of Gustav Mahler. In Hamburg in 1894, when the impresario of the opera house where he was employed stopped paying the musicians during the summer months when the theatre was closed, Mahler wrote in protest to the Burgomaster. Three years later, as the newly appointed director of the Vienna opera, he was appalled when he discovered how little some of the players earned and immediately took steps to raise their salaries, compensating for the expense by economies in other areas. However, when the conductor was his own impresario, then it was down to him.

Pierre Boulez once remarked on the suspicious similarity of the symphony orchestra to a factory, with the conductor as a kind of managing director.[17] A similar suggestion was made by a one-time President of the Du Pont Corporation who suggested that the best analogy to an executive's job 'is that of the symphony orchestra conductor under whose hand a hundred or so highly specialised and yet very different skills become a single effort of great effectiveness'.[18] Marx himself contrasted the orchestra with a factory co-operative, in which the capitalist and his agent become redundant as functionaries within production. 'In a co-operative factory the antagonistic nature of the labour of supervision disappears, because the manager is paid by the labourers instead of representing capital counterposed to them.'[19] When it comes to orchestras, there is a curious element of prophecy here. Playing in an orchestra brings a special sense of collective identity, and as orchestral musicians became increasingly professionalised, they became impatient with the conductor lording it over them, less inclined meekly to accept his authority in matters non-musical, and when they didn't share in the material benefits, began to revolt against their terms of employment. In 1882, the year before Marx died, a remarkable event occurred in Berlin when 50 members of an orchestra owned, run and conducted by one Benjamin Bilse, resigned en masse, complaining of low wages and other indignities, and then re-formed themselves into a new orchestra and proceeded to hire their own conductor. Thus was born the Berlin Philharmonic, to be followed in due course by similar events and new self-governing orchestras in cities like Prague, London and New York, which sometimes took the form of co-operatives. The Czech Philharmonic originated as the result of a strike in 1896 for improved conditions by members of the National Theatre Orchestra; they were out on strike again in 1901 but this time they were dismissed, so they turned the Philharmonic into an independent orchestra. Two years later players in the Damrosch Orchestra in New York, founded by Leopold and inherited by his son Walter, created their own short-lived co-operative. In London the next year, players in the Queen's Hall Promenade Concerts defied their conductor Henry Wood over conditions of employment, and left to form a new self-governing orchestra, the London Symphony. One reason that orchestras could act in this way is that the players owned their own instruments, their means of production, like craftworkers and their tools. This not only remains true but signals the individual relationship the musician has with their instru-

ment, which is more than a tool or implement to be manipulated, but an organic extension of their bodies. Actors, singers and dancers are only a little different: they – their own bodies – *are* their means of production. As Billie Holiday put it, 'A singer is only a voice, and a voice is completely dependent on the body God gave you.'[20]

But if musical life is centred on performance, then considered as an economic activity it involves a great deal more. Christopher Small introduced the term 'musicking' to encompass the panoply of activities that go on around the performance and behind the scenes, and the multiplicity of the roles involved.[21] As long as we're not talking about the recording studio (or the times of the Covid-19 pandemic) these of course include the audience – those who take part by listening. But the term can be extended in two directions. On the one hand, to the well-paid managers, administrators and promoters, who share the musicians' aesthetic sympathies (and may even be amateur performers themselves), and on the other, to the person taking tickets at the door, the piano-shifters, the roadies who set up the gear, the cleaners who clear up after everyone has gone, employed in the cultural sector without being creative workers or having any sense of vocation. In short, musicking comprises a market-oriented industrial apparatus of institutions and technologies that determine what is performed, published, recorded and broadcast, and remains in crucial ways invisible (or inaudible). The result has been noted by Jameson: how music becomes 'a self-contained and autonomous sphere' and not only does it 'thereby acquire an internal history of its own, but it also begins to duplicate on a smaller scale all the structures and levels of the social and economic macrocosm'. It develops its own internal dialectic, its own producers and consumers, its own infrastructure. It contains, for example, its own history of inventions, 'what might be called the engineering dimension of musical history: that of the instruments themselves.'[22]

Of course, it isn't only music where this happens. Each branch of cultural production will develop a similar ecology.

INSTRUMENTS AND TECHNOLOGY

It would help us in understanding the role of technology in modern times to consider the history of musical engineering, because musical instruments participate in the history of technology as well as the history of music, and the history of technology is the history of the means of pro-

duction, including artistic production. In the image of musical history painted by orthodox musicology, this engineering dimension is recognised, if at all, only in passing. But if the bronze age was able to produce simple trumpets made of metal, then only industrialising Europe was capable of making them with valves and pistons able to sound every note in the tempered chromatic scale (itself an invention of the eighteenth century) in tune with a whole orchestra. In this way music becomes an expression of the society which produces it, in which the idiosyncrasies and complexities of its languages and idioms are indirect reflections of the general means of production. Come the Renaissance and the increasing complexity of musical language, the growth of new instrumental idioms, changes in the location of performance to domestic and then specialised indoor settings – all this inevitably created pressure for changes in the instruments employed. Histories of musical instruments show that their makers sought to meet new demands by improving the mechanisms of their instruments; by refining their sound; by extending their compass and dynamic range; and by inventing new ones.

The typical instrument maker was often a musically gifted artisan such as a turner or a metalsmith. The register book of the Company of Turners in London records a good number of wind instrument makers between the end of the seventeenth century and the middle of the nineteenth who all learned their trade as bound apprentices to master turners. These craftsmen were imbued with the same deep and specialist practical knowledge that, as Marx observed in a letter to Engels, sixteenth century German authors writing about clockmakers described as 'learned (non-guild) handicraft';[23] the kind of knowledge, passed down by oral tradition and consolidated by practice, that AI seeks to extract and encode in so-called 'expert systems'. When acoustics emerged in the scientific study of the seventeenth century as a branch of physics, the scientists often went to such instrument makers to learn from them. So too did professional musicians, such as virtuosos who worked with favourite craftsmen consciously looking for improvements. There were a good many families. In Paris, for example, the Hotteterres, who flourished in the seventeenth century, were responsible for decisive alterations in both the flute and the oboe. In some places, like Germany, a specialist trade appeared among organ-builders. Another type emerged with the evolution of furniture and the perfection of the craft of the cabinet-maker. The best craftsmen in the Italian courts, for example, not only turned out

luxury furniture using the tools and skills of advanced carpentry but also instruments which were part of the sumptuary expenditure of their high-placed patrons. The growing splendour of keyboard instruments was one of the results.

This is where the piano was invented at the beginning of the eighteenth century by a Paduan instrument maker, Bartolomeo Cristofori, in response to a request from his patron, a prince of the Medici, for an instrument to 'improve' on the harpsichord. If as George Bernard Shaw once put it, the invention of the piano was to music what the invention of printing was to poetry, then its rise corresponds to the transition from aristocratic to bourgeois culture. Indeed, culturally speaking it was a significant agent of this change, standing at the centre of the site of social gathering, while in economic terms it demonstrates how a supply chain responds to the development of a cultural market it has stimulated itself but cannot satisfy because its mode of production is resistant to mechanisation. By the turn of the eighteenth century the piano had largely replaced all other keyboard instruments in domestic, concert and theatre use, its very success putting pressure on its craft-based mode of production. Take the example of Johann Andreas Stein of Augsburg: aided by a small number of assistants, Stein turned out about 700 claviers in 40 years, or about 17–18 a year. Two years after his death in 1792, his daughter Nanette set up her own enterprise; by 1809 she had made 800 instruments, an annual output more than double her father's. This could only be accomplished by enlarging the plant, increasing personnel, introducing a rigorous division of labour, and the purchase of certain ready treated materials; in other words, more than just enlarging the workshop. Machinery is still absent – this is still the world of Adam Smith rather than Karl Marx – but no longer is it old-fashioned artisanal production. As Arthur Loesser comments in his wonderful *Men, Women and Pianos* (from which these details are drawn), 'A piano maker who expands into a factory ceases to be a craftsman; he becomes a businessman.'[24] Or in this case, woman.

Technically, the piano is an extremely intricate apparatus which employs an abundance of serially repeated parts: keys, jacks, hammer shanks, springs, strings, tuning pins. The corresponding division of labour required in its manufacture makes an elaborate list: sawyers, bracers, markers-off, roughers-up, turners, plinthers, scrapers, carvers, hammer leatherers, stringers, finishers, polishers, gilders, tuners and action regu-

lators. Loesser showed that for all the improvements and developments in piano making since the 1770s, productivity did not increase. Broadwood in London introduced steam-power after the Napoleonic wars, but only for sawing and planing the heavy woodwork. In the 1850s, in spite of economies of scale and the judicious introduction of machines, their 600 workers turned out 2,300 instruments a year, the same amount of labour power per piano as a harpsichord maker needed a century earlier to make 18 or 20 instruments: they still couldn't manage more than three or four instruments a year for each pair of hands. The important gain was that they could do it more cheaply. In industrial terms, however, piano manufacture was anomalous. In 1851, the English census revealed no more than a dozen factories in London employing more than 500 people. One of them was Broadwood's. In this factory, however, there was practically no machinery, the workers were all craftsmen, and the labour process artisanal. Yet Broadwood had an international distribution network, with agents (often piano teachers) and established trading routes. He also knew the value of publicity: in 1818 he sent a piano to Beethoven, at a cost to himself of £78.16.6 including shipping (around £3,630 in 2020 values); today's pianos are much more expensive, ranging from £5,500 for the cheapest to around £140,000 for a top end concert grand.[25] (On the other hand, pianos, unlike violins, do not mature with age, and second-hand pianos could be had quite cheaply, especially at the end of the Second World War, when my parents bought the piano I was to learn on: it was a concert grand made by Broadwood around the same time as the one he sent to Beethoven. When one of the hammers broke, the tuner couldn't find a replacement with the right kind of felt, which was no longer made, and for ever after there was a high C with a different sonority.)

After the mid-nineteenth century, the centre of production moves across the Atlantic as new manufacturers emerge who quickly outclassed the old firms in Europe in scale of production largely by introducing iron frames and redesigning the instrument in the form of the upright. The upright called for something approaching mass production techniques, and it's not an accident that Kimball in Chicago was a friend of Isaac Singer, inventor of the domestic lockstitch sewing machine. Kimball, who becomes the world's foremost manufacturer of uprights until the Japanese learn to outpace the North Americans in the 1960s, followed his friend in aiming at a new mass market among the lower middle and skilled working classes, but although the instrument was cheaper than before, it was still

not cheap enough for outright sale in such a market. The solution was to follow Singer's example and introduce hire purchase terms, not for a machine to contribute to the domestic economy but an object whose use-value was entirely cultural. The piano now became a durable commodity within the reach of the better-off working classes. 'Don't you think the collier's pianoforte', asks a character in D.H. Lawrence's *Women in Love*, 'is a symbol for something very real, a real desire for something higher, in the collier's life?' 'Yes', comes the cynical reply, 'Amazing heights of upright grandeur.' But it was true. Social emulation was a powerful force in Victorian society, and a parliamentary report on life among miners in North East England in the 1870s found that pianos were rated 'a cut above' perambulators (in the USA, it was second to the kitchen range).

The piano owed its success to several factors. In the early phase was its particular suitability for the domestic interiors of a rising bourgeoisie desirous of emulating the aristocratic salon. The upright took it into a range of other settings, from the collier's parlour to pubs and church halls, where it often supported individual and collective singing by untrained singers, a particularly useful function. It only needed tuning occasionally. Nor was it difficult to learn – it sang at first touch, in fact, you could learn to play it by ear – and thus encouraged amateurs, who formed an actively engaged audience for the great virtuosi whom they idolised. Let Friedrich Engels, who was much more musical than Marx – he even tried his hand at composing as a young man – be our eyewitness, writing to his sister in 1842 that

Mr. Liszt has been here and enchanted all the ladies by his piano playing. The Berlin ladies were so besotted by him that there was a free fight during one of his concerts for possession of a glove which he had dropped, and two sisters are now enemies for life because one of them snatched the glove from the other. Countess Schlippenbach poured the tea which the great Liszt had left in a cup into her Eau-de-Cologne bottle after she had poured the Eau-de-Cologne on the ground. She has since sealed the bottle and placed it on top of her writing-desk to his eternal memory, and feasts her eyes on it every morning, as can be seen in a cartoon which appeared about it ... By the way, he must have earned at least 10,000 talers here, and his hotel bill amounted to 3,000 talers – apart from what he spent in taverns. I tell you, he's a real man. He drinks twenty cups of coffee a day, two ounces of coffee every cup,

and ten bottles of champagne, from which it can fairly safely be con-
cluded that he lives in a kind of perpetual drunken haze ...[26]

All this created a growing industry comprised by a series of related trades,
from the piano makers to the publishers of piano music and the growing
ranks of piano teachers and piano tuners. And piano players. Between
1851 and 1900 (according to one estimate[27]) world production of pianos
increased tenfold, reaching about 50,000 a year at the moment when it
was given a new boost as it took up position beneath the cinema screen.
We should not overlook the technological relations of the piano beyond
this musical economy. These centre around the keyboard, or more pre-
cisely, the balanced keyboard – the mechanical arrangement whereby the
notes are engaged by a row of levers resting on a pivot, so that when the
fingers depress them they operate what is called the action of the instru-
ment. This mechanism, first employed in the portative organ in the early
Renaissance, gave rise to table-sized instruments like the clavichord, the
virginals and the harpsichord, designed, since their sound was on the
quiet side, for small indoor settings. The innovation that Cristofori intro-
duced to turn the harpsichord into the piano was borrowed from the most
recent developments in clock-making – the escapement that lies at the
very heart of the timekeeping mechanism. The Medicis, his patrons, were
keen horologists; when the Dutchman Christiaan Huygens announced a
new kind of escapement in 1673, he was accused of plagiarising Galileo.
In this context it seems no mere accident that both Huygens and Galileo
were the sons of musicians and both were also interested in the emergent
science of acoustics, and the absence of documentary evidence should
not stop us asking if Cristofori too should be accused of plagiarism – or
should we call it knowledge transfer?

Pianos and clocks represent opposite forms of time. Musical time is
subjective, affective and biological, clock time is objective, mechanical
and external. They have different roles to play in the development of
bourgeois society. If Cristofori borrowed the escapement from horology
to invent an instrument for recreation and entertainment, clocks were
decisive in the capitalist imposition of time economy on industrial pro-
duction. 'The clock', said Marx, 'was the first automatic device applied to
practical purposes; the whole theory of the production of regular motion
was developed through it.'[28] From the fourteenth century onwards, E.P.
Thompson tells us, there were church and public clocks in cities and large

market towns, and '[t]he majority of English parishes must have pos-
sessed church clocks by the end of the sixteenth century.'[29] Grandfather
clocks begin to spread more widely from the 1660s, but without minute
hands, which only become common later; the spread of the pocket watch
depended on further improvements in the escapement and the spring. 'A
general diffusion of clocks and watches is occurring (as one would expect)
at the exact moment when the industrial revolution demanded a greater
synchronisation of labour',[30] until in the second half of the eighteenth
century 'normal' capitalist wage incentives begin to become widely effec-
tive. Until then labour was managed by natural work-rhythms, measured
in terms of tasks and the rhythms of nature itself: farmers must harvest
their grain before the thunderstorms set in, fishing must follow the tides
(both are still true, of course, except where the rhythms of nature are dis-
rupted by climate change). The work pattern, says Thompson, wherever
people were in control of their own working lives, was one of alternate
bouts of intense labour and of idleness. He adds, in brackets, an obser-
vation particularly pertinent to our present context: 'The pattern persists
among some self-employed – artists, writers, small farmers, and perhaps
also with students – today, and provokes the question whether it is not a
"natural" human work-rhythm.'[31] At all events, the transition to mature
industrial society required new labour habits and a new time-discipline,
achieved through division of labour, supervision of labour, bells and
clocks, fines and money incentives, as well as preaching and schooling; in
short, in Thompson's phrase, 'a new human nature'. The Protestant ethic
plays its part; idleness must be suppressed. 'In mature capitalist society
all time must be consumed, marketed, put to use; it is offensive for the
labour force merely to "pass the time".'[32] The leisured classes, who carried
pocket watches by which they organised their social life, moralised about
the idle leisure of the masses; the times would come when the mass media
would provide the means of imposing a new kind of time-economy on
the leisure time that industrial labour clawed back for itself through the
struggle for a fair day's wage for a fair day's work; in doing so, leisure was
not only monetised but also disciplined.

Marx as journalist

Later, the connection between the piano and technology will go the
other way, and as Friedrich Kittler notes, citing a source from 1823, the

piano keyboard becomes a conceptual model for the typesetting machine and the typewriter,[33] both of which will revolutionise the production of printed and written text respectively over little more than the course of Marx's lifetime. Like all invention, which populist ideology represents as the legendary eureka moment of individual genius, in fact the development of both these technologies was a long drawn out and hit-and-miss affair, with numerous patents for devices that were never constructed and prototypes that didn't work properly. What Brian Winston calls the 'supervening necessity'[34] driving such processes, the social and external forces that fuel it, was not in this case located in the book trade but the newspaper, whose expansion during the nineteenth century to become the central medium of the bourgeois public sphere – dubbed the 'fourth estate' by Thomas Carlyle in 1841 – also marks out Marx's own trajectory, from his editorship of the *Rheinische Zeitung* in 1842 to his jobbing journalism the following decade for the New York *Daily Tribune*. At the time of the former, type was set by a compositor and printed sheet by sheet on a flatbed press at the rate of 200–250 impressions an hour. By the end of the 1860s, newspapers were being printed on rotary presses fitted with papier mâché stereotypes, with paper fed in automatically from rolls and printed on both sides simultaneously, at a rate of more than 10,000 8-page sheets per hour.

During Marx's period as a correspondent, the *Tribune* was the largest newspaper in the world, reaching more than 200,000 readers. However, he resented having to do the job and referred to the newspaper disparagingly as a 'blotting paper vendor', and a form of capitalist exploitation. 'It's truly nauseating', he wrote to Engels in 1857, 'that one should be condemned to count it a blessing when taken aboard by a blotting-paper vendor such as this. To crush up bones, grind them and make them into soup like paupers in the workhouse – that is what the political work to which one is condemned in large measure in a concern like this boils down to.'[35] Needless to say, they didn't pay him very much, but he needed every penny. From some angles, journalism isn't much different nowadays.

Newspaper expansion followed a double dynamic, depending internally on improving its own technology, and externally on developments in the wider infrastructure of transport and communications; above all in the form of the railway, which accelerated and extended distribution, and the telegraph, which accelerated the provision of the news they printed.

In the composing room, however, type was still set by hand; the first effective composing machines to be adopted in the 1870s equalled the output of two or three hand compositors but suffered from serious practical defects. The solution came with the Linotype machine, which the Tribune was the first newspaper to install in 1886, three years after Marx's death. This keyboard-driven mechanism did more than typesetting, but cast the text in lines with automatic justification and then melted down the slugs to be reused (thus eliminating the time-consuming job of distributing the sorts). This achieved a huge gain in productivity, which also had the effect of reshaping of the workforce and its division of labour. Each advance in the machinery – and the process of improvement was continuous – tended to produce greater specialisation in the members of the attendant team; this would have consequences when it came to trade union organisation and demarcation disputes (especially in a country like Britain, where as Eric Hobsbawm put it, its very pioneering industrialisation had 'allowed a rather primitive, largely decentralised trade unionism, mainly of craft unions, to sink roots';[36] it also allowed the exclusion of women from occupying the highest earning grades, like typesetting).

An expanding press also required an expanding editorial workforce, but while a hierarchy would also emerge among journalists, the job they do is hardly susceptible to the same kinds of control over their labour process as in the print shop. New forces were at work, however, and there would instead emerge new codes of professional practice, especially a doctrine of objectivity, a prime example of the imposition of formal controls over the labour process where direct controls are impossible.

Here we must step back, and remember Marx's description of the feverish haste of capitalist production, 'its enormous extent, its constant flinging of capital and labour from one sphere of production into another, and its newly-created connections with the markets of the whole world';[37] for here is the link with the telegraph, another new technology essential to capitalist development, and the generalised need for the dissemination of a new type of information: stock market quotations, raw materials prices, credit rates, statistics. This was the need that Paul Julius Reuter aimed to exploit when he set up his telegraphic news agency in London in 1851 to exploit the submarine cable which had just been laid between Calais and Dover. Reuter understood that he couldn't compete with the newspaper correspondents' prerogatives for informed comment, interpretation and

graphic description. The telegraph, the first technology to treat information, in the modern sense of a data flow, as a commodity, and therefore the need to measure it, was too expensive. Instead he emphasised its advantages of speed and conciseness and constructed a model of reporting 'facts' which came from the criteria of commercial usage, where the facts had numbers attached to them. He also advocated objectivity, the exclusion of interpretation and judgement, signalled by the absence of by-lines in the reports the agency published and the requirement that his correspondents should not belong to any political party. But this stance was pure expediency. He was a foreigner reporting imperialist wars and diplomacy, and could not afford to incur the displeasure of Her Majesty's Government while at the same time needing to satisfy the varying political and ideological inclinations of different newspapers. To serve the interests of Empire and of them all, Reuter therefore devised a code of practice for his establishment which succeeded in meeting all prejudices and helped to make his agency essential especially to the growing number of provincial newspapers, unable to afford their own foreign news reporters, who came together in the Press Association in 1865. This code of practice has essentially changed very little since then and lies at the basis of the modern ideology of objectivity in journalism, which tries to separate fact from opinion but is torn between its role as watchdog and its proclivity to lend support to the powers that be and the status quo (except when the White House was occupied by a President who accused the mainstream press of 'fake news' and advanced his own 'alternative facts').

The telegraph was the first commercially successful application of the new science of electro-magnetism; electricity came into commercial and industrial use during the course of the nineteenth century for communication, light and power, in that order. The new telegraphic news of the latter part of the nineteenth century played an enormous role in shaping the sensibilities of the expanding readership. It helped to establish the 24-hour news cycle which even in the age of radio and television would remain the governing rhythm of the production of news, until the internet intervened. It also changed the craft of reportage. In 1870, during the Franco-Prussian War, the editor of *The Times* instructed his correspondents abroad that the telegraph had superseded the newsletter and had rendered necessary a different style and treatment of public subjects.

Typewriter

The typewriter, which followed a different path of development from typesetting, answered to what might nowadays be called a blockage in data transmission at the point of transcription, experienced by stenographers, because the hand that transcribed was slow. Again there were patents and prototypes and the opportunity created by the increasing pace of commerce and business communication, but oddly, the first device to produce text substantially faster than a person could write by hand had no keyboard but placed the letters on short pistons arranged in the form of a ball that struck downwards onto the paper beneath it – the Hansen Writing Ball which went into commercial production in 1867 and which in 1881, the half-blind Friedrich Nietzsche purchased to help him write (in preference to a bigger and heavier American machine). Thus begins the history of the typewriter and the author, preceded only, according to Friedrich Kittler, by Mark Twain, who purchased a Remington machine in 1874 and whose novel *Tom Sawyer* is 'the first typescript in literary history'.[38] But while Twain preferred that his ownership of a typewriter remain unpublicised, in Germany in 1882, the *Berliner Tageblatt* reported that

> The well known philosopher and writer Friedrich Nietzsche, whose failing eyesight made it necessary for him to renounce his professorship in Basel three years ago, currently lives in Genoa, and ... [w]ith the help of a typewriter he has resumed his writing activities, and we can hence expect a book along the lines of his last one. It is widely known that his new work stands in marked contrast to his first, significant writings.[39]

Kittler comments wryly: 'Indeed: Nietzsche ... changed from arguments to aphorisms, from thoughts to puns, from rhetoric to telegram style', which if you agree with this interpretation, supports the idea 'that our writing tools are also at work on our thoughts'. Also of this opinion was T.S. Eliot, who wrote in 1916 about 'composing' *The Waste Land* on the typewriter and finds that he is 'slogging off all my long sentences which I used to dote on'. Instead of 'subtlety', he says, 'the typewriter makes for lucidity', and Kittler adds 'which is, however, nothing but the effect of its technology on style'.[40] But this also raises the question of what kind of

object we're talking about, what Heidegger called an 'intermediate' thing, or as Kittler glosses it, 'the typewriter is not really a machine in the strict sense of machine technology, but is an "intermediate" thing, between a tool and a machine, a mechanism'.[41] Or is it an instrument, when the hands on the keys are those of an author who is committing their own thoughts into text, their fingers seeking out the letters not unlike the way a musician plays the notes? It all depends on whose hands they are. Kittler gives us a series of examples: 1883, a photograph shows Tolstoy dictating to his daughter who sits poised over a Remington keyboard; 1907, Henry James hires a typist and dictates his new novel; she is, of course, a woman; 1919, the poet Hofmannsthal writes of his daughter about how difficult it would be if he 'had to do without the little one as my typist'; and so the list goes on: all women (with the exception of Freud, who buys a typewriter in 1913 to help Rank with his editorial duties). This is not really surprising. He might also have mentioned that the blind Milton dictated *Paradise Lost* to his wife, without a typewriter and evidently no loss of style. But the story has another side. Kittler tells us how the typewriter promoted the employment of women, who according to US Census data, jumped from 4.5 per cent of a total workforce of 154 stenographers and typists in 1870, to 40 per cent of 5,000 in 1880, continuing to rise until it reached 95.6 per cent of 811,200 in 1930. This workforce does not buy their own typewriters (or have them bought specially for them), do not own their own means of production like craftworkers, and what they type is not of their own authorship. Here, the typewriter is not an instrument, and the typist is a wage-labourer like any other, along with a new measurement of productivity: wpm (words per minute). As the modern office with its female typing pool takes shape, a myth will grow up about the dexterity and special suitability of women for this kind of work with new technological tools; the same gendered work pattern will emerge, for example, in telephone exchanges, and then the supposed propensity of women for film editing.

PHOTOGRAPHY

In this light, the photographic camera is another kind of intermediate thing. An apparatus to capture the images in a camera obscura, it is initially considered as an instrument in the scientific sense. When Arago,

Benjamin tells us, addresses the French Chamber of Deputies in 1839 on behalf of Daguerre's invention,

> The beautiful thing about this speech is the connection it makes with all aspects of human activity. 'When the inventors of a new instrument', says Arago, 'apply it to the observation of nature, what they expect of it always turns out to be a trifle compared with the succession of subsequent discoveries of which the instrument was the origin.'[42]

The presentation of the Bill which followed spoke of the services it was capable of rendering to both the study of science and to the fine arts, of benefit to draughtsmen, the traveller, the archeologist, the naturalist and even the most skilful of painters; and the government was resolved to take the invention into public ownership because no patent could protect it, for as soon as it became public knowledge, anybody would be able to apply it, and it would become the property of everybody.[43] This speaks to the particular skills, knowledges and materials the apparatus required and the general knowledge of them within certain classes of society, mythologised as the 'gentleman amateur', and if many of the early adopters were painters, at the same time the device encouraged the practice of dilettantes and enthusiasts. A new consumer market would emerge as soon as the development of the technology allowed (adoption of the calotype process which created a negative image and thus the production of multiple copies; and of a flexible film base instead of the Daguerrotype's plate) and the line between professional and amateur would blur; in fact it was always only ever a fuzzy line, a division not of talent but of economic employment, and not only in photography but in all fields of creativity. But in the case of photography it was exacerbated by an unexpected doubling of the form of commodification, a separation between the equipment, the means of production, and the product, the photograph.

If ready photographic subjects were found in nature and architecture, landscapes and street scenes, the lens was attracted above all to the human face, even if, as Benjamin emphasised, the length of time required for exposure required artificial poses. Nevertheless the commercial development of photography gathered pace, and a new kind of keepsake, the *carte de visite*, or photographic visiting card, made its appearance. Things developed so rapidly, says Benjamin, 'that by 1840 most of the innumer-

able miniaturists had already become professional photographers, at first only as a sideline, but before long exclusively'.[44] What stood them in good stead was not their artistic talents so much as their training as craftsmen; the photographer becomes a technician. The trade extended its range from personal portraits to views, then celebrities, curios, and other forms of popular imagery. The historical importance of these small glazed prints, say a pair of photographic historians, 'overrides their artistic and technical significance, even though many of them were of the highest quality. To the historian they speak of the mass-market that they commanded; their consequence lies in their numbers and diffusion.'[45]

Photography became the first new technology of graphic reproduction by introducing a new kind of chemically produced image, and as Benjamin remarked, initially much futile thought was devoted to the question of whether photography is an art while '[t]he primary question – whether the very invention of photography had not transformed the entire nature of art – was not raised'.[46] The technical structure of photography meant that the photograph could be produced in multiple copies but not mass produced until print technology was developed to incorporate photographic images, but the commodity status of the photo is most peculiar, because sometimes it has it and sometimes it doesn't. The amateur photographer (and who isn't nowadays?) is a consumer of cameras, and before digital times, of film to put in them, which then needed to be developed and printed; but the photograph they take is not a commodity, it's not produced for sale, it's an entirely aesthetic and symbolic object with no market, without exchange-value, which commonly functions – still today – as a sentimental use-value at the level of private and interpersonal memory; not a commodity but a gift. This aesthetic use-value persists in the free circulation of personal photos in the social media. And now Facebook has got into the game, and presents you with your forgotten memories: 'On this day six years ago ...'.

At the same time, however, the photograph is commodified in the hands of the professional, from the nineteenth century high street photographer serving domestic clients to the newspaper photographer, or the high-profile fashion photographer who runs their own studio and employs assistants, not to mention artist photographers who exhibit in galleries and sell their work on the art market. Many will be wage-labourers, or especially nowadays in precarious employment, but others are merchants selling their own aesthetic product into the trade market,

which is controlled by agents and editorial gatekeepers, and where all but a few become anonymous. When the photo is sold into this trade market it becomes a commodity, to be incorporated into the medium that carries it, but this is incidental to the viewer who buys the newspaper or magazine, for whom its primary attraction is its symbolic and aesthetic content. But the photograph is highly promiscuous, and will be attracted by any commodity form that takes it to market, including postcards, greetings cards, and the posters with which students proverbially decorate their walls.

Photography also introduced a new phenomenon, a new category: the linked commodity. In first place comes the distinction between the camera and the film that carries the photo. The camera is what we nowadays call a piece of hardware, a device that belongs to the class of durable goods. But then you need the support, the photographic plate or film; early photographers had to produce their own (likewise early filmmakers). When mass produced roll film was introduced to a market of aspiring amateurs, it comprised a linked commodity, belonging in this case to the class of perishable goods which nowadays come with a sell-by date (or would if it hadn't been replaced by digital memory). When Eastman introduced the Kodak camera in 1888, a name devised to be serviceable in any of the languages spoken by the diverse immigrant populations in the USA, along with one of the most famous advertising slogans of the day: 'You press the button, we do the rest', the enterprise was dependent on an efficient mail system: the purchaser sent the camera back, the film was processed and replaced and camera and photos returned. The phenomenon of linked commodities would reappear in various guises and with various effects with other new technified cultural commodities, from the phonograph and the record, to twenty-first century computers which require software and an internet connection.

Benjamin sees mechanical reproduction in historical perspective. The ancient Greeks, he begins, 'knew only two procedures of technically reproducing works of art: founding and stamping. Bronzes, terra cottas, and coins were the only art works which they could produce in quantity. All others were unique and could not be mechanically reproduced.'[47] The surprising thing in this observation is seeing coins as works of art, but the economist Costas Lapavitsas concurs: enter the Numismatic Museum in Athens, he says, with its profusion of different coins

bearing a wealth of representations of gods, heroes, symbolic images and inscriptions, and the sensation of looking at art is immediate and indisputable.[48] Orthodox art history tells us that artist signatures first emerged in the early Renaissance, when art production shifted from co-operative guild systems to a celebration of individual creativity, but in a film interview, the museum's director, George Kakavas, points out that early coins have been signed by the engraver, who was clearly proud, he says, to have created the representation that was stamped on the coin.[49] For all that, the coin is a fungible object with none of the aura that Benjamin associated with the traditional functions of art, which is lost through mass reproduction (although the coin continues to carry highly abstracted symbolic functions deeply embedded in both social imagination and the individual psyche). The coin only acquires an aura when placed in a museum display case.

There is a curious connection between coins and the invention of printing. As Benjamin observes, graphic art became mechanically reproducible with the woodcut before writing became reproducible by print. However, according to the classic account by Lucien Febvre and Henri-Jean Martin, printing was the result of a quite different technique, and the inventors of movable type like Gutenberg were goldsmiths well versed in the techniques of casting and stamping metal.[50] Other technologies of graphic reproduction followed, including engraving, for specialised purposes like maps and music, then lithography at the beginning of the nineteenth century. Each form developed its own market, which might overlap with others but without the new format superseding the old, again marking a difference from regular commodity production where new technology drives out old.

As for painters, says Susan Buck-Morss (in her commentary on Benjamin), they 'attempted to defend themselves against the new technology [and] thereby missed the real threat to their cultural creativity, the effects of the capitalist market'.[51] Faced with a growing flood of photographs, including the reproduction of conventional artworks, and needing to compete, artists were forced to speed up production, to turn out portraits with a rapidity that robbed them of their individuality, to develop a style of 'genre paintings' which were a function of repeatability. Or else, to rethink their art, and if photography forces a rift between hand and representation, then modernism is not far away.

MASS MEDIA AND ADVERTISING

There are growing job opportunities for visual artists as printing technology develops and chases new markets. Illustrated magazines appear – in Britain, the most famous but not the first, *The Illustrated London News*, was launched in 1842 – and with them a paradox, of the kind that arises in a capitalist enterprise which cannot escape certain transitional features: engravers benefitted because a medium that should have taken to photography was for several decades technically unable to do so, and thus employed one or other form of engraving, taken either from artists' drawings or indeed from photographs. Only in the 1890s, after three or four decades of trying to solve the technical problems involved, was half-tone photographic printing widely adopted. A technique of screening by which the image was turned into a series of dots of different sizes which could then be turned into a plate for printing, this appears in retrospect as an early form of digitisation. Meanwhile another print technology appeared which transformed not the page but the environment. The expansion of the press is symbiotically tied in to the growth of advertising – the earliest newspapers carried what would come to be called 'classified' announcements – but since advertising is constitutionally responsive to opportunity, the perfection of colour lithography in the 1880s nourished the modern poster, replacing the already ubiquitous billposting of previous decades; if established artists steered clear of the form, which they considered, not surprisingly, a prostitution of their gifts, poster art would nevertheless in due course be elevated to a minor artform in its own right. But above all, advertising would become one of the great beneficiaries of the new mass circulation newspapers, helping to shape the proclivities of their proprietors and the sensibilities of their readers, and will henceforth employ growing numbers of artists, graphic designers, photographers, and those who were now dubbed 'copywriters' – a curious term when you consider its homophone, for precisely what they do not own is the copyright in the words they compose, any more than all these other hired hands who will be designated simply 'creatives'; the play on words in this nomenclature is entirely in keeping with the wordplay in the advertising copy itself, and characterises the emergence of a new mentality.

This growth also generated a host of less creative jobs, beginning with advertising agencies. These originated as simple brokers selling space on

behalf of the newspapers to would-be advertisers who, especially as the former grew in number, had no way of knowing who the readers were and if they constituted the market they wanted to reach; to fulfil their intermediary position the agencies would become major advocates of the benefits of advertising, and would generate offshoots in the shape of market research and opinion polls, as well as practices like brand names and snazzy packaging, all of which created jobs, but not the kind you could call creative except in the self-serving lingo of the advertising industry itself. In due course, after the introduction of television, these new practices would transfer from selling goods to selling politics. By this time, advertising, which began as a means of developing markets at the expense of the producer, was becoming a form of capital accumulation in its own right.

The principles of advertising are hardly new. Even the earliest examples show the tendency to wrapping up information in rhetoric and what Carlyle in the 1840s would call 'the all-deafening blast of puffery', a term first used in the figurative sense of 'inflated praise' as early as the 1730s, which would be applied especially in the case of so-called patent medicines. The degradation of language is built in as superlatives outrun each other. As Dr Johnson complained as long ago as 1759, 'Advertisements are now so numerous that they are very negligently perused, and it is therefore become necessary to gain attention by magnificence of promises, and by eloquence sometimes sublime and sometimes pathetic. Promise, large promise is the soul of an Advertisement.'[52] But as the nineteenth century advances, the subject matter of advertising is no longer focused on the luxury commodity but increasingly the relatively cheap mass produced article, which changed the rules of the game. A hundred years after Dr Johnson came new food products like condensed milk, beef extract and table condiments, along with new mechanical inventions which changed the business and social habits of the age; many of these new products would be linked to a universal brand name, another new advertising device first developed in the USA. The Singer sewing machine, which as early as 1856 could be bought on instalments. The Remington typewriter of 1874. Kodak with its famous slogan in 1888. In short, when Hobsbawm writes in *The Age of Empire* about a new political need to address the masses and 'the transformation of these masses themselves',[53] advertising makes its own contribution to this transformation through the commercial discovery of new markets for new commodities.

The striking growth of the press, daily, periodical and illustrated, the advent of the advertising industry, and of consumer goods designed by artist-craftsmen or other professionals, says Hobsbawm, made it easier than ever before to earn a living as a creative worker. 'No doubt this proliferation of professional creators produced a great deal of hack-work, or was resented as such by its literary and musical practitioners, who dreamed of symphonies as they wrote operettas or song-hits, or ... novels and poems as they churned out reviews and "essays" or feuilletons.'[54] But it was paid work, even for aspiring women journalists, probably, says Hobsbawm, the largest body of new female professionals. Women were at the centre of these developments. 'The rise of an economy of services and other tertiary occupations provided a wider range of jobs for women, while the rise of a consumer economy made them into the central target for the capitalist market.'[55] But women's market power, the historian avers, contributed little to a change in status, and 'the techniques which advertisers and journalists found to be most effective tended, if anything, to perpetuate traditional stereotypes of women's behaviour. On the other hand the women's market generated a substantial number of new jobs for women professionals, many of whom were also, and for obvious reasons, actively interested in feminism.'[56]

The advertiser, however, is faced with a problem, best encapsulated in the famous remark by Unilever founder Lord Leverhulme, that half the money he spent on advertising was wasted, but he didn't know which half. This has supposedly been mitigated nowadays by the targeted adverts of the internet, but the quip remains true because the take-up of targeted ads is still low and erratic. Leverhulme's problem is that advertising occupies a strange place in the apparatus of capitalist production. The advertisement is not a commodity on offer to the consumer but only the sign of one; the beholder doesn't pay anything to see it, on the page, in the street or on the screen, but the consumer ends up paying for it indirectly, because that's the only way the advertiser can recoup the cost.

In the early phases of its ascendancy, advertising was based, as Hans Magnus Enzensberger put it, 'not on the dictates of false needs, but on the falsification and exploitation of quite real and legitimate ones without which the parasitic process of advertising would be redundant.'[57] But it doesn't stop there. Advertising comes to add a whole new dimension to Marx's concept of commodity fetishism, by which every product is converted into a social hieroglyphic in which the social relations of pro-

duction are concealed and the commodity takes on a fantastic form in which inanimate objects are imbued with magical properties 'abounding in metaphysical subtleties and theological niceties'.[58] By drenching the public sphere in a stream of seductive words and enticing imagery to tickle the consumer's fancy, the aim of advertising becomes the creation of desires that didn't previously exist, which the customer has had no expectation of satisfying in this form, for things they don't even know they need. Desire being irrational, so is advertising. It offers an illusory solution to the contradiction that arises between use-value and exchange-value, which produces an illusory doubling of reality out of the difference between use-value and the *appearance* of use-value; the domain that W.F. Haug calls 'commodity aesthetics',[59] a process which comes to encompass the whole process of production from design to packaging to the advertisement itself. The advertiser poses as being concerned with the needs of the consumer and the use-values of the commodity but in reality is interested only in its exchange-value; use-value only figures in the calculations of the commodity producer in terms of buyer expectation to be played on. To the producer, the utility of advertising is rooted in the need to discover, organise, multiply and channel demand, in short, to promote circulation, 'for the existence of old stock spells economic death for any capital trapped in commodity form'.[60]

None of this would be news to Marx, whose youthful analysis in the *1844 Manuscripts*, as Haug puts it, 'is valid here', for what else is he describing when he writes that

> Private property does not know how to change crude need into human need. Its idealism is fantasy, caprice and whim ... Every product is a bait with which to seduce away the other's very being, his money; every real and possible need is a weakness which will lead the fly to the gluepot. General exploitation of communal human nature, just as every imperfection in man, is a bond with heaven, an avenue giving the priest access to his heart; every need is an opportunity to approach one's neighbour under the guise of the utmost amiability and to say to him: Dear friend, I give you what you need, but you know the conditio sine qua non: in providing for your pleasure, I fleece you.[61]

Freud also spoke about fetishism, in a different context but with the same sense that the fetish is an unreal object with mysterious powers,

which in Freud's case, speaks to male sexual perversion. His theories about instinctual drives and unconscious forces enter the history of advertising through his American nephew Edward Bernays. Embarking on a career as a journalist and then a press agent, whose clients included Diaghilev's Ballets Russes and Caruso, Bernays then found employ in a government propaganda agency during the First World War promoting American war aims, which he would later refer to as 'psychological warfare', and his apprenticeship was complete. Setting up in business for himself in New York after the war, and recognising that propaganda was a suspect term for peacetime activities, he invented the term 'public relations' instead. As Adam Curtis puts it in his film about him, Bernays, influenced by his uncle's theories (whose work he promoted in the USA), 'wondered if he might make money by manipulating the unconscious'.[62] (A colleague of his interviewed by Curtis recalls, 'First Eddie created Uncle Siggy in the US, made him acceptable, second, and third, then capitalised on Uncle Siggy. Typical Bernays performance.') He also took in the new field of crowd psychology opened up by Gustave Le Bon in *The Crowd: A Study of the Popular Mind* of 1895, whose work traverses the emerging fields of anthropology, psychology and sociology. Should it surprise us that the crowd first enters the scholarly purview under the sign of threat? Le Bon, who in 1871 had witnessed the Paris Commune, theorised the 'psychological crowd' as an entity that creates a collective unconsciousness governed by a 'group mind' that allows individuals to 'yield to instincts' buried in their 'racial unconscious'. Notwithstanding his political conservatism and underlying racism, as the crowds and masses of the industrial world become ever more menacing, the problematic he addresses of the phenomenon of crowd behaviour was widely felt as a pressing issue, and Le Bon would be read by such disparate figures as Theodore Roosevelt, Mussolini, Hitler, Lenin, and Freud himself.

Bernays, marrying the two, brought psychological theory into the practice of advertising on the principle that it was possible to manipulate people, persuade them to behave irrationally, to induce them to want things they didn't need, by linking a product through association and connotation to their emotions and desires – which also means, as in wartime propaganda, their fears, but you couldn't say so. The most trivial objects could be subjected to this treatment, which went far beyond the advertisement itself to incorporate gimmicks, promotions, hype and assorted other shady practices, in line with the deception of PR and applicable

to any field of activity, which works behind the scenes to feed the news media with stories to report without appearing to be advertising, which is indeed a form of propaganda. It is not an accident that comparable techniques of subterfuge have been practised by state intelligence agencies, where military theorists of psychological warfare have distinguished five types of propaganda: overt propaganda (where the source is known); covert propaganda (where the source is disguised in such a way that it could be believed to come from the enemy); strategic propaganda (where the objectives are general, long term and directed at the entire population); tactical propaganda (which addresses a particular group of persons in a precisely directed way); and counter propaganda (which combats and neutralises the effect of the propaganda of the enemy).[63] State propaganda, PR and commercial advertising are all conducted through the organisational tool of the campaign. The advertisement is not designed to be singular, but constantly repeated in order to sink in. Essential to this function is another characteristic, which also serves to make efficient use of expensive space or airtime: brevity. In the move from print to airwaves and the introduction of music, the result was the jingle, which has the special property of staying in people's minds, like an earworm, and exemplifies the concentration of meaning that defines the aesthetics of advertising. No less a composer than Stravinsky once expressed admiration for the skill of the jingle composer who is capable of making a complete musical statement in just a few seconds.

The result of the perversion of Freud was a cultural shift in which a discourse of needs, utility and consumer information gives way to one of false desires and unfulfillable promises, often couched in terms designed to appeal to the libido. And also a paradox, that the psychology of the crowd ends up promoting a new mode of individualism, in which the subject sees themself as a reflection of what they consume. The media, however, agglomerates the consumer into segmented markets, defined by the support where advertisements appear, turning their pages and screens into a commodity to be sold to advertisers on whom they would become ever more dependent. As advertising revenue increased, the press were enabled to reduce their cover price, until they came to depend on advertising to generate their profits, an equation which would hold true until the internet arrived. Equally, the very concept of commercial broadcasting is based on the same principle, and produced an entirely new genre of aesthetic creation, the 'commercial', another word which turned from

an adjective into a noun. No-one to begin with called advertising art (Bernays rather thought of it as a science, or the 'engineering of consent') but again we're left with the same question Benjamin asked about photography: not whether it is art, but whether it didn't transform the entire nature of art.

3

Cultural Commodification

GRAMOPHONE

Music first became an object of commerce with the advent of printing (the first printed sheet music was offered for sale in Venice in the early 1500s) but behaves a little differently from the book. The printed score is not an end-product in itself but an intermediary object, a means of performance, initially aimed largely at amateur musicians, and the growth of music publishing took place in a market delimited by such factors as the extent of musical literacy and the production of musical instruments. Gramophone records were different, and unprecedented: they turned the evanescent performance of music into a material object, with effects both economic and aesthetic. Recording is a medium of separation which divides what was previously indivisible into two separate moments: performing and listening. By means of mechanical reproduction, the performance itself becomes a vendible object, a new kind of commodity which opens up a whole new branch of the economy, in which music is transmogrified, paradoxically disembodied from its human transmitter and transplanted into an inanimate object which is transportable and repeatable, all without being physically consumed.

Just as photography took several decades of technical development to achieve mass consumption, the record industry only took off after a series of improvements to Edison's original phonograph. The wax cylinders employed by Edison for recording could not be mass reproduced, only copied in small numbers. The quality of reproduction was barely adequate, but the inventor imagined all sorts of uses, of which music was only one:

1. Letter writing and all kinds of dictation without the aid of a stenographer.

2. Phonographic books, which will speak to blind people without effort on their part.
3. The teaching of elocution.
4. Reproduction of music.
5. The 'Family Record' – a registry of sayings, reminiscences, etc., by members of a family in their own voices, and of the last words of dying persons.
6. Music-boxes and toys.
7. Clocks that should announce in articulate speech the time for going home, going to meals, etc.
8. The preservation of languages by exact reproduction of the manner of pronouncing.
9. Educational purposes; such as preserving the explanations made by a teacher, so that the pupil can refer to them at any moment, and spelling or other lessons placed upon the phonograph for convenience in committing to memory.
10. Connection with the telephone, so as to make that instrument an auxiliary in the transmission of permanent and invaluable records, instead of being the recipient of momentary and fleeting communications.[1]

If all these uses have now become commonplace, they were mostly beyond the capacities of Edison's prototype, and it took the replacement of the wax cylinder with the flat disc before the record industry took off on the back of the magic of music. Unlike the cylinder, the disc was easy to mass produce, and once introduced in the closing years of the nineteenth century, it rapidly changed the configuration of the medium: the phonograph was a machine for both recording and playback, the gramophone was a device for playing records but not recording them, for which specialised equipment was now needed, the disc cutter, and the new skills of the recording engineer (later would come business roles like the record producer, the studio manager, the A&R man and the agent). The technical structure of the device was also significantly different from its cousin, the telephone, which required a physical infrastructure of transmission lines to connect subscribers and first entered the market at the top, as a luxury appurtenance, quickly adopted by the tradesmen and professionals who depended on up-market customers. The gramophone was entirely mechanical, in smaller models its clockwork motor made it portable,

and both gramophone and disc were cheap enough to rapidly garner a popular market. This had huge implications for the way that music now came to be heard and treated. Already, in the years before radio, it altered ways of listening by taking music into new settings, placing it, as Benjamin noted, in new surroundings out of reach of the original itself, like a choral performance in a cathedral which resounds in a drawing room.[2] In less rarified surroundings, the gramophone record produced huge openings for new styles of popular musics bubbling up from below, above all in the dynamic burgeoning informal spaces of popular enter-tainment in the USA which succoured the extraordinary creation of jazz and the blues that transformed popular musical consciousness across the world, becoming rapidly commercialised by the methods associated with Tin Pan Alley and analysed by Benjamin's friend Adorno (of whom more in a moment).

Roland Barthes revived the medieval term *musica practica* to describe amateur musical practice in the nineteenth century.[3] People who play and sing listen differently from those who don't, even if they're indifferent performers: they have practical knowledge. But the concept has much wider import, because this is how music is transmitted from generation to generation, aurally and orally, with or without notation, the form that musical knowledge takes directly from musical practice (indeed at base, the musical equivalent of the way the baby learns to talk, which begins in babble that can just as easily turn into singing). The record served jazz as a powerful new means of disseminating this new unwritten form of *musica practica* and its style of performance. As Evan Eisenberg puts it, 'Whereas Bessie Smith had needed to go on the road with Ma Rainey in order to learn from her, Victoria Spivey and Billie Holiday and Mahalia Jackson could learn from Bessie Smith by staying put in Texas or Maryland or Louisiana and playing her records.'[4] Lacking notation, what they recorded was often treated by the record companies as 'folk song' to avoid paying copyright. A determining factor in the evolution of recorded music was the restricted capacity of the commodity form: the limited time span of the disc (until the introduction of the LP, or long play, after the Second World War). According to Hobsbawm (who wrote his book *The Jazz Scene* under the pseudonym Francis Newton), the ten-inch, three-minute 78 rpm single side was the standard format 'because it was the cheapest economic unit of record production.'[5] Musically speaking, three minutes is an arbitrary and artificial length of time, and

squeezing the music onto a record side had effects that were damaging to classical and popular music alike, but it could also have beneficial results. As Hobsbawm-cum-Newton explains, with the music compressed into the three-minute limit 'musicians were obliged to invent an extremely dense, formally strict, concise form',[6] and they did so with extraordinary success. Indeed, the recording studio initially provided jazz musicians with a space of relative autonomy, where they could determine the values of their music themselves because they weren't playing from written scores and the pieces were 'composed' just before they were recorded. Nevertheless, rank-and-file musicians began to experience recording as a new and contradictory form of exploitation, in which other people were always making more from records than they did. Records promised worldly success, but in practice, with their lowly status as labour power reflected in the term 'session musician', their remuneration was always at the bottom of the pile. But the same was true of leading performers, and Small proposed 'a rule of thumb, that if an artist or group makes a lot of money it is only after a lot of other people have made a lot more money first'.[7]

When the cylinder gave way to the disc and mass production arrived, the record business immediately acquired an international dimension. Such was the technical structure of the new medium that recordings could be made anywhere and mass produced somewhere else. The first disc to sell a million copies was recorded by Enrico Caruso in Milan in 1904 and largely owed its success to Italian immigrants in the USA (where Bernays was his press agent when he toured the USA a decade later). If this looks in hindsight like a rehearsal for globalisation – which as we'll see also happened with cinema – it is also the realisation in a new commodity of a trait identified half a century earlier in the *Communist Manifesto* as the capitalist drive to establish a world market, which gives 'a cosmopolitan character to production and consumption in every country ... And as in material, so also in intellectual production. The intellectual creations of individual nations become common property.'[8] Already in 1900 the catalogue of the London-based Gramophone Company offered 5,000 titles, with separate lists of English, Scottish, Irish, Welsh, French, German, Spanish, Viennese, Hungarian, Russian, Persian, Hindi, Sikh, Urdu, Arabic and Hebrew records. One of the reasons the device spread fast and far was that being entirely mechanical, it required no electricity; it would remain that way until after the separate development of radio

and amplification, when the record companies were forced to modernise and the industry was again reconfigured. Nevertheless, the business soon turned out to be relatively cheap to enter and allowed a plethora of small labels catering for specific small ('niche') markets; their records were pressed at factories owned by the major companies, for whom the production of records was originally treated as secondary to the manufacture of the equipment to play them on.

This is a characteristic of linked commodities: the hardware is of no use by itself but providing the complementary goods is not initially profitable in itself, and is therefore treated as a loss leader. (The same thing happened with radio in the 1920s, when manufacturers set up radio stations, but then the problem was a little different: radio programmes were not commodities offered for sale to the consumer; they needed a different way of paying for them.) But after the cylinder gave way to the disc, the price of the consumer hardware fell, and before the industry split up into separate sub-sectors, a leading enterprise like the Gramophone Company had pressing plants in England, France, Spain, Austria, as well as Riga for the Russian market and Calcutta for East Asia. They also understood how to play the market in bidding for prestige. When the Victor company in New York advertised their Caruso records in the trade press in 1905, the blurb beneath photographs of their recording artists read: 'Three show pictures of operatic artists, one shows pictures of popular artists. Three to one – our business is just the other way, and more, too; but there is good advertising in Grand Opera.'[9]

It was the publishers, however, who took control of the market, devising methods like 'plugging' to get new songs heard; evidence the case of George Gershwin, who began his career as a 15-year-old in 1914 when he left high school to become 'probably the youngest piano pounder ever employed in Tin Pan Alley', accompanying the song pluggers and visiting vaudeville houses to report which acts were using songs published by his employer.[10] Looking at the system that evolved as the music publishers muscled in, Adorno's analysis of commercial music production as 'perennial fashion' is acute, although his notorious disparagement of jazz seems to many people off-key. This is his own fault, since he failed to distinguish between jazz proper and the music derived from it, or as his biographer puts it, 'what jazz had become now that it had been transformed into dance music and light music, following on in the wake of the popularisation of blues and ragtime'.[11] But he was a trained composer, a pupil of

Arnold Schoenberg's pupil Alban Berg, and his analysis of how Tin Pan Ally worked is based on close analysis of the musical devices employed. The way Adorno sees it, the fetishistic nature of consumption is clearly visible in the case of popular music, where competition on the culture market proves the effectiveness of certain techniques (syncopation, semi-vocalised instrumental playing, impressionistic harmonies, etc.) which are then kaleidoscopically mixed into novel combinations 'without there taking place even the slightest interaction between the total scheme and the no less schematic details'. The money invested in promotion makes every divergence a risk, while 'standard procedures which have been perfected over long periods of time produce standard reactions. Not only that, but the deviations are as standardised as the standards. The result is that everything is always new and always the same.'[12]

Adorno

It's not that Adorno is just another elitist; he believes, says his biographer Stefan Müller-Doohm, that 'all music in the capitalist society of today bears the marks of alienation and functions as a commodity that must realise its exchange value in the marketplace'.[13] What decides the authenticity or inauthenticity of a piece of music is whether it submits to market conditions or whether it resists them. This doesn't only apply to music, since the same thing occurs in other domains, including radio and television, where the market relation is indirect – because the audience doesn't pay for the programme as such – but where production takes place in serial form, which requires a high degree of standardisation: quiz shows, soap operas and drama series leave little room for manoeuvre; perhaps only comedy shows are allowed room to be subversive. Most disturbingly, this also seems to apply to news programmes, which bear a striking resemblance to soap opera with their running stories, cast of major and minor characters, and formulaic narratives which allow little dissent. In short, as Beech puts it, 'the "culture industry" is culture subjected to standardisation, regulation, calculation, technology, expertise, management and marketing'.[14] Later, Adorno added a proviso: the term 'industry' is not to be taken too literally: it refers to the standardisation of the thing itself, like genre movies, and to the rationalisation of distribution, 'but not strictly to the production process'.[15] In film, for example, 'the central sector of the culture industry, the production process resembles technical

modes of operation in the extensive division of labour, the employment of machines and the separation of the labourers from the means of production', yet individual modes of production are nevertheless maintained. It is industrial more in a sociological sense, in the incorporation of industrial forms of organisation, 'rather than in the sense of anything really and actually produced by technological rationality'.[16]

When Adorno and Horkheimer first coined the term 'culture industry', says Nicholas Garnham, 'they did so for polemical reasons and to highlight what they saw as a paradoxical linkage between culture and industry', in opposition to the then dominant mass society theorists who thought in terms of either elite/mass or base/superstructure models. Perhaps this is the place to dispel a confusion. According to Marx's formulation in the Preface to *A Contribution to the Critique of Political Economy*, the economic structure of society comprises 'the real foundation on which arises a legal and political superstructure', which is comprised by the legal, political, religious, artistic or philosophic – in short, ideological forms in which men become conscious of ... conflict and fight it out'.[17] This is the base/superstructure model, but it's only a model. It is not a formula that can be easily applied to actual historical cases where the mediation of different factors becomes irreducible to simple determination, and the attempt to do so is too often merely mechanical, the kind of thinking Sartre called lazy Marxism. The best we can say is that the economic base establishes the parameters within which production can take place, or as clarified by Engels, it is determining only in the last instance. But as Terry Eagleton asked, 'Are cinemas superstructural phenomena? The answer is sometimes yes and sometimes no.'[18] It might depend on the film.

The process, of course, is dialectical, but this is a term that creates its own trap, because of its slippery philosophical overtones; in particular, the idealist notion in Hegel of human history as the unfolding of the 'spirit', which the materialism of the Marxist dialectic inverts, replacing spirit with class struggle as the engine of history, while the contradictions of capitalism spell its doom, its eventual collapse under the weight of its own contradictions. In the mechanical Marxism that in due course became orthodoxy, this was presented as a necessary and inevitable fulfilment of a preordained path. Except that history does not unfold as expected, and while the capitalist system has several times come close to implosion, it has always so far managed to save itself. The problem is already apparent in Lenin's 1916 pamphlet *Imperialism: The Highest Stage of Capitalism*,

of which Jameson observed, at the end of the twentieth century, that 'these "highest stages" now lie well in our own past; imperialism is gone, replaced by neo-colonialism and globalization'; whereas Rudolf Hilferding, he adds, just a few years earlier, spoke of finance capital as the latest or most recent stage of capitalism, 'which is obviously preferable'.[19] But this places the teleology of historical progression in question, and indeed, capitalism has demonstrated an unexpected resilience and capacity to reinvent itself, a process which has repeatedly unsettled Marxist prognostications, to the point where (as Jameson puts it elsewhere) it has become easier to imagine the end of the world than the end of capitalism.[20] Adorno tackled the problem towards the end of his life when he introduced the term 'negative dialectics', which as Peter Thompson puts it, 'asks us to reject the idea that the outcome of the dialectic will always be positive but that we do so without leaving the dialectic behind as an explanatory model'.[21] We live within contingency, there is no necessity for things to turn out in a certain way, but with the proper historical tools we can see in retrospect what happened to get us where we are. (Whether we can use this knowledge to get us out of the fix we're now in is a different question; Adorno was pessimistic.)

Jameson argues (following Giovanni Arrighi's *The Long Twentieth Century*) that capitalism's movement is discontinuous but expansive, not only in time but also in space; it moves from place to place as it takes root and is then displaced by rival centres, each time adapting its character. 'With each crisis, it mutates into a larger sphere of activity and a wider field of penetration, of control, investment and transformation.'[22] (Harvey calls this capitalism's 'spatial fix'.) These mutations can be mapped in shifts they bring about in cultural transmission, but they also leave their mark in the transformation of the cultural dominant. This is found in the split between elite culture and the newly commercialised popular culture summoned by the emergence of the mass media, but also in a split within the former, in which nineteenth century realism is displaced by modernism. This is not a causal effect but the expression of what Adorno somewhere described as analogical affinity. The ideological and social preconditions of realism correspond to a bourgeois belief in a stable social reality which is unmasked, demystified and discredited by modernism, which erupts on the eve of the First World War with the force of oedipal rebellion. At the same time comes the rise of Taylorism, scientific management and the Fordist production line, which capital

seeks (imperfectly) to imitate in the production of mass cultural commodities. The subsequent displacement of modernism, its supersession by postmodernism, shadows the rise of neoliberalism, computerisation and the new imaginary of globalisation, which is universally understood as a new stage of capitalism, and cancels the shock effects of abstraction, dissonance, ugliness, scandal and indecency of modernism, which have now, says Jameson,

> entered the mainstream of cultural consumption (in the largest sense, from advertising to commodity styling, from visual decoration to artistic production) and no longer shock anyone; rather, our entire system of commodity production and consumption today is based on those older, once anti-social modernist forms. Nor does the conventional notion of abstraction seem very appropriate in the postmodern context; and yet, as Arrighi teaches us, nothing is quite so abstract as the finance capital which underpins and sustains postmodernity as such.[23]

In this sense, in which postmodernism corresponds with financialisation, we are still situated within postmodernism, albeit in a new phase inaugurated by the internet, which provides capitalism with new kinds of spatial fixes, new opportunities for accumulation in the virtual space which now envelops the globe.

As for the term 'culture industry' and the relation of elite and mass culture, Adorno later noted that in the draft of *Dialectic of Enlightenment*, the book where they introduced the term, they spoke of 'mass culture', but then 'replaced that expression with "culture industry" in order to exclude from the outset the interpretation agreeable to its advocates: that it is a matter of something like a culture that arises spontaneously from the masses themselves, the contemporary form of popular art.'[24] This couldn't be further from the truth; its popularity is entirely manufactured. One sign of the damage done by the culture industry is that we're left with an unserviceable vocabulary, which Adorno didn't entirely escape, while arguing that the seriousness of 'high' or 'elite' culture is destroyed in speculation about its efficacy. It would be good to find a less tendentious term for the functions it nevertheless continues to play in the commodified cultural landscape, in which the number of people listening to a single broadcast of a Beethoven symphony is not only far more than could have

heard it in the whole of his lifetime, but also much more socially diverse. As for the popular, however, Adorno is not wrong to say that it loses 'the rebellious resistance inherent within it as long as social control was not yet total'. Here we might do well to distinguish the popular from the vernacular, where this spirit remains, to differentiate it from Tin Pan Alley. The vernacular that belongs to the informal domain, like the clubs and pubs where bands and stand-up comedians are succoured by immediate contact with their subcultural audiences. Nevertheless, audiences all overlap in various ways and consumption is ever fluid. The culture industry fuses old and new, familiar and novel, mixes up genres, revels in the hybrid, without regard to context, good taste or propriety of any kind. In this situation, aesthetic taste and discrimination are privatised, in the literal sense of interiorised, while it is left to critics, professional or otherwise, to fan the marketing flames.

Mechanical copyright

Mechanical reproduction upset the fragile copyright system, but we have to track back to understand why this was partly the result of miscalculation. The juridical framework for copyright was initially domestic but publishing was increasingly international, and publishers became concerned with the problem of foreign protection – for both their own authors abroad and the foreign works which they published at home. Piracy was endemic. France, where publishers were undercut by pirate editions printed in Belgium, took the lead, this time on the international stage, culminating in an international conference to harmonise copyright legislation held at Berne in Switzerland in 1886. However, while the growth of literacy promotes vernacular languages and translation, a difference appears between language and music. Music needs no translation and travels easily, with the paradoxical result that composers and music publishers were worse off than authors and publishers of the word; artists working in graphic media were also in trouble.

In recognising the need for international co-operation, the Berne Convention was not an isolated event but the reflection of transformations in the infrastructure of the circulation of goods. Two years earlier, representatives of 25 countries convened at the Prime Meridian Conference in Washington, and by an agreement which records the British imperial supremacy of the epoch, the standardisation of time around the globe was

indexed to London and the Royal Observatory in Greenwich. A symbolic moment in modern history. One would be tempted to say that this represented a definitive break with the past, a change in the very measure of history, except that it needed several decades before it was universally adopted, after the radio transmission of a time signal round the world from the Eiffel Tower in Paris in 1911.

Governments that become signatories to the Berne Convention, which is periodically reviewed and updated, are then required to incorporate the provisions into national legislation. But history has its quirks, and in deference to the host country, which had a significant industry manufacturing musical boxes and Barbary organs, the Convention decided that mechanical reproduction of music should not count as infringement of copyright. The phonograph was still in its infancy and the provision did little harm to the interests of publishers or composers; if anything, publishers generally thought there was good advertising in the device, which would surely result in increased sales of sheet music. The exclusion only encouraged the manufacturers of mechanical instruments: not just phonographs but also the automatic player piano called the pianola, which used a pneumatic mechanism controlled by perforated rolls, and for several years rivalled the gramophone in popularity, especially in the USA. As discs replaced cylinders and the record industry began to take off, however, both publishers and judges were prompted to change their attitude towards 'mechanical music'. In Britain, when the Appeal Courts heard a test case for infringement in 1899, the publishers lost; by 1905, a French court was to rule against unauthorised reproduction of songs and music, and in Italy a year later the Italian Society of Authors and Composers won a suit for royalties on record sales. When the Berne Convention met in Berlin in 1908 the situation was rectified: as well as performing rights, composers and thereby their publishers were now to be given protection against reproduction of their work by mechanical means. But this was not an isolated episode. Quite the contrary. Throughout the history of copyright, new technologies of reproduction regularly leave the lawyers behind because they introduce anomalies in the existing legal formulations.

In Britain the law was brought in line by a new Copyright Act in 1911, but the USA, which remained aloof from the Berne Convention, was even quicker off the mark, partly because a number of commercially successful American composers were watching events in Europe

closely and began lobbying for the revision of American law. For the publishers, another factor was the popularity of the player piano, all but forgotten except for its role in copyright law, because like musical boxes, they raised the question of whether the makers of the pianola had to pay copyright holders of the music they played, and the issue came before the legislators. The new US Copyright Act of 1909 was in certain respects more rigorous than any other copyright law of the time. It not only introduced provisions for both performing and mechanical reproduction rights but instigated a system of compulsory licensing with fixed royalties, under which, once a piece had been recorded then anyone else could record it too, subject only to the payment of the required royalty. An attempt to grapple with the contradictions of an expanding public domain, it also provided for damage claims, and was followed by the creation of the American Society of Composers, Authors and Publishers (ASCAP) to pursue collection of the new rights. The consequences of this system would emerge when another new technology appeared and radio stations claimed the right to play records available on public sale. There was a real symbiosis here: radio fed off records to fill up airtime and record producers were attracted to radio as an aural showcase. After battles were fought over questions of copyright and royalties, both media also provided important additional sources of income for publishers, composers and musicians, as they opened up new forms of musical activity, and led to major changes in musical style and language. As a pair of writers on the history of rock music put it, compulsory licensing 'meant that record companies never had to compete for a song, only for the performance of a song'.[25] For the record industry, it became evident that signing up top artists became more important than the supply of new songs, although these were cheap to acquire, and the result was the practice of cover versions by contracted artists, which would come to drive pop music in the age of rock'n'roll, when innovation came not from the song itself but its interpretation and transformation; a practice that was already integral, of course, to jazz.

But the ramifications of this system went much further, and scholars of intellectual property return to the player piano dispute, says Andrew Ross, because its resolution set the precedent not only for the collection agencies but also for the regulation of the radio and television industries, and possibly the file-sharing technologies in the internet age.[26]

CINEMA

Hard on the heels of recording came cinematography, the most radical new aesthetic technology yet, because in transcending the static image of photography the result was an entirely new artform, in which, to echo Benjamin's formulation, multiple fragments of moving pictures are assembled under a new law, that of montage. In the short time it took for these artistic qualities to emerge and to become articulated in the form of a dynamic visual grammar, cinema developed a particularly close relationship between art and technology: the development of both is intertwined, not just at the beginning, but down the decades, until the present-day transformation of the image by digital manipulation. This is not an argument for technological determinism, a position that reduces the aesthetic to the effect of technical properties. The relationship is not mechanical. Technology isn't neutral: the design of every prototype corresponds to a purpose built in to its conception. But this does not foreclose on adaptations that could not have been foreseen before the new apparatus was invented. In short, technology shapes but does not determine its uses, and the film camera, like the still camera, is not a machine but an instrument. The difference was explained by Umberto Barbaro, the Italian cineaste who coined the term 'neorealism' in the 1940s. A founding member of the Centro Sperimentale di Cinematografia in Rome, the oldest film school in Western Europe, established under Mussolini in 1935 and yet the harbinger of the most radical current in post-war cinema, Barbaro was a Marxist. The camera, he said (citing the early Soviet film historian Nikolai Lebedev), cannot be regarded as a machine because while the machine is indifferent to its operator, and the product of 20 different workers will be identical, the camera is not: give 20 operators a camera to shoot the same scene and the results of each one will be quite different, according to their different mentalities, states of mind, wishes, expressive capabilities and intentions.[27] Moreover, technology evolves by being responsive. The aesthetic simplicity of the first films derives in the first instance from the technical simplicity of early film equipment, and there is a sense in which early film style was little more than a by-product of the basic technical capacities of the prototype gear. The first movie cameras, for example, were mounted like still cameras on tripods with fixed heads. No following the action with the camera was possible until the benefits of doing so were sufficiently

developed through trial and error to elicit tripod heads which could pan and tilt; later would come dollies and cranes and later still the steadicam. There was no royal road to the discovery of what the art historian Erwin Panofsky called 'the unique and specific possibilities of the new medium', on which Stanley Cavell comments that 'it is not as if film makers saw these possibilities and then looked for something to apply them to. It is truer to say that someone with the wish to make a movie saw that certain ... forms would give point to certain properties of film.'[28] This may sound like quibbling, he adds, but what it means is that the aesthetic possibilities of the medium are not given in advance, but have to be created.

They are created as much by the responsiveness of the audience as the imagination of the filmmaker. Cinema preserved the form of collective consumption – indeed it defied the logic of individual possession which characterised the commodity form of vendible cultural goods like books and records. Appearing initially like a new fairground or music hall attraction, its popular success was immediate, its aesthetic evolution rapid, and above all in the USA, it began to attract investment capital, thus securing the emergence of Hollywood after the First World War as the dominant force in world cinema. But from the outset the trade in films was international, and cinema, like the record industry, was born under the sign of globalisation, not only because language was no impediment as long as the screen was silent, but also because no country where local production took root in the pre-war years could produce enough to satisfy domestic demand. The coming of the talkies would allow national film industries a de facto measure of cultural protection, and the language factor would allow small industries to establish themselves in diverse countries around the world as long as the domestic market was large enough and budgets small enough to give them a chance.

As the first industrial artform – following its early artisanal phase – cinema evolved a mode of production both collective and hierarchical. As employment expanded, a growing division of labour evolved from the same two directions that Marx identified in *Capital* as the twofold origin of manufacture, on the one hand generating its own specialised jobs around the camera, which split up into different functions as the technology and techniques of filmmaking grew more complex, on the other taking up workers from established trades and crafts such as carpenters, scene-painters, hairdressers, costumiers, even the new electrical trades. Then, of course, there were the actors in front of the camera. In

this way the film crew acquired its typical complex hierarchy, with high status awarded to the principal creative roles – director, photographer, editor, and so forth – who joined in collective authorship. Below them, the designer had higher status than the carpenter, electricians who set up the lights were subordinate to the photographer, the job of lighting and operating the camera were divided and the latter became subordinate to the former. This hierarchy was not only institutionalised when trades unions arrived on the scene, but also imposed itself on the women in the industry, whether they entered as craftworkers like hairdressers, or worked their way up by acquiring new skills. The early period saw women as screenwriters, editors, sometimes directors or even producers, but certain roles were deemed more suitable than others, like the 'continuity girl' on set. Editing in particular was seen as 'women's work', akin to skills like sewing or weaving, and subordinate to the usually male director; it was also an 'invisible' job, whose creative scope was hidden from view in the cans of rushes that no-one else (apart from the director) ever saw. It was a long time before the creativity of the editor would gain the credit it deserves. Long before that, everyone being either craftworker, performer, or ancillary, the supervision of the production process became concentrated in two symbiotic figures, the director responsible for the aesthetic domain, the producer for the economic, and the studio system emerged, where director and producer occupy the position of agents of capital in the control of the labour process; aesthetics apart, their essential function is time management (like the orchestral conductor in charge of rehearsals). In the studio system, however, the buck stopped with the producer, and if it came to the crunch – as at times it did – it was the director who got sacked and someone else put in charge of the editing. In this perspective the celebration of the director as the true and complete 'author' of the film becomes problematic. Authorship becomes a property of the studio.

As Peter Bachlin pointed out in a pioneering study of the economics of cinema, it was an industry without any tradition, which developed sometimes autonomously and sometimes by assuming forms of organisation from other sectors.[29] In a very short time it passed through almost all forms of capitalism from personal enterprise to trustification. In the process, the very considerable risks it entails, and the arrangements made to overcome them, gave its production, distribution and exploitation a very peculiar character. The earliest films were extremely short, barely one minute long, deeply and eternally fascinating but no more

than animated photographs; even when the first story-telling films with multiple shots appeared around the turn of the century, largely modelled on music hall sketches, or a series of separate shots strung together to make a travelogue, they were still only a few minutes in length. Cinema at its birth was little more than a form of disconnected and anecdotal visual display, ill-adapted to serving immediate purposes of intelligence, like the telegraph and the telephone, although in due course it would garner the interest of scientists and then the military. On the other hand, it was readily susceptible to the ethos of the new mass press, which departing from Reuter's principles of objectivity, opted for 'human interest' and 'yellow' journalism, a domain of miscellanies and sensationalism for the fascinated crowd. The 'quality' press more or less ignored the new entertainment. After covering the first Lumière show in London in 1896, *The Times* carried no further reports of the cinematograph for eight years. By that time moving pictures had spread to virtually every corner of the land, indeed around the world. In Britain, it was not only a familiar sight in popular milieux like music halls and the fairground, but penny gaffs (nickelodeons in the USA) were populating the high streets. Amid the commercial anarchy which characterised this process, the medium of film was beginning to acquire the aesthetic (and ideological) properties which were to make it so potent, but it also turned out to be a peculiar commodity with its own strange behaviour, which it took a certain time for the film business to discover.

In the beginning, films were treated as straightforward commodities which were sold on the open market like pieces of cloth at a uniform price of so much per foot, and different kinds of film were all treated in the same way. Their price was determined primarily by the cost of raw film stock, which was in limited supply until the end of the century when manufacture was automated and Kodak, with its method of continuous casting on rotating drums, cornered the market to become the film industry's first monopoly. At this stage film production was simply called 'manufacture'; not surprisingly, the price of films fell as the supply of celluloid increased, and a brisk second-hand trade developed quickly, servicing the itinerant exhibitors of the day. As fixed exhibition venues appeared and competition intensified, this became hardly sustainable as a method of distribution. To follow Bachlin, as long as exhibition venues were small and films short, the possibilities of profit resided mainly in a correspondingly large number of daily showings. Frequent programme

changes were therefore necessary, and this resulted in a large growth in demand for films and production was stimulated. Film 'factories', as studios were first called, only managed to satisfy this demand with difficulty. In every country the problem of the expansion of the market was necessarily solved by international trade (the dominance of Hollywood yet to come). The number of venues began to mushroom and grow in capacity and the first generation of purpose-built picture houses appeared. In this setting films would grow longer – the standard length of the acted film in the middle of the second decade of cinema was two reels or around 20 minutes. The true picture palace and the introduction of long films of more than an hour lay in the post-war future.

Exhibitors, especially the itinerants, instead of repeatedly screening the same film until it wore out, were forced to purchase the newest films to keep their audiences. Dealers likewise, competing with each other for the same films from producers increasingly dependent on them to supply the exhibitors. What emerged out of this confusion was in the first place, a film is a relatively durable commodity which is not used up in a single act of consumption but continues to be available for further exploitation; each copy remains within the market until it has deteriorated physically from so many showings that it's no longer viewable. (If it was especially popular, it could always be remade, by the same person or someone else. Archivists study the differences eagerly.) It was the dealer who was faced with the biggest risks, the middleman who had to recoup the money from the market, that is, from travelling showmen who fell behind in their payments or were forced out of business, or were simply difficult to keep track of. The device the dealers hit on was rental. If the film did not physically pass into the possession of the viewer, and was not consumed in the act of realising its exchange-value, then nor did it need to pass into the ownership of the exhibitor if it could be rented instead. In short, film is different from regular commodities, including other cultural commodities like the book and the gramophone record, whose sale removes the copy from the marketplace.

The distributor's intervention improved economic conditions for the exhibitor by allowing more frequent programme changes. This created a growth in the market for the producer: films could reach the consumer in greater numbers and more rapidly; moreover the new system constituted a kind of sales guarantee for their films while reducing their cost to exhibitors. As Bachlin explains, dealers turned into distributors by taking over

the risks of purchasing films and renting them out, benefitting producers and exhibitors alike; the development of the film industry accelerated and the number of cinemas increased. But the result was the distributors' domination over both production and exhibition, later leading to vertical integration or at least tie-ins between studios, distributors and cinema circuits.

Negative costs

The institutions of cinema are a result of the peculiar commodity character of the film. Where goods usually pass from the producer or manufacturer to the wholesaler, from the wholesaler to the retailer, and thence to the consumer, the terms 'producer', 'distributor', 'exhibitor' and 'audience' which apply to the film industry do not signify quite the same set of relations. A synthetic art which is marketed in multiple copies extending the exploitation of the actor's performance beyond the reach of the individual stage, the film is like a performing art in some regards but not in others. The means by which its prices are fixed, and the manner in which market domination is achieved, are therefore quite different.

Like the photograph, the film has no unique original (the negative from which it is printed can be identically duplicated); it exists in the form of multiple copies. But nor is it mass produced for direct sale to the consumer market (until the coming of domestic video in the late 1970s); its value is realised through the price of admission, like performance arts, which requires only a few hundred prints. It also has another peculiarity, observed by Thomas Guback, a US economist, when he pointed out that the cost of making prints for distribution is a very small fraction of the total costs of production, what the industry called the 'negative costs', that is, the costs of getting to the finished negative of the completed film from which the prints are made. Indeed this proportion has grown progressively smaller over the course of the history of cinema, as production budgets have grown larger and larger. This factor is key to Hollywood's imperialism. It means that films can be exported without having to divert the product away from the home market. The cost of copies is incremental, which makes the film a commodity that can be duplicated indefinitely without substantially adding to the cost of the first unit produced: 'a given film tends to be an infinitely exportable commodity; prints exported do not affect domestic supplies nor the revenue

resulting from domestic exhibition ... We can have our film and foreigners can have it too.'[30] Because the USA between the wars was the world's largest domestic film market, US producers were able to recover negative costs on the home market alone, and the distributors were able to supply the foreign market at discount prices that undercut foreign producers in their own territories. Moreover, almost all the income from overseas distribution was pure profit, that is to say, not just surplus value but super or excess profit, which is always best at attracting investment capital. Hollywood understood all this perfectly well. An industry leader addressing the Harvard Business School in 1926 explained how they approached the foreign market:

> We are trying to do that by internationalising this art, by drawing on old countries for the best talent that they possess in the way of artists, directors and technicians, and bringing these people over to our country, by drawing on their literary talents, taking their choicest stories and producing them in our own way, and sending them back into the countries where they are famous. In doing that, however, we must always keep in mind the revenue end of it. Out of every dollar received, about 75 cents still comes out of America and only 25 cents out of all the foreign countries combined. Therefore you must have in mind a picture that will first bring in that very necessary 75 cents and that secondly will please the other 25 per cent that you want to please. If you please the 25 per cent of foreigners to the detriment of your home market, you can see what happens. Of course, the profit is in that last 25 per cent.[31]

The whole structure bore down on the studio floor. Movies are produced under a regime of organised collective labour, in which, as the studio production system gets into its stride, artistic authority is dissolved into a team with its own internal hierarchy. Hollywood has been characterised as a Fordist film factory, but in fact film production is a problematic domain because of the autonomous character of aesthetic labour, from the director down to the contribution of the lowly make-up artist. The entire process is collective and collaborative. A film crew at work is like an orchestra in which, at any given moment, some of the players are busy and others are silent, waiting for the moment when they make their particular contribution, which cannot be measured in

terms of the number of notes they play. Baumol's cost disease applies. No matter. The film producer does their calculations on the basis of the expected number of minutes of screen-time shot per day. What makes this system work is that the labour process itself generates genre as a solution to the common endeavour, by providing a series of models or paradigms that tell everyone in the team (behind the camera and in front of it) what they're supposed to be doing (more or less). It also satisfies the requirements of the producers and financiers by enabling them to get what they're expecting (more or less). And it hooks the audience (more or less) for similar reasons, especially since the process is reinforced by the business of marketing and publicity which grows around it, the magazines, gossip columns, celebrity chat shows and the rest, which feed the fans and keep them coming.

Division of labour

Much early filmmaking, being artisanal in character, was a cottage industry, or in the case of pioneers like Cecil Hepworth, a suburban-house-and-garden affair. Hepworth built a studio in the back garden of a house near London at Walton-on-Thames in 1900; something of the class character of these ventures can be gleaned from such locations, well served by suburban railway lines which catered for the petit-bourgeoisie of middle managers, supervisors and better-off clerks. The new film practitioners were middle class dilettantes with a good technical education and a conventional sense of the aesthetic. Division of labour hardly yet existed. Since the earliest films were scarcely more than moving photographs, they were made with little sophistication and at ridiculously little cost – hardly more than the price of the film stock. Camera equipment and other overheads were not counted into the costs of production, and some of the labour went unpaid. Hepworth reports in his autobiography that his 'actors' were generally members of his company, family or friends, the camera was operated by someone who wasn't 'acting', and other jobs, like printing and processing, were also shared.[32] The first time he paid actors a fee was in 1905, for *Rescued by Rover* (a film which also had its own 'director', Lewis Fitzhamon). The principals were paid half a guinea each to include travelling expenses. Even so, the total cost of production was only £7 13s 9d. The film ran about seven minutes, and prints sold for £10 12s 6d (6d per foot). A total of 395 prints were sold, and this

required two remakes of the film because the negative wore out in the printing. Even considering the remake costs and the cost of the raw stock for each copy, it is clear that the profits must have been proportionately enormous.

Gradually people began to show aptitudes for particular jobs, and division of labour in the film studio was necessary as much for aesthetic reasons as economic ones. First to emerge, the cinematographer (as the role should properly be called) also fulfilled the functions later ascribed to the director, such as deciding where to place the camera and how to divide the film up into its constituent shots, as well as instructing the actors. As they learned the effects of multiplying the number of angles and set-ups, of moving the camera, the influence of lighting and more, so the film crew inevitably grew in size to cope, but the process was a halting one. Another autobiographer, George Pearson, recalls the conditions in the Pathé studio in London in 1912 when he started directing, where his crew numbered only five: a cameraman, an electrician, a carpenter, a scene painter and a handyman; he soon left them, he tells us, because the studio's style and methods were becoming outdated (they hadn't got round to using a mobile camera; their camera was still fixed to the floor, with a chalk mark in front of it to indicate the forward point the actors were forbidden to cross, to avoid their legs being cut off by the bottom of the frame).[33] Around the same time came a separation of roles between director and producer, with the director taking responsibility for the aesthetic realisation of the film, while the producer ideally combined entrepreneurial thinking with the showmanship of music hall and circus. This has a strange effect in turning attention away from the central function of the camera, and the cinematographer as the immediate creator of the image, where artistry made its first appearance.

One of the consequences of the petit-bourgeois character of early film-making was its separation from the world of labour agitation and trade unionism, which on the other hand was present in music hall, and not just among the audience. The surprising result was that the first moves in Britain towards unionisation in the film industry were made not in the fledgling studios ('film factories' as they were sometimes known) but in the cinemas themselves, with the creation, barely ten years after the cinematograph made its debut, of the short-lived National Association of Cinematograph Operators (NACO). It seems strange that the first to organise themselves should have been projectionists, who work

in almost total isolation both from each other and the world of the factory, but the immediate stimulus for the formation of the NACO was a music hall strike led by the Variety Artistes at the end of 1906, when the settlement which followed included no provision for music hall cinematograph operators. Evidence of how rapidly moving pictures took hold of a popular audience, in due course the NACO would disappear into the general union for backstage workers, the National Association of Theatrical Employees (NATE), which saw itself as part of the 'new union' movement that spread rapidly in the years leading up to the Great War, and which aimed at the mass organisation of workers, both skilled and unskilled, into industrial unions. Since the bosses treated operators as unskilled workers, alongside cashiers, usherettes and cleaners, the new unionism was much better suited to cinemas than old craft ideas. As venues mushroomed, employment grew from around only a thousand in 1907 to 120,000 on the eve of the war, when Britain had as many as 5,000 cinemas, 80 per cent of them individually owned; the advantage of tackling the cinemas one by one, however arduous the process, was that individual cinema owners often gave in quickly; at the national level, however, the exhibitors' association was able to withhold union recognition until the1930s, when NATE would become NATKE, the National Association of Theatrical and Kino Employees.

The extent of trade unionism to be found in the music halls and the variety theatres around the time of the birth of cinema testifies to the militant temper of class struggle in the late nineteenth century. An early sign was a strike in 1892, three years after the London dock strike and the formation of the Electrical Trades Union (ETU, who will enter the story again later), when the capital's 'limelight men' came out at the beginning of the pantomime season to establish a minimum wage, and the employers were forced to sign an agreement after only four days. Three main unions emerged. In the early 1890s came the backstage workers, quickly followed by the Musicians' Union, and ten years later the Variety Artists' Association. You can't see any of this in the films that appeared on the screens of the variety theatres, which for all their spontaneous creativity inscribe the narrow petit-bourgeois habitus of their makers, but we know about the composition of the workforce from other sources, like Charles Booth's account of *Life and Labour of the People in London* (1896), where we learn that the entertainment business attracted a flow of workers from the pool of industrial labour in the city, not only casual workers like

doorkeepers but traditional craftsmen like carpenters (and craftswomen, like seamstresses). The property-master, for example, 'must be a man of resource who can effect hasty repairs, and, if need be, himself make the simpler articles. There is no special course of training to be gone through for the post, but to have learned some mechanical trade is a very good introduction to it.'[34] But here's the thing: only the heads of department were regular employees; jobbing carpenters, says Booth, would go from theatre to theatre. The work was uncertain: 'for a few days, or perhaps a week or two, they have as much work as they can get through, and then, for weeks, they are without a job.'[35] In short, the entertainments world, then as now, ran on a system of what we nowadays call precarious labour. As with all systems of subcontracted labour, the theatre managements were long able to disclaim responsibility for the appalling conditions of labour and remuneration which prevailed; this was precisely the original evil which the backstage workers' union was formed to deal with.

The origins of the Musicians' Union were different. A highly skilled professional group (although standards differed), they thought of themselves as a group apart, distinct from their own social class, with a respectable history as a guild dating back to 1469 (if not earlier) when the Worshipful Company of Musicians was granted a Royal Charter and awarded the right to regulate all musicians in the City of London; but that was then – the guild became an irrelevance when public musicking in London moved to the newly built zone of the West End. It was the growing pressure of commercial concerts that brought them together again in the 1870s, with short-lived 'protective associations' in London, Manchester and Birmingham; but when this happened again in the 1890s, and provincial associations spread across the country, eventually coming together to form the Musicians' Union, it was clear that the rank-and-file lay among theatre musicians.

Unionisation in the film studios proceeded much more slowly and haphazardly, with the drift into studios of craftworkers who carried their union membership with them. There were a couple of attempts to organise camera operators, but craftworkers like carpenters, plasterers and painters seemed to find the rates acceptable. According to Pearson, speaking of the early post-First World War period, overtime was generally paid to technicians, at least in his studio; except when only a short extension of hours was required, in which case, he claimed, the 'team spirit' of the crew generally carried them over. It's easy to understand the

lack of impetus in unionisation in the studios when faced with the state of British film production in the 1920s. It hardly existed. It was driven almost to extinction by the successful offensive of the US film industry in the British market. Government was forced to bring in protective legislation, and the Cinematograph Act of 1927 stimulated production but it did so by introducing quotas which had counter-intended effects, as US-owned distribution companies undertook to produce films to satisfy quota requirements with the stipulation they should be made quickly and cheaply. Small independent companies grew up to produce them, everyone joined in, there was a race to the bottom and they soon came to be known as 'quota quickies'. But the numbers employed in the studios went up, and with the arrival of the talkies and the consequent addition of sound staff, increased further. On the other hand, working conditions worsened. Hours were increased, often well into the night and over weekends, with no overtime pay. Dissatisfaction grew rapidly but the union situation was chaotic. Sound engineers, for example, were eligible for membership of either the NATE or the ETU, but the two unions were at loggerheads with each other, while an increasing number of film technicians had no organisation at all.

Many of those associated with the creation of the Association of Cinematograph Technicians (ACT) in the mid-1930s were members of the Communist Party, who strongly favoured the model of the industrial union and understood that there was nothing to be gained from organising the studios, where attitudes were predominantly petit-bourgeois and craft oriented, without organising the laboratories, which had split off from the studios during the 1920s to become separate factories, because without them a film union would have no real working class base. This would prove a far-sighted move, as we shall later discover. Meanwhile the studios were subject to another form of differentiation among the workforce, exemplified by an exchange with a leading producer at a hearing of a parliamentary committee which reported in 1937:

Mr Maxwell: I do not mean sound recordists, cameramen and other mechanical workers.

Mr Cameron: No, I mean the brains.

Mr Maxwell: Creative brains.[36]

in which the producer interposes a questionable distinction between mental and manual creative labour in the interests of controlling the labour process.

RADIO

Radio brings another factor into play. First appearing at the end of the nineteenth century in the form of wireless telegraphy, it was initially perceived as a means of naval communications capable of going where the telegraph line couldn't, and its R&D was supported by the military, incorporating it from the start into what President Eisenhower in the 1950s would call the military-industrial complex. Moreover, embedded in the newly emerging electrical industries, it belonged to a quite different sector of capital from entertainments, with different methods and agendas. Although there were irregular broadcasts as early as 1906, the device needed a series of improvements before it came to fruition as a mass medium after the First World War, when its rapid take-up benefitted from the large number of operators and technicians who had been trained up during the war. In the process of reconversion from military to civilian use, an old word for scattering seed in a field acquired a new meaning. Radio broadcasting, however, faced the problem of technical linkage in a new form, because who would buy a radio without stations to tune in to? The photograph, once it's printed, no longer needs the camera; the record and the radio programme are of no use without the device to listen to them on, but their technical structure is different. The record is a vendible object in its own right, the broadcast is not. In fact it isn't a commodity at all for the listener, who only had to purchase the radio set; the programmes came with it for free. How then could broadcasting be paid for?

Like the first manufacturers of film cameras who produced their own films, the first manufacturers set up their own radio stations as a loss leader to encourage the sale of receivers, but this was hardly a long-term solution, and they needed to divest themselves of this function to maximise profits. Different remedies were applied in different countries, according to national propensities. In the old cultures of Europe, especially with the example of revolutionary Russia on its borders, high military and political echelons were concerned that public broadcasting would interfere with military and civil communications and seeing the

advantage of keeping radio under tighter, more direct control, the model adopted required owners of radio sets to pay a licence fee which was used to fund state broadcasters under government direction. In the USA, where licences were required only for transmitters, commercial principles operated from the outset, and the new stations were funded from advertising; in this model, airtime is equivalent to the pages of the newspaper, which can be sold to the advertiser in chunks.

The model adopted in the UK, combining a licence fee with a public service principle which kept government at a distance, would prove particularly successful. It was the GPO (General Post Office), in charge of licensing broadcasters, who themselves proposed this solution, in the desire to avoid the chaos fast developing across the Atlantic, where reports suggested the airwaves were becoming congested (and the content being swamped by advertising). They were pitted against Marconi, the industry's leading company, who made their first experimental broadcasts in 1920 but whose core interest was in selling radio equipment. The GPO already ran the telegraph system, which it acquired in 1868 in what was effectively the first modern act of nationalisation, introduced to rationalise the chaos of anarchic competition between private operators; an expedient reform that not only benefitted the newspapers but led to a hugely expanded low-cost public telegram service. Applying the same public corporation logic to the new medium, they saw it as essentially another form of communication, but by the same reasoning, content was not their concern. There was a difference between the message and the messenger. The GPO ran the infrastructure but was not, in the now familiar terms of debate about social media platforms, a publisher. Radio, however, was a different proposition, with a different technical structure: by definition the messages it broadcast were public, not private, and to assuage establishment nervousness about mass susceptibilities – exacerbated by the turbulence in Russia – clearly some form of regulation was needed. The solution to this problem in the case of cinema a few years earlier reveals a reluctance on the part of the polity to be seen to be exercising censorship, less perhaps in defence of free speech than to be free of any possible charge of party political interference. Early calls for censorship had been sidestepped by an Act of Parliament in 1909 which dealt with fire safety by putting local authorities in charge of licensing premises. Three years later, a better solution was found in self-regulation by the industry through the creation of the British Board of Film Censors (rebranded

as Film Classification in 1984), but this was not a solution available to radio because (apart from recorded music) it was live. The Postmaster General faced mounting pressure from manufacturers and enthusiasts to allow regular broadcasting, but only the manufacturers had the technical ability, the money and the incentive to move quickly. Geography also had something to do with it, since radio waves have a limited range; hence the subsequent emergence in the USA of a network of stations covering different time zones. But Britain was a small country, and the proposal that emerged was the creation of a single national broadcaster jointly owned by a consortium of leading wireless receiver manufacturers, funded by a licence fee instead of advertising. The British Broadcasting Company, as it was originally called, went on air in 1922, restyled as a Corporation when it was given a Royal Charter in 1927, but it was not at first entirely trusted. Its first licence allowed it to broadcast only news or information supplied by approved news agencies. However, the principle written into its licence that it should not sell its airtime became a central pillar of its public service remit, and its monopoly would not be broken until the 1950s.

Radio expanded the audience for music of all types, but the public service ethos established in Europe made it possible for a few well-placed individuals with more enlightened or progressive ideas to shape programming policy, and in countries like Germany and Britain, state and civic radio stations acted independently to put art music on the air. The BBC set up a symphony orchestra of its own, and in Germany, young composers like Paul Hindemith and Kurt Weill were encouraged with commissions. Many musicians, wrote Weill as early as 1926, live entirely off their radio work, and for many others it provides an indispensable supplement to their concert and theatre earnings.[37]

In the USA radio quickly succumbed to commercialism, stimulating the production of music for unreflective and uncritical consumption in the established manner of Tin Pan Alley. The commercial solution turned the tables and made a commodity out of airtime sold to advertisers through sponsorship or spot commercials, while the programmes remained free to the listener at the point of reception. US business culture was already steeped in the idea of aggressive marketing and when radio came along, quick to spot new opportunities, found that radio advertising, with its catchphrases and jingles, intensified the effects. This is an internal market which ends up turning the audience itself into the commodity which the

advertiser buys from the broadcaster, its size and its social composition, to be measured by audience research techniques introduced in the 1930s and expressed in ratings. The same considerations apply to television, which made its debut in the 1930s, to be suspended during the Second World War, and then, step by step, entering its irresistible universal rise to dominance in the 1950s.

Radio and records entered into contradictory competition with each other. Radio constituted an acoustic showcase for records, and the record industry, which had to fight for the payment of royalties, was goaded by radio into adopting electrical recording in self-defence. Nor did radio alleviate the musician's problems; on the contrary, the effects of radio on established interests in the music business, who regarded radio as unfair competition, was detrimental. A government committee in the UK in 1925 heard evidence from the music publishers of a fall in the sales of sheet music. They complained that radio reduced the life of a popular song, it was leading to fewer live concerts, destroying the amateur and pushing the professional musician out of work. By the end of the decade, as cinema converted to sound, even more musicians lost their jobs. Radio, however, continued to expand, accelerating a process of integration and merger across the cultural industries. RCA, for example, set up in 1919 when the US Navy contrived the take-over of the British-owned American Marconi, asserted its own expansionist instincts by acquiring a couple of music publishers; Hollywood studios would soon be doing the same. Meanwhile, the Depression blocked the recovery of the record industry, and sales of records and record-players plunged – this occurred in Europe as well – while the sale of radio sets trebled. Everywhere you looked, the culture industry was in flux, in constant reorganisation through mergers and take-overs across sectors, in response to two underlying factors. On the one hand, the technical development of the means of production, in which R&D cut across different media, and companies regrouped around the electronic connections which now came into play. On the other hand, pursuit of the creative talent and the copyrights which constituted the basis of the corporations' accumulating riches. The entire industry continues to operate this way, a constant game of musical chairs as companies change hands, go through mergers and suffer take-overs designed to improve the share price of the corporations that own them, the same process that Silicon Valley is nowadays immersed in.

TELEVISION

Television may look at first like radio with pictures, while its process of production takes on the aspect of the film studio, but it has its own technical structure and its own mode of production; it will also develop its own hybrid aesthetics. Much of the technical apparatus is removed from the studio floor to a control room where the director sits alongside technicians like vision mixers, and editorial staff. Communication is mediated by microphones and headphones through which the director communicates with the camera operators and the floor manager, but they cannot automatically talk back – the lines of communication only go in certain directions, determining who can talk to whom and when. Instead of one camera operator there are three or four, their autonomy reduced to using cue cards and following instructions from above; nowadays even camera operators can be absented from the floor and cameras operated remotely. Presenters and interviewers are given discreet earphones of their own as well as reading from autocues. The feedback of the film shoot – the kind that generates suggestions – is suppressed. The TV studio is a more alienating and less creative place to work in than a film studio.

Different spheres of production developed their own practices. Early television drama was performed live, imitating the stage rather than cinema, unfolding in long scenes rather than elaborate montage, with location scenes shot on film and inserted, until production shifted entirely to 16mm film, following the example of documentary. Videotape allowed an increasing proportion of studio programmes, from comedy to quiz shows, to be prerecorded in front of live audiences (or overlaid with canned laughter). Other than news and current affairs (including set pieces like elections), live broadcasting became concentrated on sports, various state occasions and special media events, requiring outside broadcast units operated by slimmed-down crews. To oversee this huge and varied activity needed growing numbers of editorial, technical and administrative staff, and all these needed diligent supervision. Seen from the studio floor, producers stand over directors, series editors stand over producers, above them come department heads and channel controllers all the way up to the highest echelons, responsible, in the case of the BBC, to a board of governors who are appointed by the government.

The BBC was not only a monopoly, it also conceived of itself as quite separate from the film industry, and even set up its own house union.

When it lost its monopoly in 1955, it became clear that on the contrary, however much it tried to hold itself apart, it was joined to a growing industry by the hip, as the ACT fought an initial successful battle for the unionisation of commercial television based on technician power. The theatre unions had little difficulty in gaining recognition – neither the actors, variety artists and musicians, nor the backstage crews – because of the connection between show business and the new commercial television companies; indeed everything on television now became a show. But the new bosses knew little about television, and their show business background would be a recipe for poor industrial relations. Show business is an affair of one-off productions, offering little or no security of employment; as far as performers were concerned, television promised no essential change in this pattern (although the multiplication of series would come to generate long-term contracts for both actors and writers). The workers most affected were the technicians. When the film union was formed in the 1930s, the focus was on organising laboratory workers, not only because of their class consciousness but because they had the power to hold up production. In television it was technicians who held this power, and exercised it in wildcat actions which included blanking the TV screens for short periods. The union added Television to its name. By 1968, it was powerful enough to force a climb-down when reorganisation of the commercial network led to threats of redundancies.

In the long term, a second trend would have greater effect in reshaping the workforce. The union's membership not only expanded, but so did the proportion of freelance members. Several factors converged to produce this effect. First, commercial television of course generated television commercials, which initially provided additional work for existing union members between jobs but soon evolved into its own specialised production sector, operating on commissions from advertising agencies with inflated budgets. Second, commercial television also created a television programme market in Britain, and as sales of programmes between companies developed, so did production. This not only gave employment to film technicians but the BBC's monopoly of employment for television technicians was broken, and the commercial companies not only offered better rates and terms of employment; with their studios often working at capacity, they would outsource production to freelancers. With the growth in production, small production and facilities companies grew up, subcontracting their services amongst each other, including

cinematographers, sound recordists, editors, rostrum camera operators and dubbing mixers, who set up companies and owned their own equipment and were classed as freelancers by the union and the inland revenue but in effect comprised a reserve army of subcontracted creative labour. By the late 1960s, the BBC itself was beginning to take advantage of this workforce to solve its own problems of over-staffing. (By way of example, my older brother, who trained at the BBC as a film editor, left to become a freelance editor in 1966, when they immediately offered him continuing work.) This had other advantages. It procured both aesthetic and political conformism, especially among the more senior creative staff, writers, directors, producers, reporters, interviewers and diverse TV celebrities, all of whom the tax system encouraged to adopt freelance status and a fee instead of a wage. The system provides a method of sustaining formal control over the labour process through the ever-present threat of the withdrawal of future work for those who try stepping too far out of line (except for a few permitted troublemakers, on either the far right or the far left).

There was another result. The ACT was already unusual in its political character, with a canny leadership that contrary to most industrial unions was further to the left than the rank-and-file, among whom craft-based thinking was strong, and well-paid technicians in a privileged industry formed an aristocracy of labour with an expectably conservative outlook. Now, with the growth of the freelance sector, including independent producers, another anomaly emerged: members who might find themselves on either side of the negotiating table, either as aggrieved unionists or as accused employer. But as we shall see, the sector was also buffeted by other currents – the counterculture of the 1960s and the political militancy that exploded in 1968.

4

Countercurrents

The culture that grew up around cinema is generally thought of in terms of the spectacle of the big screen. It has another dimension. The introduction of the Kodak still camera signalled the inauguration of another propensity of mass culture, namely, a drive to market not just of cultural products but consumer versions of the means of cultural production as such, a trick Kodak repeated in the 1920s by introducing 16mm cameras and film under the sign of amateur cine. The impact of amateur cine has been largely neglected by film historians, who think of it as an incidental accompaniment to cinema proper rather than an integral component of film culture. There is a different history to be told, in which the development of amateur cine anticipates what would happen when digital technology arrives in consumer hands and stimulates huge growth in amateur creative activity across the board. The digital swallows everything, no matter its native form, but the mechanical reproduction that preceded it consisted in what are now called analog technologies, which each had their own technical structure.

The late nineteenth century surge of amateur photographers sharpened the distinction between amateur and professional, and implied a market whose potential did not escape early manufacturers of film cameras on either side of the Atlantic. In the USA, in order to evade the patents controlled by Motion Picture Patents Company, the consortium that also held sway over production, a variety of alternative cameras appeared employing different gauges of film as well as other modifications, intended to appeal to hobbyists. If they failed precisely because of the lack of standardisation, they were in any case only partial prototypes and several other elements needed to come together to make a mass produced product viable, including a spring-driven motor, daylight loading and non-flammable film. It also involved a key change to the

film stock through the introduction of reversal film. In the conventional system, the film that ran through the camera was processed to produce a negative, from which prints were made. The editor worked on the prints, after which the negative had to be cut to correspond and the finished film printed. With reversal film, processing turns it into a positive, thus eliminating several stages, but at the same time, it presents a limitation. It meant that editing was restricted to the rudimentary assembly of shots, and making copies an extra and costly process; but this perfectly suited the industry. The game changer came from Kodak, almost the only company with the necessary resources, from R&D to marketing and advertising, who launched a new 16mm format in 1923, comprising an entire system, from camera to projector, built around the new film gauge. Their established market dominance ensured its rapid adoption, which the trade labelled sub-standard and was easily kept off the cinema screens, while a whole secondary industry developed around the concept of amateur cine, with its own magazines, competitions and prizes. The amateur film, for the same reasons as the amateur photograph, is not a commodity, and it goes without saying, the aesthetic labour engaged in making it is unpaid. In Patricia Zimmermann's reading, the modern concept of amateurism thus emerged as both the commodification of leisure among the super-rich and the middle classes, and in the same process, an inversion of professionalism.[1]

The passage from the nineteenth to the twentieth century is also the passage from the individual inventor to the business of research and development, from a process of bricolage to the systematic testing of prototypes.[2] It is not an accident that of the various contenders for the credit of inventing cinematography, the two to whom history has awarded the distinction, Edison and the Lumière brothers, were both established businessmen. Edison's 'invention factory' at Menlo Park was the very model of a research laboratory employing numerous skilled workers – mathematicians, physicists, chemists, glassblowers, engineers, designers – to generate over a thousand patents by the end of his life, from an unsuccessful electrical voting machine in 1868 to a component for an electroplating process in 1931, including, most famously, the Kinetoscope – a what-the-butler-saw-machine, moving pictures but not yet cinema – the incandescent light bulb and the phonograph. The Lumière brothers, who added projection, ran a photographic business whose workers leaving the factory were immortalised in their famous

first film. Both exploited moving pictures by training up cameramen and sending them out to bring back scenes from around the world, in another rehearsal for globalisation (and the fashioning of the twentieth century discourse of tourism and exoticism). Kodak's pre-eminence, on the other hand, was based on its market dominance in film stock; when it came to 16mm, their only serious competitor approached the problem from the other end, and Bell & Howell concentrated their R&D on the camera and accessories like lenses and lights, but using Kodak film stock. They didn't stop there. They treated their 16mm camera as the prototype for a professional lightweight 35mm newsreel camera, designed for shooting hand-held without a tripod. These cameras, which in both gauges stimulated new styles of cinematography in the same way that oils, for example, led to new styles of painting, soon came into their own, but in the process amateur filmmaking developed a cultural divide between those for whom it was a leisure-time diversion, and the 'serious amateurs', as Zimmermann calls them, who thought in terms of film as art.[3] But this entails another divide, between an idea of artiness which was already common enough in the world of amateur photography and easily co-opted by the leisure industry, and the emergence of a new breed of experimental filmmakers drawn to an avant-garde aesthetic, and averse to the illusions of the narrative realism that were institutionalised by the studio production system, above all in Hollywood. Instead they perceived the screen as a space of poetry, which drew artists and photographers into its orbit and found a home in the film club movement which began around the middle of the decade.

The recognition of film as a modernist artform and the first systematic analysis of the grammar of film narrative both belong to Russia in the intellectual and artistic ferment stimulated by the Soviet revolution and under the banner of Lenin's famous pronouncement that 'For us, film is the most important of the arts.' The two things went hand in hand, and yielded the first examples of a cinema that was radically other both aesthetically and politically, initially suppressed around the world but later regarded as classics, their directors celebrated. In a review of Eisenstein's *October* in a Mexican newspaper in 1928, the Cuban communist leader Julio Antonio Mella reckoned that

> The public, accustomed to the bourgeois style of the yanqui film, will not be able to fully appreciate the proper value of this effort from

Sovkino. It doesn't matter. It would be asking as much of them to comprehend the Proletarian Revolution after hearing about it through the cables of United Press, or the revolutionary movement of our own country and our national characteristics through the interpretations given them by Hollywood. However, here the ideological vanguards have the opportunity to enjoy one of the most intense pleasures the present epoch can offer in the terrain of art, through the youngest and most expressive of the modern arts: motion photography.[4]

No matter that such films weren't hugely popular in Russia either. In the capitalist West, they appealed to the film club movement, which emerged in the mid-1920s in cities like Paris, London, Berlin and Warsaw, where film was first recognised as an artform and filmmakers as artists, in a milieu where all forms of aesthetic exploration were encouraged, including avant-garde experimentalism.

Avant-garde is a term with a history which reminds us that cinema is not the only context for the avant-garde film. In some respects the term itself, with its military overtones ('advance guard'), which as Baudelaire somewhere remarked was probably due to the French predilection for military metaphors, is misleading. It implies a unity of purpose that doesn't exist, beyond an essentially mutinous attitude towards established values and orthodox modes of representation; that is to say, what psychoanalysis conceives as a spirit of oedipal rebellion. Better to think of it as an umbrella term for the wide variety of anarchic aesthetic tendencies (Futurism, Dada, Surrealism, Cubism, Abstract art, Constructivism, etc.) within the modernist movement, although even this proves problematic when applied to cinema in the 1920s, insofar as the films favoured by the film clubs ran the gamut from unusual studio feature films to short individual experiments. Their selection was governed by two main criteria: they were films the trade deemed uncommercial or which the censor prohibited, and they accorded to the tastes of the liberal and artistic intelligentsia who made up the membership. The original members of the London Film Society, for example, established in 1925, included George Bernard Shaw, H.G. Wells, J.B.S. Haldane, Julian Huxley, J.M. Keynes and Augustus John, as well as figures from the film world; the first film the society screened was Paul Leni's *Das Wachsfigurenkabinett* (Waxworks), the latest example of German Expressionist cinema. Soviet cinema was considered crucial, and the society would play host to visits by Eisen-

stein and Pudovkin. But these were big well-funded films. At the other end of the scale, budgets were minimal and filmmaking depended on the artisanal character of the production process, the creative labour went unpaid, and in commercial terms the films remained entirely marginal and excluded from the commercial market (just as similar movements ever since); but this is where experimental cinema flourished, because here these filmmakers were entirely free to pursue their aesthetic demons. In some places more than others. In France, for example, you find artists like Fernand Léger funding their own films, Jean Epstein supported by film clubs, while Jean Cocteau, Man Ray and the duo of Buñuel and Dali were all commissioned to make films by an old style patron.[5] All the directors named in this paragraph, and a good many more, were crucial contributors to cinema's first artistic maturity, the first to deserve the artistic credit of the authorship that goes with the function of film director.

Documentary

The coming of sound altered the dynamics just as this alternative cinema became politicised. The film club with its closed membership proved an effective model for escaping censorship and workers' film societies began to appear in countries like Germany, France, the Netherlands and Britain in direct response, says Bert Hogenkamp, to the censor's interference with the exhibition of Soviet films. Encouraged by the activities of the Berlin-based Soviet propaganda agency WIR (Workers International Relief), a workers' film movement emerged intent on both watching films and making them,[6] but their initial attempts at filmmaking were still silent. For these politicised aficionados the objective was counter-propaganda, not art, but their efforts were no match for the apparatus they attacked. Meanwhile the industry responded to the growth of non-theatrical screening by seeing another opportunity, and introduced 16mm sound projectors, catering for venues ranging from schools to church halls, which extended the sphere of circulation for an alternative non-commercial cinema, especially documentary, which in the 1930s came into its own.

According to Armand Mattelart, the country to draw the most intelligent lessons from the experience of what was 'the first modern propaganda war' of 1914–18 was Britain.[7] If so, one result was that here, in the late 1920s, a well-placed civil servant was persuaded by a maverick Scottish intellectual to set up a documentary production unit within a govern-

ment publicity department called the Empire Marketing Board, which then moved to the GPO (General Post Office) where it flowered into what history calls the British Documentary Movement. John Grierson conceived his documentary project against the background of rising Fascism in Europe, as a means to help strengthen the democratic polity through civic education, or education for citizenship. He had returned from a period of postgraduate study in the USA where he discovered the problem of the media writ large, just as 'mass communications' first began to take shape as both a dominant social phenomenon and a field of enquiry. He took his cue from an influential book on public opinion by the journalist Walter Lippman, who argued that ordinary citizens were in no position to make rational judgements on public issues: there was too much to know and the mass media didn't help. Our thinking, he wrote in 1920, is 'shrivelled with panic'. The argument, despite Lippman's right-wing leanings (and if you make allowances for words like 'civilisation' and 'man') remains entirely vigilant – 'civilisation' is too extensive for personal observation: 'The world about which each man is supposed to have opinions has become so complicated as to defy his powers of understanding.'[8] He added that the speed and condensation of information required by the media tended to produce slogans and degrade the content – what is known in today's sloganistic journalese as dumbing down – and this also remains true, even though the problem a hundred years later is not lack of access to quality information but that of drowning in an excess of information, much of it unreliable, which makes it even more difficult to digest.

Grierson conceived of documentary as a form capable of beneficent intervention in this confusion, as the interpretation of social reality for the benefit of the populace who urgently needed a better conception of their relation to the state. Since it was obvious to him that such a project would find no support from commercial interests, his solution was to see the state itself as the necessary patron for the social role of the documentary. If it needed his considerable powers of persuasion to bring this off, it was not such a far-fetched idea in a country that had accepted the argument for a state monopoly of broadcasting but in order to keep it separate from the state apparatus itself, invented a new form of public ownership to run it. The GPO Film Unit was just a sub-department in the interstices of the civil service but it was outside the commercial film industry, who viewed them with suspicion from the start (even while doing business with

them). It was also viewed with suspicion within government, arousing the hostility of the political establishment as soon as they found out what was going on from their confrères in the film business; the latter objected that film production by government departments was unfair competition. And of course the claims that Grierson made for documentary in order to gain official support in the first place – showing civil servants films by the American pioneer Robert Flaherty, the German avant-garde *Berlin, Symphony of a City*, and films from the Soviet Union – aroused suspicions. The state took appropriate precautions, and Eric Barnouw was only repeating what was well known in the movement's oral history when he wrote that for a time Grierson's unit was observed 'by a secret-service operative in the guise of a trainee film-editor'.[9] What he would have found there was described by Alberto Cavalcanti: 'We worked in conditions that were similar to those of craftsmen in the Middle Ages. The work was collective, and each person's films were discussed by everyone else. If the film of a companion required some assistance, it was offered.'[10] They were careless about credits and enjoyed a licence to experiment impossible under conditions in profit-making studios.

The Grierson school was part of a broader 'independent' film network, mainly circulating on 16mm because it was cheaper and exempt from censorship regulations, which extended through the labour movement, showing films in trade union and Labour Party branches, the co-operative and workers' film societies – in short, the parallel public sphere of left-wing socialism populated by the Communist Party and other groups like the Left Book Club. Grierson once described his own politics as 'an inch to the left of whichever party is in office'.[11] According to Harry Watt, co-director of *Night Mail*, 'Not many of us were communists, but we were all socialists and I'm sure we had dossiers.' Like Meyerhold, he said, they believed that 'Art cannot be non-political', but they knew from seeing the 'monotony' of fascist and communist propaganda that overt political rhetoric was 'a kiss of death'.[12] *Night Mail* followed one of the key formulas of the Grierson documentary: the working people seen in the film are social actors portraying themselves. Another is *Housing Problems*, where they speak for themselves (even if a little awkwardly – speaking to a camera did not come naturally). But sponsorship by government agencies had its limits, which were summed up by the decade's leading political documentarist, Joris Ivens, who of all people was entitled to make such a criticism, in his remark that 'If the British films had been

sponsored directly by social organisations fighting the bad housing conditions instead of by a gas company, they would have closed in on such dramatic reality as rent strikes and protest movements.'[13]

In 1938, the two-year-old British Film Institute estimated the number of educational films in distribution at 2,250, although this figure consisted in a rag-bag of titles not much connected with the school syllabus. Meanwhile, as markets recovered, Kodak saw another opportunity and introduced a new amateur format on 8mm, which came into its own after the war, until both these formats were displaced by the rise of video.

Benjamin and Brecht

These emergent countercurrents send us back to Benjamin's question about photography, not whether it's an art but whether it changed the whole nature of art. His essay on 'The Work of Art in the Age of Mechanical Reproduction', where he compares the film screen with other representational artforms, is full of suggestions about this.

> The painting invites the spectator to contemplation; before it the spectator can abandon himself to his associations. Before the movie frame he cannot do so. No sooner has his eye grasped a scene than it is already changed. It cannot be arrested. Duhamel, who detests the film and knows nothing of its significance, though something of its structure, notes this circumstance as follows: 'I can no longer think what I want to think. My thoughts have been replaced by moving images.' The spectator's process of association in view of these images is indeed interrupted by their constant, sudden change. This constitutes the shock effect of the film, which, like all shocks, should be cushioned by heightened presence of mind.[14]

Or again, the sight of a film being shot, he says, especially a sound film, presents a spectacle previously unimaginable, of actors surrounded by camera equipment, lighting, staff, which

> renders superficial and insignificant any possible similarity between a scene in the studio and one on the stage. In the theatre one is well aware of the place from which the play cannot immediately be detected as illusionary. There is no such place for the movie scene that is being

shot. Its illusionary nature is that of the second degree, the result of cutting ... The equipment-free aspect of reality here has become the height of artifice; the sight of immediate reality has become an orchid in the land of technology.

The result of cutting: that is, montage, to which, as Susan Buck-Morss puts it, Benjamin afforded 'special, perhaps even total rights' as a progressive form because it 'interrupts the context into which it is inserted' and thus 'counteracts illusion'.[15]

Commercial cinema was dedicated to softening the shock and reinstalling illusion – thus ensuring the need for avant-garde and oppositional cinema – but is it possible that this radical reshaping of aesthetic perception would not have an impact beyond cinema? What remains to be explored, then (but lies beyond our present scope), are the ways and degrees in which filmic thinking penetrates other artforms, narrative as well as visual, effecting a realignment of perceptual schema across the culture. Nor is it just a matter of the visual field. Film also elicits attention to the perception of time, which is why it finds both echoes and support in music. In painting, the stable surface of the canvas breaks up in a search for a new sense of temporality. Novels begin to adopt the tropes of screen narrative, like flashbacks and parallel story-telling. Stage dialogue becomes more pithy, and styles of acting more naturalistic. And it isn't just a matter of 'high art'. For his part, Benjamin believes that cinema changes the reaction of the masses towards art. 'The reactionary attitude toward a Picasso painting changes into the progressive reaction toward a Chaplin movie.'[16]

One writer who saw cinema much the same way was his friend Bertolt Brecht, whose understanding of the screen complemented Benjamin's from the position of a practitioner. The industrialised medium of cinema, according to Brecht, inflected the world with a distinct cultural horizon by affecting how people consumed literature and art. The old forms, he wrote, are not unaffected by the new.

The film viewer reads stories differently. But the storywriter views films too. The technological advance in literary production is irreversible. The use of technological instruments compels even the novelist who makes no use of them to wish that he could do what the instru-

ments can, to include what they show (or could show) as part of the reality that constitutes his subject matter ...'[17]

This analysis invites an excursus into a particular author and a particular work.

Brecht was ready and eager to find a place wherever a maverick dramatist's skills could be put to use, and his early *Lehrstücke*, didactic plays with music, were conceived for radio, in the same years Benjamin earned an income delivering highly imaginative radio talks for children. Kurt Weill, Brecht's most successful musical collaborator, was composing works for the radio at the same time, and writing about its demands and opportunities. Radio was accommodating to art music, especially in Germany where it was the keystone of bourgeois culture, and the public radio system not only favoured live performance but was ready to commission new music with the radical tendencies of the Weimar years. Weill was sober when discussing the technical limitations of the medium, the need for the clarification of sonority and how best to score music for the loudspeaker.[18] Brecht and Weill got sucked into cinema when they came up with *The Threepenny Opera* in 1928, a novel form of music theatre written to be sung by actors, which became the great German theatrical hit of the decade and landed them a film contract. Responding to a question about the sociological significance of their success, Weill thought it represented 'a breakthrough into the consumer industry, which until now had been reserved for a completely different type of composer or writer ... we addressed a public that did not know us at all ... which far exceeded the boundaries of the musical and operatic audience ...'[19] To do this on stage was one thing, however, to do it on screen quite another, and when Brecht found himself marginalised, denied his contractual right to 'co-determination' of the script, he decided to seek an injunction, along with Weill, to prevent the film's production. Weill, in a letter to his publisher, protested against the introduction of unauthorised musical episodes and denounced Pabst's adaptation as an 'operetta film' and mere 'kitsch', and said he was shocked by the attitude of the film executives for 'being in a constant state of confrontation with us'.[20] In the high-profile trial that ensued, Brecht lost (because he hadn't delivered the required draft script on time) and Weill won and was awarded damages; but this didn't stop the production going ahead.

For us, the interest in the episode lies in Brecht's account of it in a pamphlet called 'The Threepenny Trial: A Sociological Experiment',[21] where he claims that he knew he would lose but went to court in order to demonstrate publicly the structure of cultural production in contemporary capitalist society, in which the author is inevitably outbid by capital. As a legal argument the pamphlet hardly measures up, but it isn't meant to; to demonstrate his analysis, Brecht puts together an assemblage of press comments, accounts of court proceedings and assorted quotations with his own commentaries on them, in a text that brings out contradictions and refuses convenient logical or narrative coherence: this of course is a well-attested avant-garde technique (which derives from cinema: the technique of montage). The first contradiction to emerge is that of Brecht's own position as an/the author:

> Brecht refused to discuss ownership and property rights. The plaintiff wished to defend his ownership of this work for purely legal reasons only, and otherwise he viewed it as the property of the audience to whom he transferred it. In his opinion the question here is: 'Can industry do with art as it pleases?'
>
> (*Neue Zeit des Westens*)[22]

The court evades this question by focusing narrowly on contractual issues and on Brecht and Weill's right to object to changes to their work, but as Brecht sees it, what the court demonstrates is that 'the legal subject does not simply exist in and of itself but is instead produced by law'.[23] This would mean that copyright is what I earlier called a legal fiction, which comprises both what Brecht calls an intellectual product, and simultaneously the constitution of what Foucault called the 'author-function', who is not a real person, but whose creations are supposedly stamped with their personality. In the case of film, copyright was entangled in an industrial process through which the creative work reached the market, which Brecht sees as placing the figure of the author in question: 'The idea that the work of art is the expression of a personality is no longer valid for films ... In a form of production that makes unrecognisable the contribution of the individual to the production, it is difficult to protect the right of the individual'.[24] Yet, he adds, it resurfaces when it comes to the distribution of revenues; moreover, 'the film was acquired from us with the

advance from the money that its sale was to earn. It had to be sold before it could be bought.'[25] In this perspective, which was also that of the court, 'The protection of the author's incorporeal rights is eliminated because the producer "is under too great an economic pressure".'[26] We can add: that a film is 'sold before it could be bought' is to say that it is already (in this mode of production) commoditised in its very conception, or in Adorno's phrase, a commodity through and through.

It was not its commodity status that Brecht objected to as such, however, and he was also aware that turning the stage play into a film required a process of collaborative adaptation; the purpose of his legal action was to show how commodification was accomplished through law and how differently configured commodities circulated – by suppressing certain contradictions. What Brecht understood and the court did not was that 'a film is produced collectively and perceived as a work of art, before the concept of art allows for collective work.'[27] But 'What kind of collective exists today in the cinema?' he asks. His answer is only slightly fanciful. It comprises

the financier, the merchants (public taste researchers), the director, the technician and the writers. A director is necessary because the finan-cier wants nothing to do with art, the merchant because the director must be corrupted, the technician not because the apparatus is compli-cated (it is unbelievably primitive) but rather because the director has not even the slightest inkling about technical things, the writer finally because the audience itself is too lazy to write. Who would not wish under these conditions that the individual contribution to the produc-tion should remain unrecognisable?[28]

To explain how this top-down collective thinks, Brecht presents a diagram which he calls a 'Chart of the Dismantling Process', showing how the film decomposes into a series of elements, not unlike the way Adorno described the way that Tin Pan Alley worked but on a more comprehen-sive scale.

This chart renders visible the breakdown of the work, the collapse 'of the unity of creator and work, meaning and story, etc.' in which we witness 'the ineluctable and hence permissible disintegration of the individualis-tic work of art.'[29] This is not necessarily a bad thing in itself if it involves

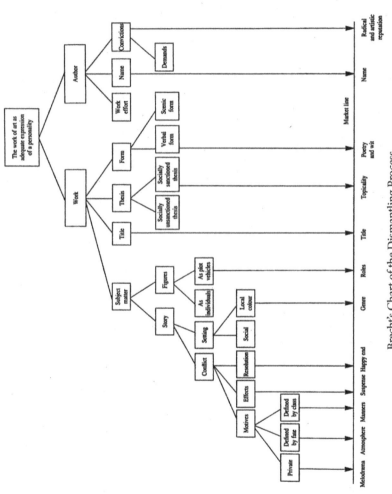

Brecht's Chart of the Dismantling Process

a pooling of collective creativity, the suggestions that suggest more suggestions, but that's not what happens. Under the sign of an ideological construct ('the work of art as adequate expression of a personality') come the two legal forms constituted by the law, the author and the work. But these split up and the author is reconstituted for the market as a name and a reputation, while the work divides and subdivides into a whole series of narrative and symbolic elements which must be configured to the appropriate genre. The chart can thus be read as a template for the analysis of genre cinema which in fact has been carried out by seasoned scholars since the rise of film studies in the academy in the 1970s. You can also imagine another version in which each box is assigned to the department responsible for carrying out the various tasks concerned, and then it becomes a management tool, and what is mapped is not creative collaboration but managerial compartmentalisation. It would be particularly apt, for example, for animation, where the different elements and layers of the image are drawn by detail workers in separate departments. Of course such diagrams already exist, in the old form of wall charts in the production manager's office, not to mention government departments and company offices generally, all of them nowadays on spreadsheets.

But asking 'What kind of collective exists today in the cinema?' implies another question: What kind should exist? Soon after the trial, Brecht embarked on another film which answered the question, *Kuhle Wampe oder Wem gehört die Welt?* (Kuhle Wampe or Who Owns the World?), and was made in fact by a collective. The group included a lawyer who drew up contracts in which ownership was prioritised over authorship, by which, said Brecht, 'we, the makers, became the authors in the legal sense, for the first time in film history or so we were told. This cost us our right to the usual guaranteed payment, but it gained us otherwise unattainable freedoms in the work.'[30] That ownership comes first is a consequence of the fact that copyright might be immaterial but it's still property, and it would be standard practice in the film industry that in order for a film to go into production the author of the screenplay had to assign its ownership to the production company and thereby lost control. This might not matter when there was effective artistic collaboration, but when the classic studio system began to break down, screenwriters – and others, like actors – would find ways to protect themselves by joining the ranks of the producers. The collective is a more democratic sort of solution, which

would be taken up in one form or another as a model for alternative film-making in subsequent decades.

RECORDING CULTURE

For most musicians considering their jobs, it was difficult to say which was the greater evil, radio, records – or the film industry. To speak of the arrival of the talkies rather than the sound film hides the devastating effect which soundtrack music had upon the employment of silent-movie cinema musicians; an effect compounded by the Depression, which kept audiences for other live entertainments at home listening to radio and records. Most of the lost employment in hotels, cafes, bars and the cinemas was never regained, a loss compounded by the introduction of the juke box in 1936. Fearful for the loss of jobs, the American Federation of Musicians, the musicians' trade union, had already mounted a campaign against mechanised competition in 1930, without gaining much ground; a recording ban in 1942–43 had more success. From the point of view of the rank-and-file musician, records and radio offered employment but when it came to remuneration, the performing musician was always at the bottom of the pile. A top rated mainstream bandleader could make good earnings. In Britain, Jack Hylton once gave details of how much he earned in his heyday in the late 1920s. His recording royalties for 1929 amounted to £29,000 (equivalent according to the Bank of England inflation calculator to around £1.88 million in 2020); Hobsbawm-cum-Newton, quoting the figure in *The Jazz Scene*, comments that he was not only the unchallenged emperor of European dance bands but also a shrewd businessman.[31] For most people the deal was nowhere near so good, especially if they were black. In Billie Holiday's account:

My friends are always telling me, 'You should be rich, Lady. I just paid ten bucks for a couple of your LPs.' I always say, I'm grateful you like my songs – even those of twenty years ago. But I have to tell them it ain't going to bring me a quarter. I made over two hundred sides between 1933 and 1944, but I didn't get a cent of royalties in any of them. They paid me twenty-five, fifty, or a top of seventy-five bucks a side, and I was glad to get it. But the only royalties I get are on my records made after I signed with Decca.[32]

She describes how those early records were made: 'We'd get off a bus after a five-hundred-mile trip, go into the studio with no music, nothing to eat but coffee and sandwiches ...'[33] They would agree on a few musical matters like the intro and the order of the solos, and record straight off. With no music. This is key. The essence of jazz is improvisation. The big markets were controlled by the music publishers, but if there were no score, the record companies could get away with treating the material they recorded as 'folk music', free of copyright, sometimes even copyrighting it themselves, thus depriving the musicians of rights in their own material. Yet the recording studio provided jazz musicians with a space of relative autonomy, where they could determine the values of their music themselves (within the time constraint) because they weren't playing from written scores and the pieces were 'composed' just before they were recorded. This was more than the everyday racism they encountered on the road, it was priced into the mode of production. The record companies counted on it.

Recording affected separate branches of music differently. For the classical sector, the copyright bill could be reduced, of course, by recording music by long-dead composers, but as well as the difficulty of recording a full orchestra, most classical works were too long for a record side and had to be split up or cut, which destroyed their integrity, while the popular repertoire of songs and dance music was much cheaper to record and easier to market. In the case of jazz and blues, however, Hobsbawm avers that while the mass media were of fundamental importance, it was 'not – odd though this may seem – for directly financial reasons',[34] and the unique thing about it is not its existence – there have been plenty of particular local musical idioms – but its extraordinary expansion, which the historian tells us 'has practically no cultural parallel for speed and scope except the early expansion of Mohammedanism'.[35]

Jazz first emerged around the turn of the nineteenth century in the Mississippi Delta, where uniquely three different European cultural traditions intersected: the French, the original colonisers; the Anglo-Saxon, commanding the hinterland, and the Spanish, flowing in from the Caribbean through the port of New Orleans, which succoured a rich musical tradition among its diverse population of French, Creoles and Africans, both slaves and free settlers. The city supported three opera companies and its first black symphony orchestra was formed in the 1830s. Here, towards the end of the century, as the emancipation of the slaves produced

an African-American proletariat technically free to choose its own enter-
tainment, a fusion took place, a unique blending of African and European
music in which neither was dominant or subordinated to the other, and
a new form of *musica practica* was created, a potent new musical vernac-
ular. Its development, however, was tied up with segregation, Jim Crow
laws and urban ghettoisation.

The first jazz musicians, says Mike Hobart, were 'semi-professional',
listing their skilled trades as their primary occupation, hired by fellow
tradesmen to provide the musical entertainment for the picnics and festi-
vals that were a central feature of life in New Orleans, as well as weddings
and funerals and community clubs.[36] Since the music was improvised and
initially escaped the grasp of music publishers, the economic basis for
the growth of jazz, like its vocal counterpart the blues, lay in the growth
of working class urban entertainment in cities with growing black pop-
ulations, including Chicago and especially New York. These circuits
provided the basis for the rapid professionalisation of jazz players. Like all
professional musicians, their time is now differently organised: they sleep
while folk work, they work while others enjoy themselves; the effect is to
separate them from their social base and insert them into the capitalist
relationship whereby, as Marx put it, the performer's relation to the public
is that of an artist, but in relation to their employer, that of a productive
worker. This dual nature of performance, says Mike Hobart, is accurately
described by Ornette Coleman in an interview. 'The one thing Jazz per-
formers have never been able to do is exercise a choice of audience and
their means of existence as related to that audience. When I perform in a
club, I am playing for the manager of that club.'[37]

Coleman also makes the point, says Hobart, that for black musi-
cians, their very blackness is an element of the commodity placed on the
market. It was also a point of contention. The earliest recordings of the
music that formed part of the ancestry of jazz, like ragtime, date back as
far as the 1890s, and the genre was already adopted by Tin Pan Alley by
the turn of the century, because it was the style of solo pianists trained in
European music and thus notated. But the first records identified as jazz
were made in New York in 1917 by a white ensemble from New Orleans
calling themselves the Original Dixieland 'Jass' Band. The success of
these records plays an equivocal role in the dissemination of the new
idiom. It both affirms and dissociates the music from its blackness. By
imitation, it becomes common property, but if the music prospered in

the process, it was also transformed by being pulled in two different directions. In one direction it would become an art music, in the other it was commercialised and lost its edge, both musically and ideologically. In becoming an art music, jazz becomes free to be taken up by musicians of any ethnicity who adopt its subaltern voice, which happens around the world, while at the same time, African-American musicians, insisting on their own identity against white hegemony, would reclaim the music for their own and propel jazz constantly forwards. In becoming commercialised, it would lose its edge as the music of a racially oppressed people giving voice to their very being, and it was in this white commercialised form that jazz spread abroad, where it proved both highly infectious and threatening to established social mores. Benjamin, reporting from Moscow in 1927, comments on the confusion which jazz had caused within the Communist Party. On the one hand, it was extremely popular, which Benjamin considered 'not surprising'. On the other, it was regarded officially as a symbol of the decadence of bourgeois society, and dancing to it was forbidden. 'It is kept behind glass, as it were, like a brightly coloured, poisonous reptile, and so appears as an attraction in revues.'[38] But this is not so very different from its reception by white 'society' in New York, London, Paris or Berlin, where, while dancing was allowed, the music was regarded as exotic and outré, despite lending its name to an era.

The improvised form of jazz survived partly because the low costs of entry into the record business allowed small 'race labels' to thrive, advertising themselves as 'The only records made entirely by colored people' and 'The only records using exclusively Negro voices' or the like. Arrangements put out by publishers could only constitute the broad outline of performance, which was highly inflected by improvisatory techniques. The proper emphasis and inflection, impossible to transcribe in standard notation (as Bartok had discovered when transcribing field recordings of Eastern European folk music), could only be provided by musicians versed in the idiom. According to Hobart,

> It is this defining characteristic of jazz music that enables it to resist the full encroachment of capitalist production techniques and makes it such an attraction to the professional musician. Even in the most regimented contexts, the musician retains a degree of autonomy that

is denied in musical forms that can be fully expressed in notated manuscript.[39]

As a result, jazz musicians found employment in the recording studios as accompanists to blues singers, and in the studio, the musicians were in control of their own aesthetic labour.

The other site of aesthetic autonomy was the jam session, where musicians gather informally after hours to play together, often in small clubs with a permissive manager, perhaps a former musician. Here they were free from commercial pressures of any kind, and the listeners were musicians and cognoscenti appreciative of technical skill, creativity and, above all, the art of ensemble improvisation. The jam session was not a free-for-all, players had to prove themselves and observe the required etiquette. In one account, by a jazz-playing sociologist, this involved two things simultaneously: on the one hand, the player 'must subordinate and integrate his musical personality, as expressed through his instrument, into the group ... with no score or conductor to guide him. On the other hand, as a soloist, he must produce startlingly distinctive sound patterns which are better, if possible, than those played by any other member of the group.'[40] This special milieu was the forcing ground for the emergence within a small caucus of young black musicians in New York during the 1940s of be-bop, a radical new departure which amounted to a new jazz avant-garde. Developed within a thriving club scene in close proximity to the major record companies, the use of fast tempi, awkward key signatures and difficult chord sequences discouraged the incompetent from participating. Some of the younger musicians claimed they set out to create a musical idiom that white musicians would be incapable of imitating. They no longer wanted to be stooges (although the phrase actually used was a racial slur). 'Herein', says Hobart, 'lies the central contradiction of the jazz aesthetic, that at the same time as jazz expresses the aspirations and experiences of the most oppressed sector of the proletariat in the world market's most developed capital, it is isolated from its cultural base.'[41] But perhaps this is only partially true, since be-bop functioned as a crucial point of inflection that could also be seen as the origin of the revitalisation of the popular musical vernacular which arrived in the form of rock'n'roll after the mid-century.

Jazz, as opposed to popular big band music, made little headway in films before the 1950s. Radio, with its capacity to cater for minority

tastes, was kinder, though not as kind as records, without which, says Hobsbawm, the stylistic evolution of jazz is quite unthinkable. Yet the gramophone record, though far and away the most important medium in jazz, was not as lucrative as might be supposed for the musician, who normally received a straight session fee, while a name artist might get a share of the royalties. 'The leading American jazz musician who shocked British journalists by claiming not to care or know how many records he sold was not merely putting on an act: his group's main income came from live performance.'[42] This is partly because jazz, although the audience was loyal, was a minority taste, record sales generally modest, and the income had to be split so many ways. Citing late 1950s prices, Hobsbawm calculates that for a short-playing record that sold for 6 shillings, the artist's and publisher's royalties together yielded 5½ pence and the musicians took 4 pence per copy on 2,000 sales; for an LP selling at 30 shillings, royalties were 2s 5d and the musicians 1s 3d. (These figures are difficult to translate into today's prices. Different online inflation calculators produce different results, but as a guide, one website gives 6 shillings in 1959 as £5.83 today, 5½ pennies as 54p, and one old pound as £23.62.[43]) A best seller could produce a tidy income, but many jazz records sold less than the numbers needed to cover their costs; as in other branches of cultural commodity production, successes have to pay for failures. On the other hand, unlike pop music, jazz records have a long shelf life. There are old-fashioned 78 rpm jazz records, says Hobsbawm, 'which have never been out of print since they were first released ten or twenty years ago, though they have probably never sold more than 2,000 copies on average per year'.[44] Something similar is true in the classical sector, for which the market is no larger. Independent labels pioneered new areas of repertoire as yet unrecorded, or old repertoire which had dropped out of use, while the major companies would reissue their backlists, re-engineered to the latest technical standards.

Hobsbawm describes the life of the average jazz player in terms that are readily recognisable in the present century as belonging to the overwhelming majority of working musicians in all genres.

It will be evident that the average jazz player gets his income – which is not normally a straight salary – in bits and pieces: a gig here, a longer engagement there, a radio programme, a recording session, with luck a basic band salary to fall back on. Even if he has that, he must move

about constantly, for in spite of the great increase in the jazz public, a
band can rarely stay more than a few weeks in the same location.[45]

This is an anarchic milieu where survival isn't easy and the musician must
make their way with the help or burden of a complex network of business
people – agents, managers, publicity folk, bookers and the shady types
who populate the night-time world.

Another factor in the rejuvenation of popular music was the micro-
phone. Vernacular musics responded differently to the microphone than
classical music. Alejo Carpentier quoted the declaration of 'a famous
interpreter' in 1951 that 'in the presence of an audience you play with
heat, but the disc is recorded cold'. What is missing is the human contact
of the live performance which produces 'a type of collective emotion'
which is lost to the recording.[46] In live performance before an audience
in the concert hall or opera house, the microphone was never used, in
contrast to the clubs, cabarets and dance halls where it was taken up in
the 1930s not just to amplify untrained voices and enable them to be
heard over the clatter and noise, but as an instrument in its own right, to
create a new singing style called crooning; this was the same decade as the
introduction of electric guitars and the Hammond organ, the first electri-
cal keyboard. But vernacular musicians didn't need to be fully rehearsed
when they arrived in the studio; as part of the deal they brought their own
material with them – they either wrote or chose it themselves – and could
use the studio in order to 'compose' as they went along. The post-war
recording studio, incorporating the new magnetic tape recorder, became
a space of novel creative opportunity, where the control room now came
equipped with delay lines, reverberation units, equalisers, filters, com-
pressors, limiters, and above all the multitrack recorder, which enabled
mixing, or remixing, to take place after recording as well during. (It also
allowed different mixes to suit different reproduction systems, from the
jukebox to the domestic record player, and when cassettes arrived, from
car stereo to the walkman, which each make their own acoustic demands.)
In this milieu, a new generation of independent producers emerged, who
would team up with a favourite engineer and particular artists and groups
and take charge of them in the studio. Mixing, says Steve Jones, is what
distinguishes popular music from classical music, citing the evidence
of a recording engineer who did both: recording an orchestra was like
taking dictation with the aim of recreating the original sound field (bal-

ancing) to the conductor's satisfaction, but in pop music there was no such original sound field, and the mix (or remix) 'is a unique artistic act whose artistry is produced through the technology'.[47] Mixers now came to be in as much demand as producers (and some played both roles), as the studio is transformed from an acoustically neutral background into a living instrument in its own right in the hands of the recording engineer, who no longer simply operates the mixing desk but becomes an active collaborator in the creation of the song. A signal example is Sam Philips' Recording Service in Memphis, Tennessee, the studio of Sun Records, where in 1953 Elvis Presley made his first discs, and which popular music writers are wont to call the birthplace of rock'n'roll.

For the musicians themselves the challenge was to ride the move from live performance in clubs to the studio, and then to match their live performance to the record, which was more problematic the more the music was shaped by the studio. In 1967, just before releasing 'Sgt. Pepper', the Beatles quit touring and declared themselves a studio band. On 'Revolver', encouraged by their highly creative producer George Martin, they had already used backward tapes and splicing techniques derived from *musique concrète* and avant-garde electronic composers like Stockhausen, and these two albums became the paradigm for a new brand of 'art rock'. EMI were lucky to have taken on the Beatles, whose global success transformed the company's fortunes. For the most part, the big corporate record companies were largely uncomprehending of new trends. When a new musical style sprang up and novice bands taken on by indie labels broke through, the big companies either bought the labels up or set up their own.

The rise of a new generation of independent record labels was only a repetition of what had happened in the 1920s when small, often local record companies had flourished by serving minority buyers in regional markets, like the American 'race labels' which promoted jazz and blues. These labels were wiped out by the Depression, only to be replaced by a new generation which sprang up in the 1940s, and benefitted from the post-war bounce back in demand. This is a pattern that corresponds to the classic conditions described by Rosa Luxemburg in *The Accumulation of Capital* in which the majors need the independents in the same way industrial capital needs small producers that play the role of innovators and pioneers towards new markets. The sequel is that one by one, successful independents are bought up by the majors, to give them direct

control of their artistes, expertise and copyrights, but at the risk, if they impose themselves too much, of alienating both the musicians and their followers. This is not a problem that ever goes away, because even shoe-horned creativity retains a necessary dose of autonomy, which cannot be alleviated by some kind of technological fix but only exploited by lucrative complicity. But the process intensifies with the growth of a new popular music culture whose primary audience after the war was the new marketing category of 'the teenager', and the rise and fall of independent labels became part of the folklore.

Imperial geography

Because of the international and cosmopolitan character with which the record industry was imbued from the outset, these conditions also speak to a wider history. The initial spread of the pre-electric gramophone corresponded to imperial geography. A British firm, The Gramophone Company established a manufacturing plant in Calcutta in 1908, and on the eve of the First World War, according to the memoirs of the grandaddy of record producers, Fred Gaisberg, set up what he called 'training centres' where musicians were taught the art of song setting, thereby generating a supply of two to three thousand new songs every year.[48] Naturally this output was highly formulaic, but it secured the company a near monopoly in the production of popular recorded music in India which had a strong influence on the emergence of the Indian film musical in the 1940s. Elsewhere activity was sporadic. In West Africa, their agents were operating in countries like Ghana, Nigeria and Sierra Leone before the First World War, importing records for the amusement of the colonial classes; in East African countries like Uganda, Kenya and Tanganyika, they would also find a market for imports from India. In the 1930s, after electrification, when the spread of records and radio went hand in hand, came the first commercial recordings of indigenous popular music. Radio stations were set up by either private enterprise or the colonial powers and the first commercial records of indigenous music followed, or vice versa. Nairobi, for example, saw the first recording sessions at the turn of the 1920s, a year after the introduction of radio, with four European companies competing against each other (two British, one French and one German). The trade was run entirely by European companies operating through local subsidiaries. Local musicians were hopelessly exploited.

They were paid by the session, royalties were virtually unheard of, and there was effectively no such thing as protection of copyright. A good deal of music was recorded, both traditional and urban, but it was sent to Europe for pressing, the discs being then exported back in a lucrative double trade which guaranteed handsome profits.

These foreign-owned companies recorded indiscriminately, mixing traditional songs and modern dance music, Christian mission hymns and Islamic chants, issuing the local music and the imported alongside each other. As a result, an unprecedented range of music became available to, say, a middle class African household, as the list of records which the writer Wole Soyinka remembered from his childhood indicates (he was born in 1932):

> The voices of Denge, Ayinde Bakare, Ambrose Campbell; a voice which was so deep that I believed it could only have been produced by a special trick of His Master's Voice, but which father assured me belonged to a black man called Paul Robeson ... Christmas carols, the songs of Marion Anderson; oddities such as a record in which a man did nothing but laugh throughout, and the one concession to a massed choir of European voices – the Hallelujah Chorus.[49]

But music has always crossed borders, travelling easily along trade routes, and is always transformed in the process – a process that is only speeded up by records, radio and cinema. A single example demonstrates the long and accelerating historical arc of the resulting metamorphoses – the tango, whose ancestry goes back to the English country dance in the seventeenth century. Popularised by the publication of Playford's *English Dancing Master* in 1651, it turns up as the French contredanse and the Spanish contradanza, whence it crossed the seas to Cuba, where it acquired a new lilt to become the habanera, and then returned to Europe. Bizet wrote his famous and shocking habanera for the opera house in 1875. From Spain it crossed the Atlantic again southwards to Buenos Aires, where it turned into the tango. But vernacular music is full of miscegenation, and tango is the offspring of various parentage, including the Italian tarantella brought over by Italian immigrants, crossed with the milonga, the song of the gaucho. According to one authority, the word itself came into use around the 1820s, a derivation of *tambo*, a term of Arab-African origin for the singing and dancing of the slaves to the

accompaniment of drums and other instruments; the earliest published use of the word tango to refer to a new dance form is a newspaper sheet music advertisement in 1866.[50] Taking shape in popular dance halls, it morphed into song form, the *tango-canción*, forever associated with its foremost exponent, Carlos Gardel, who scored a continent-wide hit with his first record in 1917. Joined by other singers, the *tango-canción* was commercialised by Columbia and Odéon, US and French companies respectively, both of which had branches in Buenos Aires, and with the coming of the talkies, after several of his songs were filmed as shorts in Buenos Aires, Paramount took him to shoot a series of musicals first in Paris and then in New York, before he was killed in an air crash in Colombia in 1935 (his body travelled back to Buenos Aires for burial by way of New York and Rio de Janeiro, where hordes of fans came out to pay their respects). By this time, tango was a global phenomenon. I have in my possession, inherited from my parents, a 78 rpm record of a Hebrew tango which they bought in Palestine in the 1930s. The story doesn't end there, of course. Tango would continually transform itself, above all with the radical innovations of Astor Piazzolla and *tango nuevo* after the mid-century, who turned it into a synthesis of the vernacular and the artistry of written composition, on a par with names like Duke Ellington, Kurt Weill, George Gershwin and Leonard Bernstein in his capacity to synthesise idioms. The traditionalists hated it, but could not deny his virtuosity on his chosen instrument, the bandoneon; a small accordion originating in Germany and favoured by sailors who brought it with them to Buenos Aires, the instrument is another sign of this mixed history. They would hate the tango-rock of more recent times even more.

Despite these transformations, tango is perhaps unusual in never losing its own identity, rooted in its underlying rhythm. Other rhythms from the Latin American periphery were more flexible, and when they flowed north, more transformative. Given the musical traffic between Cuba and the American South, Havana and New Orleans, going back to the nineteenth century and reflecting their shared African heritage, the Cuban danzón may well be the origin of certain features of ragtime. Recording transformed the island's already rich musical culture but gave it a new twist. Record production was already established in Cuba before the advent of electrical recording, when RCA moved in, installing studios and record manufacture. With the spread of radio across Latin America, mainly on commercial lines, the island became an offshore testing labo-

ratory for US penetration of Latin American media markets, supported by advertising agencies which trained up Cuban artists and copywriters and promoted Cuban music and radio productions throughout Central America. The musicians and producers were local, knew their public, and popular Cuban music thrived. In due course Afro-Cuban rhythms migrated north to New York to become infused into jazz at the moment of its renewal, and Latin rhythms found their way into more commercial musics. They would also find their way to Africa, where, in returning to its roots, Cuban music had a powerful effect.

Another dynamic developed in the English-speaking Caribbean in the 1970s, especially Jamaica, where the popular music scene was undergoing its own transformation, powered by the latest audio equipment. As Dick Hebdige recounts,[51] Jamaican interest in American black music, fuelled especially by R&B stations in Florida, prompted the appearance of discotheques – large dances, indoor or outdoor, employing powerful sound systems incorporating microphones for the DJ, who not only presented the records but talked over them, adding spice by interjecting their favourite catchphrases interspersed with humour, boasts and rhyming. A practice known as toasting, partly derived from African griot traditions and partly from the patter of the radio DJ, it would be transformed into rap when it reached New York in the early 1970s, took root among disadvantaged black youth in the Bronx, and became the core element in the emergence of hip-hop around the end of the decade. Initially regarded as a fad, rappers and DJs, says Tricia Rose, 'disseminated their work by copying it on tape-dubbing equipment and playing it on powerful, portable "ghetto-blasters"'.[52] But while hip hop 'articulates a sense of entitlement, and takes pleasure in aggressive insubordination', this process takes place neither outside nor in opposition to the commodity system: 'the hip hop DJ frequently produces, amplifies and revises already recorded sounds, rappers prefer high-end microphones, and both invest serious dollars for the speakers that can produce the phattest beats'.[53] It was several years before the first commercial recordings were made and its extraordinary foreign dissemination began, crossing the ocean to London and Paris and then sweeping the globe, from Ghana to China, Cape Town to Buenos Aires to Moscow, always adapting to the rhythms of the vernacular language and music, linking disaffected urban youth across the world in a common transgressive culture. In thus becoming the epitome of globalised musical culture as the millennium drew to a close,

rap became very big business, demonstrating at the same time the contradiction between the top-down process of economic globalisation and the borderless, cultural grassroots globalisation which surges up from below.

Magnetic tape

After discs replaced cylinders, there was no amateur recording device until the development of the magnetic tape recorder. The Depression had hit the record industry hard; sales of records and record players plunged, while those of radio receivers trebled. In the USA, RCA tried to invigorate business by developing a new long play format for use in the radio studio; in the UK, the development of prototype equipment like this was carried out by the BBC, who introduced a long play transcription format of their own. However, the market was apparently deemed too weak, and the launch of the LP microgroove record was delayed. By the time it reached the consumer market in 1951, the professional use of long play discs for programme transcription was on the way out, displaced by magnetic tape recording. These developments reshaped the market several times over, bit by bit, niche by niche.

Although the principles of magnetic recording were discovered at the end of the nineteenth century, a workable device was impossible without two things: on the one hand, amplification and loudspeakers, whose development in the 1920s was the job of the radio manufacturers (and were then incorporated into the record player), and on the other, a suitable material to record on; the technical structure of the device thus drew together the electrical and chemical industries. Various solutions were attempted and rejected until a company in Germany came up with a plastic base coated with magnetic oxide, but the prototype, marketed as an office dictation machine, was crude, the frequency range limited and distortion considerable. The Nazi regime, however, considered the military potential of the device, and continued its development in secret.

Here, not for the first time, history takes a curious detour. In 1935, in order to get round the ban on commercial broadcasting in Britain, the US advertising agency J. Walter Thompson opened a studio in London to supply a new commercial radio station beamed to England from the continent, based in Luxembourg. During the war, Radio Luxembourg fell into German hands, and BBC monitors began to notice a marked but unexplained improvement in the quality of the transmitted signal. When

Luxembourg was liberated by American forces, one of them, a certain A.M. Poniatoff, discovered why: they were using magnetic tape recorders. When Poniatoff then found the patents were available as part of German war spoils, he bought them and set up shop in California under the name of Ampex.[54]

Choosing to locate Ampex in Los Angeles was no accident. Poniatoff was not aiming at an amateur market but the entertainment industry, providing them with a new and better sound recording format for radio, records and the film industry, which offered a whole series of advantages to each of them. The tape recorder was taken up by professional music production from the moment Bing Crosby first used it in 1947 to record his network shows. Telling the press he preferred the reproduction of his voice on tape over that of discs, he put his money where his mouth was and his name helped Ampex prosper. Radio producers quickly discovered the ease with which tape could be spliced and edited, and American broadcasters and record companies began to abandon discs as a mastering medium. In the film studios, magnetic recording replaced the optical soundtrack which was now only used for release prints, and the artistry of the film soundtrack advanced by leaps and bounds. Mixing and dubbing were hugely facilitated, and combined with stereo, wide screen and colour, became part of Hollywood's fight back against television. In all these instances, the tape recorder was not just an electronic tool, but expanded the creative scope of the recording engineer who discovered its uses largely by trial and error.

In the case of the record industry, the tape recorder provided new opportunities for independent record producers, both popular and classical, and independent labels mushroomed, to occupy a market space vacated by the collapse of the indies in the Depression; as before, they used the services of the custom records departments of the corporations. In the classical sector, the tape recorder created a direct challenge to the big monopolies on their own ground. As one historian of the industry explains,

> For an investment of a few thousand dollars one could buy a first-class tape-recorder, take it to Europe (where musicians were plentiful and low-salaried), and record great amounts of music; one could then bring the tapes back to America and have the 'custom record department' of either Columbia or RCA transfer them – at a reasonable fee – to micro-

groove records. One not only could, one did. Between August 1949 and August 1954 the number of companies in America publishing LP recordings increased from eleven to almost two hundred.[55]

Roland Gelatt is misleading in only one respect: most of these independents weren't interested in classical music. The markets they supplied were niche but popular, and their primary format was originally, and for some time, not the LP but the seven-inch 45, which would drive the hit parade and the apparatus of promotion that lay behind it, legitimate and illegitimate.

COUNTERCULTURES

The adoption of magnetic tape for film sound recording brought another innovation at the start of the 1960s when cameras were paired with portable tape recorders to enable synchronous shooting on location. Equipped with a new generation of 16mm cameras light enough to rest on the operator's shoulder, fitted with lenses and film stock which allowed filming in available light, the result, in the felicitous phrase of Mario Ruspoli, one of a new breed of filmmakers who first filmed this way, was that for the first time 'sound and picture stroll along arm-in-arm with the characters in motion.'[56] The first beneficiary was documentary, where filmic representation shifted gear and a new paradigm of observed reality was installed, to be known by epithets like cinéma vérité, direct cinema or fly-on-the-wall, as well as new styles of reportage. The new documentary quickly demonstrated the feasibility of small-scale low budget filmmaking, and in the long run would powerfully influence fiction filming in both style and technique.

At the other end of the scale came a new avant-garde or 'expanded cinema' completely outside the film business. In a country like Britain, the terrain for a new kind of film practice took shape in the counterculture. Writing in 1967, the poet Adrian Mitchell noted the 'current tendency' for radicals to work together in small groups which were part of 'The Underground' – an anti-commercial, anti-war, anti-police collection of people, some good, some bad, some phoney, some real.'[57] These groups took a variety of radical organisational forms, like the London Film-Makers Co-op, created on the model of the New York Film-Makers Co-operative as an access workshop run on egalitarian, work-sharing

principles, which went so far as to install its own processing equipment, not only to economise on laboratory costs but as the only way to ensure the kind of experimentation essential to the aesthetic avant-garde. As Mitchell put it, the mass media were

> too expensive for the Underground artist. There are too many compromises. Too many people telling you how you should be seeing things ... You may charm people into giving you a job on TV and then gradually introduce more controversial material until the showdown with the governors ... Or you may go right ahead and film, within a home movies budget, showing the results in flats and clubs.[58]

A new tribe of experimental filmmakers began to produce films on minimal budgets, allowing them to retain full personal control over subject, content and style, leading to a new personal cinema of individual expression. People who gravitated into this kind of filmmaking tended not to have a union ticket and remained outside the industry, a problem that would need to be addressed as the movement developed. But there were two avant-gardes in play, the aesthetic and the political; the latter tended to form collectives, and by the late 1960s momentum lay with small groups concerned simultaneously with producing, distributing and exhibiting films, taking them on the road and showing them at political meetings in the spirit of Soviet agitprop of the 1920s. The same developments occurred in many places around the world and similar movements appeared across Europe and the Americas, broadly united with the revolutionary currents emanating from the countries of the global South, then known as the Third World (we shall come back to this in a moment). Production costs, however, wherever possible culled from grants and political funders, were unreal: neither the travails of the artist nor collective labour got paid at industry rates (if at all). In effect, a significant factor drops out of the budget, as the real costs of labour are discounted, to be assumed by the filmmaker, who doesn't work by the clock, and may even work around it.

The immediate effect of the politicisation of 1968 in Britain was played out in the arena of the ACTT (Association of Cinematograph, Television and Allied Technicians), where the freelance shop had grown more vociferous and radicalised, inspired by *les événements* in France where cinema played a powerful role. Reflecting the national esteem for what after all it

considered its own invention, France had rebuilt its film industry quickly after the war and the French film industry was the strongest in Europe. Now, amid the utopian frenzy on the streets, an assembly of diverse film technicians, directors, actors, critics and students, invoking the French revolutionary tradition, met under the name of the *Etats Généraux du Cinéma Français* (Estates General of French Cinema), and called for a root-and-branch transformation of the industry, 'a complete restructuring of its means of production and diffusion' under workers' control. Described in one not unsympathetic account as 'a thousand people completely detached from economic and legal realities ...',[59] they nevertheless represented a sector of what the poet Hans Magnus Enzensberger a couple of years later called the consciousness industry, in the process of becoming aware of their own power as cultural workers, their key position in the production of ideas, news, information and fictions, in other words, says Sylvia Harvey, 'in a position to engage in analysis and struggle at the level of ideology, and around the question of hegemony'.[60] Enzensberger argued that because the consciousness-shaping industry becomes the pacemaker for social and economic development, monopoly capitalism develops its apparatus more quickly and more extensively than other sectors of production – and must at the same time fetter it. Here the general contradiction between productive forces and productive relationships is most advanced and therefore emerges most sharply.[61]

The French militants split up into different factions, but their example wasn't lost, and in 1971 the ACTT passed a motion at annual conference calling for nationalisation of the film industry without compensation and under workers' control. This extraordinary proposal was supported by the rank-and-file largely because of the dire condition of features production in the UK, which had been thoroughly colonised by Hollywood, an endeavour all the more easily accomplished because there were no language barriers. An increasing proportion of UK movie production in the 1960s was funded by the US majors and when Hollywood suffered the effects of economic downturn towards the end of the decade and pulled its money out, UK film production collapsed and large numbers were thrown out of work. A working party was set up, a researcher appointed, and a report produced. When said researcher, Simon Hartog, presented the report at the Rencontres internationales pour un nouveau cinéma in Montreal in 1974, he described certain aspects as utopian, but the truth is the whole idea was utopian.[62] The 1970s was a decade of union mili-

tancy, but the idea of nationalisation without compensation was a step too far – for the Labour government that took office in 1974 it was never on the cards – and the policy was quietly dropped. Nevertheless, the working party had carried out a careful analysis of the contradictions of the capitalist film industry in a metropolitan country, beginning with a deceptively simple question: what *is* the film industry? or more concretely, which companies and sectors are you going to nationalise? An initial list is easy to draw up, from the studios, laboratories, film stock manufacturers, equipment hire companies, etc. who made up the production sector, to the distributors and exhibitors, who had long been engaged in all sorts of restrictive practices which limited what got shown in the cinemas they controlled; each sector had its own idiosyncrasies. But how far do you go? Do you nationalise amateur cine? What would that even mean? Another problem was production finance. What role might private capital play? What about international co-productions? What of sponsored films – advertising and publicity, industrial and educational documentaries and so forth? Even if these could be brought under worker control, what of the separate domain of television, which was simultaneously the largest employer of film technicians, a principal cause of cinema's decline, and an important market for the film industry's output?

In short, the proposal was riddled with contradictions. It called for the nationalisation of an individual sector of the entertainments industry, which no-one regarded as essential economic infrastructure, in isolation from the rest, and it did so in the wider context of a mixed economy that didn't question the logic of the concepts, apparatus and structures of the capitalist film industry, which the British state treated exclusively as a business – the concept of soft power had not yet arrived, and before it was brought into the fold of culture, cinema had been the responsibility of the Board of Trade (except for the British Film Institute, which fell under the remit of Education). There is also another contradiction lying behind the syndicalist language of the report, which Hartog alluded to as a 'possibly fundamental confusion between the film industry and cinema'. The film industry is its buildings and plant and what goes on there, but cinema is a cultural institution with many facets, constantly evolving in response to social opportunities and desires and overflowing the bounds imposed by the industry. The stance of the union was politically leftist but it was culturally conservative, and excluded the emerging sector of independent non-profit filmmaking increasingly supported by public funds which

would soon be described as the grant-aided sector – another kind of film-making and another kind of filmmaker.

Latin America

Filmmaking, as these alternative filmmakers demonstrated, easily reverts to artisanal methods of production, but since the film still needs to go through a distributor to reach an audience, which was too small to offer commercial prospects, new non-profit distributors appeared, often taking the form of collectives, to handle the work of both avant-gardes, the experimental and increasingly, the political, including films that were both. Alternative distributors in different countries opened the prospect of international distribution, and pointed towards a much wider shift taking place on a global scale, in which low budget methods of produc-tion enabled the emergence of alternative cinemas in countries where film production industries were weak or lacking, but aspiring filmmakers abundant. This was especially true at this time in Latin America, where the Hollywood majors had long achieved control of distribution and pre-vented film production industries emerging in any but the three largest countries, Mexico, Brazil and Argentina: the only countries big enough for local producers, as long as they kept their budgets as low as possible, to be able to recover their production costs on the home market; they had little access to international distribution. Because Hollywood got its money back first from what was then the largest home market in the world, the distributors could easily afford to undercut local producers abroad, on whichever continent, and still glean a good profit. With the closed mentality of the dependent bourgeoisie, it was all local producers in Latin America could do to imitate the Hollywood genres and invent a few of their own – musicals, comedies, or in Brazil, the soft porn combi-nation of the two known as *pornochanchada*. But here too there were film clubs, there were schools, a prosperous middle class and amateurs, who together comprised a non-theatrical market that was duly tracked by the US Department of Commerce, who recorded increasing sales of 16mm projectors and 8mm cameras in several countries.[63] An eagerness for the appurtenances of the 'American way of life', the spread of film clubs and magazines, art-houses and festivals, were all part of the same process of post-war cultural modernisation, but produced a sting: a new generation rejected both what they saw as the cultural imperialism of the gringos,

and the crass commercialism of local film industries, where they existed, which together prevented the emergence of authentic domestic voices. Instead they looked to new film movements in Europe for orientation, and in some respects, the independent film movement that emerged in the 1960s and called itself *el nuevo cine latinoamericano*, the New Latin American cinema, is the counterpart of the French *nouvelle vague* or the British new wave and shares the iconoclasm of both, but without an industry behind it (except in Cuba, where the Revolution of 1959 created a small but hugely influential state film industry, and briefly in Chile before the military coup of 1973).

For all the factors that have been traditionally advanced to explain Hollywood's world domination, which mostly centre on its successful populism, the appeal of the star system, the efficacy of the studios and the sheer clout of the distributors, from the Latin American point of view the central issue was cultural imperialism, which was seen as part and parcel of underdevelopment, a concept much debated by social scientists in the post-war decades. Underdevelopment operates through unequal terms of trade to deform the economy, society, the state and culture. Modernisation is forever promised and never fully delivered, as if the underdeveloped country can never catch up with the metropolis. The wish to create an authentic cinema in these circumstances was for many the same as the struggle for national liberation; the movement's philosophy, inspired by the Cuban revolution, acknowledged Frantz Fanon as a kindred spirit, and was cousin to the emergent theology of liberation.

There was talk of various types of alternative cinema: independent, critical, militant, rebel, marginal, a cinema of decolonisation, in short, anti-imperialist and revolutionary. Emerging from this feverish activity, the term 'Third Cinema' was born in Argentina in 1969, when two members of a film collective wrote a manifesto based on their experience of producing a militant documentary, *La hora de los hornos* (The Hour of the Furnaces), in conditions of clandestinity under military dictatorship, and screening it the same way. 'Hacia un tercer cine' (Towards a Third Cinema)[64] by Fernando Solanas and Octavio Getino, struck a chord across Latin America and beyond, and was quickly translated and published in small magazines devoted to film and cultural politics in several languages and continents. The term evoked the three worlds theory promulgated by China at the Bandung Conference of 1955, the founding conference of the Non-Aligned Movement, in which the First

World consisted in the advanced capitalist countries of the West, which
included Western Europe, North America and Australasia; the Second
World comprised the Soviet Union and the socialist countries of Eastern
Europe; the countries of the remaining continents, in the main exploited
by the first group, were thus the Third World (to which China declared
its allegiance). But Third Cinema is not the same as Third World cinema,
because while the Argentinians identified as Third World filmmakers, the
three cinemas they describe comprise a virtual geography of their own.
In the world of the screen, First Cinema is industrial and commercial –
studio and producers' cinema – wherever it's made, Hollywood, Buenos
Aires or Bollywood, moulded by generic conventions and the high pro-
duction values of spectacle. Second Cinema is director's cinema, at home
in Europe (where the director rather than the producer has the right to
final cut) but also wherever independent production gains a foothold,
including countries like Argentina; its budgets are more modest, its values
are individualist, psychological, bourgeois and generally politically liberal
and reformist. Third Cinema is the alternative to both, films the system
can't assimilate because they're foreign to its needs, or they explicitly set
out to fight the system and the system can't stomach them; films that
belong quintessentially to communities of struggle. The paradigmatic
form of Third Cinema was *cine militante*, militant cinema, and the anon-
ymous collective working clandestinely in the same way as the film that
occasioned the manifesto, but wherever political conditions allowed, the
movement generated numerous collectives within civil society.

Since struggle was everywhere, Third Cinema could also be made
anywhere, under whatever regime and using whatever means, and the
Argentinians offer examples from the USA, Italy, France, Britain and
Japan; all were excluded from commercial distribution and circulated
through film clubs and activist groups. But if the manifesto is volun-
taristic, then it also, as Teshome Gabriel pointed out, tends towards
schematicism.[65] An Ethiopian film scholar working in Los Angeles,
Gabriel's location and cultural identity are in themselves indicative
markers: his purview is that of the migrant or nomadic intellectual who
finds themself in the heart of the metropolis. For Gabriel, the catego-
ries, like geopolitical spaces, are not separate compartments but porous,
permeable, absorbent and diffuse. A film may overflow the categories, it
may face in two directions, it may occupy a space in the overlap between
them. This slipperiness makes Third Cinema, in its broadest sense, highly

problematic for Western audiences. It is not simply a question of explicit political challenge but of cultural otherness. In the same way that there is a history of unequal economic exchange between the metropolis and the Third World, there is also unequal symbolic exchange. The difficulty that films from the Third World countries present to Western interpretation is not just the result of their resistance to the dominant conventions of cinema, but the loss by First World viewers of their normal privileged position as the decoder and arbiter of meaning.

The viewer's privilege, which as Laura Mulvey argued in a foundational essay of feminist film studies,[66] is constructed through the male gaze, was also challenged by a current that emerged over the course of the 1970s with the creation of women's film collectives, animated by new wave feminism and impatient with the machismo and sectarianism that persisted within the New Left. In each case, the agenda responded to local conditions, but in both First and Third World countries, such groups engaged in a politics of representation in films about the lives of women, especially working class women, facilitated by a shared engagement with a feminist politics that sought to overcome the cultural divide between social classes. Here, once again, could be found a unification of avant-gardes, political and aesthetic.

Channel Four

All this is reflected in the difficulties faced by alternative distribution in First World countries, which remained economically marginal. The problem was explained in the Introduction to the 1975 catalogue of The Other Cinema (TOC), a non-profit collective set up in London in 1970 with a focus on political cinema, including films from the Third World, which spoke of the precarity of the operation and the contradiction of independent cinema, half in and half out of a profit-oriented industry. Actually less than half in. Only 27 of the 150 films in their catalogue were on the theatrical gauge of 35mm; the rest were 16mm, and only a handful of cinemas could screen them. Most screenings, as befits a political film collective, took place in non-theatrical locations – community halls, college lecture theatres, pubs, factory canteens. There was little direct involvement with the labour movement at the official level, but direct engagement with the audience was central to the new political film praxis, and TOC supported a wide network of solidarity and campaign

groups, who would send home-based filmmakers on the road with their films or speakers along with foreign films to lead a debate after the screening. When they opened a small cinema in London's West End, however, it struggled to survive, their success was brief, and in due course, the distribution wing also failed.

For a Londoner like the present writer, involved in the independent film movement of the day, there is a sad but telling irony in the coincidence that in 1982 the building that had housed TOC's cinema was taken over by the Channel 4 Television, a new station sympathetic to 'experimental' programming, and the cinema became its preview theatre. Channel 4 was established on the cusp of a sea change. Enacted by Mrs Thatcher because it looked like a good way of promoting private enterprise, it had been conceived by a Labour government after a campaign in which the film union, the BFI, and the independent sector, through the new Independent Filmmakers Association, lobbied hard for an alternative to the mainstream. The new channel was not only given a public service remit to cater for minority interests, but constituted an entirely new kind of television station with a novel set-up – the French called it third generation television – which proved a much-imitated model for many new European broadcasters when cable and satellite television arrived. The station functioned as a kind of television publishing house; it produced almost nothing on its own account, virtually everything was commissioned or bought in, boosting the whole independent sector, from established BBC programme makers who quit the corporation to go freelance, to independent collectives who now became unionised through what was called the Workshop Agreement. The result was a thorn in Thatcher's side and an anomaly in the annals of television. The commercial television network had expected Channel 4 to become their second channel and give them parity with the BBC. When instead of appointing a career executive to run it the job was given to a programme maker, Jeremy Isaacs, he proceeded to give preference to the freelance sector, and in the first few years regularly commissioned some 350 different companies, many of them operating in poky offices in the West End or out of people's kitchens. Alternative filmmaking was given its own commissioning editor and its own slots; films from the Third World were screened late in the evening. Who remembers any of this? In later accounts of Channel 4's history, the presence of both avant-gardes, the aesthetic and the political, during the 1980s, has been air-brushed out, an inconvenient

reminder of the way the channel was subsequently dragged downmarket by the neoliberal onslaught of Thatcherism, forcing ideas about public service on the defensive as the structures of television were transformed. In one respect, however, Channel 4 became a Trojan Horse for Thatcherism from the very beginning, by determining the terms of employment. Here I speak as a participant observer, one of the freelancers commissioned to make documentaries for the alternative slot. I was present at an open meeting when a freelance researcher employed by an independent production company on a film for Channel 4 complained of the exploitative terms of employment; he was told by one of the Channel's executives that since he was not employed by the Channel, this was not the Channel's responsibility. However, since commissions were abundant, many people typically found employment on other people's films in order to earn a living, and then invested their labour in their own films. We were learning what freelance really meant, although we didn't yet call it precarious labour.

Channel 4 is publicly remembered, on the other hand, as the saviour of the British film industry, which had entered the 1980s in what looked like terminal crisis in the face of competition from television and the growing popularity of a new competitor, the domestic videocassette player (whose impact we shall come to later). In 1980, only 31 British feature films were made, a 50 per cent decline on the previous year and the lowest number since 1914; production fell again the following year. Simultaneously, the UK box office fell precipitately from 101 million admissions in 1980 to barely half of that in 1984, when the industry suffered a further blow, as Thatcher dismantled the system of subvention put in place by Harold Wilson when he was President of the Board of Trade in 1950. This included a parafiscal measure, known as the Eady levy after the civil servant who devised it, of the same kind that France and Italy introduced to help their film industries recover after the Second World War, a box office levy applied to all films shown, foreign and domestic, but dispensed for the benefit of domestic producers. With one fatal difference: Eady money went back to producers in proportion to box office take, with no ceiling. As the film critic Alexander Walker bluntly put it, 'One had to be successful to qualify. If one was, one didn't need it. If one wasn't, one didn't get it.'[67] Worse still, the Eady levy functioned as a tax concession for Hollywood majors operating through British producers. Channel 4 stepped into this situation by funding independent low budget

production; the films were allowed to play in cinemas first, before television broadcast, an intelligent policy which maximised both audiences and was widely credited with stimulating a renaissance in British cinema, in which small was beautiful.

What Channel 4 also goes to demonstrate is a transformation of the labour process that went on everywhere as filmmaking was liberated from both the studio floor and the control of the studios, in part because continuing technical advances allowed greater flexibility, fluidity and smaller budgets. In the USA, the indie film movement began to take shape in the 1970s, just as the major studios were bought up by conglomerates and production came under the control of bankers and investment capital. In Latin America, sometimes supported by schemes devised by individual governments, independent production expanded, and the character of *el nuevo cine latinoamericano* broadened out. In the zeal of the 1960s, the Hollywood model of genre cinema had been repudiated as ideologically suspect; in the 1980s, the old genres began to return, in a new and playful guise that appealed to international audiences for second cinema as an intriguing new branch of art cinema; new names made the round of film festivals, and since the major distributors ignored them, entered what the trade called niche markets. Moreover, the same kind of independent production was emerging across the globe, and films from countries which had never before produced them appeared at festivals and entered international distribution. In due course the video and then the DVD stores would have shelves devoted to 'world cinema', emulating 'world music' in the music stores, both terms reflecting and feeding the growing imaginary of globalisation.

Soundings

Underpinning the diversification and multiplication of low budget production was a major shift in technique which played a critical role in both economic and aesthetic terms but went largely unnoticed, even by critics and scholars, because it belonged to the neglected domain of the soundtrack. It is not an accident that we speak of seeing a film, not of hearing it. The peculiarity of the soundtrack is that it is heard but rarely listened to, it just comes along with the pictures, an example of what Derrida called the supplement – a something extra which is nevertheless integral to the whole, like the preface to a book, or the index, or the

newspaper which is not complete without its supplement. Except the soundtrack is invisible, and now, at the same time as reducing budgets, it was released from the straightjacket of dubbing. Dubbing, also known as post-synchronisation and later ADR, or automatic dialogue replacement, is a technique originally developed in Hollywood in the 1930s (when sound was recorded optically) in the interests of complete control over the elements making up the soundtrack. In order to construct a clean and balanced soundtrack, the words spoken by the actor in front of the camera were replaced in post-production by the actor re-recording the dialogue in a sound studio to match the edited image. While many actors became adepts, the process was slow and repetitive, but it gave proper prominence to the intelligibility of speech, eliminating the vagaries of acoustics and extraneous noises. The result was a synthesis of speech, music and sound effects (which were also recorded separately), often for-mulaic and artificial, but which revealed its creative potential in films like Orson Welles' *Citizen Kane* of 1940, although recognised only much later in the newly designated role of 'sound designer'. It was also a costly pro-cedure. I recall an interview with Richard Attenborough in which he told a reporter that the single largest expense on his Oscar-winning *Ghandi* of 1982 was bringing the whole of the large and dispersed cast to London many months after the shoot for the dubbing.

Twenty years earlier, the French *nouvelle vague* had followed the example of the new documentary and adopted direct location sound recording, which helped to keep their budgets low, even by French stand-ards. New wave cinema everywhere followed the French example. This was not just an economic question. It has aesthetic consequences which go beyond the scope of the present study but should at least be men-tioned. For one thing, it allows actors to improvise (in New York, John Cassavetes began his first experiments in filming improvised fiction in 16mm with tape recorded sound in the late 1950s). For another, it allows the incorporation of non-professional actors and children, from whom the skill required for dubbing could not be expected, fulfilling the aspira-tions of the Italian neorealists of the 1940s for an authentic cinema of the everyday (their technique at the time was using non-professional actors on screen but professionals to dub their voices). It also replaced the dead acoustics of the dubbing theatre with the atmosphere and reverberation of real locations, which added to the new sense of social reality which these films brought to the screen. The soundtrack, which functions as an

ever-present accompaniment to the image but the viewer hardly attends to as such, now becomes the touchstone of two different kinds of cinema, two ways of constructing the representational space behind the screen, and thus of the world represented. I am doubtless oversimplifying and falling into the schematicism which Gabriel criticised in Solanas and Getino, and in practice the techniques were mixed, largely for pragmatic reasons, but I would argue that at the opposite extremes, the difference between the two is the same as the difference between escapist fantasy and the humanist embrace of reality, which is not a matter of taste but an ideological opposition, even while both of them belong to the art and satisfy the proclivities of the audience.

At all events, the important thing for present purposes is the overall dynamics of this hidden transformation in the mode of production, which once again demonstrates the degree to which capital is reliant on the freedom of creative labour to control its own labour process in pursuit of aesthetic renewal and innovation – as long as the bottom line holds steady and overall costs do not outstrip expectable returns. This worked differently in cinema and in television. The independent producer, whose expertise lies in bringing together a reputable creative team and selling the package to the distributors who provide the finance, had everything to gain by trusting the chosen team and benefitting from economies. There is an apocryphal story which demonstrates the point. It was common knowledge in the industry that out of every ten films released, only one or two produced the profits, a few broke even, and the rest were flops. The French *nouvelle vague* got their break by approaching a producer with the argument that if they could make ten films for the same budget he spent on only one, and they had the same success rate, wouldn't it be worth the risk? As history records, their success rate was more than average. Flash forwards to the 1980s. An American producer based at Pinewood Studios in London cited the same industry lore in explaining to me how Hollywood worked. The majors were locked into producing blockbusters with ever-increasing budgets, with the result that they all ran at a huge annual deficit which they counted on wiping out with one or two successes the following year.[68] For the independent producer, on the other hand, each film is an end in itself, but must find a distributor's backing, and therefore fit their profile, in order to get made.

In television, the dynamics were different because a broadcaster is not a studio, and filmmaking of any kind is like a recurring operating cost.

Here, direct sound came to be adopted primarily in the interests of stream-lining and cost reduction, first in reportage and then more generally. First employed in the 1960s by innovative directors like Ken Loach, permitted to experiment on the borderline between fiction and dramatised documentary, direct sound became a new norm just as production expanded and television, reviving a feature of nineteenth century magazine publishing, moved from single drama to serials and series which demanded regular steady output. (The reason for the shift is obvious: serials hook the viewer.) But here, on the small screen, where the soundscape, instead of filling an auditorium is diminished by poor reproduction, aesthetic and ideological differences swim in the same sea, which Raymond Williams, in one of the founding texts of television studies, designated as flow. Four decades earlier, Benjamin had cited a prophetic observation by Paul Valery: 'Just as water, gas, and electricity are brought into our houses from far off to satisfy our needs in response to a minimal effort, so we shall be supplied with visual or auditory images, which will appear and disappear at a simple movement of the hand, hardly more than a sign.'[69] What Williams discovered in television was 'the characteristic organisation, and therefore the characteristic experience' of this flow and thus 'perhaps the defining characteristic of broadcasting, simultaneously as a technology and as a cultural form'.[70] This makes it very different from the experience of cinema, which offers discrete narratives. What television provides is a continuous, never-ending sequence in which individual programmes succeed each other according to a planned schedule in which 'the true series is not the published sequence of program items but this sequence transformed by another kind of sequence',[71] namely, the incursion of commercials, trailers, news spots, etc., which are not announced but are not just fillers; they are designed to call attention to themselves. This is really, says Jane Feuer, a dialectic of flow and segmentation, but it also describes the television viewing situation. 'The set is in the home, as part of the furniture of one's daily life; it is always available; one may intercept the flow at any point. Indeed the "central fact" of television may be that it is designed to be watched intermittently, casually, and without full concentration ...'[72] But this is integral to television as a commercial form, designed to maximise viewers, and therefore central to the commodity logic of the medium even though the programme is not a commodity for the viewer.

A dialectic of flow and segmentation, discontinuous, interrupted, and segmented: this sounds like Benjamin's description of film, but if so, it operates on another level entirely, where far from stimulating heightened presence of mind, it becomes a soporific background to everyday life, delivering the illusion of an outside world that is live and punctual, even when it isn't. The result is the same as Siegfried Kracauer's observation that 'In the illustrated magazines people see the very world that the illustrated magazines prevent them from perceiving.'[73]

The rise of television challenged the hegemony of Hollywood in its own domestic market, as cinema going declined. Film historians have charted what happened. By the start of the 1960s, 'television had fully penetrated the nation's homes, bars, and motel rooms'.[74] By the middle of the decade, the big film studios were on the brink of collapse and susceptible to takeover. By end of the decade, when recession hit, profits were seriously down. A Hollywood scriptwriter told David Graeber what happened. In the Golden Age of Hollywood, from the 1920s to the 1950s, studios were vertical operations, headed by one man who took all the decisions. They were not yet owned by conglomerates and had no board of directors.

Oscar: ... These studio 'heads' were far from intellectuals, or artists, but they had gut instincts, took risks, and had an innate sense about what made a movie work. Instead of armies of executives, they would ... hire armies of writers for their story department. Those writers were on the payroll, supervised by the producers, and everything was in-house: actors, directors, set designers, actual film stages, etc.[75]

This system came under attack as vulgar, tyrannical and stifling of artistic talent. For a while, the resulting ferment allowed some innovative visions to shine through, but the ultimate result was a corporatisation far more stifling than anything that had come before.

Oscar: ... in the 1980s, corporate monopolies took over studios. It was a big deal, and I think a sign of things to come, when Coca-Cola purchased Columbia Pictures (for a short while). From then on, movies wouldn't be made by those that liked them or even watched them.[76]

The only correction this needs is in the last sentence: it would be more accurate to say that it was the decisions on what was made and how it was marketed that fell into corporate hands. Those who made the films were still the creative workers, now vastly overpaid and mostly squandering their talent. But the scriptwriter's conclusion is correct: clearly, he says, this ties in with the advent of neoliberalism and a larger shift in society.

The principles of neoliberalism, formulated by Friedrich von Hayek and his followers after the Second World War, were directed against both communist theories of centralised state planning and the Keynesian polices of state intervention in the economy which guided post-war reconstruction and the construction of the welfare state. Instead, they offered the working of the supposedly self-correcting competitive market itself – Adam Smith's 'invisible hand' – as the proper guide to economic policy, in which the role of the state was therefore not to manage or regulate markets in the interests of social equity but to take an active role in promoting markets, and further, to make the market form itself the regulative principle underlying the state. The theory remained marginal as long as the new liberal economic world order, installed by international institutional arrangements as the war drew to a close, stayed in place, that is, until post-war growth began to falter, producing waves of unemployment, inflation and diminished growth rates, implying a decline in the rate of profit. A decisive moment was the collapse of the gold standard and the ensuing oil crisis of 1973, which forced a fourfold rise in oil prices, with inevitable consequences in reshaping the world economy in a period that Hobsbawm describes as a transition from an international economy to a transnational economy, with a new international division of labour. In the process, manufacture not only began migrating to Third World countries but, thanks to advances in transport and communications, different parts of the same products could be made in different places and co-ordinated by just-in-time supply lines; in other words, full-scale globalisation. The process was well advanced in a sector of special interest to us: major electronics producers, says Hobsbawm, began to globalise themselves from the mid-1960s.[77]

At moments of crisis, capitalism can only adjust by seeking new markets to sustain its growth, because otherwise it contracts; there is no point of balance, stasis is impossible, because without growing profits, the system goes into reverse; quite different from biological growth, which is cyclical and seasonal and replenishes itself homeostatically. The economic lurch

of the early 1970s propelled neoliberal thinking to prominence because it provided a new rationale for escaping what was seen as an impasse, but its long term consequences were envisaged only in ideological terms in the slogans, mantras and dicta of pundits and mavens promising this or that technological utopia, and always from the perspective of First World economies of abundance. In a society of material abundance (albeit unequally distributed), where new conventional markets are not readily available, the desktop computer opened a new consumer front, simultaneously aimed at corporate, professional and amateur markets. What happened next wasn't planned, any more than the institution of cinema was in the minds of the inventors of cinematography, but the result of technological convergence, which radically repositioned the user, inserting them into a digital domain which at the same time expanded outwards and penetrated inwards, altering social interaction and changing subjectivities. The effect was like the infiltration of some previously unexploited vein of human behaviour, the discovery of zones of privacy previously resistant to commodification, or able to escape from it; what Jameson referred to as those realms of the imagination and the psyche which had always been taken as the last impregnable stronghold against the instrumental logic of capital.[78] Art, love, friendship, mutuality – all become permeated by instrumentalised values which induce the breakdown of boundaries between different spheres, public, private, outer and inner. What the digital domain now brings us is the reification of the most intimate feelings and sense of self, which is destabilised in the process. Our online presence allows the most private intimations of the user's character to be tracked through the collection of metadata. Apps on mobile devices, including wristwatches, replace the user's own feelings by measuring their bodily functions and even their moods, playing not so much on their desires as on their fears. On the other hand, the same digital sphere also offers new means of countering reification through new forms of connection and expression, individual and collective, including new forms of aesthetic creation, which can only announce themselves as utopian and liberating, and for the time being, remain so.

5

From Analog to Digital

THE DIGITAL ARRIVES BY STAGES

Let's try a thought experiment: analysing the book in terms taken from the lingo of digital technology. First, you could say that a book is a compact, portable, user-friendly system for the storage and retrieval of information. Generally hand-held and often pocket sized. Not only easy to carry around but you can read it in any available light. It provides a menu at the beginning and offers a special kind of random access memory called pages, whose utility is increased in certain models by means of an add-on program called the index. In other models, called dictionaries or encyclopaedias, the entire text is organised in the form of a database, and the experienced user is able to retrieve a great quantity of information just as quickly by pulling one down from the shelf as by pressing buttons on a computer. At the same time, because of this random access memory, you can just as easily browse as scan it at any pace desired, slow or fast, take any time to digest it, and, of course, choose any order to do so, more easily than a DVD. Books are also interactive, in a special way. The book may seem to be a read-only memory system, but it's not merely a student habit to write notes and comments in the margins. People have always used books this way. There are even classics of the genre, like Blake's marginalia in his copy of Reynolds' *Discourses*. This behaviour discloses the book not as a commodity but as a cultural artefact: it is essentially dialogical. This property, according to Mikhail Bakhtin, is a defining feature of all forms of utterance and communication. We shall come back to Bakhtin later.

Now let's dig back to the prehistory of the book. Analysis of the Dead Sea Scrolls suggests that this is just how the book originated. These manuscripts, discovered just after the Second World War, were written in ancient Palestine by a Jewish sect called the Essenes, the oldest of them in the second century before Jesus, and include the earliest surviving

copies of the books of the Old Testament. Some of them have marginalia, and different copies of the same book are full of variants. By comparison with later versions, scholars have deduced that some of the material in the authorised texts of the canon originally occurred as marginalia in an earlier copy. They had been added by a reader, and were later incorporated into the text by the next scribe who copied it. They could just as easily, of course, have left it out, or added a comment of their own. In any event, this helps to explain the problem discerned by nineteenth century bible scholars, who discovered the stylistic signs of different authors in many of the books of holy writ. There is a strange similarity here to the way that computer programs get to be written – by accretion, with the authors of later versions unaware of what the accretions consist in. The result, in both holy writ and computer programs, is an accumulation of inconsistencies, most of them fairly minor. Some of them, however, in the case of holy writ, are blatant contradictions which have caused religious schisms. This kind of error, in a computer program, causes the system to crash. The difference is that computer language is entirely artificial, purely formal or syntactical, with no semantic content, nor is it designed to be read and responded to by human eyes but consists only in instructions based on logical relations to be followed by electronic circuits intolerant of the imprecision, ambiguities and metaphors of natural human language.

Technological fixes

In the course of post-war reconversion, there were plenty of technological fixes on the way, with diverse and sometimes contradictory effects, which converged over several decades to create the domain of the digital. The word itself entered the vocabulary as an adjective – digital media, digital assets, digital video, even digital humanities – but came to signify something more than any of these, precisely because it incorporated all other media and transformed everything in progressive convergence; solid or transient, everything melted into computer code. The digital crept up on an unsuspecting world, creating fields of creative practice that were utterly new. Take the origin of computer games. The first simple screen games were devised in the early 1950s by computer scientists as research simulations or simply for recreation, and would be freely passed around. This alone tells us something which is easily overlooked: while computer science is constrained by a binary logic which is alien to artistic

thinking, that still leaves plenty of room for play, and play, of course, lies at the root of creativity. To think of computer programming in this light is to recognise it as a form of mental or intellectual work that also carries creative elements within it, or at least a high level of inventiveness, which is almost the same. (I hope any programmers reading this don't find the last sentence patronising; I am in awe of the people who wrote the video editing programme I use.) Perhaps some of those early game players became specialists in the field; at all events, the consumerisation of gaming repeated the ploy that Edison used to launch the kineto-scope (and the phonograph before it) and when video arcade games and consumer game consoles appeared in the 1970s, using joysticks, buttons and other controllers, a dedicated industry was born that drew in a new generation of technically inclined artists, designers and composers along-side programmers, which would soon outstrip every other sector of the entertainments industry.

The digital arrives by stages. It begins with numbers. First, there is Charles Babbage, nineteenth century inventor of the unwieldy Analytic Engine, of whom Enzensberger writes:

A few stone's throws from Mr Babbage's hearth, a
 Communist
sat in the British Museum, checking the arithmetic
 and finding it correct.[1]

Like *Das Kapital*, Babbage's prototype computer was unfinished. Flash forwards to Alan Turing in the 1940s and the code-breaking machine that was the prototype of the computer, a word which henceforth referred to a machine and not a human being performing calculations. The difference is not just that Turing's machine was electronic, not mechanical, but also that it was born of war and financed by the state. Not that this was the first time the state had got involved with the development of new electronic technologies: Marconi, an Italian with connections in England, developed wireless telegraphy with the help of the UK Post Office, War Office and especially the Navy; and in Germany in the 1930s, the Nazis maintained secrecy around the development of the tape recorder. The computer that arrived on desktops in the 1980s, however, depended on another result of wartime R&D, because the apparatus remained unwieldy until valves were replaced by transistors and integrated circuits, which were subse-quently further miniaturised to produce the computer chip. The first

working transistor, accomplished in 1947, emerged from the search for improvements to radar, another new piece of military technology, but it took several years of further development before it was ready for the market. The battlefields of the 1940s having given way to the Cold War, R&D was now funded by the space race and the space agencies' need for miniaturisation, which benefitted all branches of electronics. The pay-off for the corporations was the ensuing consumerisation, beginning with small devices like hearing aids, pocket calculators and wristwatches. The military-industrial complex at work has a major effect on consumer culture.

The computer brings together the gamut of different technical strands across the branches of the electronics industry. Early computers used punched cards for inputting data, a mechanism with a history going back to 1800 when it was devised by a silk weaver called Jacquard to improve the loom, borrowed by Babbage for his Analytic Engine and then applied in the 1880s, with the addition of electric sensors, to tabulate the US census. New interfaces would now be needed: keyboards, screens, the mouse, graphics tablets. Unwieldy spools of magnetic tape would have to be replaced by small spinning discs and other forms of memory. Before these things happened, however, the transistor had been incorporated into low-powered and low-cost mass produced consumer products like battery-powered radios, and tape recorders whose operation was simplified by the introduction of the audio cassette. Small transistor radios first appeared in 1954, liberating radio from a fixed power supply, not only in metropolitan countries but right across the world, not only extending the reach of recorded music but also news, information and advertising, to new publics, including largely illiterate populations in Third World countries, from the shanty-towns around the cities with neither water nor electricity to remote villages in the interior, and thus a crucial step in the creation everywhere of the new imaginary of globalisation. A decade later audio cassette players not only gave back to everyone the means of recording, though of course the quality of reproduction was poor, but they also offered the consumer the additional advantage of making it easy to copy commercial cassettes, with two notable effects. In domestic hands, it allowed music to escape the market and circulate freely beyond it. It also led to organised piracy. All this happens before digitisation. These are analog technologies, the signal delivered in continuous waves, not chopped up into digital pulses.

Magnetic recording led to videotape, which sees a parallel process of technical development that will eventually also become digitised, but this required faster and more powerful computers. Meanwhile, the first bulky and costly machines were installed in television studios in the late 1950s, and then progressively improved, with the first low-grade portable video recorders appearing in 1965, the same year as Early Bird, the first geostationary telecommunications satellite, another signal development in the globalisation of communications; the pace of technological innovation is speeding up along several fronts, and no advance is made in isolation. When the video cassette recorder (VCR) arrived in the 1970s, again it had several effects. First, it provided the domestic television viewer with the capability of recording television programmes. But second, it instituted a major rupture in the economics of the film industry by turning movies, for the first time, into take-home commodities, like records and books. The film industry, however, was initially wary of the domestic video machine, and in 1976, Disney launched an action against Sony for advertising video recorders as a way of watching your favourite Disney programme whenever you want to; eight years later, the case reached the Supreme Court and a new term entered the vocabulary, as Sony was absolved and the Court ruled that 'time shifting' was fair use and not copyright infringement. Surely the only possible ruling, since the widespread take-up of the VCR would have made any attempt to police infringement impossible and undesirable, but the case not only demonstrated once again that copyright law always lags behind technology, it also provided a precedent for issues which arose subsequently with phenomena like internet file sharing, especially of music.

When the court ruled that 'time-shifting merely enables a viewer to see such a work which he had been invited to witness in its entirety free of charge', this amounts to an affirmation that for the viewer the television programme is not like a regular commodity that they have to pay for (except for pay-to-view services). But video cassettes behave differently because they're not broadcast signals but physical objects, and video rental stores began to appear even before the Supreme Court ruling. It turned out that the video cassette was not quite the same as the book after all, or at least that punters brought up on going to the cinema saw it not as a collectible object but akin to the price of admission to an experience, only cheaper (once you'd bought the machine to play it on). By the time of the ruling, the studios had opened new divisions to produce prerecorded

tapes, and their revenue was approaching parity with the box office take. One report commented wryly that 'because of the VCR, even a bad movie can make money', and many did, but capital was never much concerned about producing trash, as long the profits kept coming. At all events, such a huge shift in audience behaviour had massive repercussions. The box office take went down, movie theatres closed, but blockbusters thrived and in 1989, Sony purchased Columbia Pictures and a Japanese corporation became the owner of its own Hollywood studio. In France, a tax on virgin video cassettes was used to provide a subsidy for national film production.

The paradox in what happened is that the VCR transformed the viewing experience by swapping projection for the far inferior television screen. The first difference is perceptual, the difference between watching the reflected light of a film projector and seeing a pattern of light shining at your eyes directly, where each frame of the former is an analog image, and in the latter, the cathode ray tube is a pulse of lines scanning the screen. Sound as well as picture was diminished in both size and quality.

A film seen on an analog television screen is not quite the real thing, in the same way that a record is the reproduction of a musical performance, not the performance itself, an experience without the aura of direct perception. Second is the setting (which remains the same when the cathode ray tube has been replaced by a digital display, although the quality of the picture improves). Sitting in front of a television set at home is not the same as watching a film on a big screen in the darkness of a cinema where strangers laugh and gasp at the same moment; the audience is dissolved into domestic groups and atomised individuals. The domestic interior is full of stray noise, the television sound is poor and the acoustics no match for an auditorium, the lights are on, people watching at home behave more freely. The difference between the two spaces remains even when the cinema audience is noisy or domestic television becomes home cinema. Watching at home is constantly liable to other distractions, and to interruption of the viewing – telephone calls, children needing attention, what-have-you. The result is to reveal the varied character of the aesthetic consumption of cinema, the dissimilar needs it fulfils for different audiences, like the difference between the ordinary cinemagoers who makes up the bulk of the audience and the discriminating cinephiles who frequent the art circuit. Doubtless actual filmgoers cannot be so easily typecast, but the former, in a familiar stereotype, follow their favour-

ite stars, are attached to genres rather than directors, and they opted for rental; the latter, equally stereotyped, regard cinema as more than diversion, frequent the art circuit, and since they consider films as works of art to be viewed repeatedly as you might listen to your favourite music, did indeed purchase their own copies, to watch them again when they want to, share them with friends instead of having to wait for them to come round again, and stack them on their shelves along with their books, gramophone records, and later, CDs and DVDs. So did parents responding to their infants' demand for the same film over and over, like their favourite storybook. And so too did schools and universities, where the VCR enabled the entry of film and media studies into the curriculum in both school and university education, with far-reaching implications as students learned to 'read' what they watched, comprehend them as texts, criticise and discriminate instead of merely imbibing them. You might think this is what the student needs, and would stand them in good stead if media became their chosen branch of endeavour (and even if they didn't); right-wing ideologues were not so sure. Scurrilous politicians and assorted journalists began talking about 'mickey mouse degrees' – which might be said to underestimate Mickey Mouse.

Digital audio

The first sector of the culture industry to be affected by digitisation was music, where it would shake up the music business from top to bottom. The CD, introduced in the early 1980s, broke with the rule previously followed by the record industry, that new formats should be backward compatible with previous ones, by requiring new consumer equipment as well as substantial retooling of the means of production, but the market was buoyant and the record industry was quickly transformed. However, digitisation also had a remarkable effect on the creation of music, because musicians were no strangers to sonic experiment. Electronic instruments had first appeared between the wars (ondes martenot, theremin, Hammond organ, electric guitar) and were variously taken up by classical musicians, film composers, and increasingly, in popular music. The 1940s saw the first experiments in *musique concrète* – the manipulation of recorded sounds – which turned into fully-fledged electronic music with the transition to tape and the addition of laboratory equipment like the sine-wave generator, pioneered by avant-garde composers

like Stockhausen, until the first generation of electronic synthesisers in the late 1960s turned these too into performing instruments. This genealogy would be forgotten as pop music went electronic and the media bandwagon ignored the avant-garde, whom they denigrated as an elitist intellectual fringe intent on having everyone on.

Digitisation unified the whole range of music technologies by allowing the easy interchange of signals – as long as everything used the same protocol. The rising Japanese company Yamaha demonstrated what was at stake when they broke with orthodox economic logic, acquiring the rights for an interface to accomplish the task, known as MIDI, and then making the patent freely available. But it was good business, promoting the adoption of Yamaha's synthesiser as the primary electronic keyboard in popular music across the world. Digital audio, whose origins lay in telephony, soon gave rise to sampling. Sampling is more than a technique but an assertion of musical values as common property, freely available across the culture, like certain rhythms or chords or melodic twists in pre-digital music. It is also transgressive, like the practice of record-scratching developed by DJs, an unintended use of the device which, as well as violating artistic norms, poses new headaches in matters of copyright. Insofar as it arrives with digital technology, what sampling manifests is the technical structure of the digital, which is based on copying code ('cut-and-paste') between different locations within the computer's architecture. When computers are linked together at a distance, you get the internet, and then comes the web, which again depends on the universal adoption of protocols and software codes for information exchange.

Meanwhile, digital audio furnished the home recording studio. Peter Gabriel said that 'the real pleasure in having a studio setup of my own is that I can experiment in a way that I could never afford to do in a commercial studio'.[2] In this case, benefit came from buying time to collaborate with other musicians, including some from Third World countries, without needing the say-so of the record companies. Some musicians, like Frank Zappa, gave up recording on tape altogether, storing the composition in the sequencer, which serves as a tapeless tape recorder. The successful musician who sets up their own recording studio has parallels in the screen star who becomes the producer and/or director of their own film. It helps them control their own creation. Zappa was totally his own man, composing, producing, engineering and mastering his own highly idiosyncratic music. But these are only the most visible examples.

According to a *New York Times* journalist writing in 1987, 'affordable recording technology ... has made it possible to turn a bedroom or a kitchen into a studio for less than $1,000', giving rise to a large expansion in non-commercial recording which he calls a 'cassette underground'.[3] Since the music business was the first sector of the entertainment industry to experience the 'threat' of digital technology, it was therefore, say Simon Frith and Lee Marshall, at the forefront of the campaign for new legislation to deal with it.[4] The result would extend the scope of copyright in such a way as to benefit corporate interests at the expense of both artists and consumers. These battles are still going on because the ground keeps shifting, in part because digitisation unleashed the means for the musician to reappropriate the technology for their own creative use. At first, it seemed as if the more the production of music becomes technified, and the more that musicians are able to take advantage of lowering costs to produce their own recordings, then the more that established routes to the market are challenged by the creativity of the street. Not just figuratively. Buskers on the streets who already augmented their meagre earnings by selling home-made audio cassettes would soon be selling their own self-produced CDs. When the internet arrived and forced a further, even more drastic shake-up in the music industry, it seemed to create new opportunities for musicians to bypass established routes to finding audiences and entering the market, such as setting up their own record labels, websites and online sales, often using services provided by one or other of the internet giants. Yet the odds were stacked against them. In 2020, in the middle of the coronavirus pandemic, a parliamentary committee investigating the economics of music streaming took evidence that it only worked for the top stars and record labels because the income from subscribers was based not on royalties-per-play but on market share, a system susceptible to manipulation by the record companies which disadvantaged the majority of musicians. As one independent singer-songwriter reported almost ten years earlier, it would take him more than 47,000 plays on Spotify to earn the same profit as the sale of one LP.[5] The pandemic boosted platforms like Spotify but threw the inequalities in the music industry into stark relief as the collapse of live performance affected not only artists, but everyone who works alongside them, from road crew and sound engineers to security guards and haulage companies, most of whom belong to the gig economy and simply lost their jobs, unsupported by emergency government assistance.

The small grassroots venues which are the lifeblood of the popular music culture closed down, some of them probably never to open again. The bands who thrived on touring these venues were set adrift. Musicians forced to survive on income from streaming couldn't pay their rent. These effects were the result of inequalities baked into the culture industry long before the coronavirus.

Video culture

The digitisation of video, similar to music in some respects, distinct in others, followed at a distance, waiting for processing power to catch up with its demands; it would remain an analog medium until the end of the 1980s when the first professional computerised video editing systems were launched. Consumerisation then came quickly, partly because demand had been growing since Sony introduced the first portable video systems in the late 1960s. The picture resolution of these early systems was sub-standard, sound recording was poor, camera and recorder were separate items which had to be linked by cable, but like the first 16mm cameras, they were not intended for professional use; they were aimed at aficionados, as proof-of-concept and loss leaders, and likewise functioned as prototypes for subsequent development. Given that Sony and its rivals were global corporations, the equipment found pioneer users around the world, who were not film or television programme makers but took it up as a tool of research, documentation, demonstration, community activism, and the first stirrings of video art. Adopted in place of 16mm projectors at exhibitions, trade fairs and congresses, by advertising agencies for casting, by PR for publicity, by anthropologists for ethnographic field work, by surgeons for demonstrating new techniques and by other medics for health and sex education, a new sector of non-broadcast production emerged with unique characteristics: it did not compete in the commercial markets of cinema and television but composed a parallel sphere of circulation where the laws of the market were weak or absent – although it also embraced the local photographer who now offered neighbourhood customers videos as well as photos of all the usual family events. The emergent video sphere was neither uniform nor homogeneous, and as Sean Cubitt put it, 'video culture as such has no centre, and therefore no peripheries.'[6] Production was sponsored directly or indirectly by corporate publicists, government agencies, non-government organisa-

tions, charities, trades unions, the church, universities, international aid and development organisations, political groups and local communities – in short, right across civil society. The result was the appearance of a division in the audiovisual public sphere. The big public was supplied by television, which was professionalised, highly centralised and ideologically conformist, and as channels multiplied, tied in with major film distributors. Video was small scale, decentralised, and in the early stages taken up by a mix of people, including aficionados who were themselves professionals but not in filmmaking. Aimed at small publics, like other small media, it could be ideologically divergent. There was a sense that this was a new audiovisual medium *sui generis*, an idea which took hold among different groups of practitioners, from aesthetic avant-gardists to social activists, who took the very materiality of the new medium in their own different directions.

By the start of the 1980s, professional video cameras had been developed, known as ENG (Electronic News Gathering) units, amalgamating camera and recorder in a single unit resting on the operator's shoulder. These, combined with satellite transmission, took over television news production, extending its reach around the world, reinforcing its attraction to the impact of spectacle, shock and violence. But non-broadcast video led in other directions. Key to its adoption was ease of use compared to the skills of cinematography, including automatic sound recording onto the same tape as the image. In the USA, a paradoxical effect of deregulation in the 1980s was free public access for community cable television stations, which grew to number some 1,200 within a few years. Leading the way in this grassroots do-it-yourself television was the New York volunteer collective Paper Tiger, whose weekly show combined irreverent, ultra-low-budget antics with democratic goals and the critique of the commercial media. In 1986, they set up a parallel project called Deep Dish to compile material from access groups around the country and with the aid of public funding, link them by satellite; the programmes covered topics like labour struggles, women's struggles, the housing crisis, racism, the peace struggle and Central America, thus demonstrating that another kind of television is possible.[7] In Latin America grassroots video took a rural turn in the form of *video indígena*, the indigenous video movement which emerged towards the end of the decade in Brazil, where video had already been taken up in the cities by community activists and trades unions; the movement would spread to other countries with large

indigenous populations, like Bolivia. Generally funded by NGOs, activists set up collectives who provided the gear and taught the communities how to operate it.

The short videos which they then circulated around the network were not ethnographic, the view of an outsider, but had an activist and political rationale; neither are they addressed to outsiders, but by communities to each other, in a variety of subgenres – including new ones, like the video letter – about topics such as rituals in danger of loss, the documentation of a land campaign, the investigation of a massacre.[8] Since the audience is made up of communities who have actively participated in the process of video making, this puts them in a very different relationship to the screen from the attitude of passive consumption elicited by the mass media; the audience is in turn a collective interlocutor and a collective author. According to Freya Schiwy, 'Indianising video production ... invokes traditions of shared labour' in which the community works together in tasks like the harvest or the construction of schoolhouses or roads, so why not producing a video?[9] Moreover, in a culture of collective community participation, the collaborative voice that emerges does not displace oral communication, but extends it. In fact, it doesn't even depend on literacy. The indigenous communicators trained by the video activists are not necessarily literate (nor necessarily men) and video, Schiwy thinks, bypasses literacy. This, she points out, goes against the common notion of a teleological continuum from oral culture to literacy and thus to modernity, or its counterpart, from photography to film to television to video. That obliges us to think about different ways of experiencing modernity, or other forms of modernity (although I acknowledge I've written this book very much from a position within the ultra-modernity of the metropolis).

Examples like these – there are plenty of others to choose from – where the video is not a commodity and is therefore unconstrained by the fetters of the market, demonstrate a great hunger for creative expression, and what Habermas called 'communicative action', to be found among diverse sectors of society whose voices are unheard in the mass media. The internet and video streaming did not create this appetite but magnified it, and in the process transformed it. New questions arise: What happens to the politics of speaking, hearing and listening in these conditions? If you take away the social environment of reception within the community, do you still have the same mode of address? Can a virtual community suffice? What is the difference between the voice that speaks in the first

person singular or, either implicitly or explicitly, first person plural, when they're removed from the fleshworld, robbed of their 'real life' social context? Whatever the answers, the growth of these new forms of public speech have had the effect of exposing more and more areas of disconnection between the governed and the governors, or what is known since the late 1970s as a democratic deficit.

Filmmakers largely held back from adopting video, in part because of its limited capacity for photographic artistry, but plenty of others did so eagerly because they didn't think in terms of art anyway. A Brazilian video activist told an interviewer in 1992, 'The social movements appropriated the medium before the professionals.'[10] In the film schools it was at first regarded with scepticism by both teachers and students, and only used for practice, not production. Within a few years, however, video was taken up across education: in schools, where video clubs started to make short videos to supplement classes in media and film studies, and universities, which provided rich opportunity at the very moment of their expansion and transformation by neoliberal policies into an increasingly marketised system. The established film schools were elitist. Art colleges were not designed to train workers for the industry, although they often ended up there. Universities, at least those that weren't themselves elitist but engaged in renewing their curricula to respond to student demand, saw the opportunity to set up entire departments by tooling up with video and answering the call for 'vocational training'. They likely thought it would be economical, cheaper than hands-on laboratory-based courses, but then had to retool when digital video arrived; at least the students kept coming.

Given the oversupply of insecure labour in the industry, lecturers and technicians were not hard to find, often almost as young as their students, as they proceeded to contribute to the reproduction of the workforce to which they themselves belonged. But this understandably naive future workforce would have to learn a whole range of skills, laid out in course handbooks in managerialist bullet-pointed lists, in order to prosper, or even survive, in the evolving media environment. Some of these skills were labelled 'transferable', others left for them to discover, for as Guy Standing puts it in his study of the precariat, to be 'streetwise' is also a skill, but a fuzzy skill: knowing how to cultivate trust and build up favours, which require poise and 'emotional labour'.[11] A tension developed. The educators, building on the work of sociologists like Stuart Hall,

and working in the best traditions of the humanities, aimed to develop students' critical awareness, but that was not what either government or industry meant by 'vocational training'. For government, it was a policy for managing entry into the labour market, for industry, a way of cutting overheads and replacing the established forms of in-house training and apprenticeship. On campus, however, a contradiction appeared, which pedagogues sometimes expressed in a roundabout way as the conflict between theory and practice.

DIGITAL CITIZENSHIP

In the opening scenes of Antonioni's film *Blow-Up*, made in 1966, David Hemmings's trendy fashion photographer uses a mobile radio telephone while driving through the streets of London – a bulky hand-held device with an aerial, and very much a status symbol. Forty years later, a couple of students of mine devised a very funny short documentary to test the thesis that students nowadays were unable to live without their mobile phones. They asked their fellow students to leave their phones with them for two days and see how they got on, with the promise that they could have them back before that if they came and begged on bended knees. The first of them arrived within four hours. The smartphone, by which students now regulated their lives, and which 'liberated' the internet from the desktop, arrived in their pockets as the result of a huge sleight of the capitalist hand. To open up a global mass market for mobile telephony involved enormous expense in infrastructure, the purchase of licences from the state, and the mass production of phones at prices affordable to both students and African farmers. The solution was found in an adaptation of the old stratagem of hire purchase, devised in the nineteenth century to sell sewing machines and pianos, but with a twist: renting the phone to the consumer instead of selling it, subsidising the upfront price to recoup its cost over the lifetime of a customer's contract, reducing access charges (the equivalent of line rental), and relying instead on call charges and data use. The industry proudly proclaimed the figures. By 2004, there were more mobile phones in the UK than people. Of course this didn't mean that everyone had them, some people had more than one, some were discarded by people induced to upgrade, but without one, you were not a full digital citizen.

The prerogatives already assumed by musicians in the acquisition of digital citizenship provide, to a greater or lesser degree, a model for other creative fields (like video) but in a context where computerisation is mobilised by neoliberal policies in a form that exacerbates the disadvantages of aesthetic labour in the face of capital. This is a double-edged process. Artistic skills are retooled, transformed and reshaped by digital technologies, but at the same time computerisation has the effect of deskilling parts of the workforce, and jobs are lost as specialist skills are replaced by software which automates occupations like graphic design and typography. This is an inherent property of computerisation, because as Mike Cooley put it in his classic study of the human/technology relationship, the tacit knowledge that exists in the worker, which they take home every night and is part of their bargaining power, is now extracted from them, to be absorbed and objectified in the machine.[12] This makes it possible to employ workers with less ability and experience than previously, while the organic composition of capital is changed as processes become capital intensive rather than labour intensive, and the cost of the means of production increases. 'The most complicated lathe one could get 100 years ago', says Cooley, writing in 1980, 'would have cost the equivalent of ten workers' wages per annum. Today, a lathe of comparable complexity, with its computer control and the total equipment necessary for the preparation of the tapes and the operation of the machine, will cost something in the order of a hundred workers' wages per annum.'[13] Moreover, the dynamic development of the computer industry meant a high rate of obsolescence, even as the cost of hardware was dramatically reduced by miniaturisation, trends observed by Cooley which have only accelerated with the introduction of the internet. Theoretically, he says, computerisation has a potential for democratising the labour process, but in practice, it reinforces the power of capital.

The effect of this process on the concrete nature of the aesthetic has been to break it up into segmented specialisms to be farmed out to piece workers, making it easier for employers to subdivide and subcontract their labour needs, and for subcontractors to further subcontract, thus rendering employment ever more precarious. Searching for jobs becomes part of the job, and getting one doesn't amount to a step on the career ladder. To obtain work, the cultural worker now needs to combine various different 'skillsets': technical, aesthetic and intellectual, along with self-promotion and networking, or what the jargon calls 'entrepre-

neurial skills in the management of social relations'. Needless to say, this dispersed and disunited sector is difficult for unions to organise, especially when the trade union ethos has already diminished. The digital mode of production requires a great deal of highly mediated social co-operation, in which, however, and unlike the orchestra or the film crew on a shoot, the individual worker is only a remote part; this is a largely atomised workforce, mostly comprised of subcontracted labour scattered among small businesses, often working alone, sometimes from home, in common with similar workers in similarly computerised service industries. This diffuse work pattern impinges on leisure, domesticity, sociality and personality. As well as time spent searching for jobs and dealing with bureaucracy, the precarious worker must be at the beck and call of potential users of their labour, and their time is dissipated in floating around pubs and cafes, in a kind of enforced idleness, on standby.[14] Even their leisure time is largely given over to networking. But the application of computerisation to the organisation of non-factory labour is not at all limited to the cultural domain, and the same principles can be applied to a whole range of services wherever information technology (since the 1990s incorporating the smartphone) renders benefits to capital in more efficiently exploiting the workforce, from outsourcing customer services to call centres, to home delivery, unlicensed taxis and other forms of online entrepreneurship, like privately renting out your spare room to vacationers. In this post-Fordist mode of production, in which capital abandons the factory production line and organises the workforce through fragmentation, dispersion and individual isolation, the aesthetic worker is far from exceptional.

The nebulous notion of the social network is no substitute for the solidarity of the trade union which it replaces. In computer science, however, 'network' is not a metaphor but a technical concept which governs the internet. Several factors lay behind the development of information technology to create the internet, which began by linking up remote computers at a group of US universities under the wing of Cold War defence research in 1969. Rehearsing this history prompts a memory whose resonance has not diminished over the years. In 1972, on my first visit to New York, a friend took me on an outing to visit his cousin, who worked at the Brookhaven research laboratory on Long Island, where scientists investigated nuclear energy. He met us at the gate – security back then was

minimal – and took us to look at the outhouse where he worked, with its computer terminal. Above it was a handwritten note, which read:

This computer terminal is connected to the computer in the main building. The computer in the main building is connected to the computer at MIT. The computer at MIT is connected to the computer at the Pentagon. The computer at the Pentagon is connected to the terminal in the Oval Office. The terminal in the Oval Office is connected to the President's finger, his finger is connected to his wrist, his wrist bone is connected to his funny bone ...'

Not far behind defence was the fundamental need of finance capital for ever more efficient communications and services in order to accelerate the circulation of money and reduce transaction costs, which began to migrate to electronic trading platforms in the 1970s, although at first only imperfectly, gathering pace in the 1980s as deregulation, following neoliberal doctrine, freed up this new mode of capital circulation. What the internet brought to finance was 'real time' access to markets across the world and around the clock, 24/7 in Twitter lingo – the very paradigm of globalisation. The same potential, but driven by a very different ethic, was inscribed in the term World Wide Web introduced by the hyperlink protocol devised by a computer scientist at CERN (Conseil Européen pour la Recherche Nucléaire) in Switzerland. Released into the public domain in 1993, everyone anywhere with an internet connection could now enter into an instantaneous parallel world, part public sphere, part marketplace, which has decisively shifted our individual and collective interaction with each other, as well as creating new forms of monetisation and indeed, new forms of money.

At the same time that IT adds to the changes taking place in the character and organisation of labour within teams of creative workers, it also creates new business practices like online commerce, with customer services which can be located anywhere while connected to the same company databases. But the dynamics of the web are multiple and equally driven by the introduction of novel forms of communicative social interaction. In the 1990s, when connectivity was still slow and content dominated by text, email discussion groups turned into forums, while a new form of personal writing appeared; a new word was added to the vocabulary when it become known as the 'blog', a playful term (a con-

traction of weblog) which epitomised the new lexicon of the web. Blogs exemplified the beneficence of the web, its encouragement of democratic dialogue, its enlargement of the public sphere in new directions. They were written in the first person, they were free, invited feedback, and caught on quickly, lending themselves to many different uses, from diaristic reflections to fan sites to political commentary, by both spare-time writers and professionals. They were taken up by academics. By 2007, when I started a blog under the title Putney Debater, there were 50 million of them, although many were corporate, commercial or run by news outlets. The commercial category included blogs attached to brand websites intended to sell things, and those in which the blogger was selling themselves, in order to attract a following and earn an income from the advertising that was drawn to the site. In the new millennium, after web protocols had been upgraded (another new computer term), another novelty appeared, in the shape of what were quickly dubbed the 'social media', comprising 'platforms' where people could post messages (written or audiovisual) to share with 'friends' and 'followers'. The distinguishing feature of social media is that their content is provided by the users, while the platform provides the infrastructure. We shall come back to how this works, how this infrastructure is paid for and its divergent and contradictory effects, but the terminology itself raises the question: 'But aren't all media social?' If the term caught on rapidly, it captured a crucial difference from the mass media, which are delivered vertically, broadcast from a central point, published under editorial control, and which the state finds it necessary one way or another to regulate. The social media, on the other hand, are decentralised, sans editorial control, and escape regulation by arguing that they are simply carriers, not publishers. This will become a problematic source of contention, still unresolved.

In another crucial trend, the web became an ever-growing repository of 'information' in its widest sense, facts, figures, statistics, news, instruction, advice, documentation of all sorts, much of it in the public domain but previously only accessible in libraries and newspaper archives. Search engines, which came online towards the end of the 1990s, made things ever easier to find. Libraries began by putting their catalogues online, then Google, now in the ascendant, launched itself into digitising the world's literature, while newspapers digitised their archives. All this is reflected in another shift in terminology which disguised what went on under the bonnet: the collection of metadata about the users of these services, with

all the implications and consequences. It became commonplace to see in this a transformation of the capitalist mode of production towards an information-rich knowledge-based economy, signalled in terms like 'cognitive capitalism' or the 'information economy', which merely foreground one or other aspect of the same process. Likewise Shoshana Zuboff's concept of 'surveillance capitalism', in which the tech giants profit from the metadata left behind by their users.[15] Then there's Jodi Dean's concept of 'communicative capitalism', informed by psychoanalysis, which 'designates the strange merging of democracy and capitalism in which contemporary subjects are produced and trapped'.[16] Based on 'the conviction that enhanced communication access facilitates democracy',[17] democracy here takes on a new quite imaginary form, as the message is overtaken by the logic of circulation: it 'need not be understood; it need only be repeated, reproduced, forwarded'.[18] What from one perspective enhances the potential for democratic participation, from another submerges it in a deluge of contesting utterances and opinions in which cogent and coherent debate becomes all but impossible. To be sure, this needs certain caveats. To speak of circulation is to speak of the internet as a network of networks, formed of the overlapping and inter-permeable circles known as virtual communities, with their own rules of discourse, where authentic debate takes place according to those rules; sometimes these circles behave like spirals, or waves bouncing off each other, and the reach of the individual contribution is amplified, but this is unpredictable. The set-up encourages participation, but there are no rules for what makes something go viral. Across the board, however, the fetishism that attaches itself to technology plays a key role, and the rhetorics of access, participation and democracy work to secure the technological infrastructure of neoliberalism, negating the potential for political change which they invoke, even as they succeed in bringing protestors onto the streets – but only to end up on screens 'upon which all sorts of fantasies of political action are projected'.[19]

With its basis in the management of information, the extraction of data, and its analysis by the techniques of 'machine intelligence' and AI, these new forms of digital capitalism as a mode of production rest on the idea that the raw materials – data – are there to be harvested, in the same way capital has always treated both natural resources and aesthetic talent, as a gift to be exploited – and of course protected by intellectual property rights. Information, however, or any digital content that the

computer treats as data, is not a normal commodity, any more than the software that runs it. There is first its elusive form. A stream of signals moving back and forth between your own device and power-hungry data farms distributed in closely guarded hidden locations euphemistically termed 'the cloud' is intangible but has certain physical properties and consumes huge amounts of energy; but it isn't quite a material object. However, while large-scale activities like digitising archives and data harvesting have certain costs attached to them, the cost of digital replication is almost zero; a file can be shared by many people without deterioration or being physically consumed. There is no unique original (only the 'original' on the creator's computer) and no way to stop its further propagation except by devices like copy protection which can easily enough be evaded (there is software freely available to do so). In the phrase that captured the imagination of the hackers movement in the 1980s, 'information wants to be free'. Above all, information is both instrumental and symbolic. In private hands, it amounts to monopolised knowledge which can be put to various uses, such as targeting advertising or political messages during an election campaign, although it still remains susceptible to hackers and whistleblowers. Authority may have difficulty distinguishing between them, but once published by the latter, their revelations belong to the digital commons, where they not only have political repercussions but their symbolic ramifications expand and enter general consciousness in much the same way as the symbolic products of aesthetic labour.

Political fallout

These emergent forces were mobilised by the New Labour government which came to power in 1997 under Tony Blair touting a new policy of 'Creative Britain', which celebrated a supposed cultural renaissance that the media labelled 'Cool Britannia', a little like Harold Wilson riding to power in the 1960s on talk of the 'white heat of technology' but in a new context, cultural, economic and political. Culturally, the youthful Blair laid claim to being the first prime minister who was a member of the rock'n'roll generation (Edward Heath was a choral conductor; Blair, in his student days, played in a rock band). Economically, the great field of opportunity of the day was information technology, now revolving around the uptake of the internet and the arrival of the World Wide Web

(mobile phones too, and the prospect of the smartphone connected to the web). As for politics, the growth of the cultural sector was seen as a beneficent substitute for the declining manufacturing sector, and as Nicholas Garnham pointed out, according to neoliberal principles, 'it legitimised the deregulation of cultural and media institutions'.[20] In the words of a columnist looking back 20 years later, 'New Labour became the political wing of Cool Britannia ... the advance party for a new mutation of capitalism.'[21]

Captured by the ethos of advertising, New Labour looked like a rebranding exercise but went much deeper, inducing the Labour Party to discard its commitment to the 'common ownership of the means of production, distribution and exchange', a cornerstone of the Party's constitution since 1918, and instead to endorse the shift from state to market initiated under Thatcher, across the whole range of public provision. (As Thatcher once said, her greatest success was Tony Blair; Hobsbawm described him as 'Thatcher in trousers'.) The linguistic shift in terminology from 'cultural industries' to 'creative industries' was an instrumental element in the process, along with the adoption of managerial language and procedures not only in cultural and media policy but also, and increasingly, in education, especially the universities, now charged with vocational training, and which Blair decisively upended immediately on taking office by introducing student fees as the tool of marketisation.

I dwell on this because the extension of precarious labour that unfolded in the new millennium was not, as so frequently portrayed, simply the result of market forces, but of the policies that governed the labour market. The policy of 'Creative Britain' and its rhetoric were designed to mobilise a very disparate and potentially antagonistic coalition of interests, and suppress their differences. Various advocates of cultural policies, says Garnham, taking up an old ideological divide that pitted art against science, 'wish[ed] to appropriate for themselves, as "artists", the attribute of creativity and exclude science and technology',[22] an exclusion that was never sustainable; even less so in the face of the sheer inventiveness of computer science and its commercial applications, like the ever-growing sophistication of computer games. The term 'creative' was chosen so as to include the whole of the software sector because '[o]nly on this basis was it possible to make the claims about size and growth stand up'. This had the effect of pushing software producers and the major publishing and media conglomerates to construct an alliance with cultural

workers and small-scale cultural entrepreneurs around a strengthening of copyright protection. Indeed, according to Garnham, 'we can only understand the use and policy impact of the term "creative industries" within the wider context of information society policy',[23] and that comes down to the role of intellectual property. The advantage lay with large corporations with the greatest marketing reach who relied on laws protecting the rights of the original creators (whether artists or software programmers) when in fact, says Garnham, 'those rights and the returns from them are transferred under very unequal relations of contractual power from the original creator to the employing corporation'. He is writing in 2005, and adds that 'The current furore in the music industry over file-sharing is a good illustration of this contradiction.'[24]

These developments also have consequences on the ground, in the physical reality of the fleshworld, in the effects they have on the urban environment as communities form around the hubs created by the corporations and conglomerates in world cities like London, Berlin, New York, or for that matter, Johannesburg or Buenos Aires. Creative jobs have a tendency to cluster, often in poor decaying inner city neighbourhoods which then become ripe for gentrification, and these communities improve the opportunities for finding work by generating an environment of bars, clubs, art galleries, shops and hipster hangouts, conducive to the floating lifestyle of young urban immigrants hustling for employment in which getting a job interview depends on informal knowledge, contacts and friends. But as Angela McRobbie points out, this is a lifestyle incompatible with having children, 'and certainly incompatible with being, for example, a single parent'.[25] It is also a milieu where political engagement is largely absent, and at neighbourhood level, suffers a disconnect from municipal issues. But here, many subcultures become visible and co-exist, within the orbit of a mainstream consumer culture which long ago learned to recuperate and commercialise them, suppressing their subversive potential in the same way as the rebelliousness of rock'n'roll was tamed, and the alternative lifestyles of the 1960s, and so on ever since. Speaking from her viewpoint as an academic, it is ironic, to say the least, says McRobbie, that when subcultures become 'professionalised, aestheticised, and institutionalised through [their] formal status in the curriculum,'[26] then pedagogy, education and the curriculum became key sites for new contradictions to play out as a growing number of graduates from the fine arts, design, media and humanities

enter this liquid labour market, where employment comes in the form of jobs with a short time horizon, a lot of ducking and diving, and little by way of a career path. 'What starts as an inner desire for rewarding work is re-translated into a set of techniques for conducting oneself in the uncertain world of creative labour.'[27] Meanwhile, as Andrew Ross observes in another study of precarious labour in the cultural sector, the figure of the artist is promoted by policy makers and ideologues, held up 'as the model citizen-worker – a self-motivated entrepreneur able to work in a highly flexible manner with a wide range of clients, partners and sponsors'[28] – as if they were no different from an artist in Renaissance Italy when they're actually like a lowly studio apprentice.

PRECARIOUS LABOUR

The concept of the precariat as a social class is new. Precarious labour as a mode of life was not, but the fate of a large number of the population dispossessed by the industrial revolution. The adjective was used as early as the 1840s, by observers of social conditions like Engels, and later by William Morris and social reformers like Henry Mayhew and Charles Booth, for whom precarious livelihoods were generally associated with the pauperisation that capitalism brings in its wake, like a trail of 'collateral damage'. This creates what Marx called a reserve army of labour, the lumpenproletariat, 'which forms a mass clearly distinguished from the industrial proletariat in all large cities, a recruiting ground for thieves and criminals of all kinds, living on the refuse of society, people without a fixed line of work.'[29] Lumpenproletariat is a derogatory term for an underclass that Marx considered so disconnected from the forces of production that they were incapable of class solidarity, even an obstacle to workers' self-organisation and liable to reactionary behaviour (he was not entirely wrong, especially about the last). A lover of lists, he enumerates them in the *Eighteenth Brumaire*: 'vagabonds, discharged soldiers, discharged convicts, runaway galley slaves, swindlers, charlatans, lazzaroni, pickpockets, tricksters, gamblers, procurers, brothel keepers, porters, literati, organ grinders, rag-pickers, knife-grinders, tinkers, beggars; in short, the entirely undefined, disintegrating mass, thrown hither and yon, which the French call la bohème'.[30] The final epithet is slightly odd for the modern reader, for whom the term evokes Puccini's opera of that name (dating from the 1890s, based on a novel of 1851 and set in 1830) and

refers to a lifestyle primarily associated with marginalised and impoverished artists, writers, journalists, musicians, actors etc., with unorthodox or anti-establishment social or political attitudes, but the confusion is indicative. Precarity has been characteristic of a growing proportion of cultural workers since the nineteenth century. Marx himself was one of them.

But although it borders on it, the lumpenproletariat is quite different from the concept of the precariat that emerges in the 1980s with the breakdown of Fordism, when numerous mainstream social scientists, economists and lawyers encountered precarity for the first time, as a new phenomenon created by post-industrial society with the adoption of 'flexible labour arrangements' in the metropolitan labour market in the transition from Fordism to Post-Fordism. They were on to something, but approached it narrowly, as Eloisa Betti explains, in terms of a model of job stability that was considered the norm in the 'affluent society' of post-war reconstruction but was far from universal. They failed to perceive the very existence of precarity 'until it started affecting the Western male breadwinner in core industrial sectors during the far-reaching process of deindustrialization' experienced in Europe and North America.[31] Critical sociologists took a different view. Already in the 1960s, for example, Pierre Bourdieu, in his studies of Algeria, argued that both precarity and its opposite, stable employment, were 'associated with the capitalistic transformation of Algerian traditional society and the rise of a more dualistic labour market, formed by a minority of stable workers employed in the modern sector and a diverse group of unemployed or underemployed journeymen experiencing unstable working and life conditions'.[32] In other words, precariatisation – an ungainly word, says Standing, but analogous to the proletarianisation of workers in the nineteenth century – was not just a phenomenon of the metropolitan centre.[33] This is not only confirmed by the large 'informal' sectors or 'shadow economies', to be found especially in underdeveloped countries, but recent historical studies, says Betti, demonstrate that forms of precarious work have characterised the entire history of industrial capitalism in both the global North and the global South. It was in the South, however, that the first neoliberal policy interventions were made, with the reforms that began in Chile after the military coup of 1973, when the dictatorship adopted the formulas of a group of economists known as the Chicago Boys, followers of the teachings of Milton Friedman, and introduced new

forms of 'flexible labour arrangements' governing temporary work, part-time work, temporary agency work, subcontracting and undocumented work, including industrial home-working. Policy, ideology and naked power here go hand in glove.

Standing's now classic study confirms that precariatisation is part and parcel of globalisation in its latest stage, in which policy combines with digital technology to create a growth of trade on a global scale, including trade in the digital, both material (the hardware) and the immaterial (data). In the process, as material production moves 'offshore' in search of cheap labour ('Made in China, Designed in California'), industrialised countries are deindustrialised and become rentier economies, extracting value from their ownership of IP. As David Graeber put it,

> Factories and workshops in China and Southeast Asia produce clothing designed by companies in New York, paid for with capital invested on the basis of calculations of debt, interest, anticipation of future demand and market fluctuations in Bahrain, Tokyo, and Zurich, repackaged in turn into an endless variety of derivatives – futures, options, traded and arbitraged and repackaged again onto even greater levels of mathematical abstraction to the point where the very idea of trying to establish a relation with any physical product, goods or services, is simply inconceivable.[34]

This spiral into abstraction was the root cause of the crash of 2008; yet thanks to IT, goods and services flow in all directions, an increasing share of the traffic consisting in parts and services moving within the multinationals' own networks through just-in-time supply lines, with the result that developments in one part of the world almost instantly affect what happens elsewhere, as demonstrated catastrophically in 2020 when the coronavirus pandemic struck. Movement stopped, shipping was disrupted, production fell, but the internet remained.

Standing describes the precariat as those whose lives are dominated by 'insecurity, uncertainty, debt and humiliation'. They are expected to perform labour, as and when required, in conditions largely not of their own choosing. They are far from homogeneous: a teenage 'urban nomad' flitting in and out of an internet cafe; a migrant using their wits to survive while worrying about the police; a single mother; an unemployed older man. They comprise women, youth, old-agers, ethnic minorities, the

disabled, the criminalised and migrants, including the undocumented; the media denigrate them in the old language as riff-raff. Migrants are of various types, such as nomadic and seasonal labourers, those who arrive thinking they're going to return, settlers who are thought of as immigrants, refugees, asylum seekers, illegals. Some have come to improve their opportunities, some to earn money to send back home, where there are whole communities that depend on such remittances. Standing discerns their common condition: they are not citizens, but denizens, with a limited range of rights. The least secure, asylum seekers and the undocumented may have minimal human rights but no economic, social or political rights. The more fortunate may have residency rights, economic and social rights, but not the political rights of full citizenship. The system that governs their status, with variations under different regimes, is riddled with holes. In the USA, millions of undocumented migrants have no right to work but are hired anyway. In Spain, undocumented migrants are thought to account for the country's huge shadow economy. In many countries, qualifications are unrecognised and migrants are blocked from following their occupation, instead obliged to scramble for jobs in the precariat. Living under threat of deportation, they have no rights to social benefits. Whenever people are lacking at least one of these rights, says Standing, they 'belong to the "denizenry" rather than the citizenry'.[35] But the precariat is also made of people *with* political rights, but deprived of other rights that are equally those of full citizenship. Their deprivation lies not just in their low earnings and meagre prospects but the lack of the entitlements that go with 'proper jobs', lack of state benefits in time of need, private resources to supplement earnings, and very likely, a lack of support in the community, or the communities from which they have become separated.

Standing regards the precariat as a class in the making, distinct from both the proletariat of industrial society and the Marxist lumpenproletariat, although serving the same functions as the latter in the provision of a 'floating reserve army' of labour, in which migrants are the 'light infantry of global capitalism', or in the case of undocumented migrants, a 'shadow reserve army'. All the same, it remains difficult to define, partly because it shades off in different directions into other social strata: the unemployed and 'social misfits'; a diffuse voluntary sector; a doubly submerged layer of carers attending to domestic needs which would once have been fulfilled by extended families that no longer function, and whom austerity

has deprived of social support. Most are women, some are children. A watertight definition is impossible. Does it include the old-ager with an adequate pension and health care coverage who does odd jobs to keep themselves occupied but may equally volunteer in a charity to have something useful to do? And while Standing is doubtless correct that prison is an incubator of the precariat, what of the recidivist who keeps reoffending because they have no job and cannot get one because they've been in prison?

Standing also makes a distinction which is particularly relevant to the creative industries, between 'independent contractors' and 'dependent contractors'. The lifestyle led by both may appear similar – self-employed, juggling jobs, constant networking – but the similarity is deceptive. The independent contractor is a professional with a strong occupational identity, like a dentist or a lawyer, security of income, and the wealth to buy the service of an accountant to reduce their tax bills. It is doubtful whether they can even be considered creative workers, let alone precarious, when their principal function is putting together deals matching finance and creative teams. Top ranking creative workers occupy a similar position of privilege, but sit at the top of a pyramid which swells to highly uncertain employment, dependency and poverty at the bottom. Performers occupy a parallel space, where fees are negotiated by agents while new talent enters competitions and talent shows which become part of the spectacle on which success in the market depends. But the labour market is oversupplied and competition simply to get a foot on the bottom rungs of the ladder is fierce. Opportunity is promised by the new phenomenon of work placement, internship and mentoring, whereby fresh graduates, students and other floating youth are offered work experience for little or no pay, often in costly and inefficient government schemes which serve only as a vehicle for channelling them into the precariat. The apprenticeships that these schemes have replaced were designed to lead to stable jobs. Internships do not, but are used by employers for cheap dispensable labour, while mentoring is just a fancy name for low-cost training.[36]

Cultural workers are not a class in themselves but are situated within a field which stretches across classes – in whatever way you define them – in which large numbers are now governed by the conditions of precarity. In the UK, when the coronavirus struck in 2020 and innumerable precarious workers were thrown out of work, with no support allocated to them because they didn't meet the criteria applied to the self-employed,

it emerged that 70 per cent of the actors, musicians and dancers employed in the performing arts fell into this pit and hit rock bottom. They weren't covered by the emergency funding government provided for the institutions and venues that employed them; opera singers were forced to become delivery drivers, designers to get jobs in supermarkets. But neither is the precariat to which they belong a class in-and-for-itself either, in any of the established ways of defining class, which presents itself as a problem for traditional Marxist thinking about classes and class struggle because if Standing is right that the precariat is a class still in the process of discovering itself, then not only will new political forces emerge as it does so (and there are signs of this happening), but it will also provide a new context in which creative labour can be socially reintegrated instead of being held up as an impossible ideal. Meanwhile, a society that encourages precarious labour is a precarious society.

6

Creativity Reconsidered

IMMATERIAL LABOUR

To comprehend the transformation of the cultural sphere in the post-Fordist economy, the Italian autonomists reintroduced the concept of immaterial labour. For Maurizio Lazzarato, immaterial labour has two aspects. On the one hand, it is found in the industrial and service sectors when skills are redefined by cybernetics and computer control. On the other, it comprises 'the labour that produces the informational and cultural content of the commodity', that is to say, 'the kinds of activities involved in defining and fixing cultural and artistic standards, fashions, tastes, consumer norms, and more strategically, public opinion'[1] – in a word, the production of subjectivity. Not individual subjectivity, however, but the subjectivity of the social collectivity, what the autonomists call the multitude, or earlier Marxism called the masses.

At first sight, this approach has the merit of discarding obsolescent distinctions between different categories of cultural creation according to the inherited ideological hierarchy that placed 'high culture' at the top and pop music and pulp novels at the bottom. However, while capitalism depends on a gendered and racialised class structure, in terms of the market it recognises no hierarchy but thinks in terms of segmented markets large and small (with the fine arts treated as a special realm, fit for capitalists' private investment). In this perspective, the idea of immaterial labour becomes slippery and hard to pin down. It oscillates, for example, between 'the classic forms of "immaterial" production' – audio-visual, advertising, fashion, software, photography, cultural activities, and so forth – and various activities of research, conceptualisation, management of human resources, and so on, all organised through computer networks. Lazzarato skips over the way this suppresses the difference between aesthetic workers exercising their creativity who are thereby productive, and the workers who organise, control and run the system, who

are not. Be that as it may, when a new regime in the labour market shifts the terms of employment, creative labour gets to be recast, as Lazzarato see it, as 'polymorphous self-employed autonomous work' performed by 'a kind of "intellectual worker" who is him or herself an entrepreneur, inserted within a market that is constantly shifting ...'[2]

For their part, Michael Hardt and Antonio Negri define immaterial labour as 'labor that produces an immaterial good, such as a service, a cultural product, knowledge, or communication.'[3] The difference in phrasing is slight but significant. It collapses Marx's distinction (as we noted earlier, the relevant passage, in *Theories of Surplus Value*, is headed 'Manifestations of Capitalism in the Sphere of Immaterial Production') between two types of aesthetic creation, vendible commodities such as books and paintings on the one hand, and on the other, the immaterial production of performing artists that he likened to orators, teachers, physicians and priests. We saw that this difference was a fundamental determinant of the forms of exploitation capital was able to impose on creative labour, even as it was increasingly commoditised and mediatised. Is this distinction no longer sustainable? Perhaps the digital sphere renders it anachronistic by turning everything, whether solid or immaterial, into code, so that it all becomes potentially vendible commodities. But no, performance is still performance, ephemeral and transient, in the presence of an audience gathered in a particular place, a social occasion, an event, not an object or a piece of digital code. The abrupt cessation of live performance in front of a fleshworld audience when the coronavirus struck is demonstration enough that it still plays a crucial role in cultural life in its own right.

However, when cultural labour is swallowed up in the digital sphere, not all of what it produces has the same commodity status – some of it is part-work that isn't traded, some of it is traded only in closed markets, some of it in open markets, some of it is given away for free, and some of it escapes. And only some of the labour involved is protected by the creator's copyright. Like patents and trademarks, copyright functions as a commodity which can be bought and licensed and sold, leaving the creator, in modern legislation, only their moral rights – the right to be correctly identified as the author, and for the work not to suffer unwarranted interference – which are not classed as property. Dating back to the French Revolution, moral rights were only introduced into British law in 1988, they are inalienable, and cannot, for example, be sold by a screenwriter

to a production company, but only renounced, which quickly became standard practice for all but the most prestigious names. Of course, none of that applies to the pieces of code produced under contract by subcontracted workers, in the same way that a report produced by an employee belongs not to its author but the employer.

In fact Hardt and Negri distinguish three types of immaterial labour. The first is involved in the application of IT to industrial production in such a way as to transform the production process (automation, robotics, etc.). This produces intellectual property, but requires capital expenditure by those who adopt the results. The second type is the analytic and symbolic manipulation of information and data (as in data-farming). This also requires capital, but produces advertising revenue (among other things). The third type is more diffuse, consisting in 'the affective labor of human contact and interaction', which takes many different forms. What makes affective or emotional labour into labour, rather than simply emotionally intelligent behaviour, is that it requires the management of the display of emotions, the work required to adjust one's emotional state for the appropriate or correct feeling in specific situations. The difference is critical. If emotional intelligence is instinctive, embodied in parenthood, learned within the arena of family and school, emotional labour is crucial to the delivery of education, health care, social services and the like – for which legitimate techniques have been developed and are in constant debate (this is especially true in areas like policing, where it is often sorely lacking, and the problem is highly politicised). It has now also been reified in other parts of the service sector like hospitality, where 'aesthetic labour' is management-speak for dressing up nicely and smiling at the customer, and all services are subjected to computerised 'micromanagement', or in other words, the Taylorisation of emotional labour in order to generate profit. In this perspective, the aesthetic domain of artwork and performance, which defies micromanagement, is the sublimated embodiment of affective labour, and the audience largely receives it as such, individually and collectively, for whom there is a natural emphasis in the moment of reception on emotional arousal and an impact that is ideologically reinforced by the media. Advertising operates on the same terrain, designed to entice the consumer with a symbolic commodity, such as a brand, or desirable objects of imaginary and fictitious values, using the same aesthetic means as the autonomous artistic creator (which is why the advertising industry calls its key workers 'creatives'). Ideology cele-

brates the paradigm of the artist, but it's the ideology of advertising which rules the roost.

The general intellect

The capitalist, says Lazzarato, is driven to find a way of establishing command over subjectivity itself. However, the subjectivity to be addressed is not individual but collective, and underpins the social order. Nor is it uniform, but divided by class, gender, identity, education; multiple, shifting, constantly changing. It is also elusive, and as more and more people are drawn into what Habermas regards as the pseudo-public sphere, if only as consumers, an apparatus of immaterial production appears devoted to the manufacture of subjectivity in the (dis)guise of 'public opinion'. This is not a new concept. The phrase is occasionally used by Marx. It turns up in the finale of Offenbach's parodistic operetta *Orpheus in the Underworld* in 1858, where in the frenzy of the famous can-can at the end, the chorus of classical tragedy is replaced by Public Opinion, whose manipulation by Jupiter makes it abundantly clear that Public Opinion can be massaged with impunity by the powers that be. The mass media, however, complicated the matter, and invented new tools to bring to bear on the problem: the audience survey and the opinion poll employed clever questions and statistical tricks, and when this was not enough, PR invented the 'focus group'.

Alternatively, social subjectivity can be seen in terms of an equally vague notion which Marx once called the 'general intellect', in a speculative passage included in the *Grundrisse* called the 'Fragment on Machines', unnoticed until the autonomists drew attention to it. The 'general intellect' encompasses the diffusion and dissemination within society at large of formal and informal knowledge, the shared intelligence and skills that underpin the mode of production; it comprises the aptitudes, proficiencies and competences that have become what we call second nature. Although these traits are unequally disseminated, the autonomists argued that as capitalism mutates into its post-Fordist version, bringing the reconfiguration of immaterial labour, the 'general intellect' becomes the primary element driving the productive process. They pin their utopian hopes on the idea that the new modes of immaterial production embody the material capacity to organise productive co-operation autonomously

from capital, thus undermining the role of capitalist control over the labour process.

The first problem here is to recognise a certain difference between the mastery of cybernetics and data, which is abstract and instrumental, and creative labour, which is not. The former comprises the kind of knowledge that AI seeks to extract and encode in so-called 'expert systems', where it becomes reified and mechanical. Marx refers elsewhere to this kind of knowledge in terms of 'universal labour', which includes 'all scientific labour, all discovery and all invention',[4] which becomes dead labour that serves as the means of exploitation of living labour. Creativity is likewise indebted to various kinds of public knowledge, cultural, technical, learned and assimilated, but it isn't abstract: it's concrete, subjective, particular and experiential. Nevertheless, the concept of the 'general intellect' could be useful if it points towards the kind of knowledge which becomes diffused across society with entry into the digital domain to produce new competencies and concepts, from the skills of navigating the internet to the new lingo of computer-speak, from the general competency of 'computer literacy' to the rarer skills of programming. Paul Mason, discussing the topic, argues that the general intellect has expanded and says that 'people know more than they used to ... they have greater and more instant access to knowledge'.[5] Dean has her doubts about this: 'For example, if we receive distressing medical news, we can – and are encouraged to – seek a second, third, and fourth opinion. Many of us will search for information on the Internet and explore alternative remedies. But we rarely find firm, reassuring answers, answers in which we are completely confident.'[6] Either way, this 'levelling-up' is captured in the meme of the 'digital native' who makes their appearance on the cusp of a generational change ('meme' being another of these new concepts). In fact, this is something that happens repeatedly as each new technology goes through an initial stage of magical strangeness before becoming second nature. Each generation accepts as natural the technologies which exist around them as they grow up, even those that are brand new; their subjectivity adapts to it with the same facility as the acquisition of language, sometimes even earlier. Just as babies are exposed to television before they start speaking, they soon start pushing buttons on a tablet. They are naturalised to the digital by curiosity, and take to it through play, and playing with the digital, which is something that grown-ups also find enticing, has the potential of galvanising creative impulses. For children,

play leads to learning, and when fortune smiles, creative impulses take root. For many adults, the digital may mobilise existing talents, and the consumer adoption of digital technology invites them to participate in aesthetic creation even at the modest level of the amateur who posts their pictures on social media, just as the virtual public sphere invites people to enter the fray of voicing their opinion.

But here another factor entirely enters the picture. We are thrown back to old dreams about the democratisation of the media, dreams going back to Dziga Vertov in Soviet Russia in the 1920s conceiving of a network of local cine-amateurs providing a continuous flow of newsreel footage; or Brecht, writing about radio in 1932 as a medium with the inherent capacity to become 'the finest possible communications apparatus in public life', a vast system of channels of communication, or it could be if it were allowed to transmit as well as receive, 'to let the listener speak as well as hear ... to bring him into a network instead of isolating him'.[7] This indeed is a technical possibility, since every receiver is in principle a transmitter, as it was in radio's infancy, and the technical distinction between receivers and transmitters inscribes a division between producers and consumers which prevents reciprocal communication. These ideas, said Brecht, are utopian, and in that case, you should ask yourself why they're utopian. But the question needs updating, because the realisation of this utopia in the form of the internet turns out to be a veritable Pandora's box, an anarchic and contradictory space, often deceptive and frequently deceitful, involving the participation of millions. A space where thousands upon thousands of flowers are able to bloom, but many are malodorous.

What has happened is that where Lazzarato's immaterial workers are people who work in media, advertising, fashion, marketing, design, etc., the same skills are exercised by all sorts of people using the same digital tools, or consumer versions of them, contributing content to the web for free, that is, without payment of any kind, either for the time expended or the object produced – the message, the photo, the video posted on social media; not just immaterial labour but invisible labour (not quite like housework, but performed in uncounted moments). The internet has created a new, highly fragmented parallel public sphere, where cultural functions are now also conducted by a public no longer comprised of passive consumers but active participants: the audience, the fan base, the targets of the culture industry, and not just those who work within it.

In succumbing to the invitation of the web, its openness, diversity and permissiveness, the user provides the stuff that generates the clicks that drive the advertising that the corporations trade on, not to mention the metadata sought out by intelligence agencies and secretive electoral campaigns, or purloined by hackers. In short, by becoming unpaid content providers, we allow ourselves to be monitored and monetised, but we also have a freedom of participation with profound social and political implications, for both good and ill. The result is a strange new kind of time economy. These platforms have discovered how to swallow time, not only storing it digitally in 'the cloud' but by inducing users to populate these sites with the products of their own casual and unpaid creative labour, which is then monetised through the data mining and advertising that produce the platform's income. Meanwhile, another insidious effect of the advance of the general intellect is seen in the rise of cybercrime, which in order not to fall victim to it instils a constant state of vigilance in the digital citizen.

There is one area, however, where the general intellect can be seen in action in something like the fully socialised form envisaged by the autonomists, in other words, where it becomes the primary element driving the productive process, and that is the digital commons, which comprises those areas of the internet that are not built on market production but are freely shared among the community. Consisting in various non-commoditised spaces devoted to software, news, information, knowledge, and various kinds of artwork, the origins of the digital commons lie in the hacker culture of the 1980s and the introduction of free software to create the open-source movement. Its common currency is coding, and the digital commons is built through collaboration in non-hierarchical peer networks, with people working towards common goals without financial compensation, drawn by the promise of liberating, empowering and emancipatory potentials. Even if the great majority of open-source programmers work for software companies, and open-source projects are subsidised by even bigger companies and the negative dimensions of monetisation loom over them, this is nevertheless a sector with its own political economy, in which labour is freely donated, that is, unpaid and unalienated, even though it remains open to exploitation by capital, which treats it as a free gift. Not just because that's what capitalism always does with natural resources, but because in this case, as Andreas Whittel has pointed out, the digital commons is itself largely based on

the principle of gift giving, only not quite in the same way as the classic account by the anthropologist Marcel Mauss. 'The gift-giving practices in the digital commons are not based on reciprocity', Whittel observes. 'The author of a Wikipedia entry does not expect that those who read the entry will be obliged to write an entry themselves ... The gifts produced and distributed in the digital commons are not addressed to specific individuals.'[8] In fact, it is not quite clear who is at the receiving end of this exchange; these are gifts to the community, like blood donations and volunteer work. A similar desire is manifest in aesthetic labour, which even if cast in commodity form, expresses the same aspiration. Here the digital domain has a beneficent effect, and the so-called 'tragedy of the commons', in which individual interests supposedly conflict with the common good, does not apply, because what is being shared is immaterial and not subject to scarcity. In the material sphere, half a loaf is better than no bread, but to share digital content is to multiply it freely. This is an offence against capitalist principles, and contradicts capitalism's need for enclosure and control of intellectual property. The digital commons is not just a disruption and interruption in the process of commodification, but a field of fierce struggle where what is possible is in direct conflict with the interests of the ruling system.

Web video

A parallel process unfolds in the field of digital video, where the internet introduces a rupture not just in the commercial market, which nevertheless remains thoroughly dominant and is anyway quite used to devising ever new competitive strategies, but also by opening up to amateurs and aficionados, who are thereby no longer excluded from potentially reaching a wide public. Although the platforms that carry them are privately owned and therefore not part of the digital commons, they are parasitical for much of their content on what is, or what is treated as such, and they owe their success to the fact that what they carry is in the public domain (as opposed to paid streaming services). Web videos take every possible form – animals doing funny things, instructional videos, public lectures, citizen journalism, campaign reports, satirical mash-ups and much more. Much of it is trivial and ephemeral, freely donated precisely because it's the product of personal aesthetic, affective or communicative labour, and people don't consider it as labour, or even work, but more

like play or a hobby. There's no formula for going viral, but platforms like YouTube encourage successful video-bloggers by enabling them to capture a share of advertising revenue, earning themselves considerable sums and blurring the boundaries between professional and amateur; the same way authors of non-professional blogs earn income from online advertising or commercial sponsorship, or join the gig economy which supplies online magazine publishers. A new category appears: the influencer. The web serves in this way as a net which catches the fish that makes the most waves, but there are many more just under the surface, which escape the susceptibilities of mainstream populism. The problem for the serious independent filmmaker swimming in this sea is getting noticed beyond your immediate circle, of outmanoeuvring the law of the internet which says that the network you want to reach is always further away than the network you're able to reach starting out from the network where you begin. (I speak from personal experience.)

On the other hand, a large parasitic industry has appeared, built on the same myth about cinema that seduces the students who enrol on film-making courses to begin with. The cinema, as William Brown puts it, 'retains its power as the *summum*' to which all filmmakers are encouraged) to aspire.[9] To achieve theatrical exhibition is the only proper sign of success – even though cinema audiences are smaller than the numbers reached through other means – and for this the film festival serves as the gateway. We should pause to note that film festivals have proliferated at the same time as cinema audiences have declined, and they come in many different varieties and sizes, from major international gatherings with corporate sponsorship to local events on shoestring budgets, and they have mushroomed in recent decades with the growth of the tourist industry. (This is not limited to film. According to one report, dating from 2008, Italy alone hosts some 1,200 cultural festivals, ranging from music to sci-fi, food to philosophy, many of them highly specialised, like Ligurian crime fiction, contemporary Calabrian song for children, or the chilli pepper).[10] With a history dating back to the 1930s, film festivals serve many functions and cover a wide range of interests, from cinephilia to marketing, cinema as both art and industry. Prestige festivals, which gather international attendance, set the seal of artistic approval on the year's new crop of films through their competitive awards; an increasing number, large and small, are devoted to documentary; local festivals, based in their communities, often address particular interest groups,

sometimes identity groups, sometimes political campaigners. What they all demonstrate is the universal appeal of cinema as social experience, with the same property that Adorno, speaking of music, called the anthropological function of bringing together communities.

It's worth reviewing how this works, because it reveals the way that info-tech generates increasing amounts of work which, in the name of promoting creativity, ends up impeding it. In much the same way, computerisation is touted for increasing efficiency, but in fact, as Graeber shows, the opposite is true: it generates a multitude of irrational jobs.[11] In what Brown calls the fleshworld, the film festival becomes a site where the people behind the camera celebrate their membership of a creative community and encounter the audience in almost the same way as performing artists. It offers recognition, and for the aspiring filmmaker, the promise of crossing the threshold to a professional living. The internet, however, has now become the gateway to the festival. In the first place, aspiring filmmakers now have to learn (or know people who can perform) a number of non-filmmaking skills, and have to do ever greater amounts of unpaid labour in order to have an online presence. Every film gets its own website and trailer, often before the film has been made; even the trailer, or rather 'teaser', is made first. All this involves various costs, including the outlay for computing hardware and software, an internet connection and so on, which as Brown puts it, 'we tend to assume cost nothing since we generally have already paid to have these things for other purposes.'[12]

Screenwriters have a small advantage. They can submit their scripts to online platforms and enter competitions, but again at a cost. Since very few are taken up, the amateur screenwriter, says Brown, loses money 'for the purpose of trying to realise an ambition that is unlikely to be achieved'; many writers are in effect paying not to get their film into production but to keep the anonymous company and its employees afloat.[13] Meanwhile, the independent filmmaker can seek finance through crowdfunding, but 'successful crowdfunding campaigns can require large amounts of labour, suggesting that one must have money (or labour in kind) in order to make money.'[14] And since the number of unsuccessful campaigns is nearly double that of successful ones, this means a large number of filmmakers lose money not in making their films but just in trying to raise the money to make them.

If you finish your film, you can use a website to submit it to festivals. In Brown's account, these websites are a scam. The films they make available

to the festivals that subscribe to their service are classed by the festivals as unsolicited, as opposed to the films the programmers select for themselves (the majority). Even if the platform is free to join, the festival might charge a submission fee. It is likely that the initial review of unsolicited material would be farmed out to junior employees, including interns possibly working for free, whose incentive is that they get to watch films and add to their CVs; they are not the best judges for the purpose. Brown reports that according to what film festival organisers have told him, maybe 3 per cent of films screened (at a relatively high-profile festival) might be unsolicited, which leaves a huge disparity between the number of films submitted and the number selected. The result is again that aspiring filmmakers 'can spend a lot of money on submission sites, which otherwise function as cash cows to help festivals cover their ... costs'.[15] It doesn't end there. When accepted into a festival, filmmakers are expected to outlay even more money for publicity. Brown sums up, 'even if in the contemporary age the barriers to filmmaking are low ('anyone can make a film'), the barriers to finding audiences are in some respects tightly guarded and expensive', so that many films lose money and their makers remain in a precarious financial position, even while maintaining the appearance of being prosperous enough.

BULLSHIT JOBS

It is very doubtful whether the labour engaged in running this apparatus, much of which is doubtless precarious, can be called creative, even if it's performed by people with creative sympathies. This is also found in other parts of the industry, which each work in their own way. Graeber, writing in 2018, reports the testimony of a worker in television production development, employed to come up with programme ideas – a part of the television industry that his informant says has expanded exponentially in the last 20 years:

> TV used to be commissioned by one channel controller who would ask producers he liked to make whatever shows they wanted. There was no 'development'. There was just making the show. Now every company in TV (and film, too) has its own development team, staffed by three to ten people, and there are more and more commissioners whose job it is to listen to their pitches. None of these people make TV shows.

I have not gotten a show sold for four years. Not because we are particularly bad but because of nepotism and politics. That's four years that have amounted to precisely nothing. I could have sat with my thumb up my arse for four years, and nothing would be any different. Or I could have been making films.[16]

Graeber counts this as an example of what he calls 'bullshit jobs', which he defines as a form of employment that is so completely pointless and unnecessary that even the employee cannot justify its existence – although they are supposed to pretend this is not so.[17] They are not the same as shit jobs, which are dirty, back-breaking and badly paid, but of clear and vital benefit to society (as the coronavirus lockdown clearly demonstrated). Bullshit jobs (of which Graeber identifies several types, like box-tickers and duct-tapers) produce no kind of social value and are sometimes even pernicious, like being paid to make scam phone calls, but many are respectable white-collar jobs, well paid, and sometimes quite cushy, but not actually involving much work of any kind.

The culture industry generates its own form of bullshit jobs. Another of Graeber's informants works for a very large American-owned post-production company in London, where he gets to make cars fly, buildings explode, and dinosaurs attack alien spaceships, which he enjoys doing and finds fulfilling. But a growing proportion of customers are advertising agencies, TV shows and music videos, for whom 'We reduce bags under the eyes of women, make hair shinier, teeth whiter, make pop stars and film stars look thinner, etc.' They airbrush skin to remove spots, whiten teeth (also done on the clothes in washing powder ads), add shiny highlights to hair in shampoo commercials; techniques used on both men but especially women. His job has become 'a combination of manufacturing demand and then exaggerating the usefulness of the products sold to fix it'. He argues that supply has far outpaced demand in most industries, so now it is demand that is manufactured.

In fact, you could argue that that is the job of every single person that works in or for the entire advertising industry. If we're at the point where in order to sell products, you have to first of all trick people into thinking they need them, then I think you'd be hard-pressed to argue that these jobs aren't bullshit.[18]

Since that has always been the function of advertising, this is a revealing argument, because although he uses the same aesthetic techniques in both cases, he's making a distinction between art and advertising: the former he finds rewarding, the latter alienates him.

Another source of cultural bullshit jobs is managerialism, which was elevated from method to ideology by the neoliberal turn. Here again it takes different forms. In the 'creative industries', where previously freelancers ran their own companies and bought and sold their services amongst themselves, there are now multiple layers of executives whose basic job is to sell things to one another, while the creatives produce pilots for shows that do not and never will exist. In the corporate sector, where it matters greatly to project an ultra-modern image, executives employ creatives for the sole purpose of preparing their PowerPoint presentations and crafting the maps, cartoons, photographs or illustrations that accompany their reports, while large corporations maintain their own in-house magazines or even television channels, which no-one ever actually reads or watches, and exist for almost no other reason, says Graeber, than to allow executives to experience a warm and pleasant feeling to see a favourable story without having to face reporters asking awkward questions.[19]

Bullshit jobs are also generated by managerialism in other sectors by the imposition of 'market reforms', which as Graeber reminds us, 'almost invariably create more bureaucracy, not less'.[20] All bureaucracies work on the principle that 'once you introduce formal measures of success, "reality" – for the organisation – becomes that which exists on paper'.[21] For example, teachers in higher education spend increasing amounts of time filling out administrative paperwork (nowadays always online) which include reports on how much time they spend on different activities including 'administration' (i.e. filling out reports). These are mapped against the agreed workload which never corresponds to the reality (again I speak from personal experience). An Academic Dean tells Graeber, 'It is not capitalism per se that produces the bullshit. It is managerialist ideologies put into practice in complex organisations. As managerialism embeds itself, you get entire cadres of academic staff whose job it is just to keep the managerialist plates spinning – strategies, performance targets, audits, reviews, appraisals...etc.'[22] Enclosed in their own world, they are almost entirely disconnected from the real lifeblood of the institution, the teaching and research which they merely tabulate. All these cadres are

expected to have the appropriate 'creative' skills to present their work (or to know who to go to in-house). Universities maintain media production units not simply to service teaching, but to produce videos which translate these managerialist values into suitable PR material in an appropriate corporate style. Except it isn't suitable and the corporate style is inappropriate. Meanwhile, higher education has become one of the most heavily casualised sectors in the UK, with something like half the teaching staff and two-thirds of researchers employed on temporary contracts.

Are Graeber's bullshit jobs examples of immaterial production? Certainly. They are all about the control of social subjectivity, just as Lazzarato perceives. Are they productive labour? No, they have no exchange-value (and even their use-value is illusory). Are they examples of creative labour? That depends. Where the job is primarily clerical, then hardly. Even when it involves the creation of digital artefacts, not much. It may use the same digital skills and the presentation is expected to be aesthetically pleasing, but there is no room here for thought or originality. Whatever the branch of activity, it is required to conform to the appropriate discourse, and it goes without saying that in this scenario the creative worker has no claim on copyright. Graeber makes the point that what counts as a bullshit job is a subjective judgement: if someone believes their job is bullshit, they are generally correct. Who better to say so? By the same logic, the only work that counts as creative is where the worker can say they don't feel alienated but they experience autonomy and satisfaction; although this, we have to admit, includes the creativity that goes into advertising as long as the creative who produces it hasn't seen through the function of their job in the way Graeber's informant has. Otherwise what we're seeing represents, in Graeber's phrase, 'an extraordinary squandering of human creative energy'.[23]

Wastage, of course, is not a new phenomenon created by digital capitalism – quite the contrary. Capitalism is predisposed to overproduction (and its counterpart, overconsumption) in every branch, and the same thing happens in the culture industry where large numbers of unsuccessful paperbacks are regularly pulped, and records, tapes and CDs end up in landfill because they get thrown away. But digital technology gives the process a new morphology, because on the one hand, it atomises creative work in new ways, and on the other, generates an excess of digital artefacts produced by unpaid creative labour. Where capital is able to derive economic value, an elaborate 'system of rent extraction' is superim-

posed on top of the apparatus of industrial capitalism,[24] much of which consists, pace Graeber, of bullshit jobs. The arrangement is empowered by the machinations of finance capital and the connivance of the political powers who promote the neoliberal ideology of free markets and deregulation, which are neither free nor deregulated, but rather reconfigured and reconstructed to serve the interests of a new form of exploitation. The very existence within this system of bullshit jobs, Graeber suggests, raises certain problems for the labour theory of value, which holds that the origin of value is labour, the work that has been invested in making it, or more precisely, the amount of socially necessary labour time under prevailing conditions. But what if the job is an empty performance of unproductive labour that contributes nothing to efficiency or anything of socially useful value? The question throws a spanner in the works of the theory, like the discovery of a new kind of elementary particle. Perhaps we need a new category of irrational labour, in which capitalism reveals its pathological nature in a new guise.

SPEAKING OUT

There is another side to the story. The closed, hierarchical, institutional and vertical model of mass communication doesn't disappear but is submerged into an open, dispersed and decentralised, deeply networked system with no barriers to entry and no gatekeepers (to the extent that social media platforms decline to act as such, to avoid the consequences of being classed as publishers with editorial responsibilities; a continuing issue). Participation comes with your internet connection in the same way as buying a radio or television provides free access to programmes. This creates a massive extension to the public sphere, which although large parts of it are controlled by big tech, nevertheless forms a domain of great democratic potential, capable of exercising huge, even transformative influence (but no direct power – remember the caveats about actually existing democracy and the imaginary democracy of Dean's 'communicative capitalism'). This virtual world is made up of many voices, a heterogeneous proliferation of competing and intersecting utterances, a veritable cacophony of discord. Nevertheless it exerts enormous counter-hegemonic pressure on authority which serves to reveal the deficits in actually existing democracy, in large part because social media have enabled a new paradigm of horizontal collaboration that meshes with

new currents in grassroots politics, which take shape both locally within fleshworld communities and on a global scale on the streets and in the squares, and not only in infectious moments of political crisis like the Arab Spring but also the ongoing pursuit of resistance and solidarity, which includes both practical applications and aesthetic expression.

Now, Lazzarato concludes his essay on immaterial labour with an enigmatic reference to Bakhtin, who, he says, 'defines immaterial labor as ... superseding ... the division between "material labor and intellectual labor" and demonstrates how creativity is a social process'.[25] We must finally turn to Bakhtin to find out what it is that's drawing his attention, where we discover that this virtual democracy is constituted by what Bakhtin called heteroglossia, a melange of disparate and conflicting discourses, language as a site of social conflict, shot through with differences between vocabularies, dialects and accents, the vernacular speech of different classes with their different codes, the lexicons of different formal discourses; full of idiosyncratic tones, inflexions and resonances, even in small and subtle ways. In Bakhtin's scheme, these utterances engage the dialogical principle, they are always in dialogue with each other, whether they belong to the multiple genres of everyday speech, or comprise artistic creations. Doubtless many utterances do not quite appear this way but adopt a monological form, self-centred, closed in on itself, the last word, intended to shut down an argument, a monopolising of discourse, typical, for example, of institutions and academic disciplines, but also an effect induced by the atomised nature of messages posted on social media. For Bakhtin, monological language is a corruption of dialogism, in which all signifying practices take shape. No utterance can be considered exclusively from the point of view of the individual who makes it; it is necessarily oriented towards another, real or imagined, as a constitutive element in the form of address, in response to the other and angled towards a reply, though the reply it receives is quite likely to be unexpected and may be unwelcome. No act of speech, no letter, no poem, no book, painting or piece of music, no scientific theory or experiment, which is not materially shaped in this way; all are dialogical in nature, inscribing the complex social situation in which each of them occurs, the product of continuous interaction and therefore also, in Bakhtin's word, 'unfinalised', open to interpretation, response and contestation by the receiver. The speaker is thereby constituted as a social being, and this applies in both the private domain and the public sphere. The author, who belongs by

definition to the latter, is not an individualistic monad living in a private internal world, but participates in an unfolding dialogue both with other authors and with the whole culture, the arena which sets the terms of the debate, into which the utterance is launched, and where it lives or dies. (Author here of course means the creator of any kind of aesthetic artefact, material or immaterial.)

In straightforward terms, the dialogical principle affirms that communication implies community, and community entails communication, but the implications go deeper. Another element in Bakhtin's schema is that while words serve every speaker for the most varied and contradictory uses and everyone lays claim to them, words belongs to no-one, but compose a linguistic commons available to all. This comes close to the claim that language is not some kind of epiphenomenon or superstructure which sits on top of society but a material factor which underlies it, through which society is constituted. In short, language is a material force because it is socially productive in its own right. This is easier to understand if we stop thinking of materialism in terms of solid objects, mechanical forces and physical energies, but also include social energies. What this means in the present context is that an artistic artefact, text or performance, is a cognitive or sensuous utterance with the power to influence the way people think and feel and therefore also behave and act.

At all events, the concept of heteroglossia gives us a very good framework, so far lacking, to understand the contradictory social forces that have been unleashed on the internet, because it places them in a context that is necessarily political as well as social. The internet is a space where people give voice in circumstances where finding a voice is not just a social act but implicitly a political one, a speaking out. The political is marked by democratic deficits because it operates through exclusions – the inscription of inequalities of gender and sexuality, ethnicity and class. These exclusions from power, which produce over-representation of some sectors and under-representation of others, are structural and long-standing. They are the site of historic struggles for democratic rights like universal male suffrage and its extension to women. But this is not just a matter of the vote, as the continuing fight for women's equality demonstrates, and there are many other ways, including institutional racism, through which people are denied the full rights of citizenship, even in the countries which claim the most liberal regimes. To speak only of these, witness the post-war struggles for civil rights in the USA

or Northern Ireland, or to bring us directly to the present, the Windrush scandal which surfaced in Britain in the 2010s. Named for one of the ships that brought Afro-Caribbean immigrants to the 'mother country' after the war, invited to replenish a depleted workforce, it emerged that hundreds of such Commonwealth citizens had been wrongly denied their citizenship, treated as denizens, and many were deported and deprived of their legal rights in a clear demonstration of institutional racism within the state. Let this example stand in for the way the internet makes it more difficult for authority to suppress the injustices of the state, or the mainstream media to downplay them, and the deficits of actually existing democracy stand revealed. The virtual public sphere magnifies marginal and subcultural voices, which form the clusters and groupings, factions and coteries that populate the nooks and crannies of the internet but also generate the swarming behaviour that propels them to go viral and drives people onto the streets in protest. This is not to credit the internet as an original cause, as if none of this would have happened without it. The effect is to amplify a process of social fragmentation which is at once a long-term trend, the effect of neoliberal policies, and after 2008 and the near-death experience of capitalism, the result of austerity.

The long-term trend, already evident in the 1960s, involved the break-up of traditional communities through post-war re-housing; the weakening of the extended family; the emergence of teenage youth as both a market and a distinct new socio-cultural formation with rebellious or at least divergent values; and then at the start of the 1970s, the rebirth of feminism. Neoliberalism brought deindustrialisation and the enfeeblement of the trades unions; economic deregulation and the regeneration of finance capitalism; the rule of monetarism and the concomitant promotion of an ideology of egotism; it was fed by privatisation, first of nationalised infrastructure, including social housing, and then of elements of the welfare state. There were differences between Europe and the USA, where the welfare state was less in evidence (for example, there is no national health service), but on both sides of the Atlantic came the further recomposition of the workforce through immigration, later intensified by economic migration and the refugee crisis.

As for the crash of 2008, Mason encapsulated what happened in a television interview: 'The banks collapsed because they had huge amounts of bad debt. And when the banks collapsed, the system collapsed because nobody knew who was carrying how much bad debt.'[26] That was because

they had used IT to create the secretive and opaque system known as the shadow banking system. In the narrow logic of neoliberal policy, the quid pro quo of bailing out the banks was austerity: applying the tourniquet of monetarism, saving the banks by creating money for reinvestment while reducing public expenditure, imposing cuts on government departments and depriving local authorities of funding for community and social services, thus exposing the fault lines of growing inequalities. For mainstream economists who were not enthralled to neoliberalism, the results of this anti-Keynesianism were predictable, but it would survive until the catastrophe of the coronavirus pandemic forced its abandonment, although only with reluctance.

The neoliberal hegemony had already seen the displacement of class consciousness as the pivot of political allegiance by identity politics, a diffuse term first coined in the 1970s for a process which began with the redefinition of sexuality by second wave feminism and gay liberation, but then embraced by other identifiable social groups defined in other ways, above all ethnicity, thus exposing underlying forms of racial exclusion, of institutional racism in public places like law and order, and structural racism in the economy, which seemed to give the lie to official versions of multiculturalism and discomfited entrenched positions on both right and left of the political spectrum. Identity politics was driven by the discovery of inequalities, the articulation of experiences of injustice shared by different excluded or stigmatised groups, and the ways in which racial, economic, gender, and other oppressions were linked, but it also had a dark side which was succoured by neoliberalism, in which the protected worker and consumer-citizen of the social welfare state with a solid class identity fragments into myriad, atomised, shifting, imaginary identities, fed by insecurity, uncertainty and egotistical fantasies. This is not the place to discuss the merits or demerits of various positions within this contentious field but to observe the effects in the clashes and collisions of the heteroglossia that characterises digital speech on social media, which so easily eschews conversational openness and becomes assertive, provocative and aggressive.

Writing reinvented

A typewritten text eliminates the character of the author conveyed by handwriting. The digital text denudes it further, because, as Mark Poster

puts it, 'the computer dematerialises the written trace'.[27] In the change from the graphic to the electronic mark, the electronic writer encounters their own words in a form that is not just intangible – there is no piece of paper to hold in your hand – but evanescent: susceptible to rewording and instant substitution, instantly transformable by cut-and-paste, where deletion leaves no trail, always provisional until you press save or send. This, says Poster, destabilises the writer's sense of unified subjectivity and disperses the figure of the subject, but different types of electronic writing reposition the subject differently. The author, in the old sense, who once used pen and paper, then the typewriter and now a word processor, is faced with a whole new range of possibilities not only in the exercise of their craft but also in its visual appearance, its layout, thus incorporating functions previously performed by the typographer and the publisher's desk editor; the latter likely ends up being deskilled or joining the ranks of precarious cultural workers. Benjamin had a remarkable premonition about this. In his book of aphorisms, *One Way Street*, 'The typewriter', he says,

> will alienate the hand of the man of letters from the pen only when the precision of typographic forms has directly entered the conception of his books. One might suppose that new systems with more variable typefaces would then be needed. They will replace the pliancy of the hand with the innervation of commanding fingers.[28]

This affects different types of writer differently. Where authorship applies, the writing largely remains linear in construction, although this is less marked in fiction, most strict in academic writing, and recent decades have seen a growth in liminal writing where fact and fiction, argument and narration, meet (the same thing has happened in film). Journalism is less affected. The journalist is exempt from design, and what they write is not their exclusive property but passes through editorial gatekeepers and subeditors to fit a template. The social media writer, on the other hand, must not only edit themselves, but their text may be subject to the fixed formatting of the platform. All, however, are subject to the vagaries of appearance imposed by the screen that shows them, where text flows differently, which further destabilises it. Thus detached, all maintain the same kind of distance from direct speech as, in Derrida's thinking, does every kind of inscription. At the same time, the new possibilities the web

offers the author include their reinvention in new forms of address that in spite of being written in the first person are implicitly less monological – while self-publication becomes unpaid labour performed for the love of it, or to satisfy a personal need.

Messaging platforms, which began before the web with bulletin boards and end up in the social media of the 2000s, position the writer differently and produce a different kind of textuality. They induce an informal style of language use, their mode is conversational, and in that sense more dialogical, and yet here another dynamic takes over, as the context is drastically narrowed, and the message becomes depersonalised. Where language use is radically separated from biographical identity, and even traces of biological identity like age and gender may be absent, the result is anonymity, either in effect or in fact: Poster observes that some of these platforms use handles (i.e. pseudonyms) instead of real names (or what are also called avatars, especially common in the world of online gaming). The effects of depersonalisation are intensified by the abbreviated form of the social media message, which is compressed into simple assertion and circulates in the ambiguous form of memes, wrapped up in hash-tags that become part of the message and further reduce it. The medium has the double quality of inviting punctual response and immediately unfastening it from the writer. It allows people to vent. The utterance becomes an intervention which people confuse with their inner voice, an encouragement to exclamation and interjection. These are perfectly normal dialogical responses in everyday life, where context and intonation are crucial to their meaning, which are lost in inscription, although intonation at least is restored by video. But where text is devoid of the context of face-to-face intercourse, it becomes unanchored, and the lack of context seems to licence rudeness, aggressive language, abuse and direct threat. People are accused of all sorts of sins and misdemeanours; there are no doubt individual reasons for such behaviour waiting to be discovered by psychoanalysis. But while the target of such messages is personally attacked, and these channels can be used for public shaming, their amplification by the social media easily renders them toxic and divisive. These effects are not limited to virtual reality, but feed back into the fleshworld, as the norms of political life and civil behaviour disintegrate, and we enter the age of the so-called culture wars.

The third type of writerly position Poster distinguishes is computer conferencing, but that was in 1990, and in 2020 what he describes has

been completely superseded by video sharing. It is no longer a clunky exchange of texts, but the realisation of a science fiction fantasy of the 1930s, which began with the simple video phone and ends up as a virtual conference hall. This is no longer writing. Here, primacy is returned to the voice (even if reading a written text) and situated in a context, albeit denuded, while the image stream at least restores the speaker's personal identity, their gender, ethnicity, age and presence, but at the same time shifts this identity into a new self-reflexive mode, in which the speaker may be forced to think anew about their self-representation. Video calling has been pushed to the fore by the coronavirus lockdown, newly domesticated to overcome family separation and enlisted to enable people to speak to their kinsfolk lying in hospital wards in isolation, while at the same time, a clever television commercial turns a disorderly kitchen in the background into an object of shame in order to sell fitted kitchens.

Likewise, the incorporation of the video call into television news and reportage throws attention on the background, especially when it comes to politicians and experts. Instead of seeing them in office or other appointed surroundings, we now glimpse them at home, and even the tiny corner of the house we get to see speaks volumes – literally so when the background is a bookcase in which to display one's intellectual credentials; but an orderly array of expensive hardbacks is very different from the overflowing shelves and piles of books and papers that surround many a scientist in their study. The video call prioritises speech, but the mise-en-scène has a definite role to play, whether or not it's fashioned deliberately. In the domestic interviews that largely replaced vox pops filmed on the streets, where people are more focused than when caught on the hop, the glimpse we get of the setting can be equally revealing of social positioning, but here the first person narrative, even when clichéd, is more touching and more urgent than the prevarications or explanations of politicians and pundits, and seemingly closer to intimate speech. But still, only seemingly. A simulacrum.

Private or public, video call or virtual conference, alive but remote, we are presented with a piece of software that is highly malleable and feels like a new medium in its own right, not quite like television and not quite like watching a film or video, despite sharing certain features with both. But here the word 'medium' breaks down. The film screen is a medium, not the film you watch on it. The television screen is another, but not the show. Is the computer screen, which incorporates both and

everything else besides, also a medium, or perhaps a supermedium? Is a piece of software running on said screen also a medium? These are different levels but they interpenetrate, and all of them dissolve the subject, splitting identity into fragments, which the self must learn to reconstitute and recompose. This, however, is an impossible task in social isolation, in the atomised condition which the web induces by extracting the subject from their body (although scientists tell us that clicking on things leaves tell-tale chemical traces in our brains).

Notwithstanding, the digital domain fosters both individual and collective creativity. Witness the way that the same video conferencing software has been used as an instrument of music making by isolated musicians playing remotely together in the conditions created by Covid-19, when all live performance was suspended. Here again the general intellect became manifest. Professional musicians, keenly feeling the loss of contact with a living audience, quickly turned to the internet to reconnect vicariously, given a suitable music room at home and the appropriate (and by now widespread) technology. Some began freely offering performances online. Local community choirs, unable to rehearse together, discovered that video conferencing allowed them to continue rehearsing and even create synchronised online performances. Before long, some very interesting experiments appeared, a few of them showed considerable visual flair on the part of the video editor, often a member of the group, who put them together. Since a great deal of this activity took place on the platforms of the open web, it was outside the market, or rather, it didn't need to go through the commodity market in order to find its audience. This says something about the capacity of music to transcend its commodity status, to throw off the fetishism of the marketplace.

Something similar happened at the other end of the scale, when several of the great musical institutions across Europe – opera houses and orchestras – caught the mood of the moment by putting recorded live performances online for free. Other organisations followed suit, and you could also click your way through virtual tours of several of the world's great museums and art galleries, again all for free. There was a strange political economy at work here, in which the arts establishment re-valorises its *raison d'être* by liberating its products from the market. Gradually, with the evidence of eager audiences and assuming its consumer power, some of these offerings were placed behind a pay-wall.

But there is also a danger. Reviewing a book by a GP about coronavirus care, a columnist reports that the author is worried about 'an "enduring ideological shift" towards online consultations and telephone triage because it's "cheaper"'.[29] He is advised in an official email to embrace a 'digital first' model 'by default'. If telemedicine prevails, he says, 'those relationships forged in person will become more remote, and the medicine GPs practise will become more perfunctory, based on the avoidance of being sued rather than on what's best for the patient'.

Supermedium

In short, let's say the internet is a thoroughly contradictory supermedium, as well as completely heterogeneous (although in this respect, so from the start was print). On the one hand, it brings forth an autonomist anti-authoritarian spirit which is built into its very design, much celebrated by the techno-utopians of the 1990s back before the dot-com bubble burst. On the other, it is now dominated by the internet giants who provide the gateways and platforms that subsume the free self-determined input of millions of people which they monetise to their own benefit. Freed from external and institutional ideological constraints, the medium that when it first appeared was celebrated as a wondrous new democratic means of spreading knowledge and social benefit at almost zero cost (once you've paid for the gear and the connection) has turned in the process into a vast network of networks, for good and for ill. On the one hand, forums of debate which foster the values of the ideal public sphere posited by Habermas; on the other, echo-chambers of unreason and paranoia, open to every kind of ideological prejudice, narcissistic posture, confirmation bias, hate speech, conspiracy theory, and political manipulation. Whatever produces this uncouth and socially destructive behaviour remains the subject of much frequently speculative debate about the depersonalisation that the medium foists on the user, the paradoxical dissociation of personality produced by a medium which celebrates bringing people together.

Indeed it does so, and some of these networks succour empathy and solidarity. Civil society is animated as established charities large and small migrate to the web, to be joined by new players, pressure groups, political associations, all employing means such as online petitions, charitable appeals and support groups offering people a measure of succour.

Their activity is disseminated through non-profit media; the biggest charities are rich enough to run adverts on television, some have international reach, but most of this activity is pitched at national level and some of it is local. Each tends to focus on particular issues but belongs to wider communities within civil society with varied ideological positions. Collectively, this is a sector that actively seeks to suppress divisiveness, though this requires vigilance (at a cost that, like security measures, becomes an overhead). All embrace the digital domain of immaterial production; thus, amid the torrents of videos, memes and messages both trivial and offensive, sometimes amusing and entertaining but just as likely to spread rumours, disinformation and conspiracy theories, there are also other currents, where social values are very much to the fore, even though they are diffuse and lacking political focus. The crucial factor in this is that the communities they represent are not virtual but embodied, real people with a first and second name, 'con nombre y apellido' as the Spanish phrase has it, who come together in diverse assemblies to take action, from the level of the neighbourhood to that of the nation and beyond, from the wave of mass uprisings at the end of the millennium that initiated the anti-globalisation movement to the globally co-ordinated protests achieved by the Occupy movement in 2011, from the spread of community food banks in answer to austerity to Black Lives Matter in 2020. On the web, the position this content occupies in the search engines is inevitably low on the list because their divergent and oppositional content goes unreported in the mainstream media, they are deselected by the search engines' algorithms and they rarely break through, except when personalities grab attention or there's an outbreak of disruptive civil obedience (for which much of the organisation takes place through encrypted channels). But it's not a question of charismatic leaders or of numbers, and this is a widely dispersed movement taking multiple forms, with a strong creative presence that runs from citizen journalism to video art, encompassing music and poetry, open-source software and interactive mobile apps, all of which refuse the hold of commodification, stand in opposition to the ideological deceptions of free-market capitalism, and mobilise alternative applications of information technology for social purposes. Let one example stand in here for many: a website developed in Spain by the Platform for Citizens Debt Audit (which I filmed in 2015),[30] an interactive tool by which citizens can

visually interrogate the budgets of municipal governments down to the finest detail, and thus expose corruption.

The greatest danger to authority lies in the capacity of the new communications networks to mobilise public response and bring it out onto the streets. Early signs included events in the Philippines in 2001, when text messages summoned millions onto the streets of Manila, forcing the government's collapse. Three years later, terrorist bombs in Madrid three days before a general election killed 191 people and injured around 2,000, and when the incumbent right-wing government patently lied about who was responsible (they blamed Basque separatists when everyone else held Al-Qaida responsible), text messaging was used to summon mass protests which changed the expected result of the election and put the left in power. What happened has been documented.[31] On the morning of the day before the election, when political rallies in Spain are officially suspended, a small nucleus of activists decided to issue a call for an illegal protest that same evening ('No political parties. "We want to know the truth." Pass it on.') which they sent to their lists of contacts from previous campaigns. The message circulated quickly through activist networks and beyond – the phone companies reported a 20 per cent increase in SMS messages on that day, and there was also increased internet traffic – and when the time came, 11 million people across the country committed an act of mass civil disobedience and the government lost the election the next day. The small group with whom the message originated had no idea when they sent it out what response it would get, but realised something was afoot when their message got passed on back to them. In their account of the events, they attribute the take-up in part to the 2 million youth due to cast their vote for the first time, precisely the sector of the population who were the principal users of mobile phones and text messaging. They also speak of a peripheral public sphere whose influence grows as the central public sphere is weakened, or in moments of crisis, paralysed.

That was the year that Facebook was launched; YouTube launched a year later and Twitter in 2006. When it came to the Arab Spring, the mainstream media jumped on the social media as the culprit. Even some activists, says Mason, proclaimed 'a revolution planned on Facebook, organised on Twitter and broadcast to the world via YouTube'.[32] What remained hidden to the international media was the build-up of grassroots political and trade union activity that lay beneath their radar, but

what truly flummoxed them was the emergence of a multitude, a leaderless and undifferentiated mass with no articulated political agenda, which is both their strength and their weakness. Equally baffled were the established organisations of the left, the trades unions and political parties, who saw new forms of protest that escaped the normal political channels as the composition of the protestors shifted. This was evident, for example, in the big anti-austerity demonstration, half a million strong, in London in March 2011, which was really two demonstrations: the official march called by the TUC and culminating with a rally in Hyde Park, and the unofficial alternative, which spread out across the West End, comprising multiple autonomous groups and blocs, unorganised, disorganised or self-organised, depending on your point of view, whose politics were a mixture of green, anti-capitalist and anarchist; noisy and carnivalesque and above all youthful. (The event is portrayed in the last chapter of my film, *Chronicle of Protest.*[33])

In fact, the make-up of this multitude depends on the political circumstances. A few years later, when the French *gilets jaunes* took to the streets in October 2018, declaring themselves an apolitical citizens' movement, the protests were once again organised on social media and came from outside the political and trade union frameworks that usually dominate large mobilisations in France. Many of the protestors told the journalists who were trying to figure out who they were that they had never previously demonstrated, and the mainstream media described them as the forgotten white middle or upper working class squeezed by rising prices (the demonstrations were sparked by increased fuel prices). The polls reported overwhelming public support and the left organisations followed, but doubts remained, and the accusation that the movement was 'petit-bourgeois'. But perhaps this is a charge that reflects what may well be an outmoded comprehension of class in the post-Fordist economy, in which, from one generation to the next, the old class structure is dissolving.

Mason is largely right that resistance in the age of austerity is overwhelmingly youthful and unemployed, led by a fragmented precariat who use the very technologies that produced their atomised lifestyle in the first place.[34] This is happening both in the prosperous North and the global South. By 2010, Mason reports, youth unemployment in both Britain and North Africa stood at 20 per cent, 30 per cent in Libya, 46 per cent in Spain. Many protestors were what he calls 'graduates with no future',

mostly in the North, alumni of higher education systems which had seen
huge expansion now robbed of opportunity and prospects, indebted and
living in close proximity to the urban poor. This milieu evidently encour-
ages a type of carnivalesque direct action in the form of street theatre,
performance and 'flash mobs'. Anarchists demonstrate by dressing up as
books with appropriate titles, like Adorno's *Negative Dialectics*, Marcuse's
One Dimensional Man, Huxley's *Brave New World*, Beckett's *Endgame*,
Fanon's *Wretched of the Earth*, the books which have brought them to
their anarchism. In Britain, a group called UK Uncut took inventive
action in protest against unpaid corporate taxes through temporary occu-
pations, such as taking over mobile phone stores or banks for a couple of
hours and symbolically turning them into public services, like a creche,
and in one case, which I filmed, a stand-up comedy club. I was hardly the
only person filming this and similar events, on the contrary, they were
designed to catch the eye of the media. Authority is bemused and dis-
combobulated by such behaviour, and the ideologues of the mainstream
media confuse cause and effect, supposing the internet and social media
to be the causal agency, and not a locus and channel for the manifesta-
tion of deep inequalities in society, the material deprivation, anxieties and
pain they cause. The internet and mobile communication have certainly
been crucial in shaping social uprisings over recent decades, but only in
the same way that they have shaped industry, finance and mass culture.
The process is unsettling and perhaps we can say that capitalism becomes
a victim of its own success in providing the multitude with the mobile
devices that are then directed against the consequences of its hegemony.

In one sense, the apparatus is neutral. For reasons both commercial
and ideological, and despite the anti-democratic nature of digital surveil-
lance, it is open to serving all political tendencies, left or right, democratic,
populist, nationalist, authoritarian, conspiratorial, what-have-you. The
internet is a space where the breakdown of political structures is occupied
by undisciplined intrusions lubricated by the peripheral public sphere, an
openness defended by its owners as a human right, but a defence made in
bad faith. Beneath it simmers a pain and anger whose strength is evident
in the way it has broken through even in the severe conditions imposed
by the coronavirus in 2020. In the USA, the last straw was a video of a
white police officer killing a black man, George Floyd, on the street in
broad daylight; the response was immediate, persistent and international,

as Black Lives Matter, which originated in a social media hashtag in 2013, exploded onto the streets.

Consider the lineage behind such images. For years, smartphones had not only been used for purposes of citizen journalism, to bear witness to violent clashes between protestors and the forces of law and order (Standing calls this 'sousveillance') but isolated incidents were caught by attentive videographers going back to George Holliday's casual recording of the beating of Rodney King by a bunch of Los Angeles policemen in March 1991, which he sold to a local television station for $500 and thus ended up as material evidence in court. Before that, back in 1963, an amateur movie-maker called Abraham Zapruder found himself filming 22 seconds of silent 8mm film of the assassination of J.F. Kennedy, and sold it to *Life* magazine, who published it only in the form of still images, minus the frame which shows Kennedy's head being blown apart. Although bootleg copies were circulating by the end of the 1960s, it was only seen publicly for the first time in 1975, when a US television journalist defied the risk of legal action to show it on network television. Nowadays it's readily available, and everyone can confirm for themselves what the footage shows: Kennedy thrown to the rear by a bullet which, according to the Warren Commission, came from behind. In the case of the Rodney King footage, which was not examined by an investigation committee in private but openly in court, the shysters who defended the police officers had a field day. As one commentator subsequently put it, they introduced 'so many levels of interpretation to the image that the jury was dissuaded from taking the beating at face value'.[35] In the words of another, they 'turned Rodney King from victim to dangerous provocateur and converted police response from raw brutality to panicky self-defence'.[36] The policemen were acquitted by a white jury from the suburbs and black Los Angeles responded to the verdict with several days of rioting, in which 54 people were killed, more than 2,000 injured and over 13,000 arrested. In 2020, the video of George Floyd was taken by a 17-year-old schoolgirl who posted it on Facebook, what it shows is incontrovertible, and the response was rapid and massive: millions of people participated in the protests in the USA alone, and the movement spread to Europe, Australasia and Japan. What is demonstrated here is not only the power of a veridical image which the historical moment renders iconic but also the acceleration that the web brings to its instant uncommoditised dissemination. Such an image is no mere simulacrum,

it transcends the alienation of spectacle, it becomes an event. But if, in the process of dissemination, the image becomes what the American colloquialism calls catawampus – wrenched out of true, misaligned, lopsided – for example, by legalised denial, or political obtuseness, then there may well be a social cost to pay, and there's nothing either authority or the mainstream media can do about it. This is not new to the web. Iconic images have always exerted power over mass consciousness. What the web and mobile communication do is to intensify, accelerate and extend such effects, in a context which although denuded, calls for completion in what we fondly still call the real world.

Architect or bee?

We're left with questions impossible to answer on the basis of mechanical models of explanation which reduce cultural creation to the effects of economic determination, like the so-called base/superstructure model, or the notion of technological determinism. A one-way process which reduces a relationship at once dialectical and highly mediated to mechanical cause and effect is an unsustainable position, in fact incoherent, because then it wouldn't be creative. As for technology, it is always designed in ways prefigured by intended purposes but always exceeds those purposes and introduces new possibilities which call for creative responses. Perhaps no answers are possible without recognising that the very word 'creative', which was always ambiguous, has become newly problematic. In the same way that 'art' never referred exclusively to 'the arts', but applied, as Raymond Williams put it, 'in matters as various as mathematics, medicine and angling',[37] so too 'creativity' never applied only to artistic creation – it could always also be found in all forms of thinking and intellectual work of any kind in any field. What it refers to, however, cannot be pinned down, and is not a measurable ingredient like some kind of essence which you can add to a cake in the mixing bowl. The word escapes definition and follows no formula, but like one of those Wittgensteinian words such as play and games, comprises an extended family of referents. Perhaps precisely because of its vagueness, however, the word has not escaped the clutches of post-Fordist ideologues, and the concept of creativity is reduced to a false and deceptive abstraction (in the same way 'gig' becomes the term for a whole range of irregular employment). As Astra Taylor observes,

the psychology of creativity has become increasingly useful to the economy. The disposition of the artist is ever more in demand. The ethos of the autonomous creator has been repurposed to serve as a seductive facade for a capricious system and adopted as an identity by those who are trying to make their way within it.[38]

Artists, media workers and other cultural labourers are hailed as 'model entrepreneurs' by industry and government. But the creativity that is valued by the post-Fordist economy is denuded and instrumentalised, no more than the competitive edge of novelty: being creative means dreaming up new products and services to bring to market – or new ways to cut costs.

If we take our cue from Williams, we should, on the contrary, widen our understanding, and look for creativity beyond the realm of the aesthetic, and not only by perceiving it in the sciences, both pure and applied, but also activities like invention, which as we've seen do not just drop from the skies and are not just the result of intuition or some Archimedes-like eureka moment; no doubt these sometime occur but only after a lot of mental work (in which, as in art, the subconscious plays a large part). More importantly, any invention depends on prior knowledge and discoveries, and is made in response to social need or opportunity – and not just by the person whose name is on the patent, who is simply the one who got there first. Think of this as another model of creativity, but instead of attempting a psychological profile of its characteristics, we should instead disentangle the conditions that bring it into play. These are grounded in the need people have to make and do things of their own volition as a way of creating themselves and their life, which comes from our species-being, along with the desire, because our species-being is social, to have these things recognised and validated by others. We live by and through reciprocity. The individual's ability to realise their expressive need (which is not uniform, in the same way that nor is athletic ability) depends on their social milieu and the horizon of hopes and expectations it allows them. It also depends on access to the means of production, which depends in turn on factors like the technology involved, and the forms of capitalisation which, as far as they can, determine the labour process and working practices. All of these influence the individual's chances of making a living by means of creative labour, or whether they choose to pursue their creative desires whilst otherwise employed – or

indeed abandon them. The novel factor introduced by digital technology is that it places the means of both creative production and its dissemination in the hands of people who are not beholden to the laws of the market, and do not need the help of third parties like publishers and agents (although lots of likes might bring them to their door).

Creativity at its highest level is the original synthesis of disparate given materials, the perception of solutions to problems and of problems that need solutions, and in its aesthetic form, the capacity for finding new forms of expression for sensations new and old. This is how we are frequently invited to think of genius (which the scientist Fred Hoyle once called 'a person who has been lucky in all their learning processes'). But the self-fulfilment that comes with aesthetic engagement does not require this kind of exceptional originality. In the performance arts, originality is at a premium only in certain milieux, like jazz clubs, venues given over to the avant-garde, or the clubs where stand-up comedians learn their skills. Generally, musicians and actors do not aim at originality but effective interpretation, which offers its own rewards – rewards also available to the amateur, freely engaging in an activity that fulfils the need for socialised self-regeneration.

There is also, however, another level of collective, or better, social creativity, to be found, although rarely, in another arena altogether, the sphere of material production, where aesthetics normally enters the picture at best in the design of commodities for the consumer market. Only in unusual circumstances, like the factory takeovers in Argentina in the early 2000s, does the workforce find itself in a position to control what it produces and take creative decisions that go far beyond aesthetics. Being so rare, it is best to provide a concrete example of this social creativity in action, in an educated workforce invited to address the prickly question of the purpose of what they were employed in manufacturing. This is an issue hardly ever discussed anywhere, because it violates the laws of the labour market and challenges the rights of the entrepreneur. Nevertheless, in the 1970s, the UK saw a remarkable initiative by a group of engineers and industrial designers who formed the Lucas Aerospace Combine Shop Stewards Committee and proposed the conversion of production for war – more than half of Lucas Aerospace's output consisted in military contracts – to the manufacture of socially useful products, ranging from wind turbines to portable kidney dialysis machines. The Lucas Aerospace Alternative Corporate Plan, which animated debate in

the socialist left, was devised at a propitious moment, encouraged by Tony Benn, industry minister in Harold Wilson's Labour government, who had come to power celebrating the 'white heat of technology'. But there was nothing blue skies or airy-fairy about what they proposed, which had two objectives: to protect jobs from the threat of redundancy, and promote social utility. The plan drew on some 150 ideas put forward by the workforce, when the committee asked for suggestions that instead of making components for Concorde, or playthings for the sumptuary consumption of the middle classes, answered a social need, and crucially, could be produced using the company's existing skills and technology. They included goods like heat pumps for energy conservation designed with ill-housed old-age pensioners particularly in mind; solar cell technology; a hybrid power system for vehicles; a life-support system for heart attack patients en route to intensive care; hobcarts for spina bifida patients; and dual road-cum-rail vehicles.

The proposals were both practical and visionary, but crossed a line by claiming the right to discuss with management the products being made, a claim on what management regards as its own prerogative, who not surprisingly rejected it out of hand. Mike Cooley's account, as a member of the Shop Stewards Committee, of the thinking behind the episode, takes its cue from Marx's observation about the difference between bees and architects: that the architect raises his structure in imagination before building it. We have not yet found, says Cooley, nor are we likely to find, a means of mathematically modelling the imagination (a proposition that many scientists working in AI nowadays admit). His conclusion remains entirely pertinent, indeed more urgent than ever:

Either we will have a future in which human beings are reduced to a sort of bee-like behaviour, reacting to the systems and equipment specified for them; or we will have a future in which masses of people, conscious of their skills and abilities in both a political and technical sense, decide that they are going to be the architects of a new form of technological development which will enhance human creativity and mean more freedom of choice and expression rather than less. The truth is, we shall have to make the profound political decision as to whether we intend to act as architects or behave like bees.[39]

Perhaps this is a utopian formulation which doesn't bear too close exam-
ination, because not everyone can be an architect or even a creative
worker; the real question is rather what it would take for alienated labour
to be less alienated and life more fulfilling – and today we must add, more
sustainable. Forty years after those words were written, when bee popu-
lations are under threat from pesticides, habitat loss and climate change,
we are still behaving like bees and the result is that both them and us are
in peril. But what is told us by the allegory of the architect and the bee
– and the Lucas Aerospace alternative plan – is that creativity and imagi-
nation are not merely pleasing supplements to human existence, and are
not limited to aesthetic expression, but comprise a faculty intrinsic to
what makes us human, and vital to the survival of our humanity.

Capitalism attempts to contain and enclose creativity through com-
modification, and the internet enables new forms of monetisation, but
networked technologies, Taylor thinks, do not resolve the contradictions
between art and commerce, they make them both less visible and more
pervasive. On the one hand, an amateur paradise is upon us, a place where
people are able to participate in cultural production for the pleasure of
it, without asking permission first. No matter how trivial or derivative,
hackneyed or stale, the abundance of 'user-generated content' reveals a
widespread intrinsic creative drive, and digital techniques enable new
expressive forms and facilitate their dissemination. But in certain fun-
damental respects the process of making things remains unchanged.
As Taylor puts it, 'The arts, to use the language of cultural economics,
depend on a type of labor input that cannot be replaced by new technol-
ogies and capital.'[40] This is exactly true: new technologies do not replace
previous forms of aesthetic labour, they augment them; and capital can
try to control cultural production but cannot close off the autonomy of
the creative imagination.

Taylor, who is a documentary filmmaker, does not call on any of the
Marxian terms I've been using here, but she knows what she's talking
about from the inside. She recounts how shortly after the premiere of
her film *Examined Life*, an unusual documentary about contemporary
philosophy, she 'found the entire thing online, ninety minutes posted in
full or cut into random snippets spread across the Internet'.[41] The film
had cost a 'whopping' $500,000 (a high cost for an independent docu-
mentary) including her own modest fee of $20,000 for more than two
solid years of work, which included serving as field producer, location

scout, driver, production assistant and coffee runner. 'Cultural work', she says, 'which is enhanced by the unpredictability of the human touch and the irregular rhythms of the imagination and intelligence, defies conventional measures of efficiency.'[42] No formula explains the relationship between creative effort and output, nor does the quantity of time invested in a project correlate in any obvious way to its value, but what's clear is that complex creative labour – the dedicated application of human effort to some expressive end – continues despite technological innovation 'stubbornly withstanding the demand for immediate production in an economy preoccupied with speed and cost cutting'.[43] We should hardly be surprised, she says, since the aesthetic impulse as such is indifferent to such priorities.

Or to put it the other way round: capital sees aesthetic values purely in decorative and instrumental terms, and unable to take real control of creative labour remains averse to its claims of autonomy, which it finds inimical. Faced with the unforeseen results of its own creation of digital technology, it tries to control the market but art, just like information, wants to be free. For Elie Siegmeister, the author of a pamphlet published by the Workers Music Association in 1938, 'We find that, as in other fields, capitalism has created the most magnificent apparatus for the production, distribution and consumption of music that the world has ever seen: yet this apparatus is so riddled with contradictions basically economic in origin that it negates its own potentialities.'[44] The same thing applies to the entire apparatus of cultural production under capitalism. It is a miracle, but a daily one, that in these circumstances creativity still asserts its prerogatives.

Notes

1. AUTONOMY OF THE AESTHETIC

1. Fredric Jameson, Foreword to J.-F. Lyotard, *The Postmodern Condition: A Report on Knowledge*, Manchester: Manchester University Press, 1984, p. xv.
2. T.W. Adorno, *The Culture Industry*, London: Routledge & Kegan Paul, 1991, p. 100.
3. Karl Marx, *Theories of Surplus Value, Part I*, London: Lawrence & Wishart, 1969, p. 411.
4. David Harvey, 'Rate and Mass', *New Left Review*, 130: 85, 2021.
5. David Graeber, *Bullshit Jobs*, London: Penguin Books, 2019, p. 262 (italics in original).
6. Karl Marx, 'Labour as Sacrifice or Self-Realization', in *Grundrisse*, London: Penguin, 1973, p. 124.
7. Karl Marx, 'Results of the Immediate Process of Production', in *Capital, Vol. I*, London: Lawrence & Wishart, 1970, p. 1044.
8. Marx, *Theories of Surplus Value, Vol. I*, p. 285.
9. Adolfo Sánchez Vázquez, *Art and Society: Essays in Marxist Aesthetics*, London: Merlin Press, 1973, p. 222.
10. Ibid., p. 221.
11. Manifesto for an Independent Revolutionary Art, 1938, www.marxists.org/subject/art/lit_crit/works/rivera/manifesto.htm
12. S.S. Prawer, *Karl Marx and World Literature*, New York and London: Oxford University Press, 1978, p. 318.
13. Ruth Finnegan, *The Hidden Musicians*, Cambridge: Cambridge University Press, 1989.
14. Voices Now Big Choral Census July 2017, http://voicesnow.org.uk/wp-content/uploads/2017/07/Voices-Now-Big-Choral- Census-July-2017-1.pdf
15. Sánchez Vázquez, *Art and Society*, p. 219.
16. Raymond Williams, *Keywords*, London: Fontana, 1976. See the entries for 'creative', 'art', 'culture'.
17. Ibid., p. 34.
18. Karl Marx, *A Contribution to the Critique of Political Economy*, London: Lawrence & Wishart, 1971, p. 216.
19. Ibid., p. 217.
20. Prawer, *Karl Marx and World Literature*, p. 2.
21. Karl Marx and Friedrich Engels, The German Ideology, www.marxists.org/archive/marx/works/1845/german-ideology/cho3l.htm

22. Friedrich Schiller, *On the Aesthetic Education of Man*, Oxford: Clarendon Press, 1967, pp. 33–7.
23. Herbert Marcuse, *Reason & Revolution*, Part II, I. 4, www.marxists.org/reference/archive/marcuse/works/reason/cho2-4.htm
24. Marx, *Capital, Vol. I*, p. 178.
25. A Contribution to the Critique of Political Economy, Appendix I: Production, Consumption, Distribution, Exchange, On-Line Version: Marx.org
26. Schiller, *Letters on the Aesthetic Education of Man*, p. 107.
27. Karl Marx, *Capital, Vol. III*, London: Lawrence and Wishart, 1972, pp. 386–7.
28. Marx and Engels, The German Ideology.
29. Karl Marx, Critique of the Gotha Programme, www.marxists.org/archive/marx/works/1875/gotha/cho1.htm
30. Julio García Espinosa, 'For an Imperfect Cinema', in Michael Chanan (ed.), *Twenty-five Years of the New Latin American Cinema*, London: BFI/Channel Four, 1983, p. 28.
31. Lucien Febvre and Henri-Jean Martin, *The Coming of the Book*, London: Verso, 1984, p. 162.
32. Ibid., 1984, p. 163.
33. J. Habermas, *The Structural Transformation of the Public Sphere: An Inquiry into a Category of Bourgeois Society*, Cambridge, MA: MIT Press, 1989.
34. Nancy Fraser, 'Rethinking the Public Sphere: A Contribution to the Critique of Actually Existing Democracy', *Social Text*, 25/26: 57, 1990.
35. Ibid., pp. 56–80.
36. William Weber, *Music and the Middle Classes*, London: Croom Helm, 1975, p. 30.
37. Jodi Dean, *Democracy and Other Neoliberal Fantasies, Communicative Capitalism and Left Politics*, Duke University Press, 2009, e-book edition, location 1417.
38. Karl Marx, *Early Writings*, ed. T. Bottomore, London: Watts, 1963, p. 176.
39. Fraser, 'Rethinking the Public Sphere', p. 61.
40. Terry Eagleton, *Ideology*, London: Verso, 1991, p. 16.
41. Ibid., p. 9.
42. Karl Marx, *Capital I*, Lawrence & Wishart, 1970, p. 76.
43. Eagleton, *Ideology*, p. 185.
44. Quoted in Mark Rose, *Authors and Owners: The Invention of Copyright*, Cambridge, MA: Harvard University Press, 1993, p. 29.
45. Quoted in ibid., p. 32.
46. Ibid., p. 28.
47. Ibid., p. 3.
48. Ibid., p. 7.
49. Ibid., p. 129.
50. Bernard Edelman, *Ownership of the Image: Elements for a Marxist Theory of Law*, Routledge & Kegan Paul, 1979.
51. Paul Hirst, Introduction to ibid., p. 8.

52. Rose, *Authors and Owners*, p. 65.
53. Ibid., p. 45.
54. Ernest Roth, *The Business of Music*, London: Cassell, 1969, p. 63.
55. Lorenzo Bianconi, *Music in the Seventeenth Century*, Cambridge: Cambridge University Press, 1987, p. 2.
56. Walter Benjamin, 'The Work of Art in the Age of Mechanical Reproduction', in Hannah Arendt (ed.), *Illuminations*, New York: Schocken Books, 1969, p. 219.
57. Dave Beech, *Art and Value: Art's Economic Exceptionalism in Classical, Neoclassical and Marxist Economics*, Chicago, IL: Haymarket Books, 2016, p. 274.
58. Walter Benjamin, 'Unpacking My Library', in *Illuminations*, 1969.
59. George Orwell, 'Books vs. Cigarettes', *Tribune*, 8 February 1946, www.orwell foundation.com/the-orwell-foundation/orwell/essays-and-other-works/ books-vs- cigarettes
60. Marx, *Grundrisse*, pp. 88ff.
61. Ibid., p. 92.
62. Arjun Appadurai, 'Introduction: Commodities and the Politics of Value', in Arjun Appadurai (ed.), *The Social Life of Things: Commodities in Cultural Perspective*, Cambridge: Cambridge University Press, 2014.
63. André Breton and Paul Éluard, eds, *Dictionnaire abrégé du Surréalisme*, Paris: Galerie des Beaux-Arts, 1938.
64. Paraphrased from Arjun Appadurai, 'The Thing Itself', *Public Culture*, 18(1): 15, 2006.
65. Néstor García Canclini, *Transforming Modernity: Popular Culture in Mexico*, Austin, TX: University of Texas Press, 1993.

2. THE CHANGING LOGIC OF ARTISTIC PRODUCTION

1. Karl Marx, *Theories of Surplus Value, Part I*, London: Lawrence & Wishart, 1969, p. 401.
2. Ibid., p. 401.
3. David Harvey, *Marx, Capital and the Madness of Economic Reason. Profile.* Kindle edition, p. 99.
4. Marx, *Theories of Surplus Value, Part I*, p. 410. Italics in the original.
5. Adam Smith, *The Wealth of Nations*, London: Everyman's Library, Vol. 1, 1991, p. 295.
6. Marx, *Theories of Surplus Value, Part 1*, pp. 174–5.
7. Jacques Attali, *Noise: The Political Economy of Music*, Minneapolis, MN: University of Minnesota Press, 1985, p. 38.
8. Eric Blom, ed., *Mozart's Letters*, London: Penguin Books, 1956, p. 158.
9. Marx, *Theories of Surplus Value, Part I*, p. 173.
10. Ibid., p. 185.
11. Ibid., p. 157.

12. W. Baumol and W. Bowen, *Performing Arts - the Economic Dilemma*, Cambridge, MA: MIT Press, 1968.
13. William Baumol, *The Cost Disease*, Yale University Press, 2012, e-book edition, location 397.
14. Marx, *Theories of Surplus Value, Part I*, pp. 410-11.
15. Karl Marx, *Grundrisse*, London: Penguin, 1973 p. 282.
16. Karl Marx, *Capital Vol. III*, London: Lawrence and Wishart 1972, pp. 386-7.
17. In Michael Chanan, dir., 'The Politics of Music', 1972.
18. Michael Chanan, *Musica Practica: The Social Practice of Western Music from Gregorian Chant to Postmodernism*, Verso, 1994, pp. 11-12.
19. Marx, *Capital Vol. III*, p. 387.
20. Billie Holiday, *Lady Sings the Blues*, London: Sphere Books, 1973, p. 166.
21. Christopher Small, *Musicking*, Hanover and London: Wesleyan University Press, 1998.
22. Fredric Jameson, *Marxism and Form*, Princeton, NJ: Princeton University Press, 1974, p. 14.
23. Marx to Engels, 28 January 1863, http://hiaw.org/defcon6/works/1863/letters/63_01_28.html (accessed 6 December 2021).
24. Arthur Loesser, *Men, Women and Pianos*, New York: Simon & Schuster, 1954, p. 133.
25. Beethoven Broadwood Piano Bicentenary, 1818-2018, www.surreycc.gov.uk/culture-and-leisure/history-centre/researchers/guides/piano-manufacturers/beethoven (accessed 6 December 2021).
26. Quoted in Mark Lindley, 'Marx and Engels on Music', *Monthly Review*, 18 August 2010.
27. Cyril Ehrlich, *The Piano: A History*, London: Dent, 1976.
28. Marx to Engels, 1863.
29. E.P. Thompson, 'Time, Work-Discipline, and Industrial Capitalism', *Past & Present*, 38: 63, 1967.
30. Ibid., p. 69.
31. Ibid., p. 73.
32. Ibid., pp. 90-1.
33. Friedrich Kittler, *Gramophone, Film, Typewriter*, Stanford, CA: Stanford University Press, 1999, p. 189.
34. Brian Winston, *Misunderstanding Media*, London: Routledge and Kegan Paul, 1986.
35. Karl Marx and Frederick Engels, *Collected Works, Vol. XL*, London: Lawrence & Wishart, 1975-2001, p. 93.
36. Eric Hobsbawm, *Age of Empire*, London: Weidenfeld & Nicolson, 1987, p. 121.
37. Karl Marx, *Capital, Vol. I*, London: Lawrence & Wishart, 1970, p. 384.
38. Kittler, *Gramophone, Film, Typewriter*, p. 192.
39. Quoted in ibid., p. 203.
40. Ibid., p. 229.

41. Ibid., p. 200.
42. Walter Benjamin, 'A Small History of Photography', in *One-Way Street*, London: Verso, 1979, pp. 241–2.
43. 'Bill Presented to the Chamber of Deputies, France', 15 June 1839, www.photocriticism.com/members/archivetexts/photohistory/daguerre/pf/daguerrebillpf.html (accessed 6 December 2021).
44. Benjamin, 'A Small History of Photography', p. 246.
45. G.H. Martin and David Francis, 'The Camera's Eye', in H.J. Dyos and M. Wolff (eds), *The Victorian City: Images and Realities*, London: Routledge & Kegan Paul, 1977, p. 234.
46. Benjamin, 'A Small History of Photography', p. 227.
47. Ibid., p. 218.
48. Costas Lapavitsas, 'Money as Art: The Form, the Material, and Capital', in *Marxist Monetary Theory: Collected Papers*, Chicago, IL: Haymarket Books, 2017.
49. In Michael Chanan, dir., 'Money Puzzles', 2016.
50. Lucien Febvre and Henri-Jean Martin, *The Coming of the Book*, London: Verso, 1984, p. 49.
51. Susan Buck-Morss, *The Dialectics of Seeing*, Cambridge, MA: MIT Press, 1991, p. 134.
52. Quoted in E.S. Turner, *The Shocking History of Advertising*, Harmondsworth, UK: Penguin, 1965, p. 26.
53. Hobsbawm, *Age of Empire*, pp. 105–6.
54. Ibid., p. 223.
55. Ibid., p. 202.
56. Ibid., p. 203.
57. Hans Magnus Enzensberger, 'Constituents of a Theory of the Media', in *Raids and Reconstructions*, London: Pluto Press, 1976, p. 35.
58. Marx, *Capital*, Vol. I, p. 71.
59. W.F. Haug, *Critique of Commodity Aesthetics*, Cambridge: Polity Press, 1986.
60. Ibid., p. 23.
61. Karl Marx, *The Economic & Philosophic Manuscripts of 1844*, New York: International Publishers, 1964, p. 148.
62. Adam Curtis, dir., The Century of the Self – Part 1: 'Happiness Machines', www.youtube.com/watch?v=DnPmgoR1Mo4 (accessed 6 December 2021).
63. Armand and Michèle Mattelart, *De L'Usage des Media en temps de crise*, Paris: Editions Alain Moreau, Paris, 1979, Chapter Two, Part Two, 'Information et Etat d'Exception'.

3. CULTURAL COMMODIFICATION

1. Quoted in Michael Chanan, *Repeated Takes*, London: Verso 1995, p. 3.
2. Walter Benjamin, 'The Work of Art in the Age of Mechanical Reproduction', in Hannah Arendt (ed.), *Illuminations*, New York: Schocken Books, p. 221.

3. Roland Barthes, 'Musica Practica', in *Image-Music-Text*, London: Fontana/ Collins, 1977, pp. 149–54. See also Michael Chanan, *Musica Practica: The Social Practice of Western Music from Gregorian Chant to Postmodernism*, London: Verso, 1994.

4. Evan Eisenberg, *The Recording Angel*, London: Picador, 1988, p. 116.

5. Francis Newton, *The Jazz Scene*, London: Penguin, 1959, p. 185.

6. Ibid. p. 186.

7. Quoted in Christopher Small, *Music of the Common Tongue*, London and New York: Calder and Riverrun Press, 1987, p. 407.

8. Karl Marx and Friedrich Engels, *Manifesto of the Communist Party*, p. 16.

9. Quoted in Chanan, *Repeated Takes*, p. 30.

10. Edward Jablonski and Lawrence Stewart, *The Gershwin Years*, New York: Da Capo Press, 1996, p. 35.

11. Stefan Müller-Doohm, *Adorno: A Biography*, Cambridge: Polity Press, 2005, p. 201.

12. Theodor W. Adorno, 'Perennial Fashion – Jazz', in *Prisms*, London: Neville Spearman, 1967, pp. 121–32.

13. Stefan Müller-Doohm, *Adorno, A Biography*, pp. 151–2.

14. Beech 2016, p. 226.

15. Theodor W. Adorno, *The Culture Industry*, London: Routledge & Kegan Paul, 1991 p. 100.

16. Ibid., p. 100.

17. Karl Marx, *A Contribution to the Critique of Political Economy*, first published 1859, London: Lawrence & Wishart, 1971.

18. Terry Eagleton, *Ideology*, London: Verso 1991, p. 83.

19. Fredric Jameson, *The Cultural Turn*, London and New York: Verso, 1998, pp. 138–9.

20. Fredric Jameson, 'The Future of the City', *New Left Review*, 21: 76, 2003.

21. Peter Thompson, 'The Frankfurt School, Part 2: Negative Dialectics', *Guardian*, 1 April 2013, www.theguardian.com/commentisfree/2013/apr/01/negative-dialectics-frankfurt-school-adorno

22. Jameson, *The Cultural Turn*, p. 139.

23. Ibid., p. 149.

24. Adorno, *The Culture Industry*, p. 98.

25. Linda Martin and Kerry Segrave, *Anti-Rock*, New York: Da Capo, 1993, p. 10.

26. Andrew Ross, *Nice Work If You Can Get It*, New York: York University Press, 2009, p. 165.

27. Umberto Barbaro, *El film y el resarcimiento marxista de la arte*, Havana: Ediciones ICAIC, 1965, p. 296.

28. Stanley Cavell, *The World Viewed*, New York: Viking Press, 1971, p. 31.

29. Peter Bachlin, *Histoire Economique du Cinéma*, Paris, La Nouvelle Edition, 1947.

30. Thomas Guback, *The International Film Industry*, Bloomington, IN: Indiana University Press 1969, pp. 7–8.

31. J.P. Kennedy, ed., *The Story of the Film*, Chicago, IL: W. Shaw & Co., 1921, pp. 225–6.
32. Cecil Hepworth, *Came the Dawn: Memories of a Film Pioneer*, London: Phoenix House, 1951.
33. George Pearson, *Flashback: The Autobiography of a British Film-maker*, London: Allen & Unwin, 1957.
34. Charles Booth, *Life and Labour of the People in London*, Vol. 8, London: Macmillan, 1896, p. 124.
35. Ibid., p. 123.
36. Quoted in Michael Chanan, *Labour Power in the British Film Industry*, London: BFI, 1976, p. 36.
37. Cited in Chanan, *Repeated Takes*, p. 63.

4. COUNTERCURRENTS

1. Patricia Zimmermann, *Reel Families: A Social History of Amateur Film*, Bloomington, IN: Indiana University Press, 1995, pp. 7, 30.
2. See Michael Chanan, *The Dream That Kicks: The Prehistory and Early Years of Cinema in Britain*, Second edition, London: Routledge, 1996.
3. Zimmermann, *Reel Families*, p. 33.
4. Julio Antonio Mella, 'Octubre', Mexico: Tren Blindado, 928, reprinted in *Cine Cubano*, 54-5: 111–12.
5. A.L. Rees, *A History of Experimental Film and Video*, London: BFI, 1999, p. 32.
6. Bert Hogenkamp, *Deadly Parallels, Film and the Left in Britain 1929–39*, London: Lawrence & Wishart; 1986.
7. Armand Mattelart, *Mapping World Communication: War, Progress, Culture*, Minneapolis, MN: University of Minnesota Press, 1994, p. 61.
8. Walter Lippmann, *Liberty and the News*, New York: Harcourt, Brace & Howe, 1920, p. 37.
9. Erik Barnouw, *Documentary*, Oxford: Oxford University Press, 1974.
10. Alberto Cavalcanti in I. Aitken, *The Documentary Film Movement*, Edinburgh: Edinburgh University Press, 1988, p. 212.
11. Forsyth Hardy, *John Grierson: A Documentary Biography*, London: Faber and Faber, 1979, p. 80.
12. Harry Watt, *Don't Look at the Camera*, London: Elek Books, 1974, p. 47.
13. Quoted in Paul Rotha, *Documentary Diary*, London: Secker & Warburg, 1973, p. 157.
14. Walter Benjamin, 'The Work of Art in the Age of Mechanical Reproduction', in Hannah Arendt (ed.), *Illuminations*, New York: Schocken Books, 1969, p. 238.
15. Susan Buck-Morss, *The Dialectics of Seeing*, Cambridge, MA: MIT Press, 1991, p. 67.
16. Benjamin, 'The Work of Art in the Age of Mechanical Reproduction', p. 234.

17. *Bertolt Brecht on Film and Radio*, ed. and trans., Marc Silberman, London: Methuen, 2000, p. 161.
18. Kurt Weill, *Ausgewälte Schriften*, Frankfurt am Main: Suhrkamp, 1975, pp. 110–14.
19. Quoted in Kim Kowalke, *Kurt Weill in Europe*, Ann Arbor, MI: UMI Research Press, 1979, p. 487.
20. Weill to Universal Edition, 6 August 1930, in David Farneth, Elmar Juchem, and Dave Stein, *Kurt Weill: A Life inv Pictures and Documents*, New York: The Overlook Press, 1999, p. 112.
21. 'The Threepenny Lawsuit', in *Bertolt Brecht on Film and Radio*, pp. 147–99.
22. Ibid., p.153.
23. Jose Bellido, 'Experimenting with Law: Brecht on Copyright', *Law and Critique*, 31: 127–143, 2020, https://doi.org/10.1007/s10978-019-09256-5
24. *Bertolt Brecht on Film and Radio*, p. 180.
25. Ibid., p.191.
26. Ibid., p. 188.
27. Ibid., p. 196.
28. Ibid., p. 172.
29. Ibid., pp. 177–9.
30. 'Collective Presentation (1932)', *Screen*, 15(2): 43–44, 1974, quoted in Bellido, 'Experimenting with Law', p. 139.
31. Francis Newton, *The Jazz Scene*, London: Penguin, 1959, p. 172.
32. Billie Holiday, *Lady Sings the Blues*, London: Sphere Books, 1973, p. 166.
33. Ibid., p. 58.
34. Newton, *The Jazz Scene*, p. 170.
35. Ibid., p. 41.
36. Mike Hobart, 'The Political Economy of Bop', *Media, Culture & Society*, 3(3): 261–79, 1981.
37. Cited in ibid., p. 263.
38. Walter Benjamin, 'Moscow', in *One Way Street*, London: Verso, 1979, p. 195.
39. Hobart, 'The Political Economy of Bop', p. 267.
40. William Bruce Cameron, 'Sociological Notes on the Jam Session', *Social Forces*, 33(2), December: 179, 1954.
41. Hobart, 'The Political Economy of Bop', p. 278.
42. Newton, *The Jazz Scene*, p. 170.
43. www.thisismoney.co.uk/money/bills/article-1633409/Historic-inflation-calculator-value-money-changed-1900.html (consulted 7 June 2021).
44. Newton, *The Jazz Scene*, p. 172.
45. Ibid., p. 177.
46. Alejo Carpentier, *Ese musico que llevo dentro*, Vol. II, Havana: Editorial Letras Cubanas, 1980, pp. 245–6.
47. Steve Jones, *Rock Formation: Music, Technology and Mass Communication*, Los Angeles, CA and London: Sage, 1992, p. 171.
48. F.W. Gaisberg, *Music on Record*, London: Robert Hale, 1946, p. 58.

49. Wole Soyinka, *Aké*, London: Arrow, 1983, p. 108.

50. Pierre Monette, *Le guide du tango*, Paris: Syros/Alternatives, 1991, p. 54.

51. Dick Hebdige, *Cut 'n' Mix*, New York: Methuen, 1987.

52. Andrew Ross and Tricia Rose, eds, *Microphone Fiends*, London and New York: Routledge, 1994, p. 78.

53. Ibid., p. 82.

54. Interview with Frank Lee held in the British Library National Sound Archive. See *Developments in Recorded Sound: A Catalogue of Oral History Interviews*, London: The British Library, 1989, pp. 26–7.

55. Roland Gellatt, quoted in Michael Chanan, *Repeated Takes*, London: Verso, p. 98.

56. Quoted in M. Ali Issari and Doris A. Paul, 'What Is Cinéma Vérité?' *Scarecrow*: 7–8, 1979.

57. 'Adrian Mitchell's Guide to the Underground', *Guardian*, 12 October 1967.

58. Ibid.

59. Claude Degand, *Le cinema ... cette Industrie*, Paris: Editions Techniques et Economiques, 1972, pp. 134–5, cited in Simon Hartog, 'Introduction: The Estates General of the French Cinema, May 1968', *Screen*: 58–89, 1972.

60. Sylvia Harvey, *May '68 and Film Culture*, London: BFI, 1978, p. 19.

61. Enzensberger, 'Constituents of a Theory of the Media', in *Raids and Reconstructions*, London: Pluto Press, 1970, pp. 20–53.

62. Michael Chanan, 'The British Contingent in Montreal', *Canadian Journal of Film Studies*, 24(2): 96–108, 2015.

63. For an example, see Michael Chanan, *Cuban Cinema*, Minneapolis, MN: University of Minnesota Press, 2004, p. 91.

64. Fernando Solanas and Octavio Getino, 'Towards a Third Cinema', in Michaal Chanan (ed.), *Twenty-five Years of the New Latin American Cinema*, London: BFI/Channel Four Television, 1983, pp. 17–27.

65. Teshome Gabriel, *Third Cinema in the Third World: The Aesthetics of Liberation*, Ann Arbor, MI: UMI Research Press, 1982, and 'Towards a Critical Theory of Third World Films', *Third World Affairs*, 1985.

66. Laura Mulvey, 'Visual Pleasure and Narrative Cinema', *Screen*, 16(3): 6–18, 1975.

67. Alexander Walker, *Hollwood, England: The British Film Industry in the 60s*, London: Michael Joseph, 1973, pp .460–1.

68. Personal communication, Larry DeWaay, 1984.

69. Quoted in Benjamin, 'The Work of Art in the Age of Mechanical Reproduction', p. 219.

70. Raymond Williams, *Television: Technology and Cultural Form*, London: Fontana, 1974, p. 86.

71. Ibid., p. 90.

72. Jane Feuer, 'The Concept of Live Television: Ontology as Ideology', in E. Ann Kaplan (ed.), *Regarding Television*, Los Angeles, CA: American Film Institute, 1983, p. 15.

73. Siegfried Kracauer, ' Photography', *Critical Inquiry*, 19(3), Spring: 432, 1993.
74. J. Hoberman, *The Dream Life: Movies, Media, and the Mythology of the Sixties*, New York: New Press, 2003, p. 38.
75. David Graeber, *Bullshit Jobs*, London: Penguin Books, 2019, p. 184.
76. Ibid. p. 185.
77. Eric Hobsbawm, *Age of Extremes*, London: Michael Joseph, 1994, p. 280.
78. Fredric Jameson, Foreword to J.-F. Lyotard, *The Postmodern Condition: A Report on Knowledge*, Manchester: Manchester University Press, 1984, p. xv.

5. FROM ANALOG TO DIGITAL

1. Hans Magnus Enzensberger, *Mausoleum*, New York, Urizen Books, 1976, p. 75.
2. Peter Gabriel in *Music Technology*, August 1986, p. 20.
3. Jon Pareles, quoted in Steve Jones, *Rock Formation: Music, Technology and Mass Communication*, Los Angeles, CA and London: Sage, p. 168.
4. Simon Frith and Lee Marshall, 'Making Sense of Copyright', in Simon Frith and Lee Marshall (eds), *Music and Copyright*, Edinburgh: Edinburgh University Press, 2004, pp. 3–4.
5. Damon Krukowski, 'Making Cents', pitchfork.com/features/article/8993-the-cloud
6. Sean Cubitt, *Timeshift: On Video Culture*, New York: Routledge, 1991, p. 130.
7. Michael Chanan, 'Playing the Access Card', *New Socialist*, 50, June: 45, 1987.
8. Pat Aufderheide, 'Grassroots Video in Latin America', in *The Daily Planet: A Critic on the Capitalist Culture Beat*, Minneapolis, MN: University of Minnesota Press, 2000, pp. 257–73.
9. Freya Schiwy, *Indianising Film: Decolonisation, the Andes, and the Question of Technology*, New Brunswick, NJ: Rutgers University Press, 2009, p. 72.
10. Alberto López, quoted in Brian Goldfarb, 'Local Television and Community Politics in Brazil', in Chon Noriega (ed.), *Visible Nations, Latin American Cinema and Video*, Minneapolis, MN: University of Minnesota Press, 2000, p. 278.
11. Guy Standing, *The Precariat: The New Dangerous Class*, London: Bloomsbury, 2011, p. 144.
12. Mike Cooley, *Architect or Bee?*, Langley Technical Services, 1980, p. 8.
13. Ibid., p. 9.
14. Standing, *The Precariat*, p. 151.
15. Shoshana Zuboff, *The Age of Surveillance Capitalism*, London: Profile Books, 2019.
16. Jodi Dean, *Democracy and Other Neoliberal Fantasies: Communicative Capitalism and Left Politics*, 2009, e-book edition, location 454.
17. Ibid., location 509.
18. Ibid., location 524.
19. Ibid., location 699.

20. Nicholas Garnham, 'From Cultural to Creative Industries', *International Journal of Cultural Policy*, 11(1): 23, 2005.
21. John Harris, 'Cool Britannia: Where Did It All Go Wrong?', *New Statesman*, 1 May 2017, www.newstatesman.com/1997/2017/05/cool-britannia-where-did-it-all-go-wrong
22. Garnham, 'From Cultural to Creative Industries', p. 22.
23. Ibid., p. 15.
24. Ibid., p. 25.
25. Angela McRobbie, *Be Creative*, Cambridge: Polity Press, 2016, p. 29.
26. Ibid., p. 43.
27. Ibid., p. 37.
28. Andrew Ross, *Nice Work If You Can Get It*, New York: New York University Press, 2009, pp. 36–7.
29. Karl Marx and Frederick Engels, 'The Class Struggles in France, 1840 to 1850', in *Collected Works Vol. X*, London: Lawrence & Wishart, 1850, p. 62.
30. Karl Marx, The Eighteenth Brumaire of Louis Bonaparte, http://www.marxists.org/archive/marx/works/download/pdf/18th-Bru-maire.pdf, p. 38.
31. Eloisa Betti, 'Historicizing Precarious Work: Forty Years of Research in the Social Sciences and Humanities', IRSH, 63: 275, 2018.
32. Ibid., p. 279.
33. Standing, *The Precariat*.
34. David Graeber, 'The Sadness of Post-Workerism, or "Art and Immaterial Labour" Conference, A Sort of Review' (Tate Britain, Saturday 19 January, 2008)', libcom.org/library/sadness-post-workerism
35. Standing, *The Precariat*, p. 16.
36. Ibid., pp. 18, 87, 99.

6. CREATIVITY RECONSIDERED

1. M. Lazzarato, 'Immaterial Labour', in P. Paolo Virno and M. Hardt (eds), *Radical Thought in Italy*, Minneapolis, MN: University of Minnesota Press, 1996, www.generation-online.org/c/fcimmateriallabour3.htm
2. Ibid.
3. Michael Hardt and Antonio Negri, *Empire*, Cambridge, MA: Harvard University Press, 2000, p. 290.
4. Karl Marx, *Capital, Vol. III*, New York: Vintage, 1981, p. 199.
5. Paul Mason, *Why It's Kicking Off Everywhere*, London: Verso, 2012, p. 146.
6. Jodi Dean, *Democracy and Other Neoliberal Fantasies: Communicative Capitalism and Left Politics*, Durham and London: Duke University Press, 2009, e-book edition, location 1212.
7. *Bertolt Brecht on Film and Radio*, ed. and trans. Marc Silberman, London: Methuen, 2000, p. 43.

8. Andreas Wittel, 'Counter-commodification: The Economy of Contribution in the Digital Commons', *Culture and Organization*, 19(4): 325, 2013.

9. William Brown, 'The Lure of Becoming Cinema', in Ewa Mazierska and Lars Kristensen (eds), *Contemporary Cinema and Neoliberal Ideology*, New York: Routledge, 2018, p. 70.

10. See Marco D'Eramo, *The World in a Selfie: An Inquiry into the Tourist Age*, London: Verso, 2021.

11. David Graeber, *Bullshit Jobs*, London: Penguin Books, 2019.

12. Brown, 'The Lure of Becoming Cinema', p. 63.

13. Ibid., p. 64.

14. Ibid., p. 62.

15. Ibid., p. 67.

16. Graeber, *Bullshit Jobs*, p. 183.

17. Ibid., pp. 9–10.

18. Ibid., p. 38.

19. Ibid., p. 50.

20. Ibid., p. 17.

21. Ibid., p. 47.

22. Ibid., p. 55.

23. Ibid., p. 188.

24. Ibid., p. 191.

25. Lazzarato, 'Immaterial Labour'.

26. In Michael Chanan, dir., 'Secret City', 2012.

27. Mark Poster, The Mode of Information, Polity Press 1990, p. 111.

28. Benjamin, 1979, pp. 63–4.

29. Anoosh Chakelian, 'The patient comes first', New Statesman 8-14 Jan 2021, p. 37, review of Gavin Francis, *Intensive Care: A GP, a Community & Covid-19*.

30. Michael Chanan, dir., 'Money Puzzles', 2016.

31. Víctor F. Sampedro Blanco, ed., *13-M, Multitudes Online*, Madrid: Catarata, 2005; Cristina Flesher Fominaya, 'The Madrid Bombings and Popular Protest: Misinformation, Counter-information, Mobilisation and Elections after "11-M"', *Contemporary Social Science*, 6: 1–9, 2011.

32. Mason, *Why It's Kicking Off Everywhere*, p. 14.

33. Michael Chanan, dir., 'Chronicle of Protest', 2011.

34. Mason, *Why It's Kicking Off Everywhere*, p. 81.

35. Ron Burnett, *Cultures of Vision*, Bloomington, IN: Indiana University Press, 1995, p. 22.

36. Bill Nichols, in Michael Renov, *Theorising Documentary*, New York: Routledge, 1993, pp. 188–91.

37. Raymond Williams, *Keywords*, London: Fontana, 1976, p. 33.

38. Astra Taylor, *The People's Platform: Taking Back Power and Culture in the Digital Age*, London: Fourth Estate, 2014, p. 58.

39. Mike Cooley, 'Architect or Bee?', Langley Technical Services, 1980, p. 100.

40. Taylor, *The People's Platform*, p. 43.
41. Ibid., p. 141.
42. Ibid., p. 41.
43. Ibid, p. 41.
44. Elie Siegmeister, *Music and Society*, London: Workers Music Association, 1943, p. 7.

Bibliography

Websites last accessed 6 December 2021.

Adorno, Theodor W. 'Perennial Fashion – Jazz', in *Prisms*, London: Neville Spearman, 1967, pp. 119–32.

—— *The Culture Industry*, London: Routledge & Kegan Paul, 1991.

'Adrian Mitchell's Guide to the Underground', *Guardian*, 12 October 1967.

Aitken, I., ed., *The Documentary Film Movement: An Anthology*, Edinburgh: Edinburgh University Press, 1988.

Appadurai, Arjun, 'Introduction: Commodities and the Politics of Value', in Arjun Appadurai (ed.), *The Social Life of Things: Commodities in Cultural Perspective*, Cambridge: Cambridge University Press, 2014, pp. 3–63.

—— 'The Thing Itself', *Public Culture*, 18(1): 15–22, 2006.

Attali, Jacques, *Noise: The Political Economy of Music*, Minneapolis, MN: University of Minnesota Press, 1985.

Aufderheide, Pat, 'Grassroots Video in Latin America', in *The Daily Planet: A Critic on the Capitalist Culture Beat*, Minneapolis, MN: University of Minnesota Press, 2000, pp. 257–73.

Bachlin, Peter, *Histoire Economique du Cinéma*, Paris: La Nouvelle Edition, 1947.

Barnouw, Erik, *Documentary*, Oxford: Oxford University Press, 1974.

Barbaro, Umberto, *El film y el resarcimiento marxista de la arte*, Havana: Ediciones ICAIC, 1965.

Barthes, Roland, 'Musica Practica', in *Image-Music-Text*, London: Fontana/Collins, 1977, pp. 149–54.

Baumol, William, *The Cost Disease*, Yale University Press, e-book edition, 2012.

Baumol, W. and W. Bowen, *Performing Arts – the Economic Dilemma*, Cambridge, MA: MIT Press, 1968.

Beech, Dave, *Art and Value: Art's Economic Exceptionalism in Classical, Neoclassical and Marxist Economics*, Chicago, IL: Haymarket Books, 2016.

Bellido, Jose, 'Experimenting with Law: Brecht on Copyright', *Law and Critique*, 31: 127–43, 2020.

Benjamin, Walter, 'The Work of Art in the Age of Mechanical Reproduction', in Hannah Arendt (ed.), *Illuminations*, New York: Schocken Books, 1969, pp. 217–51.

—— 'A Small History of Photography', in *One-Way Street*, London: Verso, 1979.

—— *One Way Street*, London: Verso, 1979.

Betti, Eloisa, 'Historicizing Precarious Work: Forty Years of Research in the Social Sciences and Humanities', IRSH, 63, 2018.

Bianconi, Lorenzo, *Music in the Seventeenth Century*, New York: Cambridge University Press, 1987.

Blom, Eric, ed., *Mozart's Letters*, London: Penguin Books, 1956.

Booth, Charles, *Life and Labour of the People in London*, Vol. 8, London: Macmillan, 1896.

Bertolt Brecht on Film and Radio, ed. and trans. Marc Silberman, London: Methuen, 2000.

Breton, André and Paul Éluard, eds, *Dictionnaire abrégé du Surréalisme*, Paris: Galerie des Beaux-Arts, 1938.

Brown, William, 'The Lure of Becoming Cinema', in Ewa Mazierska and Lars Kristensen, (eds), *Contemporary Cinema and Neoliberal Ideology*, New York: Routledge, 2018, pp. 57–72.

Buck-Morss, Susan, *The Dialectics of Seeing*, Cambridge, MA: MIT Press, 1991.

Burch, Noel, *Life to Those Shadows*, Berkeley, CA: University of California Press, 1990.

Burnett, Ron, *Cultures of Vision*, Bloomington, IN: Indiana University Press, 1995.

Cameron, William Bruce, 'Sociological Notes on the Jam Session', *Social Forces*, 33(2), December: 177–82, 1954.

Carpentier, Alejo, *Ese musico que llevo dentro*, Vol. II, Havana: Editorial Letras Cubanas, 1980.

Cavell, Stanley, *The World Viewed*, New York: Viking Press, 1971.

Chakelian, Anoosh, 'The Patient Comes First', *New Statesman*, 8–14 January 2021.

Chanan, Michael, *Labour Power in the British Film Industry*, London: BFI, 1976.

—— ed., *Twenty-five Years of the New Latin American Cinema*, London: BFI/ Channel Four, 1983.

—— 'Playing the Access Card', *New Socialist*, 50, June 1987.

—— *Musica Practica: The Social Practice of Western Music from Gregorian Chant to Postmodernism*, London: Verso, 1994.

—— *Repeated Takes*, London: Verso, 1995.

—— *The Dream That Kicks: The Prehistory and Early Years of Cinema in Britain*, Second edition, London: Routledge, 1996.

—— *Cuban Cinema*, Minneapolis, MN: University of Minnesota Press, 2004.

—— 'The British Contingent in Montreal', *Canadian Journal of Film Studies*, 24(2), 2015.

Cooley, Mike, 'Architect or Bee?', Langley Technical Services, 1980.

Cubitt, Sean, *Timeshift: On Video Culture*, New York: Routledge, 1991.

D'Eramo, Marco, *The World in a Selfie: An Inquiry into the Tourist Age*, London: Verso, 2021.

Dean, Jodi, *Democracy and Other Neoliberal Fantasies: Communicative Capitalism and Left Politics*, Durham, NC and London: Duke University Press, e-book edition, 2009.

Developments in Recorded Sound: A Catalogue of Oral History Interviews, London: The British Library, 1989.

Eagleton, Terry, *Ideology*, London: Verso, 1991.

Edelman, Bernard, *Ownership of the Image: Elements for a Marxist Theory of Law*, London: Routledge & Kegan Paul, 1979.

Ehrlich, Cyril, *The Piano: A History*, London: Dent, 1976.

Eisenberg, Evan, *The Recording Angel*, London: Picador, 1988.

Enzensberger, Hans Magnus, 'Constituents of a Theory of the Media', in *Raids and Reconstructions*, London: Pluto Press, 1976, pp. 20–53.

—— *Mausoleum*, New York: Urizen Books, 1976.

Farneth, David, Elmar Juchem, and Dave Stein, *Kurt Weill: A Life in Pictures and Documents*, New York: The Overlook Press, 1999.

Febvre, Lucien and Henri-Jean Martin, *The Coming of the Book*, London: Verso, 1984.

Feuer, Jane, 'The Concept of Live Television: Ontology as Ideology', in E. Ann Kaplan (ed.), *Regarding Television*, Los Angeles, CA: American Film Institute, 1983, pp. 12–31.

Finnegan, Ruth, *The Hidden Musicians*, Cambridge: Cambridge University Press, 1989.

Fominaya, Cristina Flesher, 'The Madrid Bombings and Popular Protest: Misinformation, Counter-information, Mobilisation and Elections after "11-M"', *Contemporary Social Science*, 6: 1–9, 2011.

Fraser, Nacy, 'Rethinking the Public Sphere: A Contribution to the Critique of Actually Existing Democracy', *Social Text*, 25/26: 57, 1990.

Frith, Simon and Lee M arshall, 'Making Sense of Copyright', in Simon Frith and Lee Marshall (eds), *Music and Copyright*, Edinburgh: Edinburgh University Press, 2004, pp. 1–18.

Peter Gabriel in *Music Technology*, August 1986.

Teshome Gabriel, Teshome, *Third Cinema in the Third World: The Aesthetics of Liberation*. Ann Arbor, MI: UMI Research Press, 1982, pp. 355–69.

—— 'Towards a Critical Theory of Third World Films', *Third World Affairs*, 1985.

Gaisberg, F.W., *Music on Record*, London: Robert Hale, 1946.

García Canclini, Néstor, *Transforming Modernity: Popular Culture in Mexico*, Austin, TX: University of Texas Press, 1993.

García Espinosa, Julio, 'For an Imperfect Cinema', in Michael Chanan (ed.), *Twenty-five Years of the New Latin American Cinema*, London: BFI/Channel Four, 1983, pp. 28–33.

Garnham, Nicholas, 'From Cultural to Creative Industries', *International Journal of Cultural Policy*, 11(1): 15–29, 2005.

Goldfarb, Brian, 'Local Television and Community Politics in Brazil', in Chon Noriega (ed.), *Visible Nations: Latin American Cinema and Video*, Minneapolis, MN: University of Minnesota Press, 2000.

Graeber, David, 'The Sadness of Post-Workerism, or "Art and Immaterial Labour" Conference, A Sort of Review (Tate Britain, Saturday 19 January, 2008)', https://libcom.org/library/sadness-post-workerism

—— *Bullshit Jobs*, London: Penguin Books, 2019.

Guback, Thomas, *The International Film Industry*, Bloomington, IN: Indiana University Press, 1969.

Habermas, J., *The Structural Transformation of the Public Sphere: An Inquiry in to a Category of Bourgeois Society*, Cambridge, MA: MIT Press, 1989.

Hardt, Michael and Antonio Negri, *Empire*, Cambridge, MA: Harvard University Press, 2000.

Hardy, Forsyth, *John Grierson: A Documentary Biography*, London: Faber and Faber, 1979.

Harris, John, 'Cool Britannia: Where Did It All Go Wrong?', *New Statesman*, 1 May 2017, www.newstatesman.com/1997/2017/05/cool-britannia-where-did-it-all-go-wrong

Hartog, Simon, 'Introduction: The Estates General of the French Cinema, May 1968', *Screen*, money as art: 58–89, 1972.

Harvey, David, *Marx, Capital and the Madness of Economic Reason*. Profile. Kindle edition.

Harvey, Sylvia, *May '68 and Film Culture*, London: BFI, 1978.

Haug, W.F., *Critique of Commodity Aesthetics*, Cambridge: Polity Press, 1986.

Hebdige, Dick, *Cut 'n' Mix*, New York: Methuen, 1987.

Hepworth, Cecil, *Came the Dawn: Memories of a Film Pioneer*, London: Phoenix House, 1951.

Hobart, Mike, 'The Political Economy of Bop', *Media, Culture & Society*, 3(3): 261–79, 1981.

Hoberman, J., *The Dream Life: Movies, Media, and the Mythology of the Sixties*, New York: New Press, 2003.

Hobsbawm, Eric, *Age of Empire*, London: Weidenfeld & Nicolson, 1987.

—— *Age of Extremes*, London: Michael Joseph, 1994.

Hogenkamp, Bert, *Deadly Parallels: Film and the Left in Britain 1929–39*, London: Lawrence & Wishart, 1986.

Holiday, Billie, *Lady Sings the Blues*, London: Sphere Books, 1973.

Issari, M. Ali and Doris A. Paul, *What is Cinéma Vérité?* Metuchen, NJ: Scarecrow Press, 1979.

Jablonski, Edward and Lawrence Stewart, *The Gershwin Years*, New York: Da Capo Press, 1996.

Jameson, Frederic, *Marxism and Form*, Princeton, NJ: Princeton University Press, 1974.

—— Foreword to J.-F. Lyotard, *The Postmodern Condition: A Report on Knowledge*, Manchester: Manchester University Press, 1984.

—— *The Cultural Turn*, London and New York: Verso 1998.

—— 'The Future of the City', *New Left Review*, 21, 2003.

Jones, Steve, *Rock Formation: Music, Technology and Mass Communication*, Los Angeles, CA and London: Sage, 1992.

Kennedy, J.P., ed., *The Story of the Film*, W. Chicago, IL: Shaw & Co., 1921.

Kittler, Friedrich, *Gramophone, Film, Typewriter*, Stanford, CA: Stanford University Press, 1999.

Kowalke, Kim, *Kurt Weill in Europe*, Ann Arbor, MI: UMI Research Press, 1979.

Kracauer, Siegfried, 'Photography', *Critical Inquiry*, 19(3), Spring: 421–36, 1993.

Krukowski, Damon, 'Making Cents', pitchfork.com/features/article/8993-the-cloud

Lapavitsas, Costas, 'Money as Art: The Form, the Material, and Capital', in *Marxist Monetary Theory: Collected Papers*, Chicago, IL: Haymarket Books, 2017, pp. 1–20.

Lazzarato, M. (1996). 'Immaterial Labour', in P. Paolo Virno and M. Hardt (eds), *Radical Thought in Italy*, Minneapolis, MN: University of Minnesota Press, www.generation-online.org/c/fcimmateriallabour3.htm

Lindley, Mark, 'Marx and Engels on Music', *Monthly Review*, 18 August 2010.

Lippmann, Walter, *Liberty and the News*, New York: Harcourt, Brace & Howe, 1920.

Loesser, Arthur, *Men, Women and Pianos*, New York: Simon & Schuster, 1954.

Manifesto for an Independent Revolutionary Art, 1938, www.marxists.org/subject/art/lit_crit/works/rivera/manifesto.htm

Marcuse, Herbert, *Reason & Revolution*, Part II, I. 4, www.marxists.org/reference/archive/marcuse/works/reason/ch02-4.htm

Martin, G.H. and David Francis, 'The Camera's Eye', in H.J. Dyos and M. Wolff (eds), *The Victorian City: Images and Realities*, London: Routledge & Kegan Paul, 1977.

Martin, Linda and Kerry Segrave, *Anti-Rock*, New York: Da Capo, 1993.

Marx, Karl, Letter to Engels, 28 January 1863, http://hiaw.org/defcon6/works/1863/letters/63_01_28.html

—— *Early Writings*, ed. T. Bottomore, London: Watts, 1963.

—— *The Economic & Philosophic Manuscripts of 1844*, New York: International Publishers, 1964.

—— *Theories of Surplus Value, Part I*, London: Lawrence & Wishart, 1969.

—— *Capital, Vol. I*, London: Lawrence & Wishart, 1970.

—— *A Contribution to the Critique of Political Economy*, London: Lawrence & Wishart, 1971.

—— *Capital, Vol. III*, London: Lawrence & Wishart, 1972.

—— *Grundrisse*, London: Penguin, 1973.

—— *Capital, Vol. III*, New York: Vintage, 1981.

—— Critique of the Gotha Programme, www.marxists.org/archive/marx/works/1875/gotha/ch01.htm

—— The Eighteenth Brumaire of Louis Bonaparte, www.marxists.org/archive/marx/works/download/pdf/18th-Brumaire.pdf

Karl Marx and Friedrich Engels, *Manifesto of the Communist Party*.

—— The German Ideology, www.marxists.org/archive/marx/works/1845/german-ideology/ch03l.htm

—— The Class Struggles in France, 1840 to 1850, in *Collected Works, Vol. X*, London: Lawrence & Wishart, 1850.

—— *Collected Works, Vol. XL*, London: Lawrence & Wishart, 1975–2001, p. 93.

Mason, Paul, *Why It's Kicking Off Everywhere*, London: Verso, 2012.

Mattelart, Armand, *Mapping World Communication: War, Progress, Culture*, Minneapolis, MN: University of Minnesota Press, 1994.

Mattelart, Armand and Michèle, *De L'Usage des Media en temps de crise*, Paris: Editions Alain Moreau, 1979.

McRobbie, Angela, *Be Creative*, Cambridge: Polity Press, 2016.

Mella, Julio Antonio, 'Octubre', Mexico: Tren Blindado, 1928, reprinted in *Cine Cubano*, 54–5: 111–12.

Monette, Pierre, *Le guide du tango*, Paris: Syros/Alternatives, 1991.

Müller-Doohm, Stefan, *Adorno: A Biography*, Cambridge: Polity Press, 2005.

Mulvey, Laura, 'Visual Pleasure and Narrative Cinema', *Screen*, 16(3): 6–18, 1975.

Newton, Francis, *The Jazz Scene*, London: Penguin, 1959.

Orwell, George, 'Books vs. Cigarettes', *Tribune*, 8 February 1946, www.orwell foundation.com/the-orwell-foundation/orwell/essays-and-other-works/books-vs-cigarettes

Pearson, George, *Flashback: The Autobiography of a British Film-maker*, London: Allen & Unwin, 1957.

Poster, Mark, *The Mode of Information*, Cambridge: Polity Press, 1990.

Prawer, S.S., *Karl Marx and World Literature*, New York and London: Oxford University Press, 1978.

Rees, A.L., *A History of Experimental Film and Video*, London: BFI, 1999.

Renov, Michael, *Theorising Documentary*, New York: Routledge, 1993.

Rose, Mark, *Authors and Owners: The Invention of Copyright*, Cambridge, MA: Harvard University Press, 1993.

Ross, Andrew, *Nice Work If You Can Get It*, New York: New York University Press, 2009.

Ross, Andrew and Tricia Rose, eds, *Microphone Fiends*, London and New York: Routledge, 1994.

Roth, Ernest, *The Business of Music*, London: Cassell, 1969.

Rotha, Paul, *Documentary Diary*, London: Secker & Warburg, 1973.

Sampedro Blanco, Víctor F., ed., *13-M, Multitudes on-line*, Madrid: Catarata, 2005.

Sánchez Vázquez, Adolfmo, *Art and Society: Essays in Marxist Aesthetics*, London: Merlin Press, 1973.

Schiller, Friedrich, *On the Aesthetic Education of Man*, Oxford: Clarendon Press, 1967.

Schiwy, Freya, *Indianising Film: Decolonisation, the Andes, & the Question of Technology*, New Brunswick, NJ: Rutgers University Press, 2009.

Siegmeister, Elie, *Music and Society*, London: Workers Music Association, 1943.

Small, Christopher, *Music of the Common Tongue*, London and New York: Calder and Riverrun Press, 1987.

—— *Musicking*, Wesleyan University Press, Hanover and London, 1998.

Smith, Adam, *The Wealth of Nations*, London: Everyman's Library, 1991.

Solanas, Fernando and Octavio Getino, 'Towards a Third Cinema', in Michaal Chanan (ed.), *Twenty-five Years of the New Latin American Cinema*, London: BFI/Channel Four Television, 1983, pp. 17–27.

Soyinka, Wole, *Aké*, London: Arrow, 1983.

Standing, Guy, *The Precariat: The New Dangerous Class*, London: Bloomsbury, 2011.

Taylor, Astra, *The People's Platform: Taking Back Power and Culture in the Digital Age*, London: Fourth Estate, 2014.

Thompson, E.P., 'Time, Work-Discipline, and Industrial Capitalism', *Past & Present*, 38: 56–97, 1967.

Thompson, Peter, 'The Frankfurt School, Part 2: Negative Dialectics', *Guardian*, 1 April 2013, www.theguardian.com/commentisfree/2013/apr/01/negative-dialectics-frankfurt-school-adorno

Turner, E.S., *The Shocking History of Advertising*, Harmondsworth, UK: Penguin, 1965.

Voices Now Big Choral Census July 2017, http://voicesnow.org.uk/wp-content/uploads/2017/07/Voices-Now-Big-Choral- Census-July-2017-1.pdf

Walker, Alexander, *Hollwood, England: The British Film Industry in the 60s*, London: Michael Joseph, 1973.

Watt, Harry, *Don't Look at the Camera*, London: Elek Books, 1974.

Weber, William, *Music and the Middle Classes*, London: Croom Helm, 1975.

Weill, Kurt, *Ausgewälte Schriften*, Frankfurt am Main: Suhrkamp, 1975.

Williams, Raymond, *Television: Technology and Cultural Form*, London: Fontana, 1974.

—— *Keywords*, London: Fontana, 1976.

Winston, Brian, *Misunderstanding Media*, London: Routledge & Kegan Paul, 1986.

Wittel, Andreas, 'Counter-commodification: The Economy of Contribution in the Digital Commons', *Culture and Organization*, 19(4): 325, 2013.

Zimmermann, Patricia, *Reel Families: A Social History of Amateur Film*, Bloomington, IN: Indiana University Press, 1995.

Zuboff, Shoshana, *The Age of Surveillance Capitalism*, London: Profile Books, 2019.

Index

Thanks to our Patreon subscribers:

Andrew Perry
Ciaran Kane

Who have shown generosity and
comradeship in support of our publishing.

Check out the other perks you get by subscribing
to our Patreon – visit patreon.com/plutopress.
Subscriptions start from £3 a month.

The Pluto Press Newsletter

Hello friend of Pluto!

Want to stay on top of the best radical books
we publish?

Then sign up to be the first to hear about our
new books, as well as special events,
podcasts and videos.

You'll also get 50% off your first order with us
when you sign up.

Come and join us!

Go to bit.ly/PlutoNewsletter